Monet

Monet

Sandro Sproccati

CHARTWELL
BOOKS

This edition published in 2004 by
CHARTWELL BOOKS
A division of BOOK SALES, INC.
114 Northfield Avenue
Edison, New Jersey 08837

Translated by Richard Pierce

ISBN 0-7858-0200-2

Typeset in Italy by FOTO.CO.L. Service, San Martino Buon Albergo, Verona
Printed and bound in Spain by Artes Gráficas Toledo S.A.U.
D.L. TO-72-2004

CONTENTS

PREFACE

Claude Monet is commonly considered the most consistent and representative Impressionist artist. Obviously one cannot but share this opinion: his Impression, Sunrise, *executed in 1874, inspired the "official" name of this movement, and his canvases exude that* joie de vivre *that is somewhat superficially regarded as the essence of Impressionism. But Monet's role in the history of modern art lies elsewhere; it is much more far-reaching and meaningful; it transcends the bounds of nineteenth-century art and, naturally, the sphere of the movement that his name symbolizes.*

His oeuvre not only goes well beyond Impressionism from a chronological standpoint (his art was innovative and vital up to his death in 1926), but even in the early period, from 1865 to 1880, it tended to follow its own course and was only one of the half-dozen most important expressions of Impressionist art. So in order to grasp the value and breadth of Monet's place, we would do well to note that it embodies a grandiose undertaking that leads straight to the heart of twentieth-century art. Monet's oeuvre reveals a total awareness of the impasse of classical representation *and an all-embracing effort to solve this problem in a modern key: by verifying the psychological factors central to artistic vision, without which art is mere convention and deception.*

The concept of painting as the difficulty of perception and immersion in the subject (in which the distance that tempers the relationship with the world is abolished, as it were) stems from a similar critical consciousness that Monet was the first to experience in all its dramatic import. Fog, smoke, illusory manifestations of matter, the reflection and refraction of light, atmospheric conditions and other phenomena that obstruct or disturb sight – all make the painter's task all the more difficult as he challenges nature in the steadfast conviction that this is a decisive procedure that will perhaps allow him to grasp the very meaning and aim of pictorial language. A highly controversial procedure, to be sure, that questions the cognitive value of the image, which would seem to be an elementary matter but for Monet was extremely problematic. And thus the image becomes the fruit – albeit slightly bitter – of the struggle with perception, an ambiguous and precarious achievement much like the creative breakthroughs realized in the novels of Henry James, Marcel Proust, James Joyce and Franz Kafka. Monet is to be set alongside these writers and a few painters – Cézanne, van Gogh, Matisse, Duchamp and, to some extent, Picasso – to take his well deserved place as one of the true founders of modern artistic sensibility.

Sandro Sproccati

THE PAINTER OF LIGHT

The capital of the nineteenth century

The life of Claude Monet spans 85 years of European history – from 1840 to 1926. Thanks to his longevity and prolific energy, he forms a sort of ideal link between the late Romantic period and twentieth-century avant-garde art. From 1865 on Monet's temperament and strength can be seen to represent if not all modern art, at least its principal course, which begins with the crisis of Realism as expressed in the "excesses" of Impressionism, passing through the Impressionist revolution and eventually paving the way for twentieth-century abstract sensibility.

At the time Monet was born, the artistic atmosphere in Paris was still dominated by the aesthetic theories of Jacques-Louis David, who had died in 1825, and Jean-Auguste-Dominique Ingres, who died in 1867. This atmosphere was therefore already overripe and dormant, virtually sterile. The only exceptions to this general state of lethargy were the explosive presence of Eugène Delacroix, the most important French Romantic painter, and the slow rise of the new Naturalist school, whose exponents were still practically unknown. So it should come as no surprise that Monet's first teacher in 1856 at Le Havre was a follower of David: Jacques-François Ochard, who interested his sixteen year-old pupil only for his technical skill. Apart from this, it is obvious that neither the epic manner of David, the official "chronicler" of both the Jacobin revolution and of Napoleon's achievements, nor Ingres's smooth, almost sculptural style marked by cold formal perfection, could really subjugate a burgeoning painter like Monet who was nurturing a secret flame of genius and license, merely waiting for the opportune moment and the right stimuli to transform

this flame into a powerful, all-consuming fire.

In 1925, by the time Monet's vision had reached its fulfillment and his career was drawing to a close, the world of art had fundamentally changed and the concept of artistic creation had taken on a totally new meaning. The cause of this momentous change cannot be ascribed only to Monet, or to any other of his peers, such as Cézanne or van Gogh. It was too great, too all-encompassing, to be effected by individual artists united by their common aims and style into a movement. This was part of a drastic, wide-ranging phenomenon, a vast social and economic upheaval that revolutionized modern Western life at all levels, a crisis that affected many different structures and institutions, be they political, religious or merely symbolic. Society was changing

Above: Jacques-Louis David, Portrait of Madame Récamier, *1800; oil on canvas; 170 × 240 cm / 66 × 93½ in); Musée du Louvre, Paris. Neoclassicism, which permeated early nineteenth-century*

French culture, is exemplified in this painting that became a sort of prototype for many other works executed in this period. Monet became acquainted with David's style through his teacher Ochard, but almost immediately rejected it.

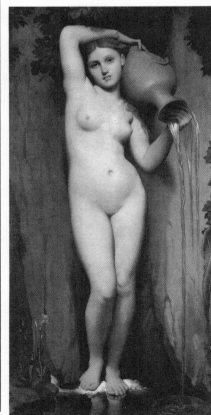

Left: Jean-Auguste-Dominique Ingres, La Source, *1856; oil on canvas; 163 × 80 cm (63½ × 31 in); Musée d'Orsay, Paris. Ingres's late works help us to understand what forms of Neoclassicism survived in nineteenth-century society. This painting displays*

three crucial elements: the Neoclassical taste Napoleon III's regime reproposed as the "official," obligatory stamp of academic art; a touch of light, mythological and exotic romanticism, in which Ingres excelled, and a certain symbolic interpretation of the narrative contents.

rapidly. The dramatic strides taken by the progress of technology and the concomitant creation of an ideological framework to justify such progress, and render its negative aspects more acceptable, went hand in hand with a shift in power from the sovereign figure to money and a shift in value from property to goods. Like everything else, the world of art was caught up in this ferment, as artists looked for change, and the work of art, which had formerly been an instrument of the social status quo, now became a platform for social comment and criticism.

The importance of the artistic and literary output of the early twentieth century – from Braque and Picasso's Cubist works to the novels of James Joyce, from Marcel Duchamp's "readymades" to Mondrian's geometrical compositions – stems precisely from this new dimension of poetic and creative activity, which contemplates the inexhaustible need for novelty, a lack of faith in traditional styles and language and their descriptive, imitative faculties, the rejection of the work of art as an apologia of the powers that be (either religious or political) and, consequently, the concept of art as a criticism of society, if not actually a pure act of revolt. In the last stage of his life Monet witnessed a continuous explosion

of aesthetic "revolutions" that followed one another in quick succession, the various artistic movements outdistancing one another as they came into being, dominated the art scene for a while, and were then soon outmoded.

It was at the ouset of his career, soon after the mid 1850s, that the groundwork for this future artistic turmoil was laid. This period saw the emegence of a new concept of art understood as an investigation into the destiny and aims of creative activity in which creation is characterized as research into its own meaning, its own confines, its own vital space. The historical role of the artist was disoriented and led astray by new and problematical social-economic

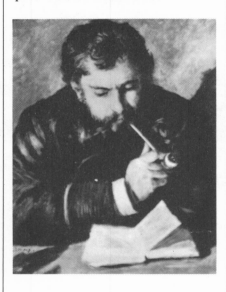

Above: Pierre-Auguste Renoir, Claude Monet, 1872; oil on canvas; 60 × 48 cm (23½ × 18¾ in); Mr. and Mrs. Paul Mellon Collection, Upperville, Va. Monet and Renoir's work

companionship dates from about ten years before the execution of this work. They met in the studio of their teacher Charles Gleyre a short time after Monet had returned from Algeria.

Right: Eugène Delacroix, The Death of Sardanapalus, 1827; oil on canvas; 395 × 495 cm (155½ × 193 in); Musée du Louvre, Paris. This famous painting is one of the most symptomatic expressions of Delacroix's "neo-Baroque"

aesthetic – a highly personal interpretation of Romanticism, quite morbid and steeped in decadent literary motifs and therefore venerated by Baudelaire and the young artists like Monet who were developing their personal styles in the late 1850s.

conditions.

Monet was one of the most attentive and receptive witnesses to the problems of the age. When the first Exposition Universelle was held in Paris in 1855, he had already been in Le Havre for ten years. He had lived in Paris during his early childhood, up to 1845, and returned to complete his painting studies only in 1859. But in this crucial period the new atmosphere in the capital was spreading rapidly throughout France and nurtured the experiences of the innovators of the day: Courbet, Millet, Corot, Delacroix, Daubigny – as well as younger painters such as Manet, Pissarro and Degas. All these artistic experiences were united in their rejection of the religious and political themes that had played such an important part in Neoclassical art and in Romantic painting.

Never before had artists felt such a desire for nature. In France during the Second Empire, landscape became in a certain sense the only subject worthy of being painted. The most modern Romantics (Delacroix and Corot) as well as the most courageous pioneers cultivated landscape painting both lovingly and tenaciously. Gustave Courbet, the leading artist of the Realist movement, succeeded in interpreting nature and, above all, matter and physical tangibility, as all-encompassing metaphors of the human soul; Jean-François Millet rediscovered in the honest simplicity of peasant life – with its spontaneous feelings and gestures – the poetry of an almost "religious" type of painting by then already quite out of fashion. And even Honoré Daumier's caricatures,

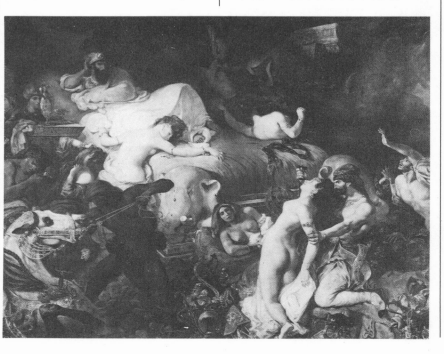

though allergic to this pursuit of the countryside, reveal a revived faith in the lifelike descriptive power of painting.

What had happened? In brief, the aesthetic of Naturalism also originated as a rejection of the transformations imposed by the new industrial society. Other factors in its development were the growing influence of science, the burgeoning democratic and materialistic theories and the advances made by social and ethnological studies. At the base of all this was the conviction that pictorial language was able to produce truth. In this regard we need only think of the role played, from 1850 on, by such a "scientific" invention as photography which is so intimately connected to the idea of an optical rendering of the concrete object. By means of the accepted forms of representation in perspective, painting was also called upon to capture the real and return it emotionally invigorated but intact to the viewer.

The 1855 Exposition Universelle was of crucial importance. Perhaps the person who best understood its significance, especially with regard to the new situation of the artistic product, was the poet and critic Charles Baudelaire, a pivotal figure in nineteenth-century culture. As Walter Benjamin said, he was first to realize, in the most meaningful manner, that "the bourgeoisie was about to revoke its commission with the poet." Baudelaire noted a curious phenomenon: despite appearances, in the pavilions of that immense fair, in the midst of that grand array of products of every kind, the works of art had the same value as all the other

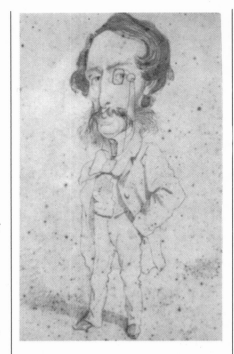

Above: Claude Monet, Caricature of Jacques-François Ochard, c. 1856; 32 × 24 cm (12⅝ × 9¼ in); The Art Insitute, Chicago. Ochard was Monet's first art teacher. From

1855 to 1859 the young artist produced many caricatures of his friends and acquaintances at Le Havre and almost always managed to sell them at a good price.

objects on exhibit; they too were "merchandise," commodities produced for the market (or even conceived so as to generate their very own market); that is to say, they were objects for sale. The artist had to come to terms with a harsh reality: he had lost an age-old privilege, his position vis-à-vis the powers that be. He could no longer create on commission; his work was no longer requested before being produced; now his task consisted in creating objects (the work of art) that sprang solely from his own sovereign will to create and were only later put on display for potential buyers to see. Thus the "art market" was born, and the Parisian Salons were its prototype. Baudelaire was a shrewd and painstaking critic. In his articles on the 1845, 1846 and 1855 Salons he dwells on the role of the artist in modern society, from which he derived a new concept of aesthetics: "The Beautiful contains both an element of the eternal, which is invariable and the

dimensions of which are hard to determine, and a relative, transitory element which, if you will, consists, in turn or all together, of the changing modes, morality and passions of the time." The "relativity" of beauty, its transitory, contingent truth, stems from its being the result not of an eternal, socially established necessity, but of the artist's will that is ever-changing because it individual. Thus, Baudelaire adds, "the Beautiful is always bizarre." In the new industrialized capitalist civilization, commodities must be put on display; only then could they be purchased and take on value. In order for goods to correspond to a certain amount of money and acquire a precise social meaning, a need and demand must

be created for them; they must be exhibited in a brash, aggressive manner – by means of the showcase, the market and publicity. Art, too, became a commodity among commodities. It would not be possible to understand the delicate transition from the expressions of the Romantic Sublime to the secular and non-ideological images of Impressionist painting without bearing these historical facts in mind. When artists such as Cézanne, Degas or even Monet himself began to make the meaning of painting dovetail with the in-depth study of the subject (taken as the totality of matter, light and atmosphere) in its optical relations to the forms of the painting, they availed themselves of the

Above: Camille Corot, The Hôtel Cabassus at Ville d'Avray, *1834-40; oil on canvas; 28 × 40 cm (11 × 15¾ in); Musée du Louvre, Paris. During the entire late Romantic* *period Corot's art was the most evident anticipation of the moderate Impressionism of Sisley, Bazille, Pissarro and, to some degree, Monet in his earliest phase.*

Below: Gustave Courbet, Le vieux pont *(The Old Bridge), c. 1850; oil on canvas;* *60 × 73 cm (22⅞ × 28¾ in); Musée des Beaux-Arts, Algiers.*

possibility to choose, day by day, the themes to be painted and the techniques to be adopted, in complete freedom from external conditioning. Commissions no longer existed, the artist was no longer obliged to represent official or significant subjects, and a Cézanne for example could paint the same motif – the banal landscape near Aix-en-Provence with Mt. Sainte-Victoire – time and time again to plumb the depths of its potential compositional values. To sum up, the atmosphere that was paving the way for Impressionism in France was marked in equal measure by the realist escape to the countryside and by the new urban dimension of the art market, the Salons and exhibitions. And both these phenomena stemmed from the fact that art had lost its centuries-old role. In addition, the very foundations of nineteenth-century Naturalism, even in its literary version as embodied by the

Delacroix's Art

Eugène Delacroix, Jacob Wrestling with the Angel, *1849-61; mural painting: oil and wax; 714 × 488 cm (281 × 191 in);* *Saint-Sulpice Church, Paris. The poet and critic Charles Baudelaire was baptized in Saint-Sulpice in 1821.*

The Romantic painter Eugène Delacroix (1798-1863) inspired Baudelaire to express some of the most brilliant nineteenth-century art criticism. After observing certain paintings by Delacroix in the 1855 Exposition Universelle, Baudelaire conceived the possibility of a "modern" art set free from the imitation of nature and/or "reality". "First of all," he writes, "it is to be noted – and this is very important – that even at a distance too great for the spectator to be able to analyze or even to comprehend its subject-matter, a picture by Delacroix will already have produced a rich, joyful or melancholy impression upon the soul. It almost seems as though this kind of painting, like a magician or a hypnotist, can project its thought at a distance. This curious phenomenon results from the colourist's special power, from the perfect concord of his tones and from the harmony, which is pre-established in the painter's mind, between colour and subject-matter. If the reader will pardon a stratagem of language [used] in order to express an idea of some subtlety, it seems to me that M. Delacroix's colour thinks for itself, independently of the objects which it clothes. Further, these wonderful chords of colour often give one ideas of melody and harmony, and the impression that one takes away from his picture is often, as it were, a musical one." Here we are told that an understanding of the "theme" is not indispensable for a reading of the work; that the artist's ability and knowledge, his skill in manipulating the laws and techniques of painting (the harmony of tones, the power

of the colours, the way they blend, the impressions of melody, etc.) can by themselves create an inner coherence and structural perfection in the work of art. In this case, the painting can "project its thought at a distance." In other words, the painting's worth is an autonomous, self-sufficient mechanism independent from the objects the colour "clothes."
The poet then reminds us: "The right way to know if a picture is melodious is to look at it from far enough away to make it impossible to understand its subject or to distinguish its lines. If it is melodious, it already has meaning and has already taken its place in your store of memories." To be able to appraise a painting equally well if not even better, at a distance, despite being unable to discern the subject clearly is a concept of appreciation totally analogous to the one that informs Monet's mature works; instead of being observed from a single viewpoint, as is the case with Renaissance painting, these works must be viewed by moving round them in a trajectory so that the image is destroyed and then recreated alternately before the onlooker. In the light of such an experience, typical for example of Monet's Water Lilies, *another statement made by Baudelaire (also referring to Delacroix, in his essay on the 1846 Salon) takes on further meaning: "A picture is a machine, all of whose systems of construction are intelligible to the practised eye; in which everything justifies its existence, if the picture is a good one; where one tone is always planned to make the most of another; and where an occasional fault in drawing is sometimes necessary, so as to avoid sacrificing something more important." Apart from the fact that this implies an aesthetic that is already totally "abstract" in concept, this statement takes on meaning as a sort of preamble of Impressionist sensibility, a declaration of an implicit convergence between the work of Delacroix and Monet.*

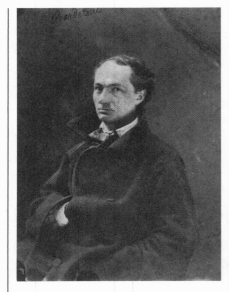

Left: Nadar, Portrait of Charles Baudelaire, *c. 1863. This is one of the best photographs of the great French poet and is at the same time one of Nadar's most successful works.*

Baudelaire's classical expression of melancholic boredom and spleen was caused by the intense physical suffering he went through towards the end of his life.

Below: Jean-François Millet, Gleaners, *1857; oil on canvas; 83.5 × 111 cm (33 × 44 in); Musée d'Orsay, Paris. As in* Angelus *and* The Sower, *Millet's*

original and skilful use of light renders that ideal of the "epic" representation of peasant life and labour that was a pivotal point of his realism.

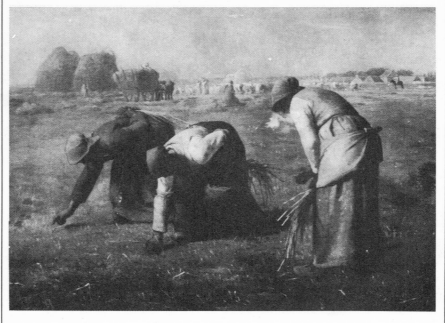

Goncourt brothers, underscore the ambiguity of the iron-clad relationship between the dynamic life of the metropolis and the yearning for the uncontaminated world of nature. The following passage from the Goncourt brothers' *Journal* illustrates this feeling: "I return on foot from rue d'Amsterdam to Auteuil through the crowd. A mauve sky, in which the artificial lights seem to reflect a huge fire – the noise of footsteps makes one think of an immense river flowing – the crowd all in black, black like burnt paper, with a dash of red, so characteristic of modern crowds [...] Place de la Concorde: the apotheosis of white light in the middle of which the obelisk stands out with its champagne sherbet colour. The Eiffel Tower was like a lighthouse abandoned by an extinct generation, a generation of giants." This is a magnificent painting in words of the almost magical aura that emanated from the urban forest that was Paris at this time. From 1855 to 1870, the period when Monet's painting was slowly becoming known and acquiring its own style, Paris was going through great difficulties, both spiritual and physical. The city was writhing under the pressure of Napoleon III's grandiose architectural and town planning projects, while at the same time extending its tentacles outward. The metropolis was spreading in all directions, overrunning the surrounding woods and forests, at times destroying them and at others absorbing them in a chain of peripheral "blisters." And the city was also contaminating the lovely, melancholy villages celebrated in the verses of Gérard de Nerval, the last of the Romantic poets and the first modern one.

The idea of the crowd, the true soul of the contemporary city, was one of the most significant concepts of the time. The masses revealed all their awesome magnitude from the time Baron Haussmann, on the Emperor's orders, gutted the heart of Paris, creating vast spaces throbbing with light and bustling crowds. The boulevards, the new conduits conveying the increasingly overwhelming surge of humanity, redefined the structure of the capital.

Baudelaire is certainly the most qualified source for an understanding of the formidable central role played by the city masses in the evolution of creative styles at this time. He elaborated on Edgar Allan Poe's idea of the present-day individual as a "man in the crowd" who roams about in continuous, inebriating contact with millions of other human beings, anonymous like him; a person who finds his true cultural and anthropological status in his lot as a mere number in an indifferent, one-dimensional world. In his essay *Le peintre de la vie moderne* (The Painter of Modern Life), devoted to the artist Constantin Guys and published in 1863, Baudelaire outlined a theory of art as the faculty of capturing reality while it is taking place in its daily, immanent form – an "impressionist" skill, as it were. He

launched an impassioned attack against the academic vice of drawing on old models to analyze contemporary subjects, and asserted the urgent need for a kind of painting that would be capable of grasping and exalting "the beauty and harmony of life in the capital cities, a harmony opportunely preserved amidst the turmoil of human liberty."

From this standpoint even fashion, which was to become so dear to the *fin de siècle* artists, is the "mantle of modern beauty" and betokens that fugitive, intimately ephemeral element without which no aesthetic virtue can exist. The Goncourt brothers also confirm this in presenting the aims of their famous *Journal*, when they point out that they have "portrayed the men and women in the light of a certain day or hour [...] by showing them at intervals in different guises in accordance with their various changes, and by trying not to imitate those memorialists who present their historical figures "carved in stone" or with colours made cold by detachment..." The Goncourt brothers viewed life with what was clearly an Impressionist mentality, "with the aim of representing men, so mutable, in their momentary truth [...] with those inevitable nuances that restore the intensity of life – and lastly, by taking note of the fever that so characterizes the intoxicating existence of Paris."

Below: Constantin Guys, Champs-Elysées, *c. 1860; Musée du Petit Palais, Paris. Guys was born in the Netherlands in 1805 and moved first to London and later to Paris. He inspired Baudelaire's famous essay* Le peintre de la vie

moderne (The Painter of Modern Life, 1863) and although his oeuvre was not very interesting from an art-historical point of view, it faithfully documented the various aspects of mid nineteenth-century European high society.

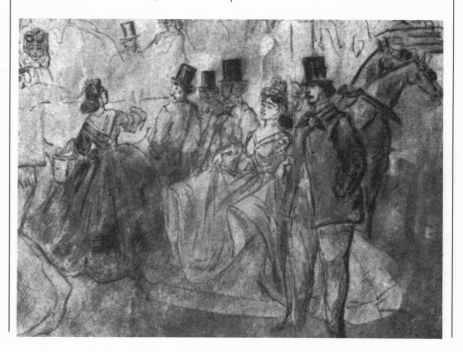

The Streets of Paris

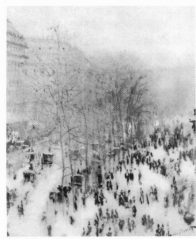

Claude Monet, Boulevard des Capucines, 1873; oil on canvas; 79.4 × 59 cm (31¼ × 23¼ in); The Nelson-Atkins Museum of Art,

Kansas City. This is one of the two paintings Monet devoted to this elegant Parisian boulevard. Both works teem with vitality.

The spiritual life of a large city is always mirrored in its unique physical presence, that is to say, in its architecture and town plan; but it is also to be seen in the obscure depths, the mysterious recesses, of its boundless mantle of stone. Here, every nook and cranny, every minute detail, often reveals the meaning of a fully developed and defined, historically unmistakable culture. The boulevards and, formerly, the passages *are among the urban aspects that most truly characterize Paris. They represent opposing conceptions of the nineteenth-century metropolitan street, yet both epitomize an epoch and a civilization. The origin of the* passages, *passageways which grew up between 1825 and 1850, is connected to the expansion of the textile industry. These small but elegant galleries protected by gates or sometimes by doors, contained cloth and clothing shops that often were grouped together into "associations" in order to finance the decoration and cleaning expenses as well as to offer customers the largest possible range of products in an enclosed, relatively compact, hospitable area. They were a sort of forerunner of the department store, and rightly considered to be one of the clearest signs of the economic change in progress during the first phase of modern capitalism. Today the architectural beauty of the* passages, *veritable jewels of eclectic Romantic art, can unfortunately be appreciated only in the few photographs taken of them, as almost all the original buildings disappeared between the beginning of the twentieth-century and the Second World War. During their heyday they were hailed in tourist guides as "recent inventions of industrial luxury," "passageways*

covered with glass and marble-inlaid walls that pass through entire blocks of buildings" that are "a city, or better, a world in miniature." The spacious, long boulevards in the heart of Paris were built during the reign of Napoleon III, from 1852 to 1870, and the operation entailed an unprecedented demolition of the medieval core of the city. There is no doubt that, besides expressing the aesthetic and social tastes of the time (they were perfect showcases for the ostentation of the rising French bourgeoisie), the boulevards were also created for reasons of public order – the need to ensure that popular revolts could no longer use the former intricate maze of old alleyways as both a refuge and a stronghold. So the project of Baron Eugène Haussmann, prefect of the Seine département *from 1853 to 1869, reconciled the ideal of architectural pomp with purely political motives. Yet from 1871 Boulevard Bonne-Nouvelle, Boulevard des Capucines, which Monet depicted filled with people, colour and light in his famous 1873 painting, Boulevard des Italiens (the "nights" of which are narrated in the first part of Proust's* Remembrance of Things Past: Swann's Way*), Boulevard Saint-Michel, Boulevard Montparnasse and all the other wonderful avenues pulsating with life – were, ironically enough, destined to suffer the disgrace of popular barricades. Thus these exemplary products of modern town planning not only were the main backdrop for the worldly ceremonies of the most sumptuous metropolis in Europe, they were also the arena of some of the most dramatic and crucial events in French history, up to the Nazi invasion in 1940 and the student revolt in 1968.*

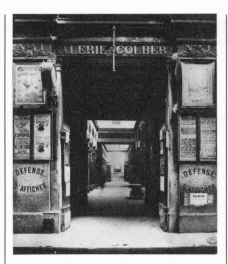

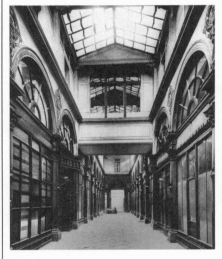

Left above and left center: two photographs of the Passage Colbert, c. 1850; Bibliothèque Historique de la Ville de Paris. The shot above is of the entrance from the rue Vivienne, while the other one shows a part of the main section of the passageway. The latter photograph gives an idea of how merchandise was displayed in the shop windows,

which were elegantly framed by the architectural moulding. Unlike later galleries built in an eclectic style, the early nineteenth-century passages were for the most part like neighbourhoods. At times elegant and aristocratic, at other times decidedly popular, these galleries were a miniature of the life and spirit of Paris.

Below: Boulevard des Italiens, Paris, c. 1860; coloured print. Demonstrating a "modern" interest in city life, Monet also painted two views of the nearby Boulevard des Capucines in 1873. Unlike this print, in both of Monet's

works the boulevard is represented from above, with a broad panoramic view. In fact he painted the works by looking out of a window in Nadar's studio, where the first Impressionist exhibition was held in 1874.

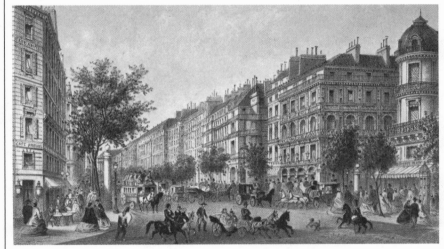

The painting of modern life

In the early 1850s the relationship between the new social dimension of urban society and the escape to nature entailed some conceptual problems. Among these was the contradictory role of photography. From its outset photography had clear connections with realistic art, as can be seen by the fact that the person most responsible for inventing photography,

Louis-Jacques Daguerre, was a scenic painter of illusionistic stage sets. In 1839 Daguerre announced that he had discovered a method for making a direct positive image (the luminous spots produced directly by reality, filtered by a camera obscura) on to a silver plate. Fifteen years later, at the 1855 Exposition Universelle, photography was honoured for the

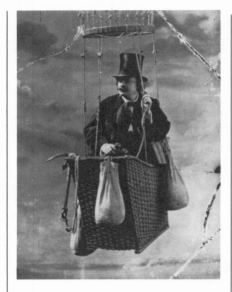

Above: Nadar, Self-portrait on a Balloon, 1860; photomontage. Although this photomontage was obviously created in the studio, the picture is of an actual event: from 1858 Nadar took a series of spectacular aerial photographs of Paris from a hot-air balloon. This feat bears witness to the prevailing spirit of enthusiastic technological positivism of the time that also influenced artistic output.

Right: Louis-Jacques Daguerre, Boulevard du Temple, 1838-39; daguerreotype; Bayerisches Nationalmuseum, Munich. The research undertaken by Joseph-Nicéphore Niépce at the end of the eighteenth century produced its first concrete result in 1826 – heliography. Daguerre met Niépce around 1830. By perfecting the latter's technique he created daguerreotype a few years later.

Below: Louis-Jacques Daguerre, View of Monmartre, c. 1830; tempera on paper; Musée Carnavalet, Paris. The view here was probably produced with the aid of a camera obscura.

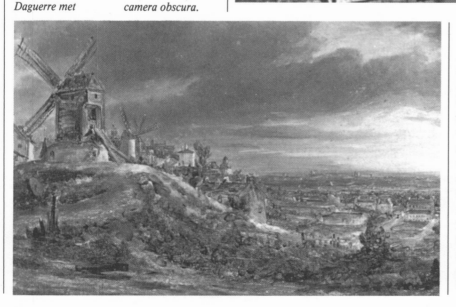

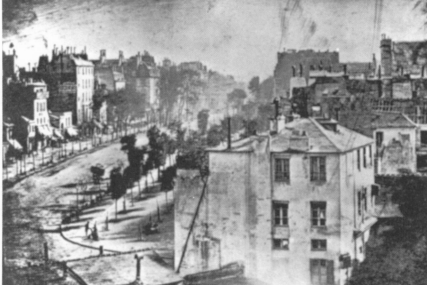

first time by a special exhibit. This was partly due to the noteworthy technical advances made by photographers such as Carjat and Nadar. The latter began a highly successful career as a portrait photographer from the time he opened his studio in 1854, and in 1858 realized his greatest achievement – a series of spectacular aerial views of Paris taken from a hot-air balloon.

The amazing invention of a device that prints the impression of the real on to a two-dimensional support (by means of a geometrical projection similar to perspective painting, but this time through a wholly scientific process) seemed to remove all obstacles to total perception. This development enormously increased the faith that lay at the base of the Naturalist aesthetic. In 1856 the Goncourt brothers wrote: "Realism is born and explodes at the very moment in which Daguerreotype and photography demonstrate how much art differs from the real."

But there is a subtle ambiguity in this statement, just as there was in the entire relationship between photography and art. Painting "differs from the real" – the new images obtained through the camera obscura proved this. But if this is so, why must art compete with a means that, from the standpoint of a convincing truth, has won right from the start? And again, why choose such an obvious level of comparison? Are we really so sure that authenticity lies in optical-mechanical data? After all, the great art of the past did not aim at representing the world, but tried to interpret it.

Things become even more complicated if we consider that photography itself began from the start to "compete" with painting; it tried to free itself from its purely technical aspects to proclaim itself a free creative act in itself and ended up pursuing pseudo-Impressionistic effects. In the second half of the nineteenth century the normal "realistic" concept of photography was opposed by a kind of heretical tendency called flouist, the prerogative of which consisted in intentionally blurring the image, rendering its outlines fuzzy, in order to charge it with emotional values and emancipate it from its purely optical character. Indeed, the "soft focus" technique is to some degree related to the auroral vaporous quality in Monet's works after 1870. Baudelaire was opposed to photography – at least on a theoretical, aesthetic plane, since he himself had posed many a time for photographs – not because of its artistic potential mentioned above, but because of its almost servile conformity to the excesses of Realism. His art criticism may be interpreted as a long, tireless attack against the ideologies of scientific positivism and the artistic concepts they generated.

Photography was only one of the manifestations of the need to extend the function of sight that so characterized this period. This need was psychologically rooted in the culture of a society that was making great strides economically and technologically.

The consistency of the "return to nature" on the part of many nineteenth-century artists was based on the two-fold impact – both positive and negative – of historical evolution on aesthetic attitudes; the economic revolution taking place encouraged faith in reality and in the wherewithal to perceive this reality but at the same time it alienated man more and more from his natural origins. The most representative case of this was the Barbizon school, whose petits maîtres (Troyon, Millet, Daubigny, Rousseau and, to some extent, Corot) were the first to speak of the need to paint en plein air, out-of-doors. They made no mental elaborations of a subject first viewed outside and then painted in the studio, but preferred to seek their subjects on the spot, in the living core of the landscape, in order to grasp its essence immediately. It was as if nature could no longer be repeated "by heart," as if the development of modern sensibility, by then ensnared in the coils of machines and the artificial universe, served only to impede the human soul. Knowledge had become more and more mathematical and subject to classification and it excluded the authentic manifestation of the world of nature. The artist thus tackled this problem head-on: direct experience, and not the systematic method of the exact sciences, should inform his work. Here already in the fleeting emotion of the landscape rather than in the analytical elaboration that redefines it in the studio lies the seed of the "non-realistic" development of the art that was to follow. The notion behind this is that the truth which art should approach does not lie precisely in nature per se, but rather in the ephemeral condition of its manifestation here and now. During the first phase of Impressionism from 1860 to 1870 being faithful to reality in the minds of the young artists was not so much a question of adhering to the world as it is or as one supposes it to be, as it was a matter

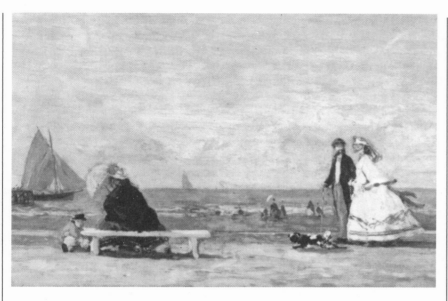

of becoming attentive observers of the appearance reality takes on while one is observing it. The basic difference between their art and that of all the preceding generations was the new key role played by sight and visual sensations. Thus, while the philosophy of Realism, for example, holds that there is an objectivity outside the individual, an indisputable universe to which the human eye can only adapt itself, for the Impressionists only the sensations the eye draws from reality are certain and objective. The fleeting quality of "impressions" is therefore not a limit to be overcome; it is the very form of the world's existence. This also explains what Cézanne meant when he said that Monet was only an eye. This has often been incorrectly interpreted as a condemnation of a painter capable only of registering external objects passively. "Monet is only an eye... but what an eye!": by this Cézanne wanted to point out the distinguishing characteristic of Impressionist representation, manifested to the full in its most authoritative exponent: the vital importance now attached to the dynamics of vision.
The artist Eugène Boudin in his old age said that his greatest merit was having persuaded Monet to paint *en plein air* around 1857-58. The two painters had met at Le Havre, where Claude, then sixteen years old, was devoting his energies to making caricatures of family friends, acquaintances and prominent persons in the town. Boudin, fifteen years Monet's senior, immediately understood the extraordinary technical skill in those ingenuous, youthful drawings, and was only too happy to take his young friend with him during his long sessions along the

Above: Eugène-Louis Boudin, Beach at Trouville *(detail), c. 1863; oil on canvas; 17.8 × 34.8 cm (7 × 13½ in); The Phillips Collection, Washington D.C. The lowering of the viewpoint, which made the sky predominant,* allowed Boudin to render vibrant light in his paintings, which are articulated horizontally in a highly inventive manner. The technical quality and fascination of his works greatly influenced young Monet.*

Seine or on the seashore, so as to show him how art must perceive the momentary magic of light as it appears before our eyes. According to Boudin: "Everything that is painted directly on the spot has a strength, a power, a vividness of touch that one does not find again in the studio [...] One must show extreme stubborness in retaining one's first impression, which is the good one."
Before 1857 outdoor painting simply did not exist for Monet. From the time Boudin taught him its importance, the young artist was never the same. From that moment landscapes painted outdoors became the most important question for him. Rather than his theme par excellence, I would say that it is the sphere in which all the utter singularity of his idiom is best expressed and enhanced. The experiments he carried out during this period remained such; they have hardly any value as works of art in themselves. But when Monet went to Paris in 1859 and enrolled in the Académie Suisse so as to learn

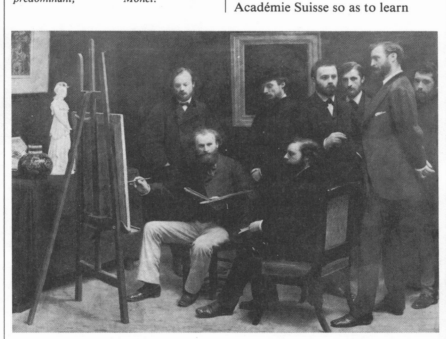

Above: Henry de Fantin-Latour, A Studio in the Batignolles Quarter, *1870; oil on canvas; 204 × 270 cm (68½ × 82 in); Musée d'Orsay, Paris. This painting is biographical and "commemorative," like all of Fantin-Latour's major works. It was executed just before the outbreak of the* Franco-Prussian War as a homage to Manet and the other artists in the Impressionist circle. From left to right: Otto Scholderer, Manet (at the easel), Renoir, Zacharie Astruc (seated), Zola, Edmond Maître, Bazille and Monet (partly hidden from view).*

more solid basic techniques he knew quite well what he was searching for, thanks to Boudin. In this way he was able to derive the maximum benefit from everything he learned and everyone he met in the capital. This can be seen in his letters to Boudin in 1859 and 1860 in which he speaks of the Salons with critical proficiency. At the 1859 Salon he studied the works of the leading Naturalists and the Barbizon painters, but was deeply affected by the work of Delacroix. At the Académie Suisse he struck up a friendship with Camille Pissarro, with whom he unwittingly inaugurated the

original nucleus of what was to become the Impressionist movement. Pissarro introduced him to the artistic milieu: hence the impact made by Courbet, who went to the Académie Suisse every so often; the reading of Baudelaire's essays on art; the frequenting of the Brasserie des Martyrs café and his first meeting with the critic Duranty, who later defended and popularized his art and that of his fellow avant-garde painters.
But despite the stimuli that Paris offered, Monet remained for some time a landscape painter in the strict sense of the word. While he painted with Boudin and the Dutch artist Johan Barthold Jongkind (the three began working together at Le Havre in the summer of 1862 and enjoyed a lasting friendship), Monet theorized and painted much like them. It was only later, around 1865, that he began to understand that city life was also a "landscape" in its own right, neither more nor less than the mouth of the Seine and the gardens of Normandy. He saw that the *plein air* technique was not indispensable for rendering only romantic forests or rugged plains, but could also serve quite admirably to capture immediately the intoxicating atmosphere of restless city life with its turmoil, crowds, houses, alleyways and brightly coloured shops.
Besides the noteworthy changes in pictorial syntax that mark the

Above: Paul Gavarni, Edmond and Jules de Goncourt; *lithograph. The Goncourt brothers were typical exponents of the realistic aesthetic in literature. However, their sincere passion for "social truth"* did not prevent them from leading a rather sophisticated, snobbish life marked by their collections of precious objects and the many elegant dinners with other Paris intellectuals.*

principal difference between the works of Monet and those of the founders of *plein air* painting, it must be stressed that even as far as motifs are concerned the young Monet deviated to quite an extent from the Barbizon school's cult of nature and country life. Thus after 1865 he did not miss any opportunity to take in what the Paris scene had to offer. His eye became almost photographic; it wandered feverishly through the city streets, peered into the windows, lingered over the squares and streets along the Seine (St. Germain l'Auxerrois and the Quai du Louvre, both built in 1866), scrutinized the gardens teeming with high society life (Jardin de la Princesse), soared over the terraces where the incomparable rituals of high fashion and *savoir vivre* were celebrated (the Terrasse à Sainte-Adresse). His "modernist" tendencies were revealed in the 1870s when he began to paint different versions of the Gare Saint-Lazare with its smoke and steam, hustle and bustle, and singular atmosphere, as if this railway station were an enchanting and sublime creation of nature. It was Constantin Guys who

Above: Johan Barthold Jongkind, The Beach at Sainte-Adresse, *1863; watercolour; 30 × 53 cm (11¼ × 20⅞ in); Musée d'Orsay, Paris. This site was also the subject of many of Monet's famous paintings done from 1864 to 1867. The technique of plein air painting is another close link between this work and those of Monet, even though Jongkind was much more influenced by the seventeenth-century Dutch landscape artists than his younger colleague.*

Below: Camille Pissarro, Corner of a Village, *1863; oil on canvas; 40 × 52 cm (15¾ × 20½ in); O'Hana Gallery, London. An important example of early Impressionist art. One notes Pissarro's tendency to articulate the canvas in solid volumes and clear-cut surfaces that seem to be "carved" out of the sunlight – a pictorial procedure that heralds Cézanne's future inventions.*

Right: Claude Monet, Quai du Louvre, *1866; oil canvas; 65 × 93 cm (25 × 36 in); Gemeentemuseum, The Hague. This precious panorama of the Latin Quarter (seen from the eastern balcony of the Palais du Louvre) is based on a principle of landscape painting that transforms the city into "nature" so as to heighten its vitality. In Monet's cityscapes the view is almost always from above, as in the famous aerial photographs of Paris by Nadar.*

inspired Baudelaire's famous essay *Le peintre de la vie moderne*, but Monet was the authentic "painter of modern life." The level of awareness that would in time make him the foremost exponent of Impressionism stemmed from a series of minor factors. The time spent on military service in Algeria in 1861, for example, inspired him to reinforce his already vigorous faith in the primacy of light in painting. With its amazing profusion of colours and wonderful visual experiences, continuous changes and dizzying effects of light, North Africa helped him to invigorate his artistic vision, the intent of which was to reproduce the extemporaneous,

generation – made by Edouard Manet, who was becoming famous at this time. In 1863 his *Déjeuner sur l'herbe* was shown at the Salon des Refusés, provoking a great scandal among an entire society of respectable persons and bigots. The Salon des Refusés, or "exhibition of rejected painters," was Napoleon III's novel solution to the problem of the vociferous complaints made by many established artists whose works had been excluded from the official Salon. There had been a celebrated precedent for this idea: in 1855 Courbet had rebelled against the overweening power of the reactionary art market and critics at the Exposition Universelle by

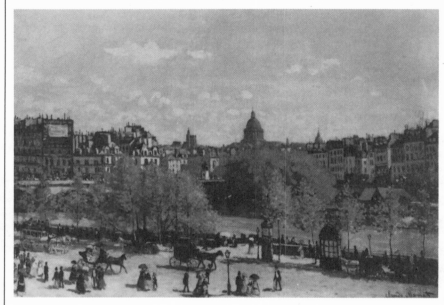

mutable "substance" that lies hidden behind the appearance or the mask of an immutable reality. This was the crucial, unique period in Monet's artistic formation. During what is usually the most delicate period in a young person's intellectual development, between the ages of 18 and 23, he underwent various stages and experienced influences of inestimable significance. First there was his sojourn in Algeria; then his meeting with Jongkind, whose translucent seascapes, together with the influence of Boudin's painting, led Claude to an ethereal, almost immaterial notion of the visual phenomenon that resumed and renewed the particular sensibility of van Goyen, Ruisdael and the other great seventeenth-century Dutch landscapists; the discovery of fellow artists with similar aims and the formation of the first Impressionist group (with Pissarro and, in 1862, Sisley, Renoir and Bazille); and lastly, the impact – which was decisive for an entire

mounting his own personal, virtually clandestine, pavilion where he could exhibit his works without constraint. The most urgent practical problem for artists was that of circumventing the academic censorship that

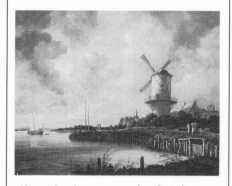

Above: Jacob van Ruisdael, The Mill at Wijk, *second half of the seventeenth century; oil on canvas; 83 × 101 cm (32¾ × 39¾ in); Rijksmuseum, Amsterdam. Van Ruisdael's painting, based on tonal values but also so translucent that it seems cold, stems from a need for "optical certainties" that are the result of a careful study of atmosphere and light. This is what aroused Monet's interest in this artist around 1860.*

The Aesthetic of Realism

Giorgio Vasari, Parrhasios's Veil, 1548, fresco; Casa Vasari, Arezzo.

In order to define the characteristics of nineteenth-century Realism with a degree of precision, it is necessary to take into consideration the intrinsic political objectives and social value attributed to artistic creation of this kind. Realism can thus be considered a movement and not merely a convergence of interests. Its aesthetic can then be clearly distinguished from the preceding forms of realism and hence from all other artistic styles based on the "imitative" concept of visual expression.

Realism presupposes a faithful rendering of reality without idealization. The artistic theory of imitation – in other words, the certainty of being able to create pictorial or sculptural plasticity by giving priority to the relationship between image and reality – came to the fore during the Italian Renaissance with the studies made by Cennino Cennini, Leon Battista Alberti and Leonardo da Vinci. However, the remote origins of this concept are to be found in Greek culture, although it was the later Roman statues that give us the first comprehensive evidence of imitative art.

A confirmation of the ancient precepts which is at the same time an extreme example of the "moral significance" of imitation, is offered by the famous anecdote concerning the ancient Greek painters Zeuxis and Parrhasios told by Pliny in Naturalis historia. *These artists had decided to establish once and for all which of the two was the greater painter. Zeuxis showed his rival a still-life with grapes that were so perfectly rendered they attracted the attention of the greedy birds in the sky. He then asked Parrhasios to show him his painting by removing*

the veil that covered it. And with this Parrhasios won the day, because it was the veil itself that was painted. The cliché of art as imitation plays on certain axioms that are anything but indisputable. For example, it assumes that the image of reality impressed on the retina coincides perfectly with our total perception of that same reality; that the relationship between the seeing subject and the seen object is static and not dynamic (the eye is fixed on an immobile model); that the concept of "similarity" is obvious in itself and has a scientific basis; and that the outline of things can therefore be translated readily into two-dimensional terms.

Building on these premises, which should "legitimatize" the descriptive and narrative faculties of painting, nineteenth-century Realism – as the critic Champfleury explains in his essay Le réalisme *(1857) – added a firm belief in the total harmony between truth and morality. In this context Daumier used the satirical drawing to denounce the reactionary maneuvers of Louis Philippe's reign, during which the historic rupture between artists and the Establishment occurred, which was the basis of the Realist movement's radical political tendencies and its aim to stand by the multitude of poor and wretched people who populate the modern world. Thus Millet's canvases of peasant life celebrated humble toil, and Courbet was a self-proclaimed champion of all revolutions, paying dearly for his sympathy with the Commune in 1871. Similar radical or "socialist" implications, which were considered imperative, were partly responsible for critic Jules Antoine Castagnary's attempt to offer a new definition of* naturalisme *as opposed to* réalisme *– he wanted to demonstrate that it was possible to achieve an art dedicated to the "naturally true" without being involved in the class struggle.*

monopolized the most prestigious exhibitions and generally admitted only mediocrities and official painters. The avant-garde painters supported one another in this battle. Monet made a public display of his appreciation of Courbet's friendship, forgetting for the moment that his own works implicitly condemned the methods and results of the latter's art. Courbet reciprocated with great affection, at least as much as he could muster – up to the time he discovered he was unable to comprehend one of Monet's most important artistic endeavours, *Le dejeuner sur l'herbe*.

Morning impressions

Two paintings, painted just two years apart, in 1863 and 1865, are now considered milestones in the development of modern art. They have the same title, *Le déjeuner sur l'herbe*, and apart from the similarity in subject-matter and indeed the similarity of the artists' names, they have one important feature in common: each work in its own way marks the dawn of Impressionism. Yet the two paintings are quite different and stem from dissimilar artistic premises. A comparison of the two renditions of *Le déjeuner sur l'herbe* reveals more diversity than affinity and shows that their relationship is on the whole more external than substantial.

Looked at closely, even the subject is not exactly the same. On the surface there is no doubt that both works take as their theme a carefree picnic in the woods outside the city. A deeper examination, however, reveals an important difference: Monet in 1865 interpreted this subject freely, treating it as one of the many ordinary, even banal moments typical of modern life, while his

senior, Manet, had preferred to complicate his work by means of a series of theoretical, apparently "symbolic" elements that with singular obstinacy distort the sense of the subject represented. For example, the trio in the foreground enjoying a picnic in the woods astounds the viewer because of the incongruous, mysterious presence of a nude woman seated next to two fully dressed men. A good deal of the notoriety of Manet's painting was due precisely to the

Above: Claude Monet, Le déjeuner sur l'herbe, *1865-66; 130 × 185 cm (50¾ × 72 in); Pushkin Museum, Moscow.*

Below: Edouard Manet, Le déjeuner sur l'herbe, *1863; 208 × 264 cm (81 × 102¾ in); Musée d'Orsay, Paris.*

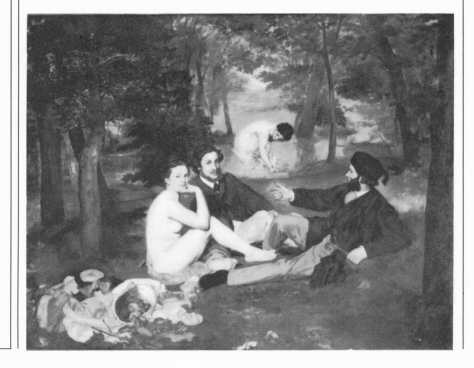

absurdity of this image, the meaning of which critics have time and again tried in vain to uncover: a "conversation" of this kind could not help but cause a huge sensation. A female nude, however provocative, would certainly not have shocked the sophisticated Parisian public that was so used to the many "impudent" Venuses of ancient art. But Manet set this nude among people in modern dress and, what is more, in the familiar context of a picnic in the country, and so the painting took on the sense of a violent attack against the morals of the time. Manet's boldness did not end here; it called much more into question. This work is profoundly subversive because it merges two realities which, according to nineteenth-century aesthetic taste, must absolutely be kept separate: the mythical dimension of the museum and the dimension of contemporary daily life. With its explicit reference to Titian's (or Giorgione's) *Concert champêtre* (which Parisians could quite easily view in the Louvre), Manet violated all the rules of artistic

decorum and good taste, going so far as to poke fun at the inviolable sanctity of Renaissance painting and taking Courbet's realism way beyond its normal confines, into the very core of institutionalized culture. This great work penetrates the sanctum sanctorum of classicism, the evocation of which is underscored by the "Greekness" of the woman emerging from the stream in the background.
Unlike Monet, Manet visited museums. He appreciated the classical Italian and Spanish painters – from Titian to Velázquez and Goya. His artistic achievement consists in having combined rather antiquated taste and motifs with a boldly modern technique. He was not at all a "naturalist," because his works – at least until 1865 – dealt for the most part with traditional subjects. Yet he was a revolutionary, because he subjected these themes to the desecration of Courbet's style, to the caustic Realist idiom. In *Déjeuner sur l'herbe* (and even more so in *Olympia*, 1863-65) Manet actually heightens the "dissolving" effects of Courbet's technique by courageously deciding to eliminate chiaroscuro almost completely through simplification and abrupt transition, using single tones and loosely modelling volume not with lines but with colour. The strong contrast that results, due to the fact that there are no intermediate tones, makes the work resemble a vast score of almost monochromatic patches that sharply differ in the high- or low-key tones that follow one another in an alternating serial rhythm.
This is the most interesting formal aspect of Manet's work, the characteristic that would make him at once one of the most beloved

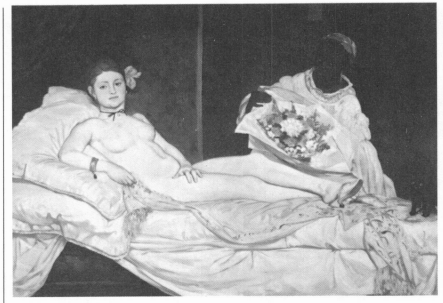

and detested painters of the time. Indeed, the impulse towards Impressionism in his oeuvre is limited to his elimination of academic chiaroscuro. We need only place *Olympia* alongside any of the many female nudes executed by that champion of academicism, Adolphe William Bouguereau, to understand how at that time the distinction between avant-garde and conservatism was based on formal, stylistic considerations that for us – after a century of artistic transgression – seem oversubtle and captious, often irrelevant; and yet these very considerations aroused strongly felt enthusiasm or ferocious rebuke in the public that was caught up in this dispute in the 1860s and 1870s.
Monet's *Déjeuner sur l'herbe* contains no violent attack against tradition and museums. Instead it seems to be peacefully unaware of the problem of the relationship between the traditional and the modern. Monet's audacity and surety are to be found elsewhere: unperturbed, he directs his experimentation towards the contingent effects of light. His *Déjeuner sur l'herbe*, a large work, was painted almost entirely outdoors, at Chailly, during a vacation taken with his friend and fellow artist Jean-Frédéric Bazille (whose contribution to the Impressionist movement was cut short by his death at the front during the Franco-Prussian War). Bazille posed for the painting, inspiring the figure of the bearded man with the bowler hat, and Monet's young companion Camille Doncieux was the model for the woman seated near the tablecloth. Though this work is now in fragments, it still retains most of its original pictorial vigour and that powerful faculty of

Above: Edouard Manet, Olympia, *1863; oil on canvas; 130.5 × 190 cm (51¼ × 74 in); Musée d'Orsay, Paris. Olympia caused an uproar when it was first exhibited at the 1865 Salon. Its "provocation" has nothing to do with the indecency of the subject, but is rather a question of the modernity of Manet's treatment, which is so anti-classical.*

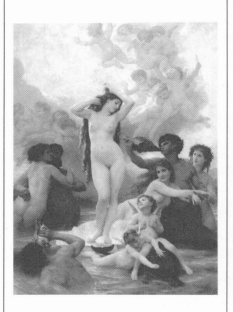

Above: William-Adolphe Bouguereau, Birth of Venus, *1879; oil on canvas; 300 × 218 cm (117 × 85 in); Musée d'Orsay, Paris. This is how the distinguished exponent of academic painting resolved the problem of the nude without causing a public scandal (on the contrary, he was highly praised for this work). And yet his rendition of the Neo-Platonic myth is certainly no less lascivious or immoral than Manet's nudes. The fact is, Bourguereau's work deals with myth, which lends a veneer of "high culture" to the subject, as does the fact that the old masters – beginning with Botticelli – also painted "mythical" nudes.*

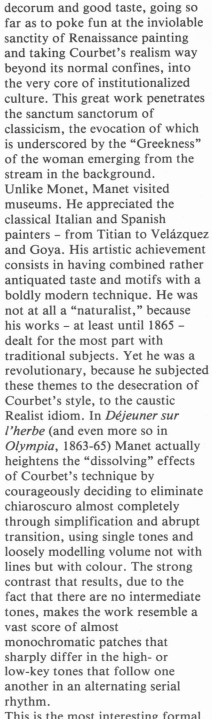

Below: Titian (or Giorgione), Concert champêtre, *c. 1510; oil on canvas; 110 × 138 cm (42¾ × 53¾ in); Musée du Louvre, Paris. Once attributed with certainty to Giorgione and now considered an early work of Titian by most art historians,* this rural fête *scene is one of the most highly appreciated paintings of all time. It therefore comes as no surprise that Manet, with his extraordinary mixture of tradition and avant-garde, took it as a model for his* Déjeuner sur l'herbe.

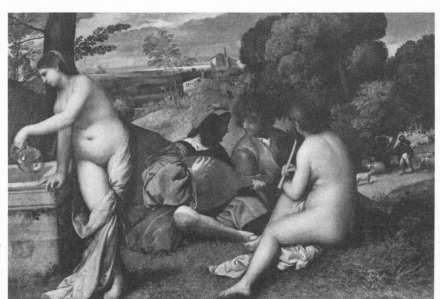

transfiguration that made the painting so elusive for his peers, especially Courbet, who amicably suggested to Monet that he should not attach so much importance to this element. The work is a consummate analysis of the capacity of light to transform the substance of real objects, and hence of the influence exercised by atmosphere on visual perception. Monet takes up the "symphony of contrasts" invented by Manet, but he breaks up and splinters the source of light. The painting thus vibrates and shimmers through an infinite series of little patches of colour which, on a visual plane, are similar to the monochrome patches in *Olympia* and are deeply radical in style. The whole forms a vast fabric saturated with a light that is almost sonorous in its intensity. For the first time light is the true subject of a painting: everything depends on the light and everything adapts to it.

More mundane and apparently light-hearted than its predecessor, Monet's *Déjeuner* (1865-6) plays on the neutrality and ordinariness of the theme in order to use its elements as starting points for effects of light – the women's clothes (especially the dazzling dress in the center of the largest fragment of the painting); the tablecloth on the grass; the blond and dark hair; the grass, flowers and food; and above all the incredible foliage that dominates the scene, a veritable cascade of coloured flashes, a restless, swarming mosaic of light refraction and reflection. This is a painting that is fundamentally alien to what had been seen before in art. Only after 1868-70, out of a sort delayed "conversion," did Edouard Manet himself endorse the treatment and use of light as

employed by Monet, thus approaching the style of his rival whose surname so resembled his own. Indeed, even as late as 1866 Manet was still inclined to complain about this similarity in their names which, he maintained, created considerable problems for him, since the public, already unwilling to accept his works, often mistook him for an artist they considered to be even more incomprehensible than himself. Up to the time he espoused Impressionism, Manet openly scorned *plein air* painting, stating that the old masters knew nothing about this procedure and that it was therefore unnecessary. Monet on the other hand made outdoor painting his battle cry. He was able to achieve the fundamental expressive invention of coloured shadows principally because of his long, careful study of natural light. Convincing examples of this are *Terrace at Sainte-Adresse* and *Women in the Garden*, both painted in 1866. From the point of view of compositional balance and formal perfection, the latter work

Above: Jean-Frédéric Bazille, Monet after His Accident at the Inn in Chailly, *1866; oil on canvas; 47 × 65 cm (18¼ × 25¼ in); Musée d'Orsay, Paris. Bazille and Monet were close friends throughout the 1860s. Bazille was killed at Ardenne in 1870 during the Franco-Prussian War.*

is probably the masterpiece of this period. Monet set up his easel in the garden at Ville d'Avray; the idea was to capture nature as a photograph would do, by means of the light that permeates and animates it. Yet the rendering of such a natural effect produces a marked degree of artifice on the canvas. The vibrations of the atmosphere are rendered through the agitation of the numerous closely applied layers of flat brush strokes. The gaiety of the summer sunlight on the foliage of the trees, the ceaseless tremor of the daylight, the reflection of its fragmentation on the faces are all elements made manifest by a new technique employed by Monet involving a particular kind of brushwork never before adopted which establishes a singular relationship between light and darkness.

Monet's eye becomes photographic, so to speak, and does away with composition in the classical sense of the word in favour of a neutral immediacy of the act of perception. In his hands, therefore, the shadows become an

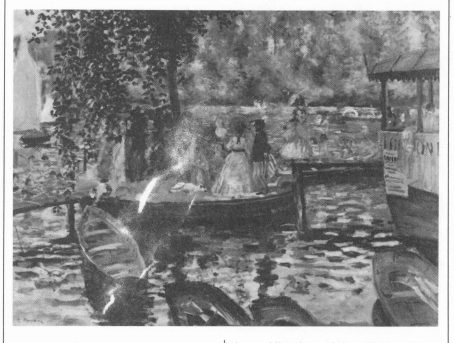

Left: Claude Monet, La Grenouillère, *1869; oil on canvas; 75 × 99 cm (29⅝ × 39¼ in); Metropolitan Museum of Art, New York. Above: Pierre-Auguste Renoir,* La Grenouillère, *1869; oil on canvas; 66 × 81 cm (26 × 31⅞ in);* *National Museum, Stockholm. These two paintings are a sort of work for four hands in which the stylistic dissimilarities, rather than highlighting these artists' different approach, are really complementary, creating a splendid, harmonious counterpoint.*

intensification of the colour of the objects they cover; that is to say, they become the pure removal of a luminosity that generally appears heightened, the feverish utterance of clearly defined, saturated, intense colour as in *Fishing Boats at Sea* (1868), dominated by a compact, monolithic, truly magnificent green. For Monet *plein air* painting was a way of perceiving and conceiving reality; it modified the very foundation of the relationship between subject and object, between artist and nature. The principle, and its

application by Monet, have been seen as more than a mere technique, but as a nascent vision of universal and cosmic order.

In 1869, at Saint-Michel near Bougival, Monet and Renoir (who had been friends for about six years) began to paint the same subject side by side – the bathing place La Grenouillère. This site offered them the opportunity to study the chromatic play sunlight created on the surface of the Seine and in this way, through a close collaboration that was characterized by both friendly rivalry and an exchange of ideas, they could lay the foundation for the development of fully mature Impressionism. Some critics have argued that Monet's views of this scene are more convincing than Renoir's because of their greater strength and compositional breadth, seeing them as the first truly Impressionistic works because of their free, fluid technique and rapid, broad brush-strokes with bold colour contrasts.

The two paintings entitled *La Grenouillère* reveal the need to work together and to share

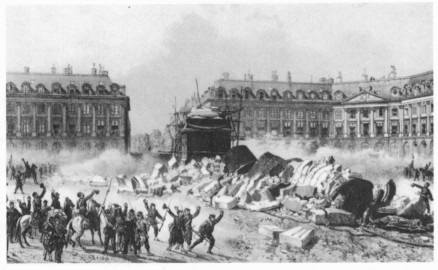

Above: The Demolition of the Column in Place Vendôme, May 16 1971; *engraving; Musée Carnavalet, Paris. Commissioned by Napoleon Bonaparte to commemorate his victory at Austerlitz, the column in Place Vendôme was considered one of the most important symbols of Napoleon III's imperial regime as well.*

Below: photograph of the Commune barricade in Rue de la Paix in 1871. Barricades are used in all city insurrections, and the Paris Commune built a good deal of them. They were destroyed at once when the government army attacked Paris.

experiences which the new painting idiom was beginning to feel. At this time Bazille, Monet, Renoir and Sisley saw one another frequently. Shortly afterwards, in England, Monet met Pissarro again and they spent a few months together painting on the Thames. The tendency to form groups was typical of the founding fathers of Impressionism, even though there was no proclamation, no common programme, no manifesto signed by them all that would support the theory that it really was a group as such.

The choice of *La Grenouillère's* subject-matter could not have been

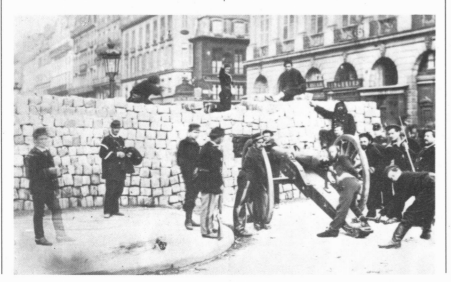

Artists and the Commune

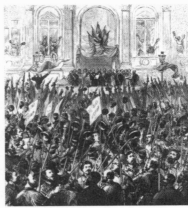

The Proclamation of the Commune of Paris at the Hôtel de Ville, March 26 1871; *engraving; Musée Carnavalet, Paris.*

The dramatic events that struck France from July 1870 to June 1871 left a deep and lasting wound in the French soul. The long reign of Realism, for the most part connected to Napoleon III's regime, came to an end with the Franco-Prussian War. That part of French culture that was identified with Grandville and Daguerre, Sainte-Beuve and the Romantics – the France that Baudelaire loathed and the positivists adored – began to show signs of strain before the German cannons and then crumbled in the dust, together with the column in Place Vendôme, under the blows of the communards. Yet Impressionism prevailed during this very period of tumult, and the most far-reaching manifestations of nineteenth-century art were to germinate in this decade. On 19 July 1870 Napoleon III declared war on Germany, more as a pretext to bolster his waning prestige than for motives of foreign policy. In only two months the situation became catastrophic: the French army was routed at Sedan on 2 September, and the next day the imperial regime was overthrown and a provisional republican government was formed. After another humiliating defeat at Metz (27 October) the Minister of the Interior Gambetta asked the nation to resist to the bitter end. The siege of Paris began, coming to an end only three months later (28 January 1871) when the city, reduced to a state of helplessness through hunger and disease, finally surrendered. France was forced to accept mortifying peace terms. It was this suffering and shame that provoked the most momentous insurrection since the French Revolution. On 26 March the Commune, whose members were mostly anarchists, radical republicans and socialists, was proclaimed. It replaced the municipality of Paris and usurped the state's authority. The Assembly was elected by universal suffrage and had both legislative and executive powers, after the example of Robespierre's Convention. The aims were socialist-type economic reforms and the redistribution of all resources. However, this first socialist experiment in the Western world was short-lived. After reorganizing the regular army troops, Thiers, the former head of the government, counterattacked. Paris suffered a second siege: this time it was civil war. On 21 May the army broke through the barricades the communards had erected on the boulevards. An atrocious bloodbath ensued, which lasted a week. No fewer than 20,000 people died in the fighting and thousands more were summarily executed or deported. Yet it was not long before this national tragedy took on the meaning of a veritable rebirth. Napoleon III's dictatorship had dissolved, and the advent of the Third Republic seemed to guarantee a regeneration of society, culture and the arts. For example, during the time in which the repression was at its height, one of the most crucial events in European literary history occurred. At the end of 1871 a sixteen year-old boy arrived in Paris, his jacket pockets stuffed with manuscripts – marvellous, disturbing poetry which almost by itself was able to guarantee continuity to the revolutionary utopia of the Commune. This young man, Arthur Rimbaud, whose creative activity would soon end, in 1875, took upon himself the political task of saving Western man. Even the more moderate Emile Zola was moved to write in 1872: "The hour is well chosen to state some truths. After each social disaster there is a certain sense of stupor, a desire to return to untarnished reality. The false basis on which one has lived has crumbled, and one looks for firmer ground to build upon more solidly. All great literary and artistic blossomings have taken place in periods of complete maturity or else after violent upheavals. I confess to hoping that from all this blood and all this stupidity a strong current will emerge, once the Republic has pacified France."

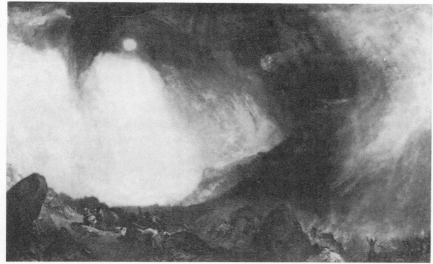

more felicitous. The reflection of sunlight on the water – the true subject of this painting – sums up the scope of these painters' work because it so vividly embodies the salient factor in the Impressionist aesthetic: the problem of the relationship between light, colour and the moment of perception. The reflection on the water represents the ultimate subject for an eye that is no longer interested in vindicating its own illusions but tries, by dint of dilating the pupils and squinting, to lose itself in the play of the real; that is, in the final analysis this eye is willing to do without its parameters in order to capture the fleeting moment of a beauty that does not allow itself to be trapped in any scientific prison. This is the key to the origin of Monet's audacity. Only he could so confidently suggest those quasi-psychedelic effects as those seen in *The Magpie, Snow Effect, Outskirts of Honfleur* (1869-69) or in the astounding *Zaan River at Zaandam* (1871), which shows the reflections of the red roofs and the yellow windmill on the Dutch river, rendered by means of tiny touches of pure, isolated colour that the Fauve painters would also achieve at the beginning of the twentieth century.

Three years elapsed between the sparks of *La Grenouillère* and the all-enveloping fire of *Impression, soleil levant* (Impression, Sunrise). The step Monet took is so big it is almost difficult to believe. During this period he does not seem to have undergone any particularly radical influences; on the contrary, one might say that his artistic vision basically fed on itself, as it were, on its very own premises and potential. However, world-shaking events had been taking place at this time – the Franco-Prussian War, the fall of Napoleon III, the siege of Paris and the Paris Commune,

Above: Joseph Mallord William Turner, Snowstorm: Hannibal and His Army Crossing the Alps, *1812; oil canvas; 145 × 236 cm (57 × 93 in); Tate Gallery,* London. *The romantic vision of total identification with nature is expressed by Turner as extreme formlessness, which later deeply influenced avant-garde art.*

Right: Alfred Sisley, Barges on the Canal Saint-Martin, Paris, *1870; oil on canvas; 55 × 74 cm (21⅞ × 29¼ in); Stiftung Oskar Reinhardt, Winterthur. Sisley's impressionism, especially when* compared to that of Monet, appears to be calm and tenderly lyrical. The two friends' paths began to take different directions in 1870, when Monet came into contact with Turner's pictorial idiom.

Below: Edouard Manet, Monet Working on His Boat at Argenteuil, *1874; oil on canvas; 82.5 × 105 cm (32 × 40¾ in); Neue Pinakothek, Munich.*

all of which contributed to the irrevocable decline of the Realist ideology and paved the way for the blossoming of the more recent inclination towards the lyrical and the emotive. The sensibility that sustains the famous "manifesto painting" of 1872 is decidely lyrical. *Impression, Sunrise*, with its pink and violet tones, its fog that abolishes and defies all perspective, the orange sky worthy of an Altdorfer, with that daytime star that is as a red button spilling blood on to the water – simply has no equal in any other work of the time. This is not to say that Monet is more delicate than Sisley, more poetic than Renoir, more analytical than Cézanne, or more extraordinary than Degas. He is simply more modern, more receptive to that dissolution of the image that was to be the destiny of future art. At this time he was more modern than even Cézanne, the artist who in a few years would

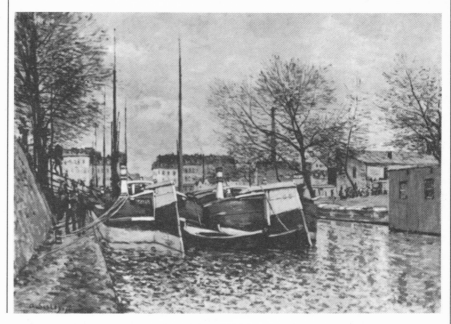

lay the foundation for Cubism. Monet's lyrical impulse stems from a deep-seated mistrust of the rigid, inflexible nature of sensory perception and corresponds to a drastic rejection of Cartesian logic in favour of forms of philosophical relativism that anticipated the postmodernist crisis.

The background for this belief lies in Monet's personal history, his controversial artistic formation; in the ideal, which he was quick to develop, of the individual being at one with the world that surrounds him. The artist must therefore immerse himself in the cosmos and its flux and be swallowed up by it, just as William Turner had suggested. During Monet's sojourn in London during the war years (1870-71) he had become acquainted with his illustrious forefather. Now if one wants to single out an influence that acted as a sort of detonator for Monet's creative explosion in the 1870s, one

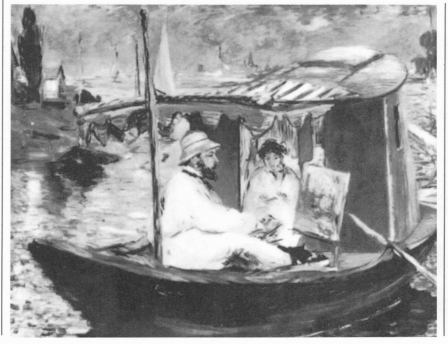

has only to consider the influence of this great English artist who during the first half of the nineteenth century had painted such masterpieces as *Snowstorm: Hannibal and His Army Crossing the Alps* (1812), *The Burning of the Houses of Parliament* (1835), and *Rain, Steam and Speed* (1844). In these works there is a notion of space that has nothing whatsoever to do with the Romantic rhetoric of Géricault or Boulanger; there is a feeling of total oneness with nature, a move towards the disintegration of visual certainties, which give way under the pressure of the unendurable, utter communion between the individual and the universe.

Monet purged such a stance of its metaphysical and religious

overtones. And having thus secularized it, he recovered its relevance to the twentieth-century crisis in values.

Monet followed in Turner's footsteps, plunging into the living heart of nature; his eye got lost, merging with what he saw.

this convention useless. Every object shines in the light because of the light it takes in and the rays it reflects; thus its colour is never the same. From the standpoint of its pictorial rendering, one could say that the individual object is independent from its molecular structure. The world is made up of continuous and complicated flows

capable of being extricated from its context and from the confused whole that surrounds it. The critic John Rewald says that already in the Grenouillère period "the study of water gave pretext for the representation of formless masses livened only by the richness of nuances, of surfaces whose texture invited vivid brush strokes […]

The destruction of visual certainties

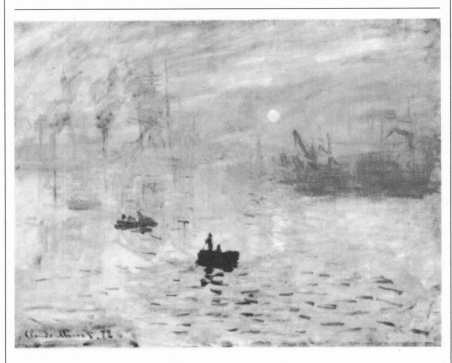

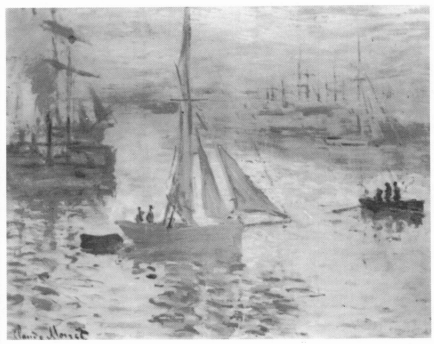

of light rays; nothing can be isolated and defined in it. Therefore in Monet's opinion it is absolutely impossible and even absurd to speak of the intrinsic aspects of an object.
This innovation of Monet's is connected to the other one – the total abolition of outline. Perhaps it would be more exact to say that the very idea of the graphic element is abolished, not only as drawing that precedes colouring in, but also as a real border line between one phenomenon and another, as the possibility to conceive the object as potentially

What official artists would have considered "sketchiness" – the execution of an entire canvas without a single definite line, the use of the brush stroke as a graphic means, the manner of composing surface wholly through small particles of pigment in different shades – all this now became for Monet and Renoir not merely a practical method of realizing their intentions, it became a necessity if they were to retain the vibrations of light and water, the impression of action and life."
Impression, Sunrise took this procedure to its extreme consequences. When it was shown at the first Impressionist exhibition in 1874 its title led the short-sighted critic, Louis Leroy, to dismiss it as "impressionist," allowing him to acquire notoriety for having used the term in a derogatory sense to describe painters who to this day are known as such. Certainly, at the time trusting to one's impressions was considered quite unseemly; it was like stopping at the first, and easiest, stage of a painting. And even when the critic Jules Antoine Castagnary tried to offer an unbiased interpretation ("they are impressionists in the sense that they render not a landscape, but rather the sensation produced by a landscape"), there

At the beginning of the 1870s the end of the first phase of Impressionism coincided with artists attaching less value to the intrinsic qualities of the subject in order to concentrate on the more intellectual need for a creative development of the image. It was at this point that Monet's works evinced two remarkable technical innovations.
The first consists in his rejection of the traditional interpretation of colour, a decision that can already be noted in certain paintings dating from the late 1860s. Until then it was taken for granted that every concrete object was endowed with its own particular colour, which at the very most could vary according to the characteristics of its physical surroundings. In *The River* (1868), kept in the Art Institute of Chicago, or in the many portraits of *Camille Monet on the Beach at Trouville* (1870), and particularly in *Impression, Sunrise* (1872), Monet goes so far as to consider

Above left: Claude Monet, Impression, Sunrise, *1872; oil on canvas; 48 × 63 cm (18¾ × 24½ in); Musée Marmottan, Paris. This painting marks Monet's first drastic break with the moderate form of Impressionism, and foreshadows the direction he would later take.*

Above right: Claude Monet, Sunrise, Seascape, *1873; oil on canvas; 49 × 60 cm (19 × 23¾ in); Private Collection, Paris. Quite similar to the preceding work in style and emotional impact, this painting is a sort of amplification of the concept of "impression," which for Monet meant a critical approach to the image that would eventually lead to its dissolution.*

Right: Pierre-Auguste Renoir, Claude Monet, *1875; oil on canvas; 85 × 60.6 cm (33 × 26½ in); Musée d'Orsay, Paris.*

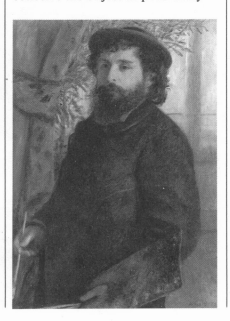

was nevertheless an echo of collective mistrust in his words. Monet's works were of fundamental importance at the first exhibition of the Société anonyme des peintres, sculpteurs et graveurs inaugurated on 15 April 1874 at Nadar's Paris studio. His experiments demonstrated an implicit interest in the progressive separation of pictorial language from its centuries-old link with external reality. According to the critic Michel Butor, the transitory nature of the subjects he chose – the concept of "impression" in Monet must be understood in this sense – is tantamount to a flat rejection of the stability of the model, which is imperative in Naturalist art. "With his insistence upon what is fleeting, Monet makes the age-old faithfulness [of representation] explode." This instantaneous quality "requires an extraordinary power of generalization and abstraction [...] What he is seeking is not something that can be painted well, but on the contrary, as he himself was to say many a time in his letters, something that is "impossible to paint"." Thus if we could isolate certain areas in Monet's paintings we would realize that his painting, at least from 1872, already bears the seeds of abstractionism. "In the celebrated *Impression, Sunrise* [...] the red circle in the upper part is there to tell us that the complex striping in the lower part is the sun, since we certainly could not imagine this were the painting cut into two parts. The upper half is the actual title of the lower part."

The Argenteuil period (1872-78) is

perhaps the brightest moment in the development of Monet's personal idiom. During this time he pursued his painterly experiments with great enthusiasm, taking little heed of the fact that his audacity was exposing him to many an existential difficulty. In 1873 he had a small houseboat built and began to go down the Seine in this "floating studio," on which he could paint, eat and rest at his pleasure. Here the principle of immersion in the landscape comes to the fore, almost as if to sum up the total sense of Monet's experiments. He was no longer satisfied with observing the river from the bank or from on high, on a bridge. He felt he could not "understand" the river in this way. He had to actually go into the water, live in the current, which for him was the very flow of experience and art... This was getting under the very skin of things, a desire to penetrate beneath the surface to find their vital core, scent, sound and feel. The subject's relationship with the world transcends its condition of being a "vision" and becomes intellectual involvement, total participation, profound cognitive intimacy. Only under the impulse of such ideas could Monet have achieved the levels of transfiguration manifested, for example, in *Marine View – Sunset* (1874), which marks the timely return of the striping and decomposition of colour (from yellow to red to violet) that had so amazed the public in his 1872 masterpiece.

It is as if Monet was driven to bring the pupils of his eyes closer

Above: Claude Monet, Manet Painting in Monet's Garden in Argenteuil, *1874; oil on canvas; whereabouts unknown (once part of the Max Liebermann Collection).*

Below: Edouard Manet: The Monet Family in Their

Garden at Argenteuil, *1874; oil on canvas; 61 × 99.7 cm (23¼ × 38¾ in); Metropolitan Museum of Art, New York. In this period Manet, by then converted to the Impressionist aesthetic, began to visit Monet.*

to the object, to open them so much that he was blinded by the excessive contact. The effects of this sort of total glance can also be verified in the various versions of *Regatta at Argenteuil*, in which the water is no longer the same as in *La Grenouillère*. In the latter the water abounds in a light that, paradoxically enough, is bathed in and glistens with utter realism; in the former it is rather more analogous to an opaque, intense material thickness: substantial colour, the hard substance of the river, the sky and the trees which, like Narcissus, refuse to be reflected in the water and dive into it to become one with it. Here in the Argenteuil landscapes, at the time when Monet was becoming the true master of his generation, the painting is somewhat less extreme, less radical, than it had been a few years earlier. The acme of poetic and chromatic liberty in *Impression, Sunrise* was to be seen again only in the *Gare Saint-Lazare* series, executed five years later. And still his feverish eye was not placated. Note how it was able, or was perhaps obliged, to dilate the *Boulevard des Capucines* (1873) into a strange, extremely wide plaza, opening out the perspective effect as only Cézanne began to do in the same period. The principle

Below: Claude Monet, Camille on the Beach at Trouville, *1870; oil on canvas; 38 × 47 cm (14¾ × 18½ in); Private Collection, New York. Right: Claude Monet,* On the Beach at Trouville, *1870; oil on canvas; 38 × 46 cm (14¾ × 17½ in);*

Musée Marmottan, Paris. These works are part of a series of portraits of Camille that Monet painted during their holiday in Normandy in July 1870, a short time after their marriage and just before Monet went to London.

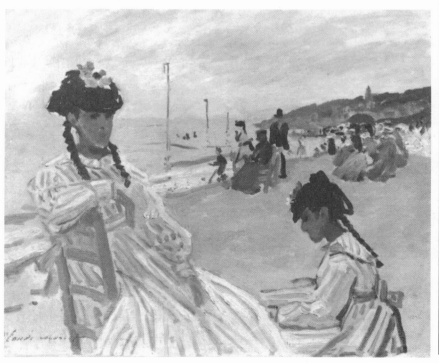

of immersion leads Monet to that point in which it is no longer possible to "see," because the necessary detachment is lacking. The flow of events, in its eternal, impelling state of becoming, leaves neither time nor space to be captured. The photograph is out of focus, as it were, the colour boils over on the surface like matter that cannot mask its real self. In the surprising *Regatta at Argenteuil with Cloudy Sky* (1874) one feels this "boiling over" effect: the painting, rather than telling us something about the boats, the wind, the leaden water or the clouded sky, "represents itself." It vindicates its rights, so to speak. In 1876 Monet seemed to be attracted by the Paris fog, a subject that was already the theme at Le Havre. When it was suggested to him that fog was not a suitable motif for a painting Monet came to the conclusion that he was outside of time, out of fashion,

24

alienated from everything, but he did not take offence. He announced to Renoir that he had had the great idea of devoting his energies to the even more "obscure" problem of the reign of the steam engine, the Saint-Lazare railway station. "At the moment when the trains depart," he declared, "the smoke from the locomotives is so dense that hardly anything is recognizable. It is a magic spell, a veritable phantasmagoria." The series he painted represents some of the best art of the 1870s and demonstrates Monet's exceptional receptivity. The theme was chosen for its paradoxical nature. It was a mere pretext, an alibi, for the celebration of colour. It is a almost as if one could breathe in those puffs of matter, those auroral, futuristic vapours, those patches and flocks of painting in the pure state. The light rains down from the glass roof of the station. Behind the smoke one can make out the phantoms of the buildings, the moving locomotives, the whiffs of steam that rise up and whorl into ridiculous plumes, the general confusion of the station and the difficulty in depicting it.
The "phantasmagorias" follow one another in quick succession: watery transparencies, green and blue surfaces in *Vétheuil in the Fog* (1879); reddish, delicately dream-like occultations in *Hoarfrost, near Vétheuil* (1880); flashes of clarity in the group of *Ice Floes* (1880-81). Monet's inexhaustible curiosity and his modernity are virtually one and the same. He was bold enough to paint what no other contemporary would dare do: smoke, ice, fog. Thus the real object, be it the city, the

Below: Paul Gauguin, Vision after the Sermon (Jacob Wrestling with an Angel), *1888; oil on canvas; 73 × 92 cm (28¼ × 35¼ in); National Gallery of Scotland, Edinburgh. One of the first Symbolist paintings. Gauguin does not describe what he sees, but – in a new pictorial language of telling simplicity with a marked abstractionist vein – represents the object of the vision (almost a picture within a picture) of the Breton peasant women who are spellbound by their overpowering faith.*

The Scientific Theories of Colour

In Impressionist painting the approach to the problem of colour – its relations to light, its dependence upon outdoor atmospheric and visibility conditions – is for the most part a question of the artist's instinctive talent (a combination of intuition, inspiration and experience) rather than any forml, technical prowess. However, there is no doubt that the sudden wave of interest, around 1880, in phenomena connected to the psychology of vision owes quite a lot to the style that had become predominant at the time. Thus if Monet and Sisley, for example, rarely went so far as to foresee the long-run effects that would result from the associations of brush strokes of pure colour in their works, it was nonetheless the experiments of Impressionism that gave rise to the need for a more "exact," more coolly controlled art. Using as his basis the optical and physiological theories of Eugène Chevreul, correlated to a positivist interpretation of Goethe's Theory of Colour, *Georges Seurat in 1882 began to work on his own method of breaking down colour (pointillisme) which takes into account all the psychological consequences produced on a level of visual perception. In his few but solid masterpieces he achieved some technical-scientific results that allowed him to establish absolutely new relationships between colour and light, between the world and painting. In particular Seurat developed the revolutionary "system of simultaneous contrasts of colour" that had led Chevreul to state: "Placing colour on a surface does not mean merely colouring the surface to which the brush has been applied with a particular colour; it also means colouring the neighbouring space with the complementary of this*

Georges Seurat, Bathers at Asnières, *1894; oil on canvas; 201 × 300 cm (78¾ × 117 in); The National Gallery, London.*

colour." Other experiences and experiments were decisive for Seurat's method: those of Ogden Rood and James Clerk Maxwell, the spiritual godfathers of the "divisionist" current of Neo-Impressionism. As Pissarro said, they are to be credited with the conviction that it is opportune to "substitute optical mixture for the mixture of pigments [...] because optical mixture stirs up luminosities that are more intense than those created by mixed pigments." The rigorous analysis of pictorial means – not only colour, but the graphic-compositional structure as well – opened new horizons for art. Seurat became friends with Charles Henry, a scholar of aesthetics and the physiology of perception who in 1886 propounded a "chromatic wheel" that was central to the future development of abstract art. Among other things, it demonstrates how it is possible to limit the palette to four fundamental colours (blue, red, yellow and green) and their intermediate tones (violet, orange, yellow-green, green-blue); the viewer's eye then involuntarily creates all the shades and hues by blending the tiny regular dots of primary colour the artist has applied to the canvas. This is more or less the principle behind electronic images, so that some critics consider Seurat and Signac, who invented pointillisme, *the precursors of modern-day sensibility in the visual arts and the field of images in general.*

locomotives, the trees in the country, water and even light – the entire universe of the Impressionists – disintegrates under the vigorous strokes and tremors of a brush that is by now wholly dominated by its very own restlessness and courage. The ultimate risk Monet ran was that of having to give up painting, of having to declare that it was impossible to paint... Plunging into the act of perception in the last analysis means doing away with the distance that serves to see objects or – as Monet himself suggested – not being able any longer to organize experience within the framework of pictorial conventions. These (perspective of volume and outline, chiaroscuro, colour, the myriad artifices of "good painting") are destined to give way to the need for a sharper emotional penetration, something that anticipates the aesthetic of empathy.

The critic Michel Butor offers a

Above: Vincent van Gogh, Wheatfield with Crows, *1890; oil on canvas; 50.5 × 100.5 cm (19½ × 39 in); Rijksmuseum Vincent van Gogh,*

Amsterdam. The new pictorial language of artists such as van Gogh, Gauguin and Seurat marked a profound change in art after 1880.

space of the Dutch masters is countered by Monet's space, which pours out over the viewer."
Actually, what the French painter seems to have destroyed is precisely the "set" or "scenery," the correct distance between the eye and the world, in order to heighten the physical qualities of the canvas: the support, the material fabric, the texture of the brush strokes. Therefore even when he reached the so-called turning-point in 1882-83 and his taste began to turn to experiences akin to those of the young Seurat and van Gogh, Monet is really only making a slight adjustment. The paintings of the cliffs of Etretat (1883) and Belle-Île (1886), like *Spring* (1882) and the two versions of *Woman with a Parasol* (1886), reveal a Monet true to his mundane stance and alien to partially or totally Symbolist concepts. He was intolerant of drawing, outline and the flat application of colour. Certainly, these were the years

when a new sensibility, by then the antithesis of Realism, began to affect artistic endeavour. With Gauguin, van Gogh and, shortly afterwards, the Nabis group, there slowly came to the fore a principle of painting as an intellectual, ideal, Neo-Platonic synthesis of the world, which is not at all interested in its material aspects, but rather in its potential as a language in code, as it were, a "symbolic" product of a superior mind. The tools with which such a lofty language was to be made comprehensible were the sinuous, refined, synthetic line, and the flat, bright colours placed in large backgrounds of clearly delimited surfaces.
Monet'a artistic fever was of another type, as we have seen. Thus in 1889, at the moment of the "official" consacration of Symbolism, when Gauguin had just finished his *Vision after the Sermon* and was about to begin *Yellow Christ*, while van Gogh was beginning his *Wheat Field with*

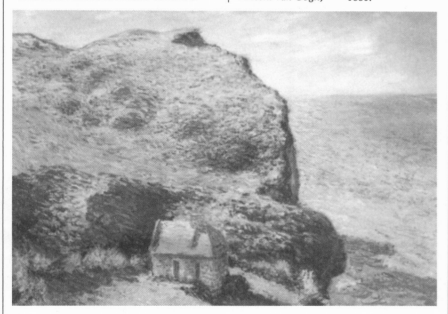

valid hypothesis concerning the relationship between Monet's space and the classical construction of perspective space: "When, in a certain setting, every element is given its exact distance, the space represented becomes more powerful than the surface of the canvas with its irregularity, its real or apparent depth, so much so that we forget that surface altogether. The viewer's perception is fixed in a definitive interpretation. Leaning in some way on the parapet which is the frame, he lets his imagination wander into the distance thus placed at his disposal; he runs off along Ruisdael's paths, glides over Lorrain's Arcadia. Monet makes short shrift of such flights of fantasy [...] The empty, dizzying

Above: Claude Monet, The Custom House at Varengeville, *1882; oil on canvas;*

60 × 81 cm (23¼ × 31½ in); Museum of Art, Philadelphia.

Right: Paul Cézanne, Sainte-Victoire Seen from Bibémus Quarry near Aix, *1898; oil on canvas; 66 × 82 cm (25¼ × 31¼ in); Museum of Art, Baltimore. One of the most interesting offshoots of Impressionism (thanks to which, however, the movement disavowed its own*

aims) was Cézanne's late production, which paved the way for Cubism and other avant-garde currents. Cézanne and Monet were the artists who succeeded most in injecting new vitality into the painting of impressions by radically changing its original meaning.

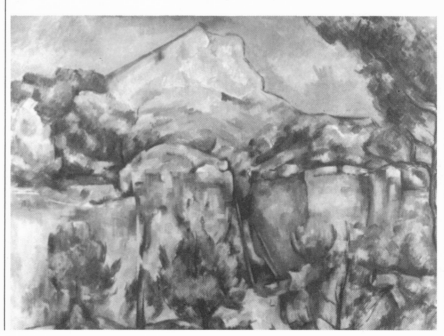

Crows and Ensor was proposing the spiritual séance of his *Entry of Christ into Brussels* – in that unique, tumultuous period in the history of art, Monet also found new inspiration, once again, and began the first of his great series of the 1890s, the *Hay Stacks*.

His oeuvre and vision are quite removed from pagan idols, Christian prophets, primitive magic, talismans, or the sinister premonitory properties of animals and plants. His aim is to translate on to the canvas, by adhering to both the effects of light and the difficulties of sight, the motionless, absurd conic effigy of a hay stack in the middle of a field. But what vigour there is in that unsteady eye. Van Gogh's wheat field is the fruit of an inner concept that is difficult and out of joint because it stems from an existential affliction, profound suffering and a sort of inspired madness. Monet's hay stacks are monuments to their author's artistic prowess: they transmit the virtues of colour, the creative power of light and the vigour of the eye that endows it with sense and order.

Below: Paul Cézanne, The House of the Hanged Man, Auvers-sur-Oise, 1873-74; oil on canvas; 55 × 66 cm (22¼ × 26¼ in); Musée d'Orsay, Paris. This rural landscape, shown at the first Impressionist exhibition in 1874, *is one of the most convincing works in Cézanne's Impressionist period. Pissarro had to intercede in favour of Cézanne to overcome the resistance of some Impressionist artists who were afraid Cézanne's works would jeopardize the exhibition.*

Here again we are faced with some of the greatest expressions of Monet's art: *Le déjeuner sur l'herbe*, *Women in the Garden*, *La Grenouillère*, *Impression, Sunrise*, *Gare Saint-Lazare*, and the *Hay Stacks*. We might very well call them works of critical, arduous periods in a career that without these works would perhaps have been more linear and in certain respects even more acceptable. But certainly the overall estimation of his oeuvre would have suffered to quite an extent. From this moment on, for the rest of his life, Monet would never dream of turning back to measured progress and tranquil reflections. One might say that he became bewitched by the obsession with the subject. He studied it, almost dissecting it. He rendered it at different times of the day, in different seasons of the year, in the manifold conditions of light and setting, going so far as to record the conditions of each sitting directly in the title, something that in itself is incredible: summer, sunset; winter, dawn; sunset, effect of snow; effect of snow one grey day, and so on. Once the art of space, painting now becomes the dimension of time. The *Hay Stacks* must be appreciated together, as a series. Observed in this way, they reinstate the temporal element into the purely spatial syntax of painting. This is where the logic of *plein air* painting would lead. The variation of time is accompanied by an unprecedented difference in results. Leaving aside the image of the hay stack and its shadow, and bypassing the problem of its endless metamorphosis (a problem

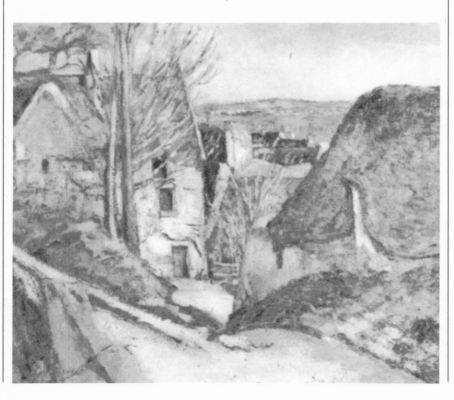

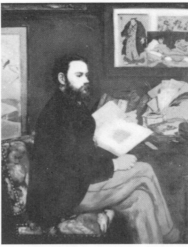

Impressionism and the Art Critics

Edouard Manet, Emile Zola, 1868; oil on canvas; 146 × 114 cm (56¼ × 44¼ in); Musée d'Orsay, *Paris. Note the Japanese print and the reproduction of Manet's Olympia on the wall above the table.*

The influence of the art critics' reaction to Impressionism was two-fold. On the one hand the rapid formation of a theoretical awareness on the part of the artists was accompanied by the supportive attitude of art critics and men of letters such as Emile Zola, Jules Antoine Castagnary, Edmond Duranty and Joris-Karl Huysmans. On the other hand there was also the involuntary stimulus that the negative reviews had on persons naturally inclined to feel rejected and quite alien to the compromises of bourgeois respectability. One might say that the Impressionists – in this respect already akin to their future companions of twentieth-century avant-garde art – erected their collective identity not so much on the classical idea of a "school," a communion and heritage of technical and stylistic choices, but rather on the independence of each artist from the official schools, the accepted traditions and the pre-conceived rules.

At any rate it is important to bear in mind the extraordinary evolution the movement went through in such a relatively short span of time. At first it was quite natural for all the "progressive" critics strenuously to defend all those artists who, in their opinion, were fulfilling the aesthetic of Realism. Around 1865 to praise Monet or Pissarro and, more daringly, Manet was tantamount to confirming an already customary admiration for those painters (Corot, Courbet, Daubigny and Rousseau) who were considered to be the masters among the younger artists. Shortly after 1870, however, no sooner had the difference between Impressionism and the movements that had fostered it become evident, than those very same critics became less favourable, less unconditionally enthusiastic.

Works such as Monet's Impression, Sunrise, *Cézanne's* House of the Hanged Man at Auvers-sur-Oise, *and Renoir's* Gleaners, *all shown at the first Impressionist exhibition in 1874, were so unusual and bold that they caught even the most updated observers off guard and disoriented them. Castagnary, for example, could not avoid keeping a certain distance: "The common concept which united them as a group [...] is the determination not to search for a smooth execution, but to be satisfied with a certain general aspect. Once the impression is captured, they declare their role terminated [...] What is the value of this novelty? Does it constitute a real revolution? No, because the principle and – to a large extent – the forms of art remain unchanged [...] It is a manner and nothing else." Louis Leroy, in an article about Berthe Morisot, was much less complimentary: "Now take Mlle Morisot! [...] When she has a hand to paint, she makes exactly as many brush strokes lengthwise as there are fingers, and the business is done. Stupid people who are finicky about the drawing of a hand do not understand a thing about impressionism, and the great Manet would chase them out of his republic."*

Almost as if to make amends for such views, and much to the relief of the painters themselves, there was the understanding demonstrated by the true men of letters. Besides Zola, the standard-bearer of avant-garde art as early as 1866, mention must be made of the role played by Huysmans who, five years before writing the novel that brought him fame, A rebours, *made his debut as an art critic in 1879 with certain comments of surprising pertinence and modernity, stating that Impressionism offers "an astonishingly just vision of colour; disregard for conventions adopted centuries ago to reproduce this or that light effect; work in the open and the search for true tonalities; movement of life, large brush strokes; shadows established with complementary colours; preoccupation with the whole [of a subject], rendered through simple means."*

from which Monet did not shirk), there remains the formidable play of rectangular surfaces in the two superimposed bands, presented in an infinity of pictorial combinations and in an utterly pure, distilled "dance of colours." The viewer cannot but respond with an equal number of emotional and aesthetic reactions.

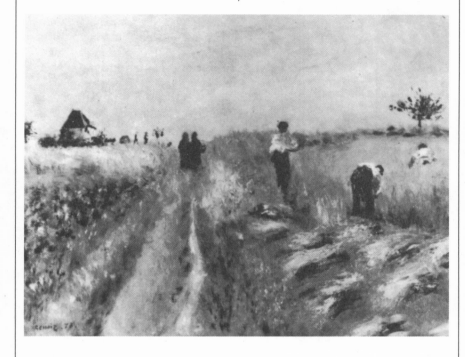

Form and formlessness: the water lily pond

Other cycles created in the two decades from 1890 to 1910 clarify Monet's experiments, especially as regards the analysis of chromatic expression. One could argue that in this period the subject of the painting, so obsessively contemplated, at first sight seems to have an ambiguous, contradictory role; the more Monet insists upon considering the subject central to his oeuvre, the more it becomes a pretext, or even misleads the viewer. For example, in the series of poplars and the pictures of Rouen cathedral, it is not immediately clear what Monet was aiming at in so stubbornly working on only those subjects for such a long time, what it was that drove him to neglect everything else in order to concentrate on the inexhaustible variations they underwent before his eyes. The spectator is at a loss to understand the role and value of the reality represented in these works, since it seems always to be extraneous to the deepest meaning of Monet's

artistic endeavour.
The truth is quite simple. Monet's insistence on going to the same site for two or three years, his stubborn refusal to paint anything else, demonstrate that it is not the theme itself that is important, but being able to paint it ad infinitum. The constant repetition makes us suspect that Monet was not really attracted by one view over all others, but that he remained faithful to a particular view only because, perhaps for purely practical reasons, it lent itself to such repetition and to being developed within a series.
We can begin to make out a motive behind all this which we could call the "motive of variation," the starting-point of which must be uniformity and constancy. For this repetitive creative procedure, it is necessary to establish a comparison, to put together many different views of the same landscape, building or river. This is not so as to repeat that landscape, building or river ad nauseam, but

to declare that there are never two identical, or even similar, views. Painting the same subject over and over is tantamount to pointing out that the result is always different, thus demonstrating that the painting is not the subject.
All perception implies a degree of interpretation: the eye transmits an impression to the brain that depends as much on external factors such as light and atmosphere as on the state of mind of the observer. The emotion elicited by the act of seeing is in itself absolutely singular and makes the image unique. However, in this way the notion of the "same subject" begins to lose its meaning; as Monet himself suggested, it is a notion best ignored in painting. Colour can become an autonomous element with the ability to transcend the thematic pretext from which it springs, as Matisse would later say, to "lend weight to the differences, emphasize them." Monet's cycles introduce us to a procedure that consists in bringing out the difference between reality and painting – not on the basis of the rigorous laws the abstract artists (Mondrian, Malevich and, to some extent, Kandinsky) would later adopt, and yet with just as much insistence. Monet's debut was characterized by an increasing need for realism but, paradoxically, that need produced an escape from the real world and the first step towards abstraction. All this is amply illustrated by the famous *Rouen Cathedral* series (1892-94), in which each temporal-meteorological moment has its own special meaning. As in *Le déjeuner sur l'herbe*, Monet was pursuing a perfect, sublime balance between perception and artistic rendering. Rouen cathedral – with its play of fullness and void, light

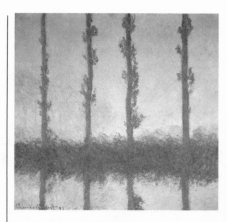

27

and shadow, with its massiveness and intrinsic aesthetic texture, all dominated by pictorial values – lends itself as no subject had before in this way to the process of disintegration, to Monet's ferocious and yet exuberant criticism of the basic traits of representation. According to the Italian critic Francesco Arcangeli the marble aspect of this edifice "becomes a large coagulation of colours: it is as if there were a

process of inner fermentation, almost secretion, in this image of the cathedral."
The disintegration of pictorial matter and brushwork is more evident in this series than elsewhere. On moving close to the canvas one notes the "wall" therein – much like a painting by Jean Fautrier – that obstructs the onlooker's view and his desire to penetrate the space of the work. That wall, that opaque and initially

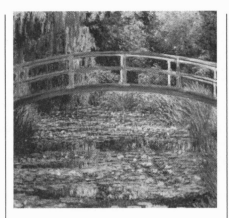

inexpressive mass of plaster seems to negate the very quality of a pictorial event, its chromatic nature. Then, as the French critic Michel Butor explains, if one stands further back to look at the work, "at a certain distance the impression of painting will return; a little farther off, or a little later, the tangibility of the façade's surface matter, the sunken, bristling aspect [returns] and from this matter there emerge all sorts of imaginary materials: gold flows, silver gushes out, and the sky falls." The negation of perspective space is therefore instrumental in making matter flow and is a radically anti-realist gesture, a gesture that reminds us of Monet's happiness at the sight of the puffs of steam at the Gare Saint-Lazare in 1877: "Hardly anything is recognizable. It is a magic spell, a veritable phantasmagoria." And it brings us back, in equal measure, to the idea of immersion, of an eye that drowns in the material "river" of the painting.

This hallucinatory, insatiable eye has finally found its absolute existential and poetic dimension; the struggle against the visible world, the possibility of representation, and hence of the painting, continuously denied. Immersion is another facet of the principle of variation, that is, the imperative that generates the pictorial cycles – because repeating by varying is a means of producing a closer approach, deep into the core. Monet is in search of themes suitable for such immersion, which will make it possible to eliminate the distance between the seeing subject and the seen object. However, this is not really a question of subjects, but of psychic conditions, magical moments, moments of grace. And he finds some magnificent ones in London at the beginning of the twentieth century. In 1904 he exhibited 37 *Views of the Thames in London* at Durand-Ruel's gallery. "I like London so much," said Monet, "but only in the winter [...] It is a mass, an ensemble, and it is so simple... What I like most of all in London is the fog. It is the fog that gives it its marvellous breadth... in that mysterious cloak." Once again it is fog, like smoke and steam, that provides Monet's work with its indispensable poetic substance. He needs obstacles, barriers that make the basic act that precedes painting impracticable and that transforms seeing into a difficult, complex operation.

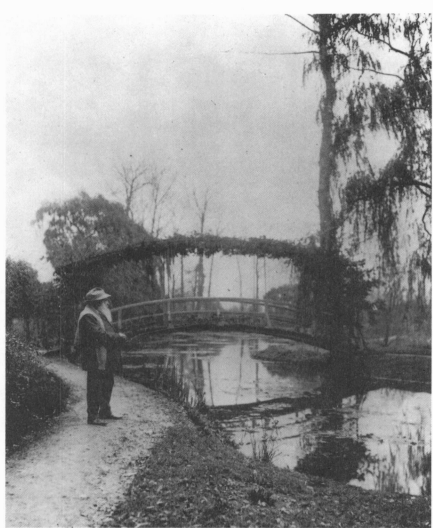

Above: Claude Monet, Water Lily Pond, *1899; oil on canvas; 89 × 92 cm (35 × 36¼ in); The National Gallery, London. One of the most characteristic and famous features of Monet's pond at Giverny is the so-called Japanese bridge. Besides a good number of single canvases, Monet painted two long series of this bridge over the pond. The first of these (which includes the work reproduced here)*

introduces the theme of the pond, which up to then had never been painted on a systematic basis. The second series (1922-24) is one of Monet's final and most audacious achievements, realized with an astonishingly modern style based on the "free" proliferation of hues and brush-strokes that create "larval" images corroded by the fury of Monet's pictorial idiom.

Left: Monet near the Japanese bridge in a photograph probably taken in the autumn of 1922.

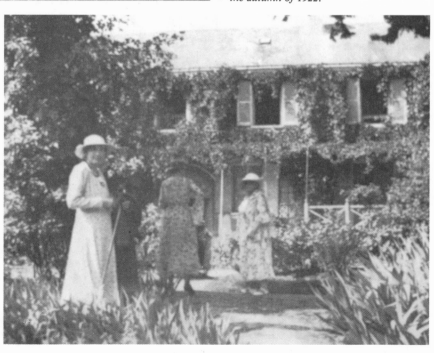

Right: visitors at Monet's garden in Giverny (photograph taken in the 1920s). Monet bought the house and estate at Giverny after having lived (at different times) in the village on the Seine since 1883. It was only later, in the 1890s, that he got the idea of the water lilies and

pond. And it was only around the turn of the century that he began painting those marvellous aquatic plants. Monet was a passionate gardener and there is no doubt that the pond and water lilies were planned and cultivated with a view to transforming them into paintings.

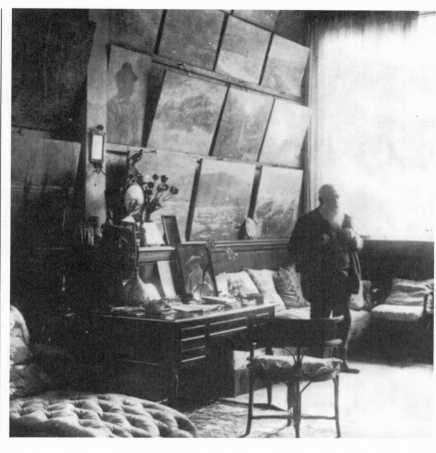

Above: photograph taken around 1920 of Monet in his studio at Giverny. Some of his paintings on the wall, dating from earlier periods, can be identified. It seems that Monet – who did not like to work in the studio, since he felt he should work outdoors from the motif – conceived his studio as a sort of autobiographical museum, a place where he could meditate on the long path he had taken and have a clear idea of where his pictorial research had led, and was leading, him.

Below: Monet and his biographer Gustave Geffroy in a photograph taken around 1920. An art critic and journalist, Geffroy was a close friend of Monet's. He began writing about him in 1886 with an article on his house. They later met periodically, took trips together, and Geffroy was often a guest at the house in Giverny.

Below: Claude Monet, Morning and Green Reflections, 1914-26; Room I, Musée de l'Orangerie, Paris. The photograph shows part of the first room in the Orangerie. Monet himself supervised the restructuring of this pavilion so as to create the proper environment for his huge panels.

As in the series devoted to Rouen cathedral, in the views of the Thames the pictorial surface becomes a compact mass, a dense wall of heavily applied brush strokes and bold palette knife touches. The effect produced oscillates between being a declaration of the picture as a concrete object, an impregnable surface, a denial of space, and the clamorous magic of colour that pours out of every nook and cranny and swells up with descriptive truth – the sun in a hazy sky, the ever-changing weather, the violet emerging from the Houses of Parliament and the waters of the Thames, which are ablaze with the reflection of daylight. A critic of the time, Octave Mirbeau, described the London paintings in the exhibition catalogue with these words: "The multiple drama, endlessly changing and subtly varied, somber or enchanting, agonizing, delightful, florid, terrible, of the reflections on the waters of the Thames; [reflections] of nightmares, dreams, mystery, fire, hell, chaos, floating gardens, the invisible, the unreal."

Monet's notorious restlessness, his craving always to paint his subject directly on the spot (*sur le motif*), led him to all sorts of places over the years. The site was crucial to this philosophy and went even beyond the aims of *plein air* painting. He used an infallible method all his life: during the winter in his studio he completed the sketches he had prepared outdoors in the summer. Moreover, all his life he was on the move from place to place: Paris, Ile de France, Fontainebleau, Argenteuil, Bougival, Chatou, Vétheuil; all the bends in the Seine up to Le Havre; and then Normandy – Trouville, Honfleur, Belle-Île, Etretat, Varengeville, Pourville, Rouen; London (in 1870 and after 1900); Holland – Zaandam, Voorzaan, Haaldersbroek. The important thing was to keep painting: "One must paint as much as one can, in any way, without being afraid of producing bad painting."

In 1908 he went to Venice, which fascinated him because it seemed almost to have been built with the specific purpose of appealing to him as the supreme "poet of light." Here he produced his *Views of Venice*, many of which were of the Ducal Palace. "The artist who conceived this palace," he noted, "was the first impressionist. He left it here to float on the water, to sping forth from the water and glitter in the air of Venice, just as an impressionist painter lets his brush strokes shine on the canvas to communicate the sensation of the atmosphere. When I painted this work, it was the atmosphere of Venice I wanted to paint. The palace that appears in my composition was a mere pretext to represent the atmosphere. Yet Venice is immersed in this atmosphere. It swims in this atmosphere. Venice is Impressionism in stone." The jewel of the lagoon had everything Monet wanted: light, water and the deliberate play between water and light enhanced by the architecture.

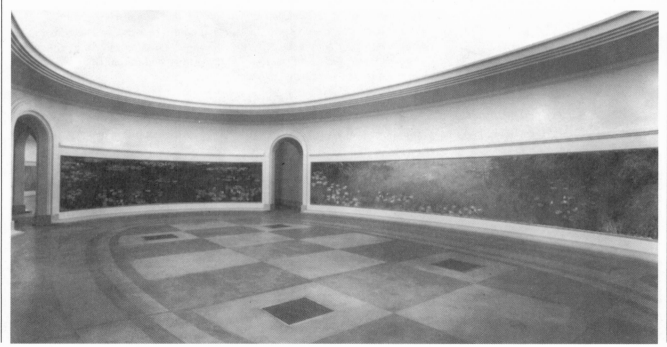

In November, just before returning to France, he also discovered the Venetian fog. Venice thus encapsulated all the most precious concepts of his art and was an extraordinary, unique place for him. It was a place with its own inner reality. Monet always sought to achieve an ideal union between the subject and the inner life of the painting; that is to say, between the needs of painting as dictated by its intimate nature and the contingent, but not casual, theme that inspires the artist. In 1890 he decided to create his very own subject par excellence, his ad hoc site. He

bought a little estate at Giverny not far from Paris, had a pond dug in the grounds and planted water lilies in it.

Monet was something of a paradox. He wandered continuously from one place to another, from one region and country to another, in search of whatever marvellous effects of nature or urban inspiration he could find. And yet he also worked for thirty years on the same little pond, painting the same botanical-aquatic elements, cultivating on the canvas the same, eternal flower garden again and again.

The *Water Lilies* are the climax of decades of experimentation in painting. These works are a prodigious representation which, on a gigantic scale, blends with its subject to the point of transforming it (and thus transforming reality) into painting; more than the subject of the decorative panels that portray it, the water lily pond in itself is an amazing picture, a work of art, a

Below: Paul Cézanne, Still-life, c. 1880; oil on canvas; 47 × 56 cm (18 × 21¾ in); Private Collection, Paris. Cézanne's "constructivist" period began around 1880, when he definitively abandoned the Impressionist idiom. This painting was part of the private collection of Gauguin, who inserted it – almost re-working it – in a work of 1890, Portrait of Marie Lagadu, which is a sort of delicate homage to the Provençal master both in its style and theme.

Below: Georges Braque, The Road to L'Estaque, 1908; oil on canvas; 60 × 50 cm (23¾ × 19½ in); Museum of Modern Art, New York. Cézanne's works had an immediate impact on the style of Braque, who was able to study the works of the "grand old man" from Aix at the famous retrospective show held in 1907. Braque abandoned his Fauve style and began working on the Cubist analysis of pictorial space.

Cézanne's Bathers

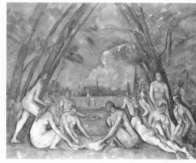

Paul Cézanne, Les Grands Baigneuses, 1898-1905; oil on canvas; 205 × 251 cm (79¾ × 97¾ in); Museum of Art, Philadelphia. Symbolically created in the period bridging the nineteenth and twentieth century, this masterpiece underscores the need for new expressive means and a revolutionary idea of painting.

Paul Cézanne's oeuvre is usually considered the other side of the coin to Monet's oeuvre. The roles played by these two founding fathers of the avant-garde – born in 1839 and 1840 respectively and both leading figures in the Impressionist movement – are complementary and in more than one respect converge felicitously even though they represent two different moments in the course of modern art. While Monet proposes an idea of painting as the total empathy of vision with the object viewed, Cézanne seems to be drawn to the problem of the relationship between image and rational awareness, hence more inclined to a reconstruction of the world within the boundaries of the painting. This reconstruction inevitably ends up highlighting not the viewed object, but the method, the very system of painting, that individualizes and organizes it artistically.

This is why the direction taken by Cézanne must be considered one of the most demanding of all. He was a complex painter, inaccessible not only to the public at large, but also to the taste of many famous innovators as well. Even his fellow Impressionists had some qualms about accepting him as one of them between 1870-80, mostly because they felt his works might cast a negative light on the entire group. Credit is due to Pissarro for having sensed Cézanne's worth and talent right from the start and for having helped and encouraged him in every way possible. Pissarro invited Cézanne to participate in the first Impressionist exhibition, which took place in 1874, but as John Rewald says, he "apparently had some difficulty in getting several of the others to agree to his participation, for they feared that the public might be too outraged by his canvases. But Pissarro [...] supported by Monet, pleaded the case of Cézanne with so much conviction that his friend was finally accepted [...]."

Monet's support of Cézanne confirms their reciprocal understanding and esteem. Like Monet, Cézanne worked intently for years in order to plunge headlong into a few obsessive themes and analyze them thoroughly, Mt. Sainte-Victoire from 1890 on, for example, and the Bathers for over three decades. This latter subject became fundamental to his final creative period because, from 1900 to his death in 1906, the large compositions with nude women amidst trees acquired an incredible level of maturity, and as such were examples of subtle but already evolved Cubist art.

The Bathers are for Cézanne what the Water Lilies were for Monet. But whereas Monet's masterpieces were understood only after the Second World War, Cézanne's striking green and brown canvases were immediately appreciated and became an integral part of the new art right from the 1907 retrospective show that consacrated the master from Aix-en-Provence and entrusted him to the young revolutionary artists of the time. That same year Picasso began working on Les demoiselles d'Avignon, while in 1908 Braque went to paint at L'Estaque, one of Cézanne's favourite painting sites, as if to pay homage to the artist who had first inspired his geometric vision, the painter who had maintained that it is necessary to treat nature "in terms of the cylinder, the sphere and the cone."

decorative panel, a celebration of colour and luminous matter. Monet created this from nothing, step by step, with great care. He fertilized, sowed and weeded. He understood that in order to execute a series of paintings totally consistent with his artistic vision he first had to create a "model" for them, building and shaping it into a sort of prototype painting. When René Gimpel and Georges Bernheim visited the artist's studio at Giverny, they found themselves looking at one of the greatest achievements in contemporary art: "A dozen canvases set in a circle on the floor, side by side, all about two meters wide and one meter twenty centimeters high; a panorama of water and water lilies, light and sky. In that infinity, the water and sky had no beginning or end. It was like witnessing one of the first hours of the birth of the world." The amazement of these observers is perfectly understandable: here was an old artist who belonged to a generation that had been in its prime half a century before, an Impressionist, one of those whom Picasso had already dismissed as obsolete painters alien to modernity, forcefully asserting himself as one

rupture in art, a sort of lacerating high note, an existential drama. Nature is no longer contemplated; Monet plunders its deepest recesses, which are teeming with fog, reflections and larvae, and he examines its innermost secrets as if from within. At the same time Monet was losing his sight, and so his vision trembled somewhat, but this only served to make him see nature more in depth. He abandoned the practice of visual contemplation, of artistic language as a mirror of reality. The *Water Lilies* are still, to some degree, the static representation of a water surface; but the novelty – with respect to the reflections of the Seine, the English Channel, the Thames and the Zaan – is that this so-called body of water reflects nothing at all. It is neither a mirror nor a reflection. The first people to see these works, Gimpel and Bernheim, understood this immediately. They spoke of light and sky, but in the *Water Lilies* the sky cannot be seen and the only light is that given off by the colour. It is not light represented, it is pictorial light.
The viewpoint was chosen so that the pond would have no horizon; it covers the entire canvas in an

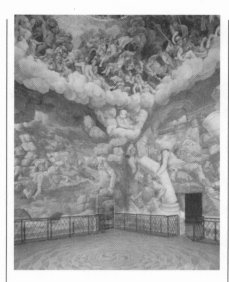

Above: Giulio Romano, The Fall of the Giants, *1532-34; fresco; Palazzo del Te, Mantua. The Mannerist "Hall of the Giants" is the oldest example of "environmental art," that is, an experimental fiction that attempts to* *involve the viewer by besieging him from all sides. The fall of the sacrilegious city is articulated on the four walls and the cupola vault of the hall in a continuous flow, creating an overwhelming sense of empathy in the spectator.*

heart of the watery existence, into the swarming recesses, of the pond at Giverny. They invite the observer to immerse himself more emotionally and enthusiastically into the painting.
There are many different elements in that process of immersion. There is the liberty of painting and the violence of nature. There is the sun, the sky, the fog, the light, the thick hazy summer air, the frost and thaw. There is the syntax of colours and the germination of matter. Lastly, there is Monet's despair, expressed a few years before his death: "At night I'm constantly haunted by what I'm trying to achieve. I get up exhausted every morning. The dawning day restores my courage, but my anxiety returns as soon as I set foot in my studio. Painting is so difficult; it's torture. Last autumn I burned six canvases together with the dead leaves from my garden. It's enough to make one lose hope. Still, I wouldn't want to die before saying all I have to say, or at least without having tried to say it. My days are numbered..."

Left: photograph of Monet's water-lily pond with the Japanese bridge at Giverny. Below: Claude Monet, Water Lilies, Sunset, *c. 1907; oil on canvas; Private Collection, Paris. A comparison between the "model" and* *Monet's painting helps us to understand the poetic tension underlying his artistic endeavour, which was a sort of never-ending struggle with the vehicle of painting and its contradictions.*

of the leaders of the new pictorial language, almost surpassing his younger fellow artists and proving significantly in his work that it was possible to reject the idea of a formal structure in art.
Some critics have taken the rather exaggerated view that Monet is a precursor of post-Second World War artistic sensibility, regarding him as the link between Turner's romanticism and Jackson Pollock's action painting. But it is certainly not wrong to consider the final phase of Monet's production the act that sanctioned an irreparable

attempt to force the viewer to plunge into the variegated and liquid mass before his eyes. The colour emerges from that mass in puffs and gusts, in clots and constellations. The arrangement of the reality that is observed may on the whole be identified with that of the painting; both are in the form of a chromatic wall set before the spectator. The pond rises, becomes a curtain, and then bends and becomes round, in the end besieging the viewer from all sides. The *Water Lilies* attempt to absorb the viewer and lead him to the

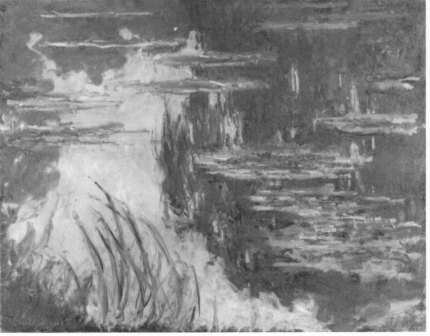

THE WORKS

"All my efforts are directed simply at realizing the greatest possible number of images intimately connected to unknown realities."

Claude Monet

Biography

Claude Monet was born in Paris, in rue Lafitte, on 14 November 1840. His father was a shopkeeper from Le Havre. In 1845, when Claude was five, the family moved back to this small town on the Channel, where the boy spent his entire childhood. At fifteen he began doing caricatures and portraits of his friends, and very soon began selling them. In 1855 his parents sent him to study drawing with Jacques-François Ochard, who had been a pupil of David. The following year Monet met Eugène Boudin, who inspired and influenced him considerably, encouraging him to take up *plein air* painting, which Monet would come to regard as the cornerstone of modern naturalism.

In 1857 Claude's mother died. In 1857 and 1858 he perfected his style by working side by side with Boudin. The next year his father – who had finally accepted his son's vocation – asked the city to give the boy a grant to allow him to continue his art studies in Paris. The request was turned down, but Monet went to Paris all the same, living on money saved from the sale of his drawings. He enrolled at the Académie Suisse, which was occasionally visited by Courbet and Delacroix. This was not an academy in the strict sense of the word, but a "school" without tuition where painters had models and didactic material at their disposal – in other words, a place where a young artist without means could find stimuli and encouragement for his work. At the Académie Suisse Monet met Camille Pissarro and, through him, came into contact with the painters who frequented the Brasserie des Martyrs. At this famous café one could meet and converse with the various exponents of the Realist movement and sometimes with critics and men of letters such as Baudelaire and Duranty.

The letters Monet wrote to Boudin in this period betray a precocious confidence of judgement; he spoke with competence of the 1859 Salon and some of the Barbizon school painters such as Troyon and Daubigny. In 1860 he painted some landscapes at Champigny-sur-Marne. His last caricature was published in "Diogène." That autumn he began his military service in Algeria.

In Algiers the colours and light of the Mediterranean made a deep impression on him. In 1862 he returned to Le Havre on sick leave and spent the summer painting in the open with Boudin. At the seaside they met the Dutch painter Johan Barthold Jongkind, with whom the young Claude struck up a lasting friendship. Monet's father decided to buy him out of the army and Claude returned to Paris near the end of 1862 and began frequenting the studio of Charles Gleyre, where he became firm friends with two young fellow painters, Jean-Frédéric Bazille and Pierre-Auguste Renoir. He often went to the Louvre to admire the works of Delacroix, whom he considered his spiritual master. With his new friends he painted in the Fontainebleau forest. In 1863 the small group of future Impressionists was enthusiastic about *Le déjeuner sur l'herbe*, which Edouard Manet was exhibiting at the Salon des Refusés. Yet Monet and Bazille's adoration of Delacroix continued, and they even went so far as to spy on the old painter in his studio at rue Fürstenberg.

In the summer of 1864 Monet was at Honfleur with Boudin and Jongkind. Before the end of the year he had a serious quarrel with his father, who withdrew all economic support. In a letter to Bazille, Monet wrote: "Every day I discover more and more beautiful things; it's enough to drive one mad; I have such a desire to do everything, my head is bursting with it! [...] I am fairly well satisfied with my stay here, although my sketches are far from what I should like them to be; it is really terribly difficult to make a thing complete in all its aspects."

In October, thanks to Bazille's intercession, he was able to sell three of his paintings to the art collector Bruyas from Montpellier. In 1865 Monet exhibited for the first time at the Salon, where his work was received quite favourably. *Mouth of the Seine at Honfleur* was praised by critic Paul Mantz in the "Gazette des Beaux-Arts." He moved for the summer to Chailly, near the Fontainebleau forest, staying at the Hôtel du Lion d'Or. Here the complex innovations of Manet's painting led him to embark on a very large-scale painting, also entitled *Le déjeuner sur l'herbe*, in which he used his friend Bazille and his companion Camille Doncieux as models. This was the most masterfully innovative work conceived up to that time.

Courbet, curious about this rising young painter, went to visit Monet, but the meeting was not a success: he made some discouraging remarks about the new painting that demoralized Monet and indirectly led him to abandon the work. Shortly afterwards Monet left the canvas, which remained unfinished, as security to his landlord, to whom he owed rent money. That autumn he met the American painter James McNeill Whistler, who had been living for some time in England.

In 1866 Camille posed for the portrait *Camille* (or *Woman in the Green Dress*), which owes a lot to Courbet. The work was accepted for the Salon and was praised by Emile Zola in "L'Evénement." The same year Monet painted the famous *Women in the Garden*. His Parisian cityscape, *Saint-Germain l'Auxerrois*, was exhibited at the same Salon (1866); this work was painted on a terrace of the Louvre together with other important paintings such as *Quai du Louvre* and *Garden of the Princess*. In these paintings Corot's spatial arrangement is combined with influences from the new "photographic eye" approach then in vogue (during this time Nadar was taking his aerial photos of Paris from a hot-air balloon). In the autumn, after destroying two hundred canvases so that creditors could not lay their hands on them, Monet went to Sainte-Adresse, where he painted *Terrace at Sainte-Adresse*.

In 1867 his companion Camille gave birth to Jean. Monet was represented at the 1868 Salon by *Fishing Boats at Sea*, which was also highly praised by Zola. In May he was at Fécamp with Camille and little Jean. Then they escaped from his creditors to Etretat, near Le Havre, where Monet was supported by the wealthy merchant Gaudibert, who bought some works and saved the painter from his debts. Monet had even attempted to commit suicide in a moment of desperation, but fortunately Gaudibert's kindness and friendship bolstered his spirits. In 1869 Gaudibert provided Monet and Renoir with a house at Saint-Michel, near Bougival, where they began to paint the same subject side by side – *La Grenouillère*.

On 26 June 1870 Claude and Camille were married; Courbet was one of the witnesses. The Monets moved to Trouville, in Normandy. To avoid having to do military service (the Franco-Prussian War had broken out on 19 July), Monet took refuge in London, where he discovered the work of William Turner. In the English capital he was again with Daubigny (who had moved there in 1867) and Pissarro, with whom he painted along the Thames or in Hyde Park. Pissarro said: "We also visited the museums. The watercolours and paintings of Turner and Constable have had an influence on us." Monet met Paul Durand-Ruel, who had opened an art gallery in New Bond Street and was to be the first merchant of Impressionist art. On receiving news of his father's

death in 1871 Monet returned to France and then went to Holland, where he produced the Zaandam series. He was in Paris at the end of the war (March), where he found out that Bazille had been killed in action. After the Commune (April-May) he visited Courbet in prison. Later, with Manet's help, he was able to settle in Argenteuil. In 1872 he painted *Impression, Sunrise*. He met Gustave Caillebotte, an amateur painter and wealthy art collector who gave him financial support and who was to be one of the most important French art patrons in the last quarter of the century. In 1873 Monet, following Turner's example, set up a floating studio, a houseboat he used in order to go down the Seine.

On 25 April 1874 Monet, Cézanne, Degas, Pissarro, Morisot, Sisley and Renoir held the Impressionist group exhibition at Nadar's former studio. This was organized by the Société anonyme des peintres, sculpteurs et graveurs, conceived in opposition to the official academic Salons. The public greeted the exhibition with petulant scorn. From 1875 to 1878 Monet worked mostly at Argenteuil, where he studied the laws of complementary colours and delved into the technical potential of colour and light in painting. The year 1877 saw the production of the brief but important *Gare Saint-Lazare* series. In the summer of the same year Monet was invited to the castle of Montgeron by the banker Ernest Hoschedé, who became Monet's firm friend and with whose wife Monet was to fall in love.

In 1878 Monet had to leave Argenteuil to escape from his creditors. He took up lodgings in Paris, where Camille gave birth to a second son, Michel. Hoschedé went bankrupt and that autumn took his family, together with Monet's, to Vétheuil. A strange relationship developed between the four of them.

On 5 September 1879 Camille died of consumption at the age of 32. The next winter was extremely cold. Vétheuil was snowed in and the Seine froze over. But around New Year's Day a sudden rise in the temperature brought about an amazing spectacle – blocks of ice began floating down the flooded river, which Monet captured in his *Ice Floes* paintings. He exhibited in the Salon for the last time in 1880. The following year he went to Fécamp to paint the Normandy sea once again. At the end of the year he settled in Poissy with Alice Hoschedé and their respective children.

In 1883 he was at work at Le Havre and Etretat. In March he held a one-man show at Durand-Ruel's gallery, exhibiting 50 paintings. He left Poissy for Giverny, on the Seine river, where he lived in a small country house. On 30 April he learned of Manet's death. Giverny proved to be a veritable natural paradise, extremely beautiful and a rich source of artistic inspiration. Monet went to Liguria in Italy with Renoir that autumn, returning to Giverny in 1884 with 50 works done in Bordighera – half of them either sketches or unfinished works. In March 1885 he did the door-panel decorations for the *grand salon* in Durand-Ruel's apartment in Paris. In May his works – together with those of Pissarro, Manet, Renoir, Morisot, Sisley and Seurat – were exhibited at the fourth Exposition Internationale at the Galerie Petit. In October he was visited by Guy de Maupassant, who confessed to a great admiration for his works. Monet made a brief trip to Holland in 1887 to paint the tulip fields. In September the journalist Gustave Geffroy wrote a long article on Monet's house in Giverny, underscoring the little private museum the painter had on his walls: works by Degas, Manet, Jongkind, Boudin, Signac, Pissarro, Sisley, Corot, Cézanne, Vuillard, Delacroix, Fantin-Latour

and Renoir. The dining room walls were entirely covered with Japanese prints.

The year 1889 witnessed the birth, with the *Hay Stacks*, of the famous series that were to continue for thirty years. These works were based on the principle of the expressive nature of blotches and spots, chromatic values and nuances, and they have been described as a sort of precursor of action painting. That autumn Monet promoted a public subscription with the aim of purchasing Manet's *Olympia* from his widow and donating it to the French state.

In 1890 he bought the house and estate at Giverny and began to build the pond in which he later planted the celebrated water lilies. He again took up the theme of the Seine frozen over. In March 1891 Ernest Hoschedé died and Monet married his widow Alice. In December he returned to London to paint. In 1892, at Rouen, he rented a room with a view of the cathedral façade. The *Rouen Cathedral* cycle was finished in 1894, amidst doubts and second thoughts.

At the beginning of 1895 Monet went to Norway, where he painted the fjords and other northern landscapes in a style that seems to hark back to that of the 1870s. In June he spent a brief holiday in the Pyrenees. From 1896 to 1900 some works of his and of other Impressionists were bought by the French government. In 1899, the year Sisley died, Monet was in London and began his series on the river Thames, executed in his room at the Savoy Hotel, where he returned for four consecutive years to study and work on the same subjects. In 1903 his friend Pissarro died in Paris.

After an illness that greatly weakened his sight, Monet went to Venice in 1908; here he painted many famous views. In the meantime he was engaged in his "secret cycle," the *Water Lilies* in

the pond at Giverny. In 1911 his second wife Alice died. Monet went through a long period of depression and despair. Three years later his firstborn son Jean died. Only Jean's widow, Blanche Hoschedé (who was both Monet's stepdaughter and daughter-in-law), helped the old painter in the period of solitude during the war years. Following the advice of his friend, the famous French politician Georges Clemenceau, he built a large studio in which he began working on huge panels known as the *Orangerie Water Lilies*. In the meantime his health was deteriorating.

In 1919 Renoir died. Monet was going blind but refused to have an operation. He offered twelve canvases painted from 1914 to 1918 to the French state, to be set up in a pavilion in the garden of the future Rodin Museum. Despite the support of Clemenceau, then Prime Minister, the project did not materialize and it was decided to place the paintings in the Orangerie. Throughout 1921 Monet worked with an architect on the restructuring of this nineteenth-century pavilion.

At the beginning of 1922 Monet was virtually blind, but he stubbornly continued painting outdoors, terrorized by the idea of having to stop painting. In September he realized he could no longer work. In 1923 he agreed to have an operation on the eye that was worst affected and his health improved somewhat. Between 1924 and 1925 he continued to paint large mural panels in total, almost desperate solitude.

On 26 June 1926 Monet was visited by eye specialists. A letter from Blanche to Clemenceau spoke of a tumour in his eye. That autumn physicians treated him to reduce the effects of the cancer. On 6 December 1926 Claude Monet died at Giverny.

Painting and atmosphere

Apart from his earliest efforts such as the caricatures done from 1856 to 1858, and his more or less academic studies, one could say that from the outset Monet's oeuvre aimed at reshaping Courbet's realism in a luminist key. The specific feature of his art lies in the progressive accentuation and personalization of features that in all respects were naturalistic. More than Daumier, the influences in his first period seem to be Corot, Courbet, and the exponents of the Barbizon school such as Daubigny, Troyon and Théodore Rousseau. Compared to these artists, however, young Monet stands out in his manifest search for a particular luminosity of the image, for what could be called a metaphysical clarity in perception. This tendency saved him from slavish imitation and at the same time allowed him, at least at the beginning, to share in the general culture of the preceding generation of painters.

Another factor that should be mentioned is that in this early period Monet hardly studied the masters of the past. True, for an artist of his temperament, stylistic regeneration was primary; yet he belonged to an era in which not having this type of apprenticeship was a rarity indeed. Monet detested the classical painters, disliked museums, and ignored the great Renaissance masters. During his Paris period (1859-60, and then after 1862), at an age when a burgeoning artist was supposed to apply himself heart and soul to copying Raphael, Titian, Michelangelo, or even van Dyck and Velázquez, Monet took great pains to avoid the Louvre (except for the rare occasions when a friend dragged him there for a brief and "useless" visit, or when he went to study Delacroix). His interest in the past did not go beyond the bourgeois realism of seventeenth-century Dutch art, from Jacob Ruisdael to Jan van Goyen and Adriaen van de Velde: traces of these artists' style can be appreciated in works such as *Hunting Trophy* (1862) or *Studio Corner* (1861), which are still closely connected to the mid-century cultural climate in France. In these works the dim tonalities of realistic painting (reminiscent of Courbet's earthy gravity) are already tinged with clear, brilliant reflections that are consistent with Monet's tendency in the years to come. Furthermore, he paid a certain amount of attention to the problems of harmony and compositional balance, which shows that these works do not reflect the Realist aesthetic, with its insistence upon the truth of external reality.

The budding of a new artistic personality is clearly seen in *Farm in Normandy* (1863-64). Commenting on this work, John Rewald says that Jongkind's influence on Monet was probably more decisive than Boudin's: "Unlike Boudin he [Jongkind] did not paint landscapes in the open; yet his sketches and watercolours done on the spot, his vivid brush-strokes and his intimate feeling for colour helped him remain true to his observations and reproduce them in all their freshness."

And yet it is not so much the works of Jongkind that influence *Farm in Normandy*, as the countryside itself, which is rendered so forcefully and courageously. It is the sky which is the real subject of this painting, a sky that is totally new in its luminous power, a sky that had never before been painted in art. Here for the first time one notes the radical consequence of *plein air* painting, which Monet had been practising at least since 1857, from the time Boudin had demonstrated its value to him. And it is the atmosphere that peremptorily dominates this scene. Monet's model is not the painters in the Louvre, but nature, with its changing effects of light and atmosphere, its flux, its fleeting scintillation.

The main paintings executed in 1864 are all characterized by this attempt to make daylight the protagonist. Two splendid seascapes, *Cape of La Hève* and *Lighthouse at the Hospice at Honfleur* (both done in 1864), reveal this to the full. The latter work was probably painted in company with Jongkind, who executed an analogous subject. And *Boatyard near Honfleur*, painted the same year, also betrays the pre-eminence of the sky and daylight over any other subject-matter. Here Monet employs a thick, full-bodied brush stroke that at times anticipates van Gogh's style, as in the yellow spot on the middle tree trunk, and that condenses and coagulates the heavy brilliance of the grey sky and the leaden sea. It is characteristic that Monet renders the splendour of light there where preceding painters could only render its negation when the weather was bad. This occurs, for example, in *View of the Coast at Sainte-Adresse* (1864) or in *Mouth of the Seine at Honfleur* (1865), two other magnificent seascapes; or in the various versions of the *clairières* (clearings) in the Fontainebleau forest: *The Road from Chailly to Fontainebleau* (1864), *The Bodmer Oak, Fontainebleau Forest* (1865), and above all the *Road from Chailly* (1865).

These country, or better, forest landscapes play a very important role in the history of Impressionism. They bear witness to the shift in the young painters who studied with Gleyre (Monet, Renoir, Bazille, Sisley) to the Barbizon school aesthetic, a shift that marks the first stage in the

long course of Impressionism. These landscapes are a sort of preparatory study for Monet's 1865 masterpiece, *Le déjeuner sur l'herbe*. Two parts of this work, which technically speaking are unfinished, have survived; these life-size pieces are kept in the Musée d'Orsay in Paris (the left section, 418 × 150 cm / 164 × 58 ½ in) and in a private collection in Paris (the central fragment, 248 × 215 cm / 96 ¼ × 83 ¼ in). There are two other versions or, more probably, studies of this work: *Luncheon on the Grass* at the Pushkin Museum in Moscow (a schematic view of the entire painting; 124 × 181 cm / 48 × 70 ½ in), and *Bazille and Camille* at the National Gallery of Art in Washington (Ailsa Mellon Bruce Collection; 93 × 69 cm / 36 × 26 ¼ in).

The largest work (the unfinished one that was cut into sections) was intended to be 4 m (13 ft) high and 6 m (19 ft) wide. The models for almost all the figures were Jean-Frédéric Bazille and Camille Doncieux, Monet's future wife. And yet the model for the man with the beard seated in the central fragment is said to be Courbet, the person most responsible for the sad fate of this painting, as it seems he persuaded Monet not to finish it. The most noteworthy aspect of *Le déjeuner sur l'herbe* is the chromatic symphony created by the light pouring down and becoming pulverized among the tree leaves. From a formal viewpoint this corresponds to the abrupt, short brush-strokes which take up and conclude the experiments already carried out in *Road from Chailly*. This painting marks one of the crucial stages in modern art. Leymarie calls it "Monet's manifesto," while Seitz rightly considers it an "amplification of the realists' figurative themes" translated into an "enhancement of formal research." The Italian critic Francesco Arcangeli speaks of it as follows: "Nothing was more moving at the Paris exhibition [in 1952] than the large central fragment of *Le déjeuner sur l'herbe*: the light is at first a bit cold (just as the sun in Ile-de-France is a bit cold); but it is violent, hurtling against objects almost in solid lashes and staining them with large spots; the shadows are soaked in greyish-blues, olive greens; the palette is intense and reduced, with only a few high tones: black, blue, green, some browns and light browns." Monet himself said this of this work in writing to Bazille: "I can no longer think of anything but my painting, and if I don't manage to finish it I believe I'll go mad."

In 1866 Monet painted his first noteworthy cityscapes; *Quai du Louvre*, *The Garden of the Princess*, and *Saint-Germain l'Auxerrois*. Another interesting painting is *Camille (The Woman in the Green Dress)*, which has something Spanish and, unusually enough for Monet, classic about it, although it shocked the conventional society of the time. Only Zola, in his review of the Salon, praised it highly. But the fundamental work of 1866 (which some critics, however, date a year later) is without a doubt the celebrated *Women in the Garden*, painted entirely outdoors at Ville d'Avray (only a few touches were added in Monet's studio at Honfleur). Once again Camille was the model, this time for all the figures.

It is not surprising that this painting – which Bazille bought in 1867, when Monet was in financial straits – was rejected by the Salon committee. In fact it is a revolutionary work, both in terms of its colours, brushwork, light and its composition. Although the gamut of tonalities appears to be somewhat connected to the physical, dramatic quality of the naturalism of Boudin and the Barbizon painters (as well as of Courbet), the departure from these influences takes place by means of Monet's use of modulated coloured shadows. The pivotal structure of *Women in the Garden* (the work is based on the figures revolving around the tree) produces a significant attack against the classical concept of perspective space, the solidity of which is undermined by the dabs of colour and by the elimination of black to depict shadows. We are thus witnessing the first, however partial, rejection of Renaissance perspective in modern art; Monet arrives at this by taking to extremes the idea of a totally solar painting in which light saturates and almost dissolves every object. On observing *Women in the Garden* in a shop window at rue Auber, Edouard Manet declared himself scornful of *plein air* painting, pointing out that the old masters did not even know what it was. This is indirect proof of the modernity of this work and of its revolutionary nature.

Terrace at Sainte-Adresse, now in the Metropolitan Museum, New York, was also painted in 1866. The spatial and chromatic arrangement – with that spacious horizon like a stage set filled with distant boats and columns of smoke, the stage bathed in light and those vividly coloured actors and objects placed slightly below the artist's viewpoint – makes this radiant view of a seaside resort even more original that *Women in the Garden*, and therefore unjustly less known. One immediately recognizes this work, from all standpoints, as one of the most typical manifestations of the new pictorial sensibility, which was now well on its way to becoming the triumph of Impressionist culture.

38

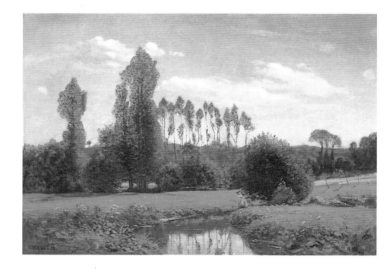

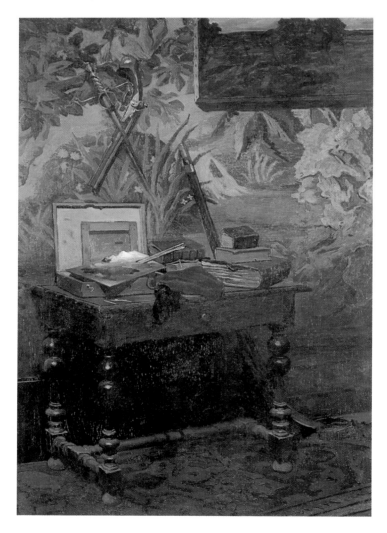

Above: View near
Rouelles, *environs
of Le Havre, 1858;
oil on canvas;
Private Collection,
Japan.*

Below: Studio
Corner, *Paris 1861;
oil on canvas;
182 × 127 cm
(70¼ × 49½ in);
Musée d'Orsay,
Paris.*

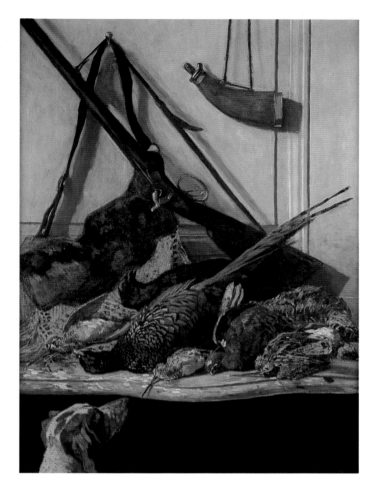

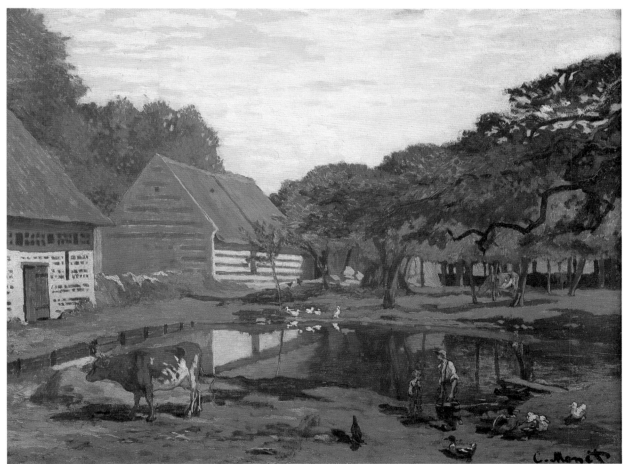

Above: Hunting Trophy, *Le Havre (?), 1862; oil on canvas; 104 × 75 cm (40½ × 29 in); signed and dated; Musée d'Orsay, Paris.*

Below: Farm in Normandy, *near Le Havre, late 1863 or 1864; oil on canvas; 65 × 81 cm (23 × 31½ in); signed; Musée d'Orsay, Paris.*

40

Still Life; Piece of
Beef, *Paris (?), c.*
1864; oil on canvas;
24 × 33 cm
(9 × 12¾ in);
signed; Musée
d'Orsay, Paris. This
work reveals the
need for structural
solidity, which was
the basic problem
of the realistic art
that stemmed from
Courbet.

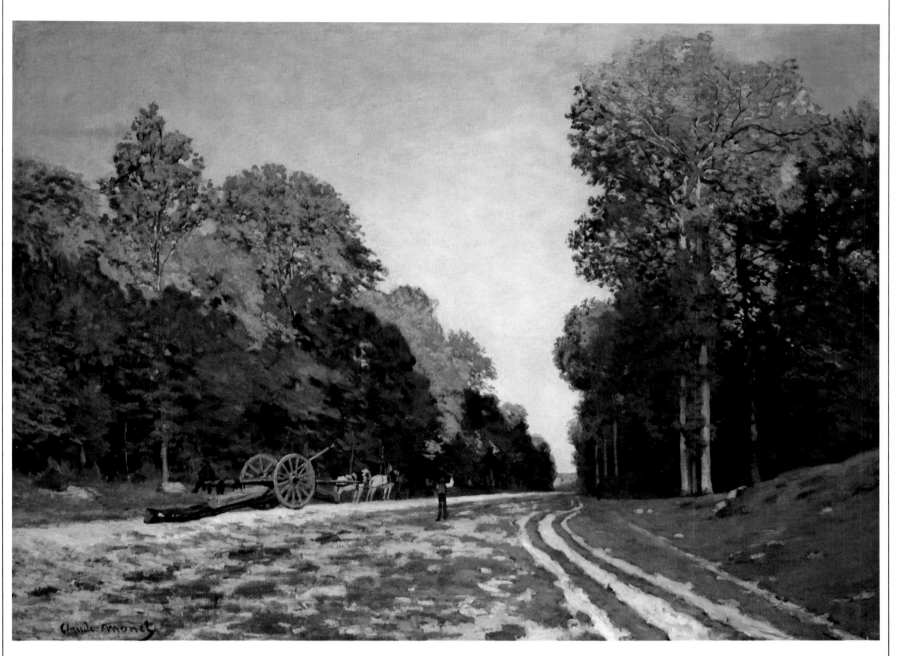

The Road from
Chailly to
Fontainebleau,
*Fontainebleau
forest, 1864; oil on
canvas; 98 × 130
cm (38 × 50¾ in);
signed; Private
Collection. The first*
*of the three versions
Monet painted on
the road in the
forest theme.
Though executed at
different times, the
three paintings are
quite similar to one
another.*

42

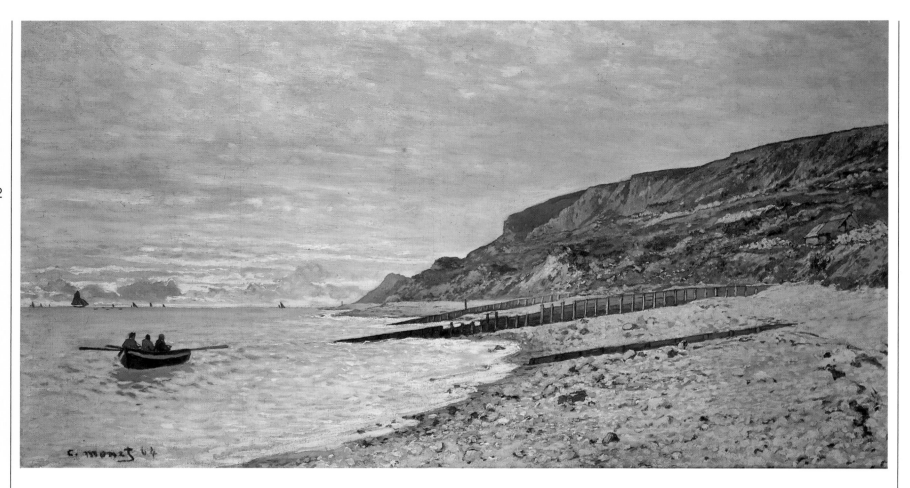

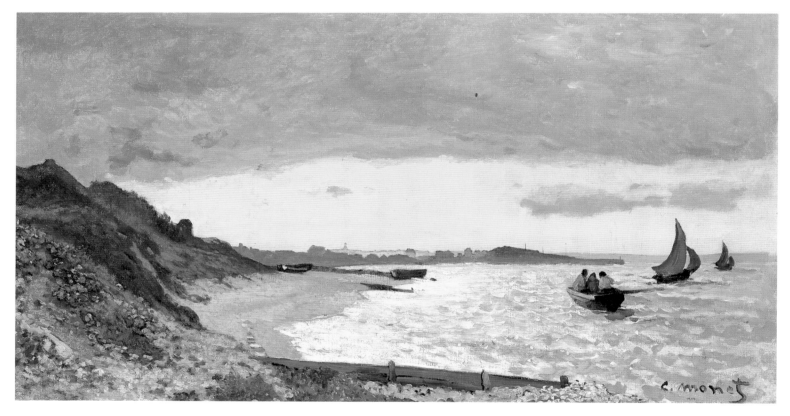

Above: Cape of La Hève, *Sainte-Adresse, summer 1864; oil on canvas; 41 × 74 cm (15¼ × 28¼ in); signed and dated; Private Collection, New York.*

Below: View of the Coast at Sainte-Adresse, *Sainte-Adresse, summer 1864; oil on canvas; 40 × 73 cm (15½ × 28¼ in); signed; Institute of Arts, Minneapolis.*

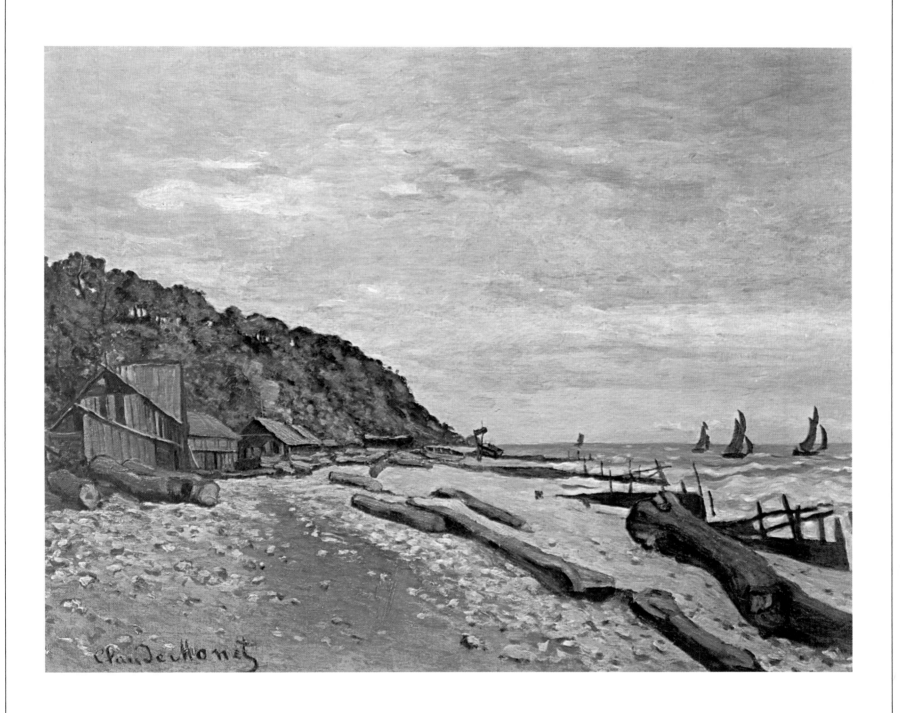

Boatyard near 57 × 81 cm
Honfleur, (22 × 31½ in);
Honfleur, summer *signed; Private*
1864; oil on canvas; *Collection.*

44

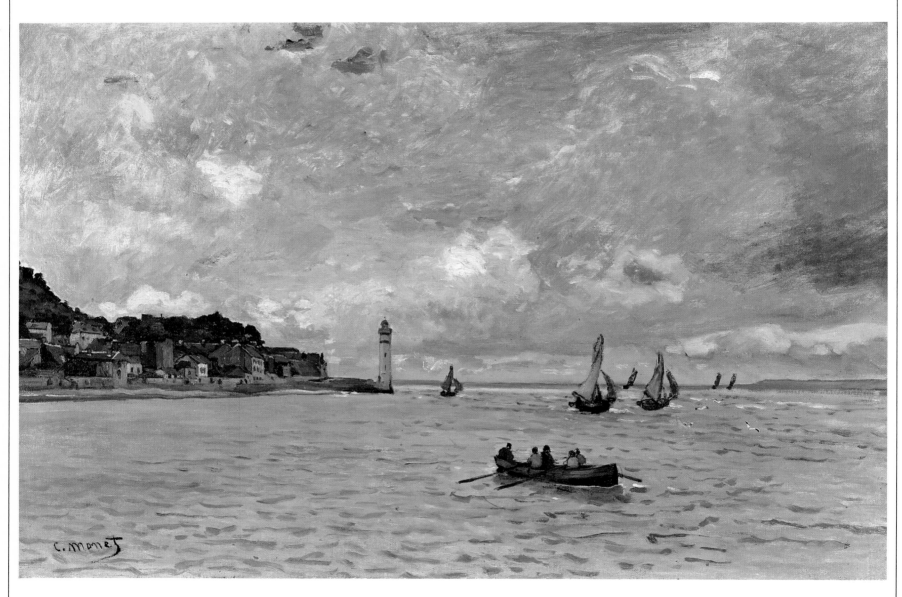

Lighthouse at the
Hospice at
Honfleur,
*Honfleur, summer
1864; oil on canvas;
54 × 81 cm
(21 × 31½ in);
signed; Kunsthaus,
Zurich. Situated on
the opposite side of*
*the mouth of the
Seine, the village of
Honfleur provides
an attractive
contrast to the
austere industrial
and port town of Le
Havre, which
Monet also painted
many times.*

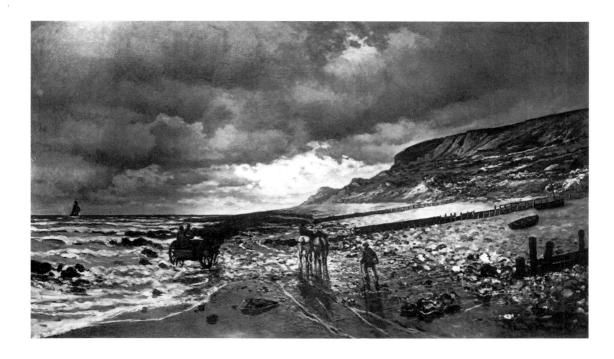

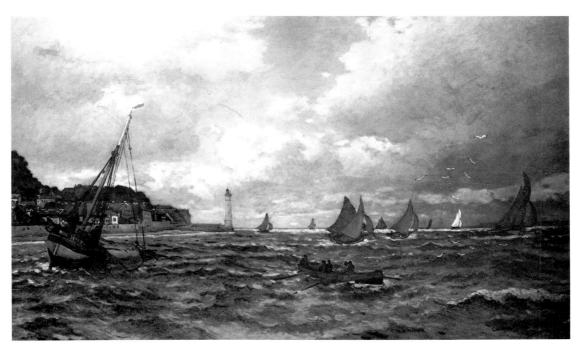

Above: Cape of La Hève at Low Tide, *Sainte-Adresse, 1865; oil on canvas; 90 × 150 cm (35 × 58½ in); signed; Kimbell Art Museum, Fort Worth.*

Below: Mouth of the Seine at Honfleur, *Honfleur, summer 1864 or spring 1865; oil on canvas; 90 × 150 cm (35 × 58½ in); signed and dated (1865); The Norton Simon Foundation, Pasadena.*

46

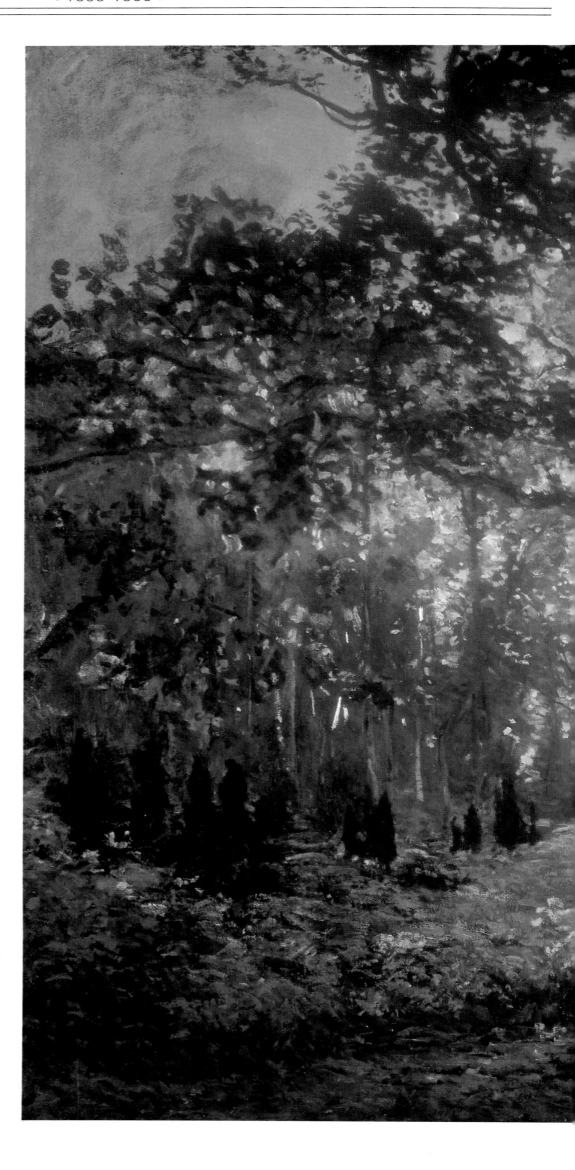

The Bodmer Oak,
Fontainebleau
Forest, *environs of
Barbizon, summer
1865; oil on canvas;
97 × 130 cm
(37¼ × 50¼ in);
signed;
Metropolitan
Museum of Art,
New York. This is a
rather unusual
subject, as Monet's
"impressionist"* *taste much
preferred wide open
spaces, vistas in
perspective between
rectilinear "wings"
(such as the trees
along a forest
road), and the
luminous skies in
clearings, seascapes,
or even in the
panoramic
cityscapes viewed
from above.*

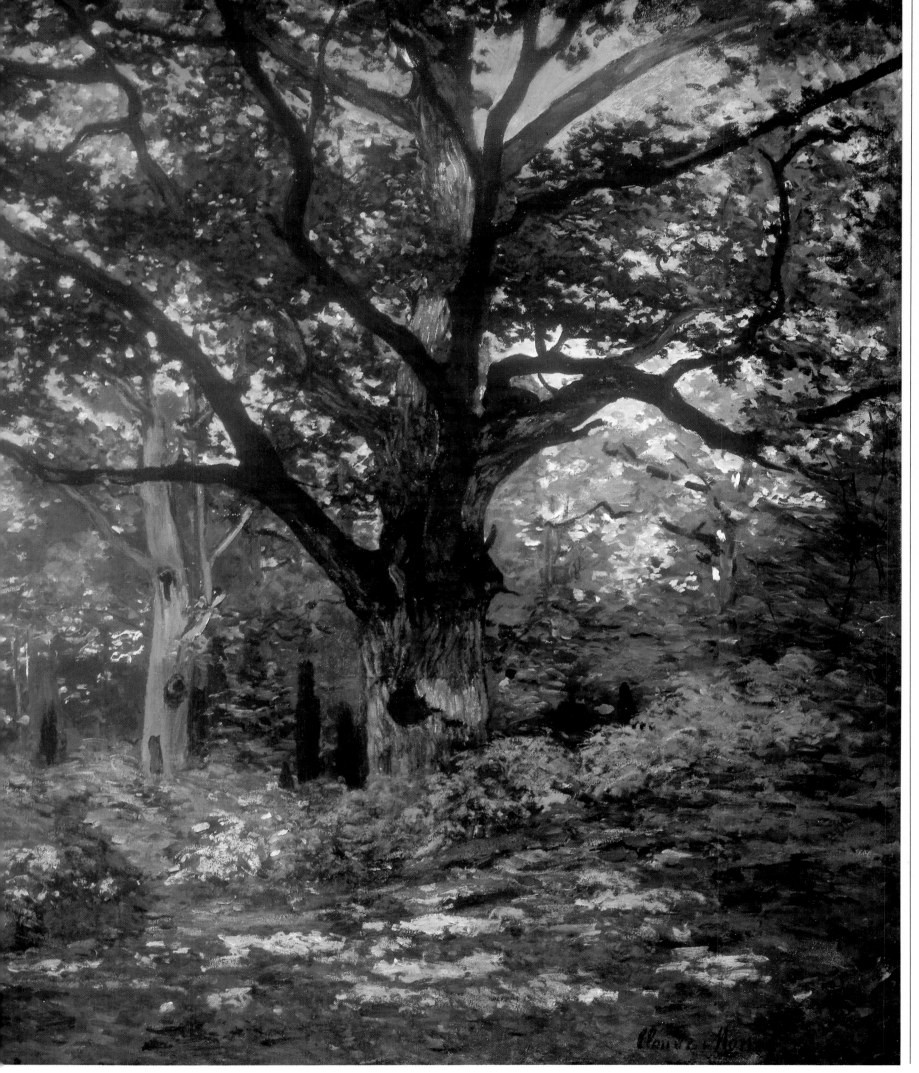

48

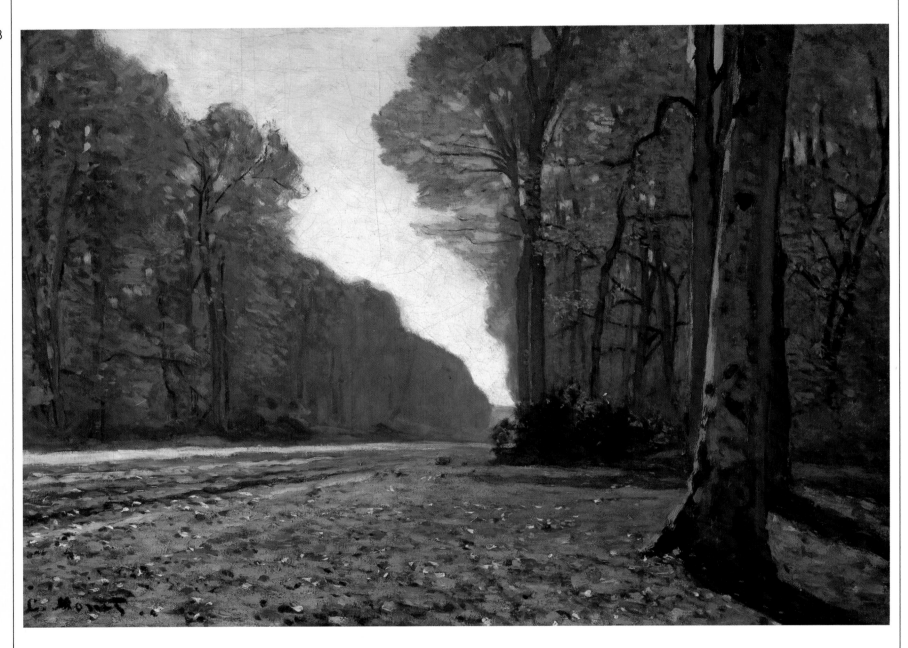

The Road from
Chailly,
*Fontainebleau
forest, summer
1865; oil on canvas;*
43×59 cm
*(16¼ × 23 in);
signed; Musée
d'Orsay, Paris.*

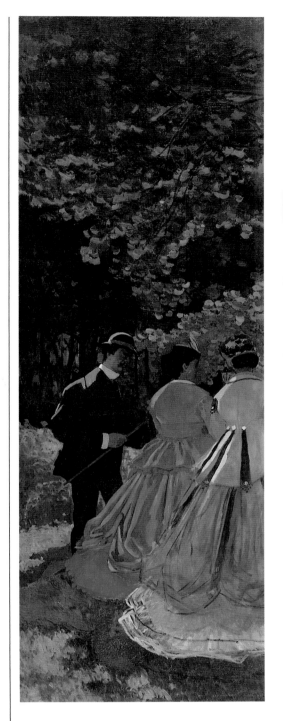

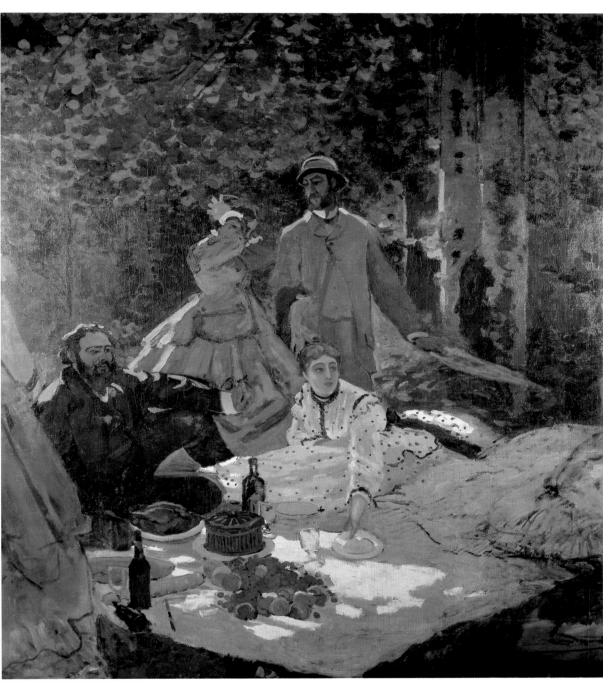

Le déjeuner sur
l'herbe *(two*
fragments),
Fontainebleau
forest, summer
1865; oil on canvas;
418 × 150 cm
(163 × 58½ in) and
248 × 217 cm
(96¾ × 84½ in);
Musée d'Orsay,
Paris.

50

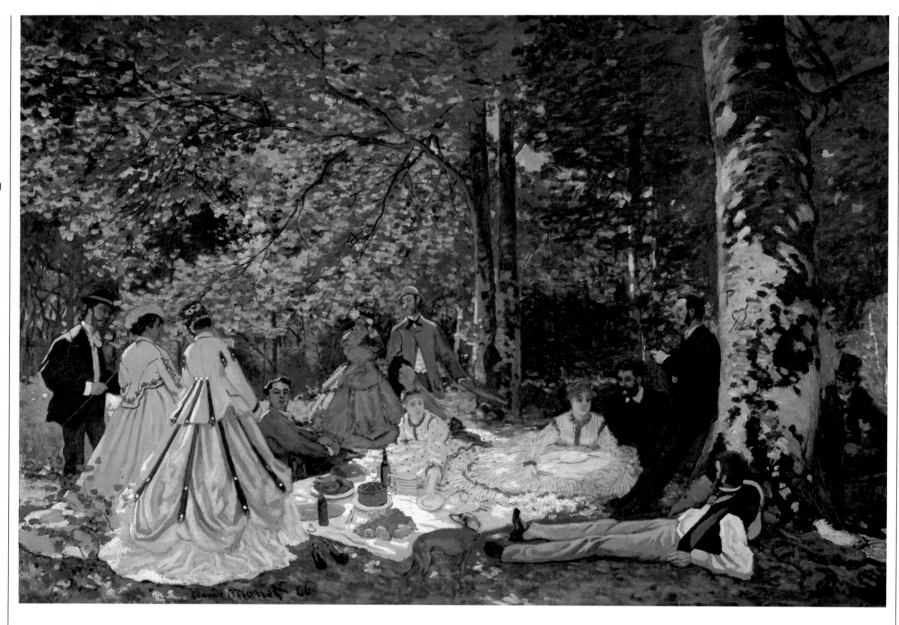

Opposite above: Le déjeuner sur l'herbe, *Fontainebleau forest (?), 1865-66; oil on canvas; 130 × 181 cm (150¼ × 70½ in); signed and dated (1866); Pushkin Museum, Moscow. Although Monet wrote the date 1866 on this work, he began working on it* in 1865. *This may be a study for the painting reproduced on page 49; but it is more likely to be another version on a smaller scale that was perhaps done in a studio in Paris.*

Opposite below: Bazille and Camille, *Fontainebleau forest, summer 1865; oil on canvas; 93 × 69 cm (36⅛ × 27⅛ in); Ailsa Mellon Bruce Collection, National Gallery of Art, Washington. This was a study for the painting reproduced on page 49.*

Above: The Green Wave, *Trouville (?), autumn 1865; oil on canvas; 48 × 64 cm (19⅛ × 25½ in); signed and dated; Metropolitan Museum of Art, New York.*

52

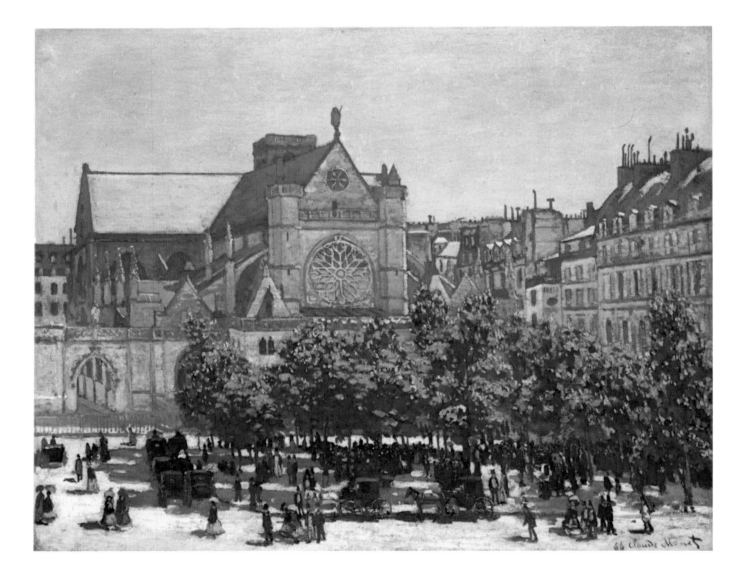

Above:
Saint-Germain
l'Auxerrois, *Paris,
spring 1866; oil on
canvas; 81 × 100
cm (31½ × 39 in);
signed and dated
(1866); Neue
Nationalgalerie,
Berlin. According
to some art
historians, this
work was painted in
1867.

Opposite: The
Garden of the
Princess, *Paris,
spring 1866; oil on
canvas; 91 × 62 cm
(35¼ × 24 in);
signed; Allen
Memorial Art
Museum, Oberlin
(Ohio). This work
was painted from
the eastern balcony
of the Palais du
Louvre.*

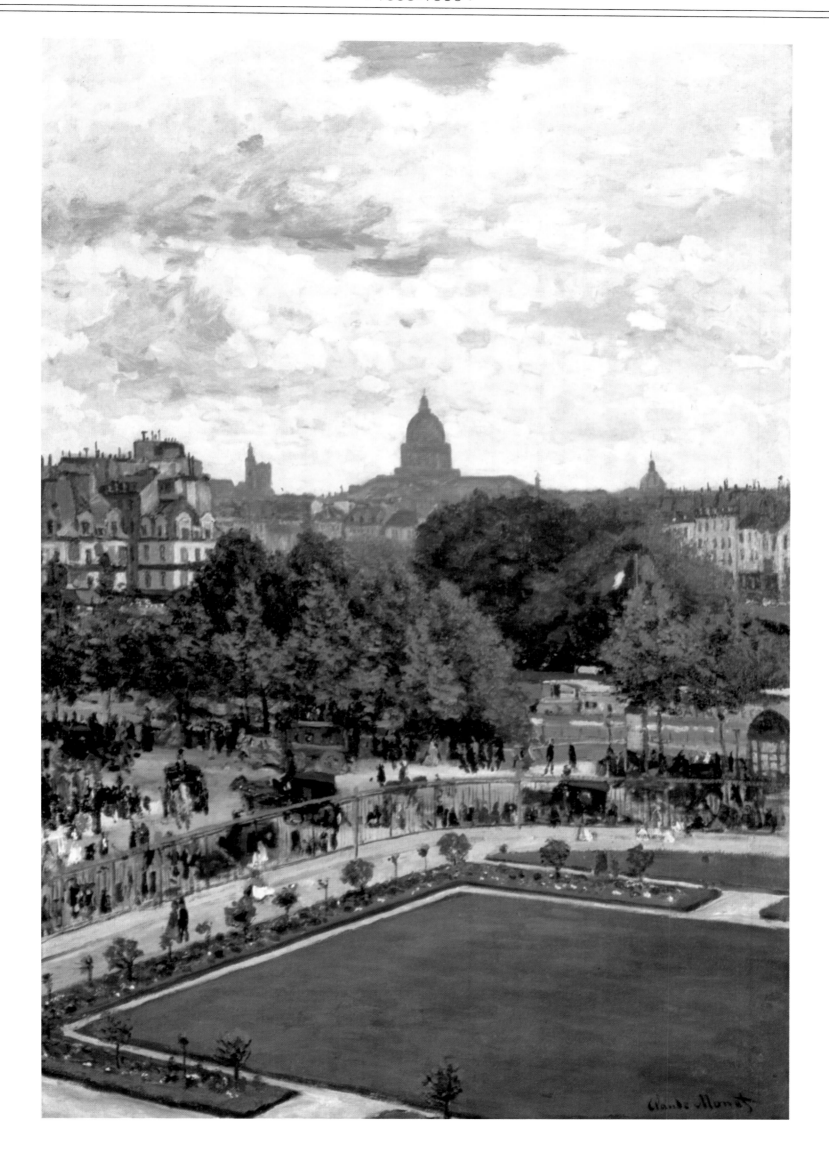

54

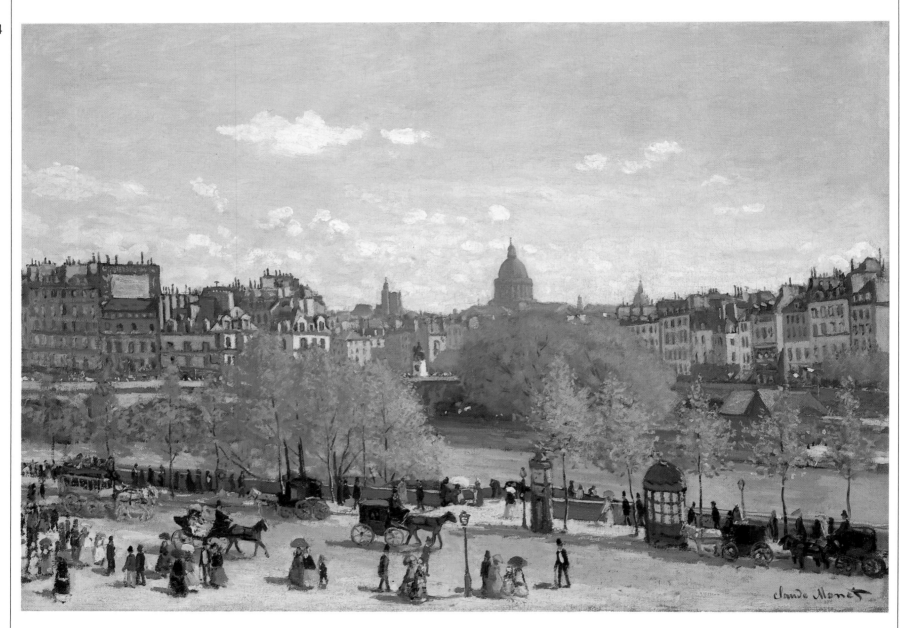

Above: Quai du Louvre, *Paris, spring 1866; oil on canvas; 65 × 93 cm (25 × 36 in); signed and dated; Gemeentemuseum, The Hague. Like* The Garden of the Princess *on the preceding page, this work was painted from the eastern balcony of the Louvre.*

Opposite: Camille (*or* The Woman in the Green Dress), *Paris (?), spring 1866; oil on canvas; 228 × 149 cm (88¼ × 58 in) signed and dated; Kunsthalle, Bremen.*

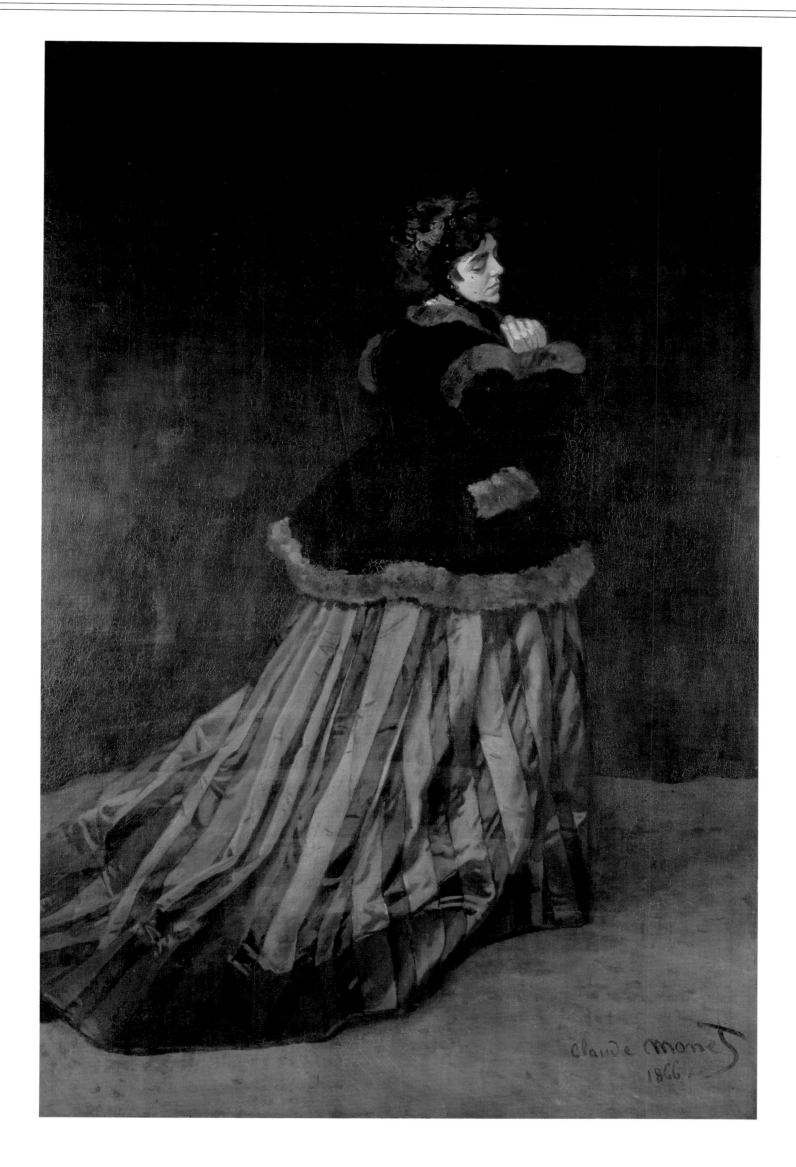

56

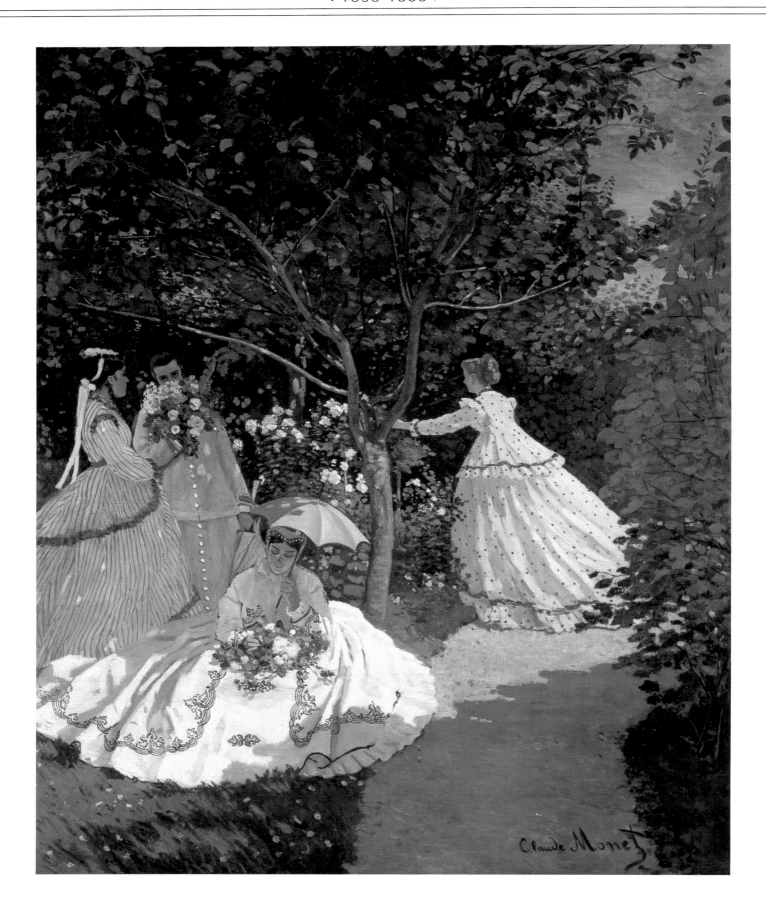

Women in the
Garden, *Ville
d'Avray, late spring
1866; oil on canvas;
255 × 205 cm
(99¼ × 79¾ in);
signed; Musée
d'Orsay, Paris.
Some scholars think* *this painting was
finished in 1867,
but the fact that
Bazille bought it
from Monet in
January of that
year seems to
exclude this
possibility.*

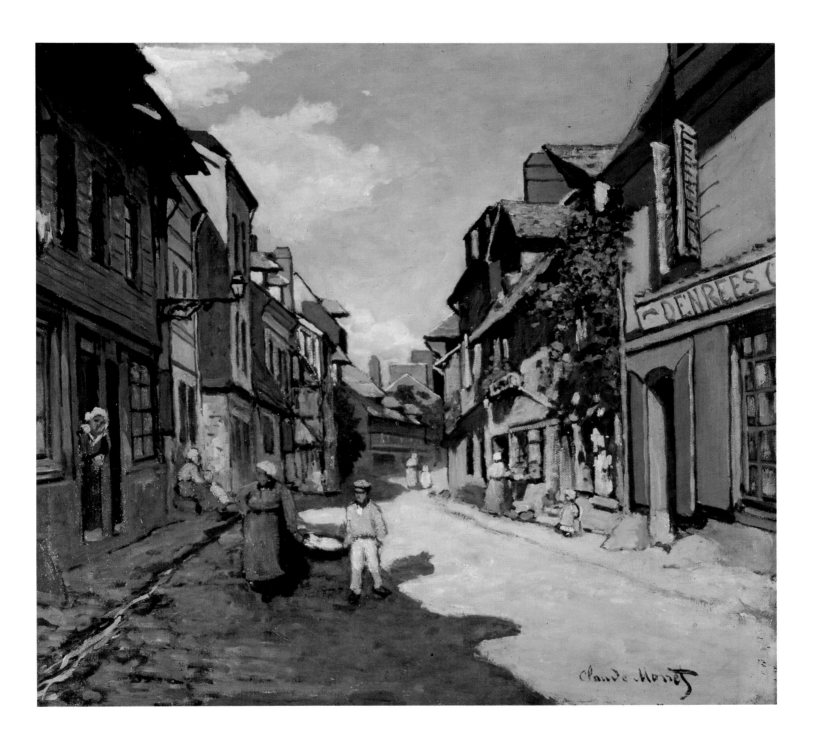

Country Road in
Normandy, *1866;*
oil on canvas;
58 × 63
(22½ × 24½ in);
signed; Kunsthalle,
Mannheim.
According to some
art historians this
work was painted in
1867.

58

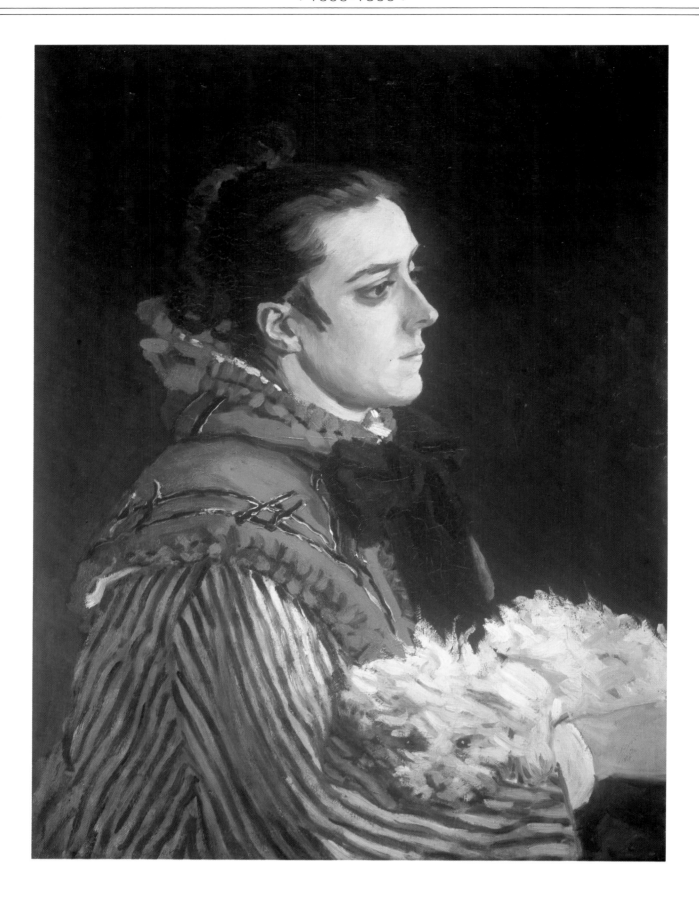

Camille with a 73 × 54 cm
Small Dog, *Ville* *(28¼ × 21 in);*
d'Avray (?), 1866; *signed and dated;*
oil on canvas; *Kunsthaus, Zurich.*

Garden in Bloom at Sainte-Adresse, *Sainte-Adresse, autumn 1866; oil on* *canvas; 65 × 54 cm (25 × 21 in); signed; Musée d'Orsay, Paris.*

60

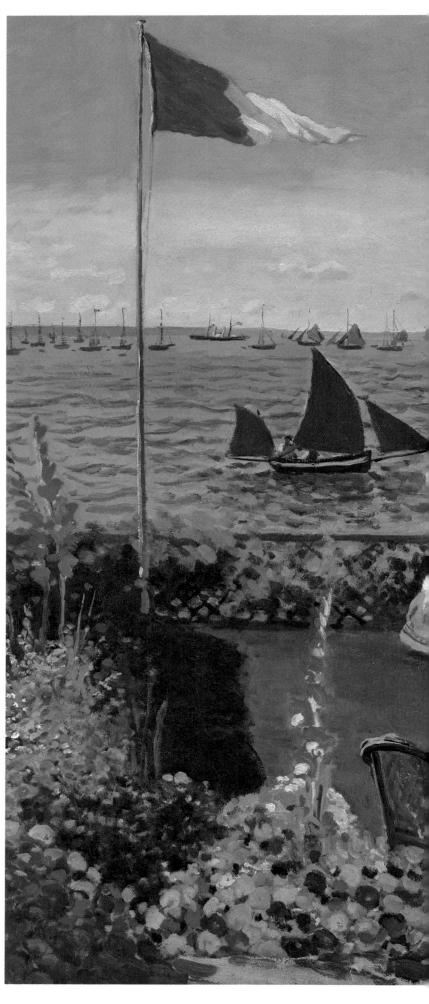

Above: The Port of Honfleur, *Honfleur, autumn 1866; oil on canvas; 148 × 226 cm (57¼ × 88 in); once in the Eduard Arnhold Collection, Berlin and presumably destroyed during the Second World War.*

Right: Terrace at Sainte-Adresse, *Sainte-Adresse, autumn 1866; oil on canvas; 98 × 130 cm (38 × 50 in); signed; Metropolitan Museum of Art, New York. The splendid effect of light, the vivid and sparkling colours, and the vibrant brush strokes make this a sort of "manifesto" of Impressionism. It is exactly these features that have led some critics to state that this work was painted during Monet's following sojourn at Sainte-Adresse in the summer of 1867.*

The construction
of the painting

Between the late 1870s and the early 1880s Monet's art rapidly developed into the unadulterated form of Impressionist expression that was characteristic of so many of his works. The evolution of his technique was parallel to that of other leading young painters such as Renoir, Sisley, Pissarro and Cézanne; the relationship between Monet and Renoir, for example, was a professional companionship based on the exchange of personal discoveries and inventions to their mutual advantage. However, we should bear in mind that in this period these two artists' innovations were fundamentally empirical. For the moment their aim was still to lead the Naturalist aesthetic of imitation, from which their art derived, to its extremes. These artists set out to pass beyond the expressive potential of realism without, however, abandoning its field of action. In effect the representatives of the future Impressionist revolution were undermining from within the bases of pictorial realism in a rather confused or at least not altogether conscious way. It was precisely the need for a radical reinterpretation of Courbet's art, together with the adoption of Manet's new technique, that led Monet to acquire a vast store of solid technical skill and psychological awareness. In other words, he was acquiring the tools that would later allow him to make his analysis of

the effect of light "scientific" and to achieve, with great determination and resourcefulness, the pure painting that was the inevitable result of this analysis. This path was by no means easy or smooth. Among the paintings executed in 1867 are some that should be mentioned for their surprising stylistic uncertainty: *The Beach at Sainte-Adresse* at the Art Institute of Chicago, *The Cradle – Camille with the Artist's Son Jean* (National Gallery of Art, Washington), and *The Cart: Snow-covered Road at Honfleur, with Saint-Siméon Farm* in the Musée d'Orsay in Paris. In these works one notes a rather hasty, almost improvised rendering of chromatic effects, obtained by means of homogeneous hues and compact brush strokes, revealing a sensibility that is quite at variance with the artistic vision manifested shortly afterwards in *La Grenouillère* or in the paintings of the Holland cycle. And they are unquestionably a step behind the best paintings he produced in 1866 (*Women in the Garden, Terrace at Sainte-Adresse*). These works seem to be disconnected from the mainstream of Monet's art and have made more than one critic wince. It must, however, be recognized that Monet's artistic experience was marked by sudden reversals, self-critical doubts, and the occasional unevenness in quality.

In 1868 one work, although qualitatively flawless, betrays strange regressive tendencies – *The Luncheon*. This painting can be related to the oeuvre of Edouard Manet in at least two ways. It contrasts with Monet's *Déjeuner sur l'herbe* of 1865 (which is directly related to Manet's work of the same name painted in 1863), the theme of which it seems to take up and extend: from outdoors to indoors, from the forest to the artist's home; and, in purely ideological, technical terms, from *plein air* painting to an "academic" work in the studio. The second connection with Manet's art is the fact that Manet also painted the subject of a lunch in a home: *Luncheon in the Studio* (1868), at the Neue Pinakothek in Munich. The parallelism is quite evident: two "lunches on the grass" (1863 and 1865) and two "luncheons in the studio" (both painted in 1868). Lastly, from a stylistic point of view, Monet's *Luncheon* is one of the works that most closely adheres to Manet's concepts: the faces whitened by the light, those clear-cut, markedly "unimpressionistic" shadows; and that tablecloth with its *trompe-l'oeil* effect that could be called neo-Caravaggesque. How surprising it is, therefore, to find in the same year such a splendidly solar and truly original painting as *The River* (Art Institute of Chicago). According to Michel

Butor this work is part of a series with a complex structure containing a sort of visual puzzle whereby certain areas of the picture are legible only thanks to the presence of other didactic areas. *The River* sets into motion a play of links and references among the objects reflected upside-down in the water and the objects that one presumes are real; the two areas rotate, so to speak, on an axis (the glance of the woman seated on the river bank) that makes them complementary and mutually indispensable: "To her right the roofs of the houses are on top, to her left they are on the bottom. This arrangement forces us to re-establish behind the leaves the normal figure of the houses reflected [in the water] by inserting on the surface of the water [...] a reflection of the houses at right that is their perfect mirror image. The entire canvas is animated by these duplications."
Though still based on an empirical method, Monet's painting upsets the relationship between the seeing subject and the seen object. From around 1868 to 1875 the reflection of the sun on water seems to be the most immediate realization of the above-mentioned need for visual reorganization. The pivotal nature of these reflections as pictorial subjects in the work of a passionate frequenter of waterways and beaches is not only the consequence of his love for the

Seine or the Thames, the Normandy coast or the Dutch basins and waterways, but on the contrary is the driving force behind that passion, its wellspring. The reverberations on the water are the real motif of *La Grenouillère*, which Monet painted in 1869 at Bougival, where he rented a house with Renoir. That famous bathing resort with its café-restaurant, the haunt of hordes of excursionists and fishermen, was virtually depicted in one single, prodigious view: the two works of these artists are really one picture, a duet of inestimable value, an exceptional product of teamwork.

John Rewald explains that this work companionship allowed Renoir and Monet to make a critical revision of most of the pictorial norms of the time: "Thus they could further develop their knowledge of the fact that so-called local colour was actually a pure convention and that every object presents to the eye a scheme of colour derived from its proper hue, from its surroundings, and from atmospheric conditions." It would be naive to consider this flouting of the rules merely a further approach to the truth of nature. What Monet's art achieves is the urgent re-establishment of the liberty of the creative gesture, and thus the freedom of colour and every formal aspect from the twofold bond of the faithful rendering of the object and of the dependence on the conventions needed to represent this object.

It is precisely the conventionality of objective vision that lies at the base of the logic Monet employed to detach himself from the flatness of imitation: *Fishing Boats at Sea*, which can be dated around 1868 or 1869, in which the personal, interpreted perception of the scene is translated into a refined hallucination of colours; or *Rough Sea at Etretat*, painted during the same period, which has an Expressionist and almost Munchian quality about it; and the magnificent landscape *The Magpie, Snow Effect, Outskirts of Honfleur*, which was probably painted in 1869 (through some art historians prefer to date it at 1872). The high poetic level achieved by Monet deserves to be emphasized. For example, in *The Magpie* the utter enchantment of a view of the sun and frost, of the magical, hidden vitality that stands out – by contrast – amidst the sense of immobile, eternal grace emanating from the snow-covered countryside.

In 1870 Monet produced more mundane, sober paintings showing the beach at Trouville; there are various portraits of Camille, sometimes with her cousin, several views of the seaside and of the hotels on the promenade. These works are interesting above all for the variety and boldness of the viewpoints. When analyzed side by side, one sees that the portraits of Camille are basically studies, sketches, almost notes for later, hypothetical elaborations (which, however, Monet never developed). The precision of perspective in the unusual viewpoints immediately brings these works close to the experiments of Degas, which were soon to follow, whose style, however, represents the absolutely opposite concept. For although he was involved in the eminently modern search for an image of original expressive power based on the immediate and anticlassical values of the photographic view, Degas never went so far as to abandon a certain academic quality in his graphic, chromatic, and chiaroscuro rendering. On the contrary, the direction taken by Monet led to the progressive dissolution of line and the object; and already in these works of the early 1870s his pictorial language openly betrays his inclination to abolish all artificial principles of decorum and vain demonstrations of technical prowess.

After the evocative first fog-bound view of *The Thames and the Houses of Parliament* (1871), a partial and temporary recovery of formal perfection is to be noted in Monet's Dutch series of the same year: *Zaandam, The Zaan River at Zaandam, Houses on the Zaan River, The Voorzaan at Zaandam, Windmills at Haaldersbroek, Zandaam*, etc. These are the works of an already mature artist with a prodigious control of his technical means and an instinctive capacity for poetic synthesis, open-mindedness and conviction. Note the lyrical and descriptive effect produced by the streaks of colour representing the reflection of the houses and other objects in *The Zaan River at Zaandam*. Here reality becomes something both concrete and mental, a sort of screen between man and the heavens that makes us certain of our existence; but it is also the product of a definite will to see on the part of the human imagination as a key to the interpretation of the universe. This is a constructive tendency and it distinguishes Monet's oeuvre from the "lighter" works of many of his peers. With the obvious exception of Cézanne, Monet is the only Impressionist artist to face, in a coherent manner and from this period on, the problem of the scientific and psychological consistency of perception; he therefore questions the very "truth" of the mechanics of sight, of the transmission of information from the eye to the brain, of cerebral, cognitive synthesis, and lastly, of the pictorial rendering that must take all this into consideration.

64

Above: The Beach at Sainte-Adresse, *Sainte-Adresse, June-July 1867; oil on canvas; 93 × 130 cm (36 × 50¾ in) signed and dated; The Art Institute, Chicago. This work is one of the rare* melancholy works of this period, a bit more mysterious than Monet's usual sunlit paintings and therefore perhaps indicative of a negative mood. *Right:* Beach at Sainte-Adresse, *Sainte-Adresse, June-July 1867; oil on canvas; 74 × 100 cm (29½ × 40 in); signed; Metropolitan Museum of Art, New York.*

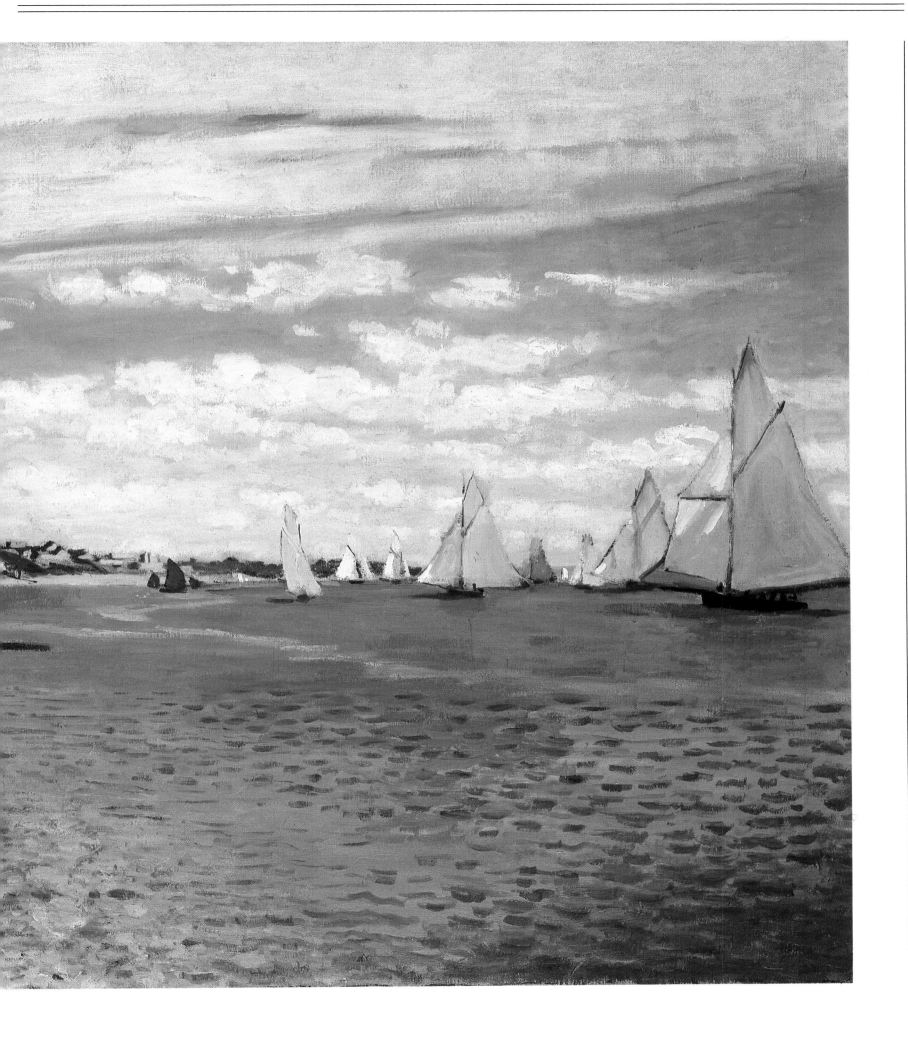

66

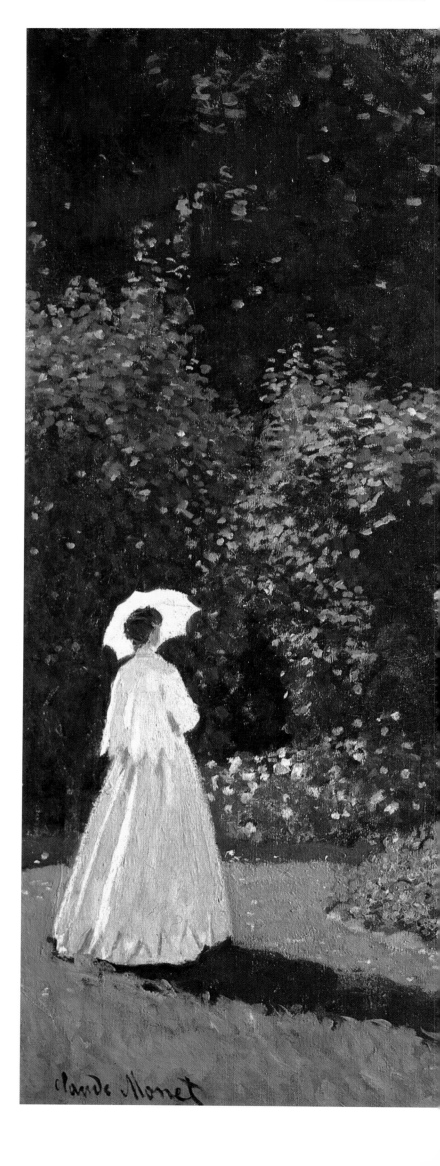

Jeanne-Marguerite Lecadre in the Garden, Sainte-Adresse, June-July 1867; oil on canvas; 80 × 99 cm (31 × 38½ in); signed; The Hermitage Museum, St. Petersburg. In the works of the second half of the 1860s, the problem of light is linked with that of redefining the role of nature which, in its perpetual mutability, is the primary cause of the uncertainty of perception.

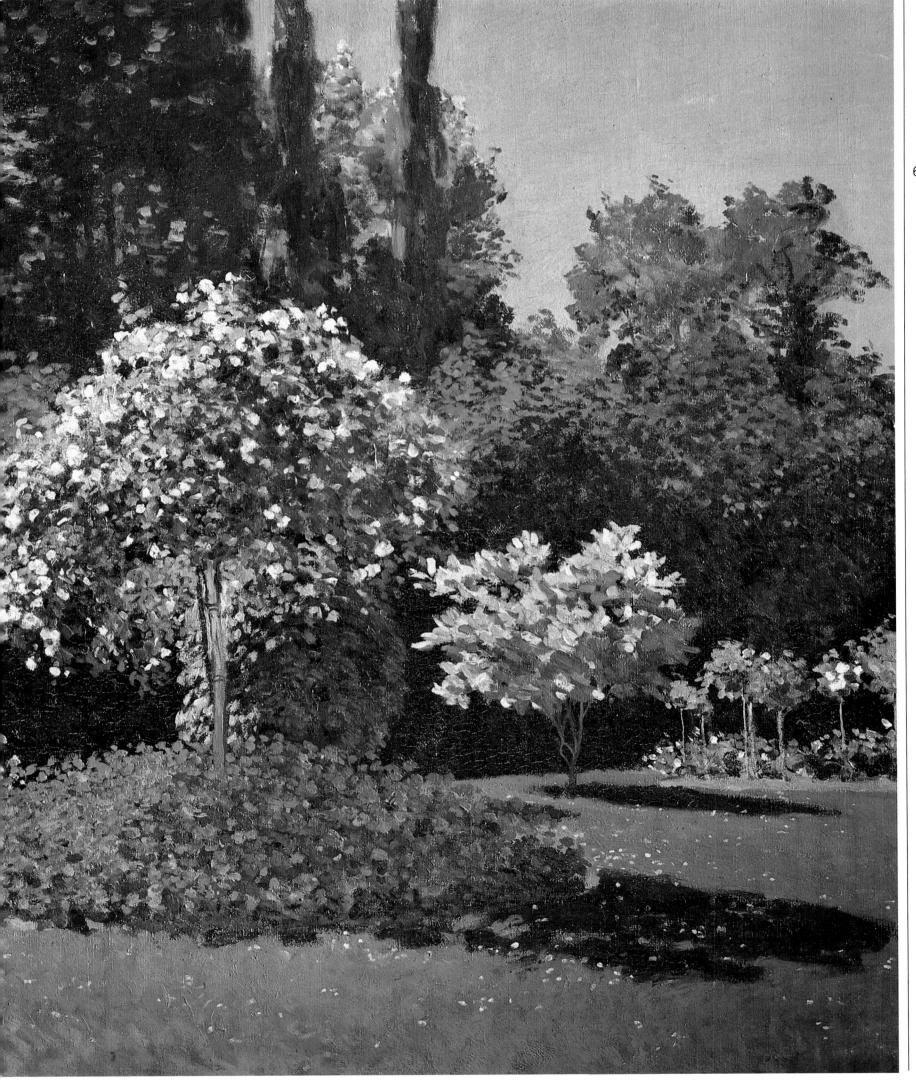

68

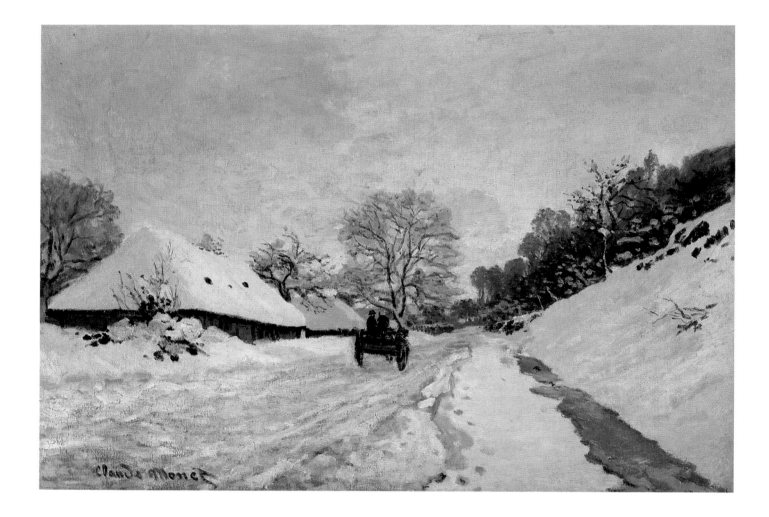

Above: The Cart;
Snow-covered Road
at Honfleur, with
Saint-Siméon Farm,
*Honfleur,
autumn-winter
1867 (?); oil
on canvas;
65 × 92.5 cm
(25 × 35¼ in);
signed; Musée
d'Orsay, Paris.*

Opposite: The
Cradle – Camille
with the Artist's
Son Jean, *Le
Havre, August
1867; oil on canvas;
116.8 × 88.9 cm
(46 × 35 in);
National Gallery of
Art, Washington.*

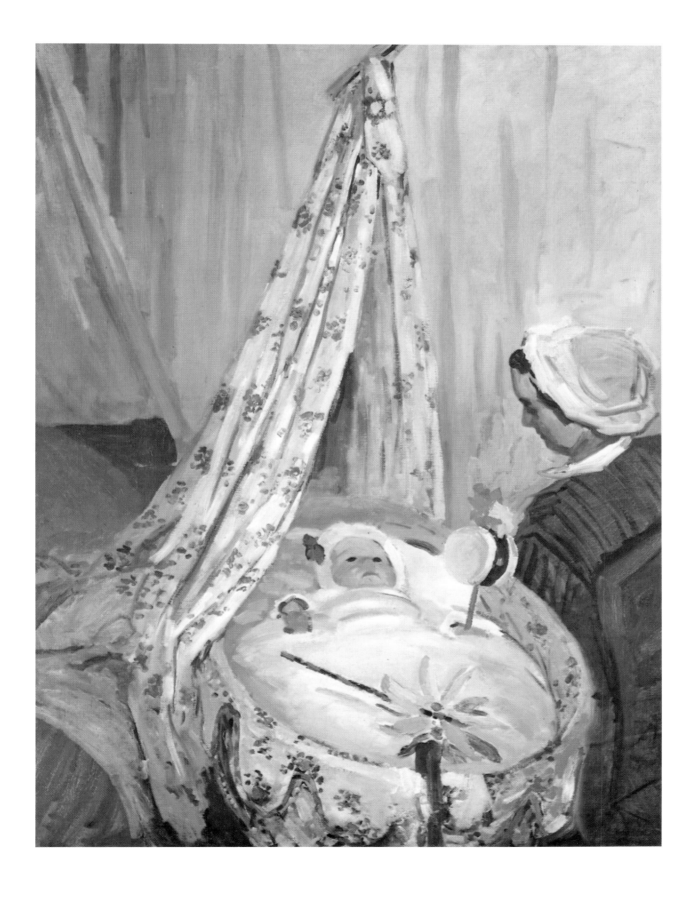

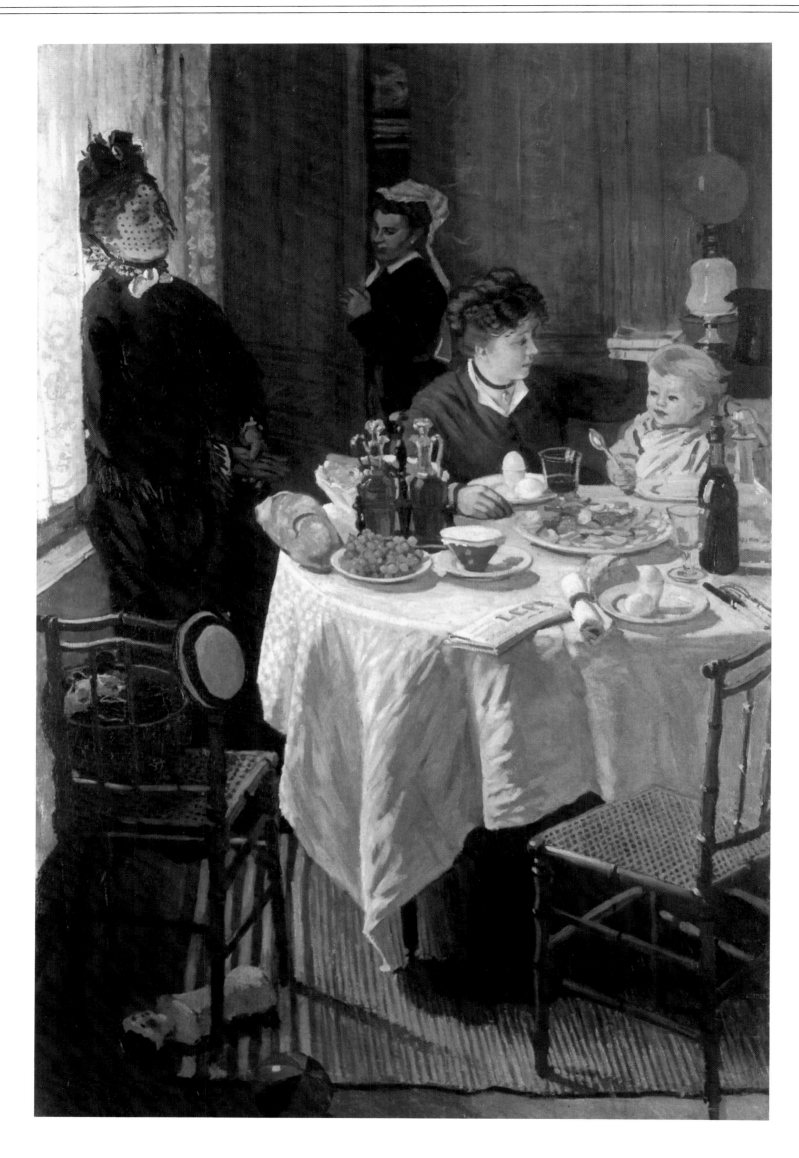

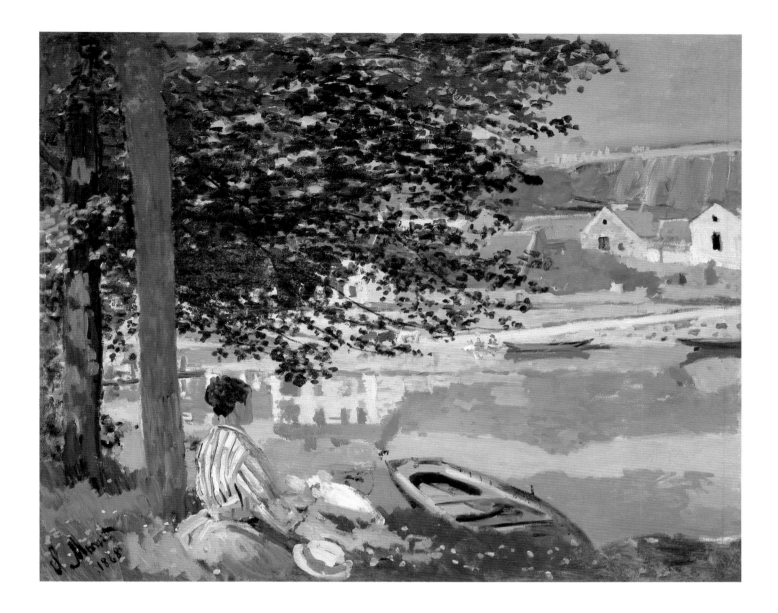

Opposite: The Luncheon, *Fécamp, 1868; oil on canvas; 191 × 125 cm (74¼ × 48¾ in); signed and dated; Städelsches Kunstinstitut, Frankfurt.*

Above: The River (*or* The Seine at Bennecourt), *Bennecourt, summer 1868; oil on canvas; 81 × 100 cm (31½ × 39 in); signed and dated; The Art Institute, Chicago.*

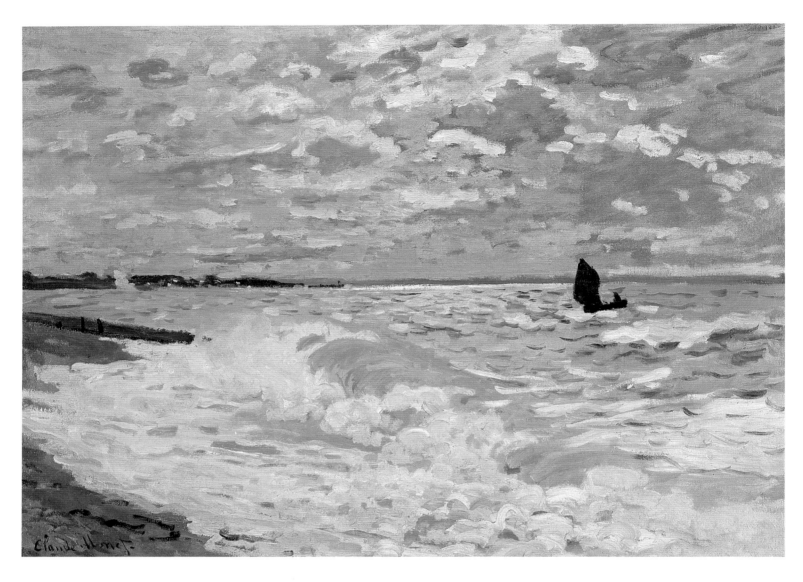

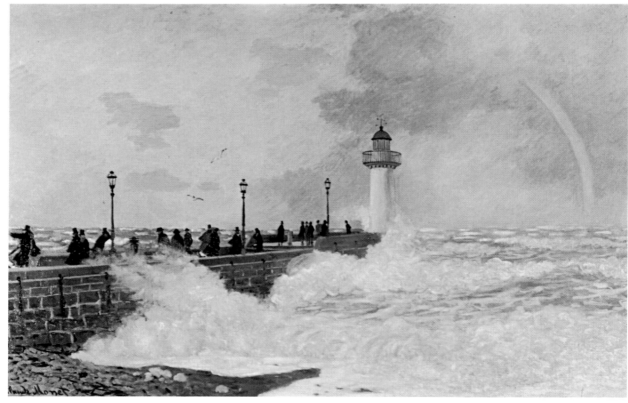

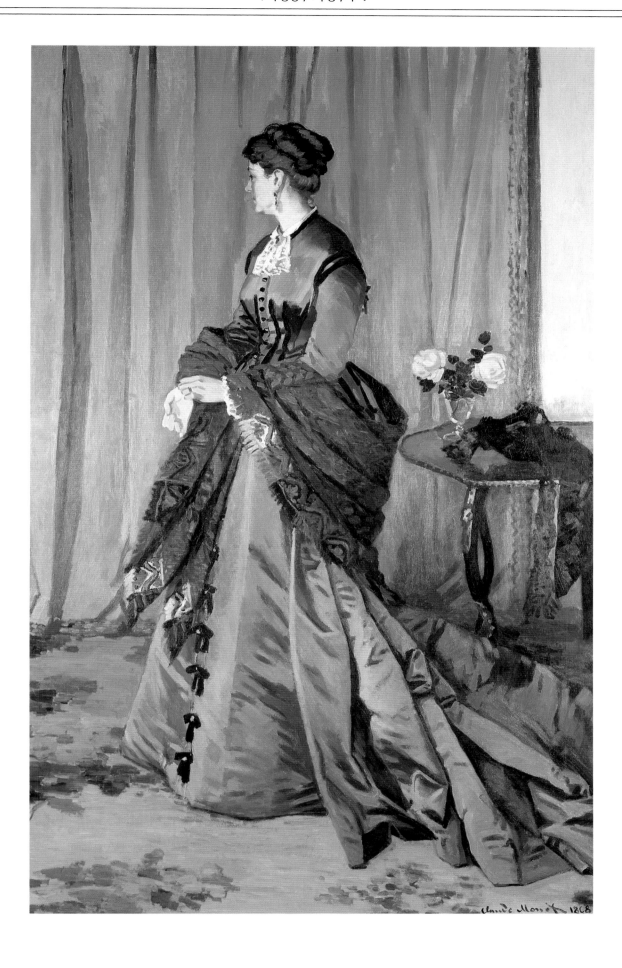

Opposite above:
The Sea at Le
Havre, *Le Havre,
summer 1868; oil
on canvas;
60 × 81.5 cm
(23¾ × 31¼ in);
signed; Carnegie
Museum of Arts,
Pittsburgh.*

Opposite below:
The Jetty at Le
Havre, *Le Havre,
summer 1868; oil
on canvas;
147 × 226 cm
(57 × 88 in);
signed; Private
Collection.*

Above: Portrait of
Mme Gaudibert, *Le
Havre (?), summer
1868; oil on canvas;
216 × 138 cm
(84 × 53¾ in);
signed and dated;
Musée d'Orsay,
Paris.*

74

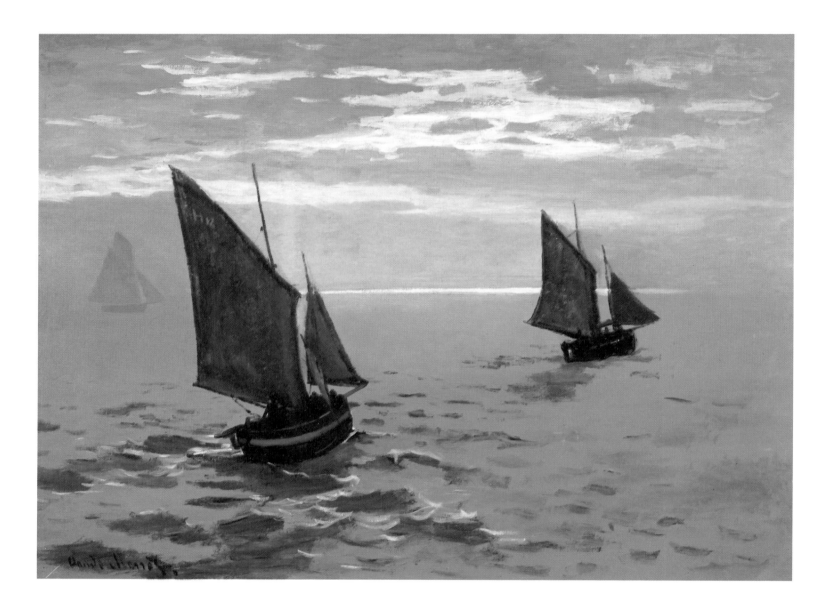

Fishing Boats at
Sea, *Le Havre,*
1868; oil on canvas;
96 × 130 cm
(37¼ × 50¼ in);
signed; Hill-Stead
Museum,
Farmington
(Conn.).

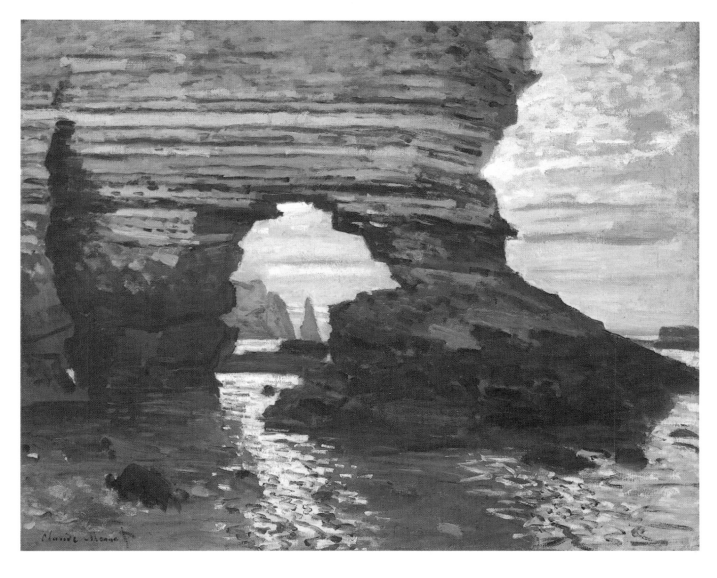

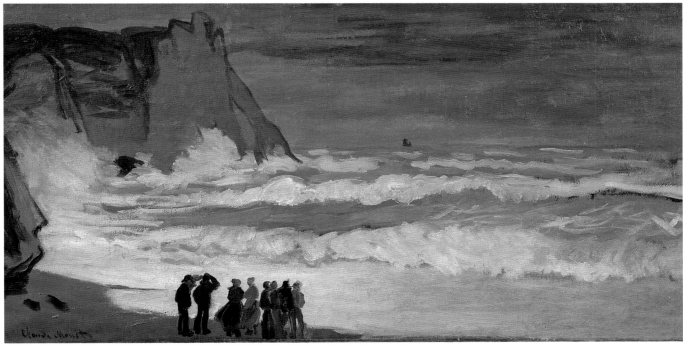

Above: Cliffs at Etretat, *Etretat, c. 1868-69; oil on canvas; 81 × 100 cm (31½ × 39 in); signed; Fogg Art Museum, Cambridge (Mass.).*

Below: Rough Sea at Etretat, *Etretat, c. 1868-69; oil on canvas; 66 × 130 cm (25¾ × 50¾ in); signed; Musée d'Orsay, Paris. Both these works* *prefigure, in theme and expressive rendering, the great cycle of the Etretat cliffs Monet would paint in the 1880s.*

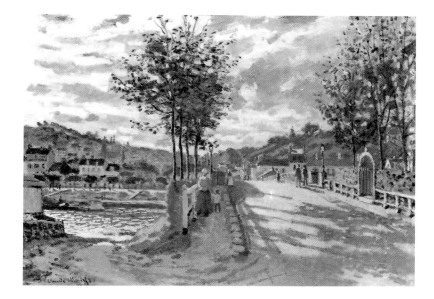

Left: La
Grenouillère,
*Bougival, summer
1869; oil on canvas;
75 × 99 cm
(29⅛ × 39¼ in);
Metropolitan
Museum of Art,
New York. The
river is a mere
pretext for the
rendering of the*
true subject of this
painting: the play
of light on water,
which for Monet
and Renoir became
the pivotal point of
their new
Impressionist
pictorial style.
Above: The Seine at
Bougival, *Bougival,
spring 1869; oil on
canvas; 63 × 91 cm
(24⅘ × 35¼ in);
signed and dated;
The Currier Gallery
of Art, Manchester
(New Hampshire).*

78

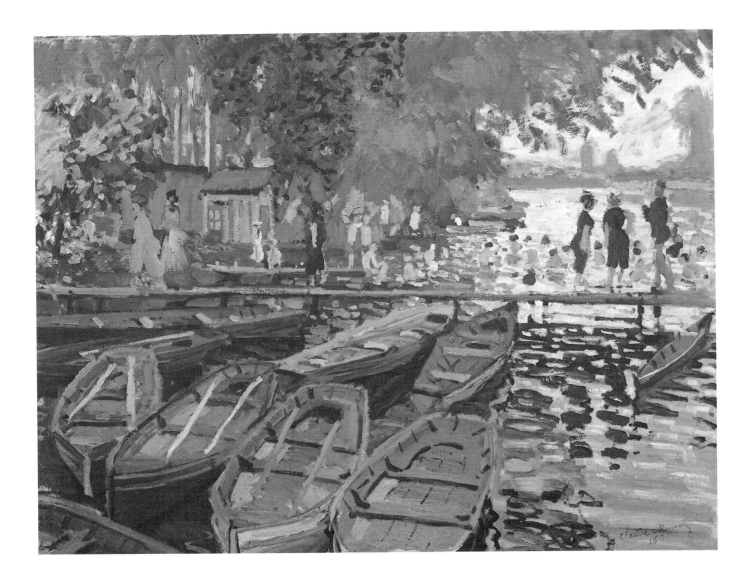

Bathers at La
Grenouillère,
*Bougival, summer
1869;*
oil on canvas;

*73 × 92 cm
(28¼ × 35¾ in);
signed and dated;
The National
Gallery, London.*

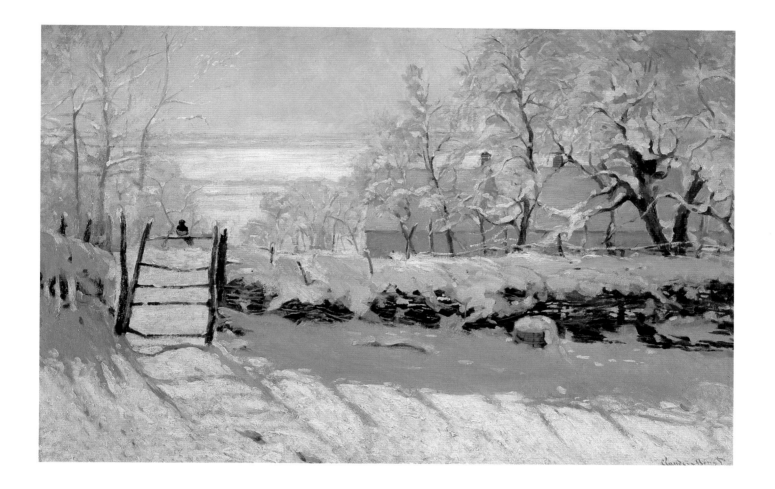

The Magpie, Snow
Effect, Outskirts
of Honfleur,
environs
of Honfleur,
December 1869; oil
on canvas;
89 × 130 cm
(34¼ × 50¼ in);
signed and dated;
Musée d'Orsay,
Paris.

80

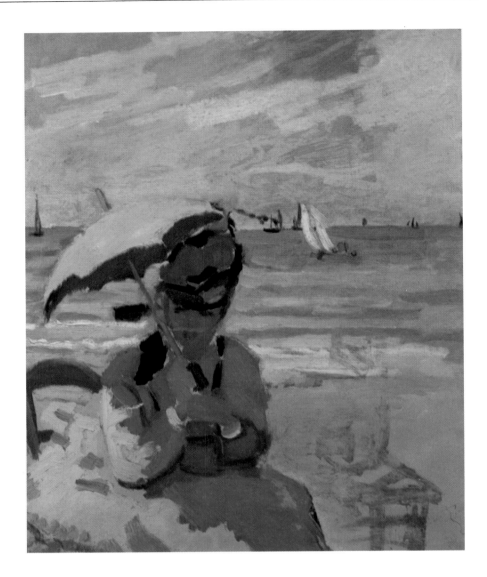

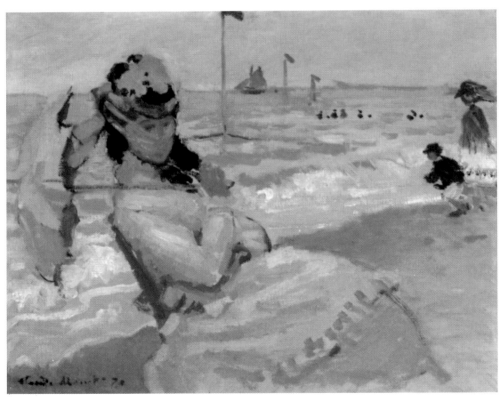

Above: Camille
Monet on the Beach
at Trouville,
*Trouville, July
1870; oil on canvas;
45 × 36 cm;
(17½ × 14 in);
Private Collection.*

Below: Camille on
the Beach at
Trouville,
*Trouville, July
1870; oil on canvas;
38 × 47 cm
(14¾ × 18 in);
Private Collection.*

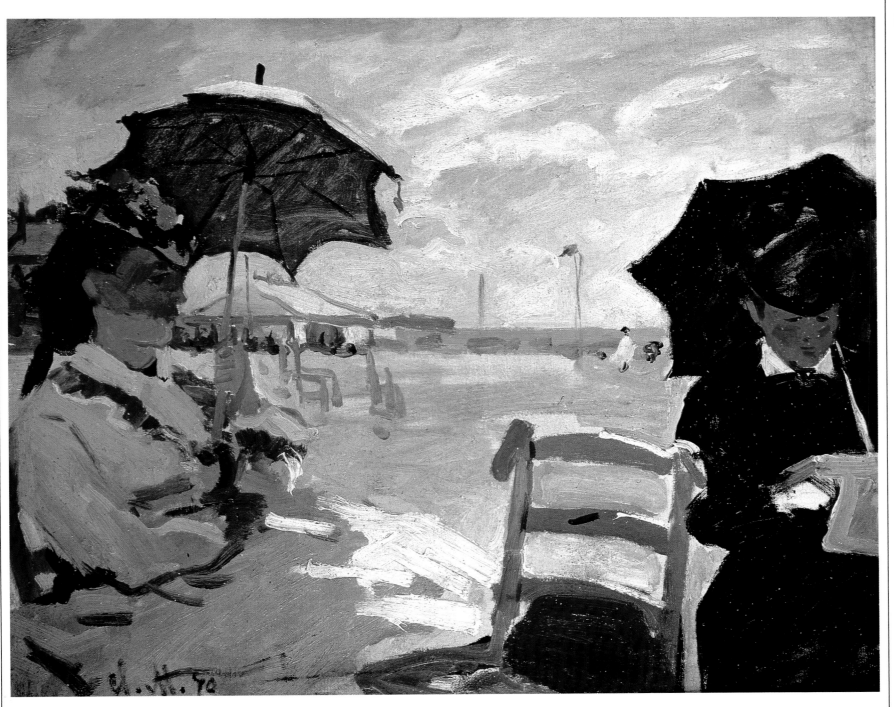

The Beach at
Trouville,
*Trouville, July
1870; oil on canvas;
38 × 46 cm
(14¼ × 17¼ in);
signed and dated;
The National*
*Gallery, London.
The woman on the
left is almost
certainly Camille
Doncieux, whom
Monet had married
a few days earlier.*

82

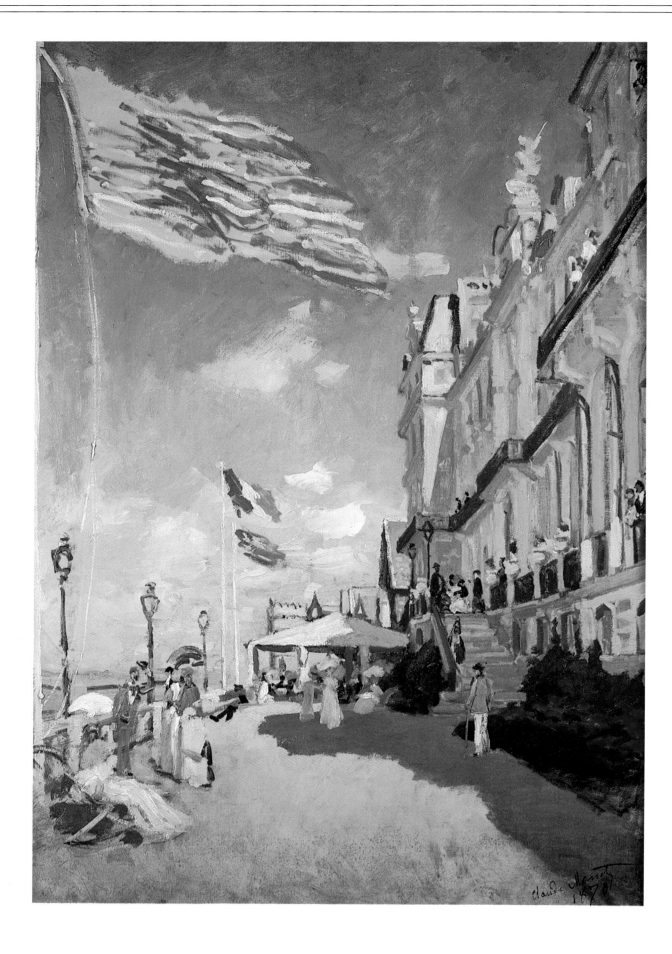

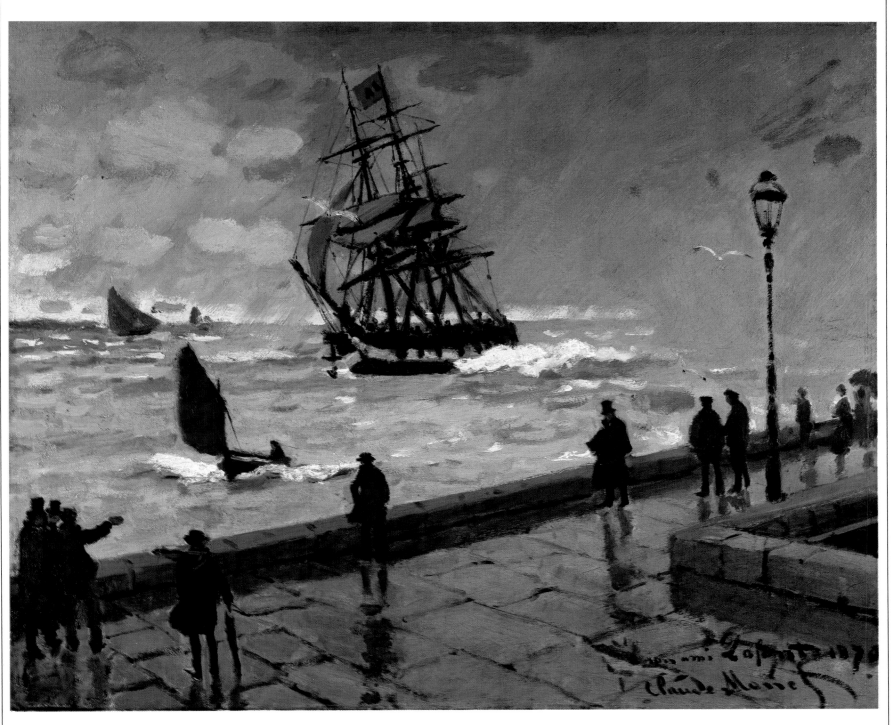

Opposite: Hôtel des Roches Noires, Trouville, *Trouville, July 1870; oil on canvas; 80 × 56 cm (31 × 21¼ in); signed and dated; Musée d'Orsay, Paris.*

Above: The Jetty at Le Havre, Bad Weather, *Le Havre, summer 1870; oil on canvas; 50 × 60 cm (19½ × 23¼ in); signed and dated; Private Collection.*

84

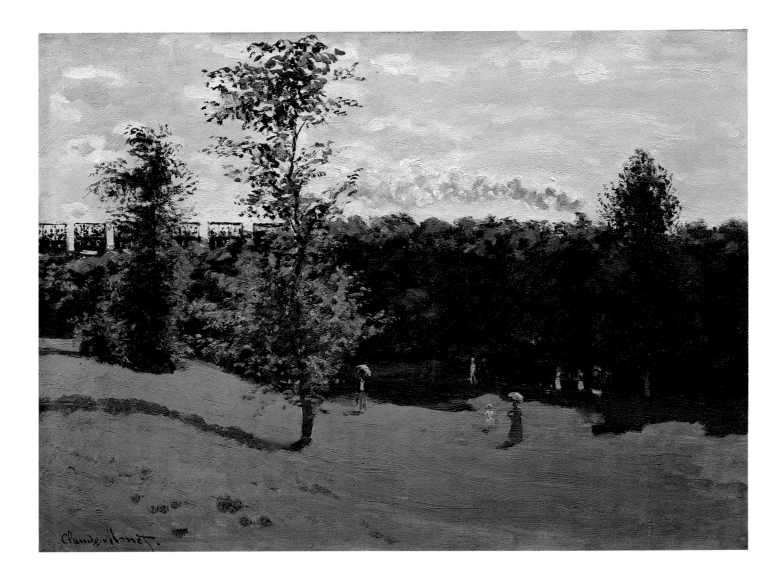

Train in the
Country, c. 1870;
oil on canvas;
50 × 65 cm
(19½ × 25 in);
signed; Musée
d'Orsay, Paris.

Some art historians
feel this work was
done in 1871, while
others say it was
finished before
Monet went to
London in 1870.

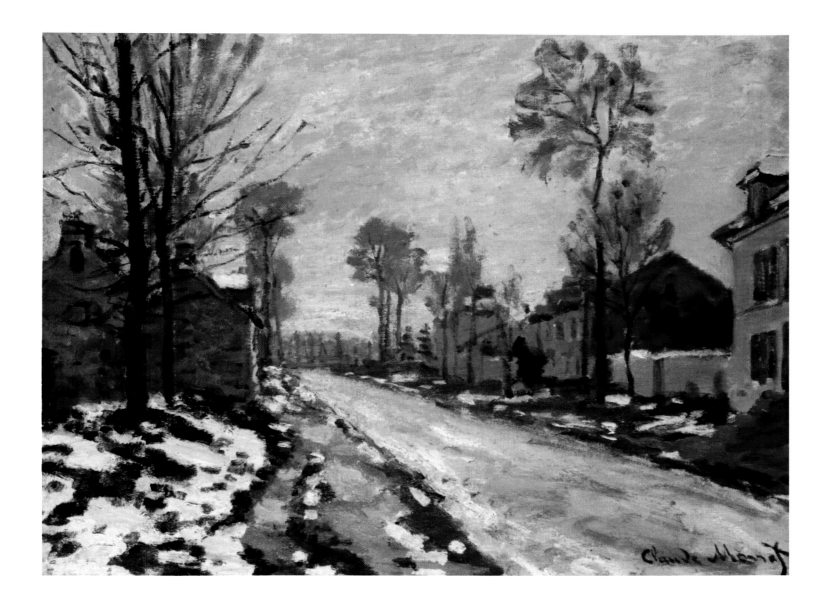

Road to
Louveciennes,
Melting Snow,
Sunset,
Louveciennes, c.

1870; oil on canvas;
40 × 54 cm
(15½ × 21 in);
signed; Private
Collection.

86

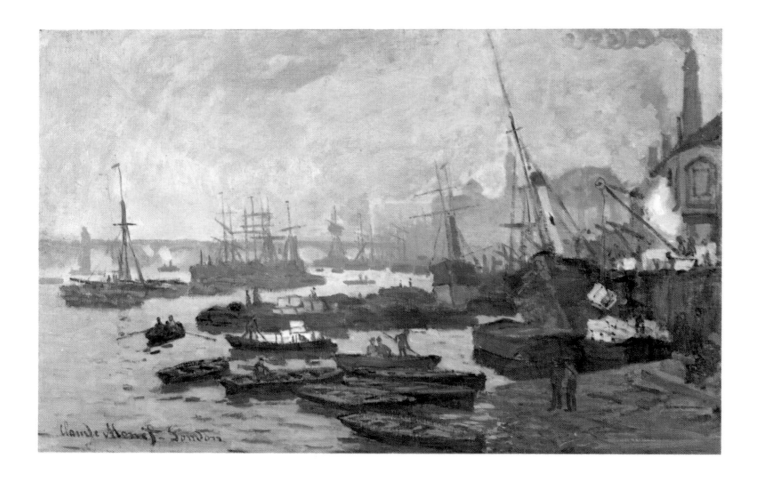

Boats in the Port of
London, *London,*
January 1871; oil
on canvas;

47 × 73 cm
(18 × 28¼ in);
signed; Private
Collection, Paris.

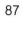

The Thames and *47 × 73 cm*
the Houses of *(18 × 28¼); signed*
Parliament, *and dated; The*
London, January *National Gallery,*
1871; oil on canvas; *London.*

88

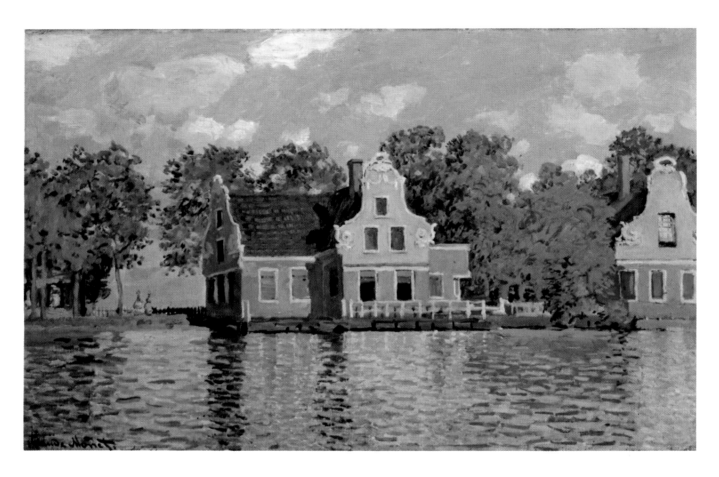

Above: Houses on
the Zaan River,
*Zaandam, spring
1871; oil on canvas;
41 × 74 cm
(15¼ × 28¾ in);
signed;
Städelsches
Kunstinstitut,
Frankfurt.*

Below: Zaandam,
*Zaandam, spring
1871; oil on canvas;
48 × 73 cm
(18¼ × 28¾ in);
signed and dated;
Musée d'Orsay,
Paris.*

The Voorzaan at
Zaandam,
*Zaandam, spring
1871; oil on canvas;*
39 × 71 cm
(15 × 27½ in);
*signed; Private
Collection.*

90

Windmills at
Haaldersbroek,
Zaandam,
Haaldersbroek,
spring 1871; oil on
canvas; 40 × 72 cm
(15½ × 28 in);
signed; Walters Art
Gallery, Baltimore.

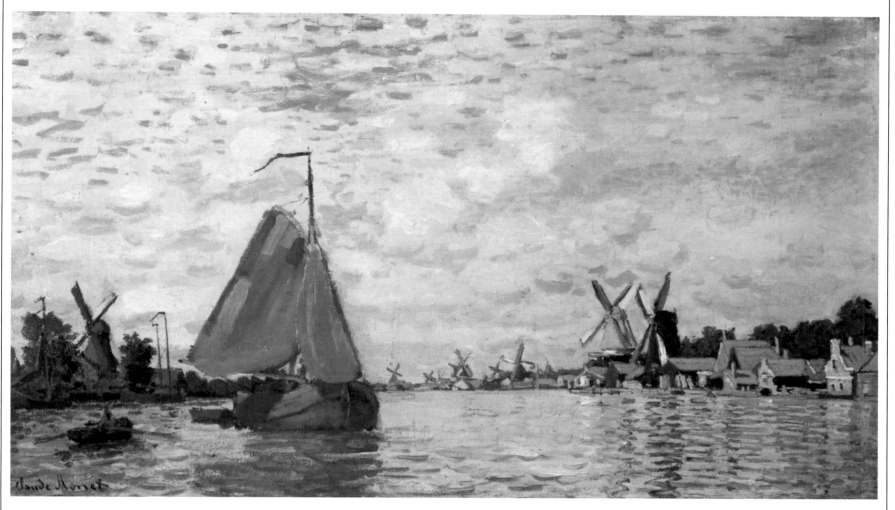

The Zaan River at
Zaandam,
Zaandam, spring
1871; oil on canvas;
42 × 73 cm
(16 × 28¼ in);
signed; Private
Collection.

Impressionism in its prime

One of the most significant events in Monet's life was the discovery of William Turner's painting in 1870 during his visits to the London museums and galleries together with his friend Pissarro. Monet was in London for at least two very good reasons: he wanted to avoid having to fight in the Franco-Prussian War, and he had to escape from his Parisian creditors. Pissarro spoke of this experience: "We also visited the museums. The watercolours and paintings of Turner and of Constable have had an influence on us." Monet was particularly affected by this and was destined to reshape Turner's informal space until it became – in the eyes of more than one critic – the indispensable link between English Romanticism and post-Second World War non-objective painting. Monet viewed Turner's art as nothing less than the model for a legitimate dissolution of form under the impetus of exuberant colour. However, this model was interpreted in a wholly personal manner by applying the chromatic principles Monet had already studied from 1868 to 1872. Only the consolation afforded by such an illustrious and indisputable precedent as Turner gave Monet the courage to produce *Impression, Sunrise* (1872), a sensationally revolutionary painting and therefore atrocious in the opinion of most of his contemporaries. Francesco Arcangeli states that the impression is defined as a "phenomenological conception of the world; [it] expresses the relation with the living that changes every day, every hour; it is therefore a sort of flux in which the painter is immersed and which he captures." Moreover, this work "is not only the famous painting that gave its name to

Impressionism; it is also a masterpiece, so audacious that the unprecedented reactions it provoked at the first important exhibition [...] in which it was shown, are still quite comprehensible. Imagine [...] an orange-red sun standing out clearly like a ball in a blend of light brown and pink, that casts a handful of vivid reflections on the roadstead where the boats move off in the green-furrowed water."

Turner's example bore fruit after a span of two years, although for the most part the development of Monet's pictorial language was an interior process, without any great upheavals or revelations from other sources. His painting in this period seems to proceed in a very erratic, contradictory fashion, alternately withdrawing into tranquil visions and Impressionist idylls and opening out in sudden bursts of extreme innovative vigour with pioneering, avant-garde experiments. In that same year, 1872, Monet painted *Regatta at Argenteuil*, a miracle of sobriety and lyrical harmony built on the problematic relationship between reality and colour. The entire Argenteuil period contains that same well-balanced, intense style made up of magical examples of faithfulness to the landscape and to the themes painted – while at the same time maintaining the deliberate tension between subject and painting. Monet achieves a kind of poetic freedom in his attempt to render optical truth. Some confusion has arisen concerning the dates of the works executed in this decade. *Impression, Sunrise* was exhibited only at the 1874 Impressionist show in Nadar's former studio, but this does not mean that the date Monet put on the painting (1872) is to be considered false. The two

year lapse between execution and exhibition can most probably be explained by the painter's caution or initial uncertainty regarding the work. Many of the books and catalogues dedicated to Monet's oeuvre overlook an oil painting that is quite similar to *Impression, Sunrise* in both theme and execution; it is part of a private collection in Paris and is dated at 1873. This work, which Robert Gordon and Andrew Forge entitle *Sunrise, Seascape*, is as bold and interesting as its twin, with the same setting and similar atmospheric conditions, with a more somber and subdued, less brilliant colour scheme.

Regatta at Argenteuil also has a noteworthy "alter ego," which was executed a short time afterwards in which, however, the atmospheric, light and air conditions are quite different: *The Barks; Regatta at Argenteuil* (1874, Musée d'Orsay, Paris). A comparison of these two beautiful seascapes can reveal a great deal about Monet's interpretation of the "optical truth" of painting and the tasks of Impressionism. In the first painting the bright light of day transforms the canvas into a miraculous mirror radiating a myriad of different facets and substances (crystals, pearls, red blots, precious gems, strips of sunlight, and therefore a felicitous variety of brilliant, warm, radiant hues). In the second work there is a single, homogeneous brush stroke that is obsessively repeated in the water and in the sky, a mixture of brown, grey and opaque blue with a touch of whitish lead – hence a dense texture and compact, impenetrable surface which become the dominating motifs.

One could say that in this period every painting offers its own personal solution to the problem of

rendering atmospheric effects, so much so that it is almost easier to find stylistic differences than similarities between one work and another. Thus, in *The Luncheon (Decorative Panel)* (also known as *Monet's Garden at Argenteuil*; 1873-74), the summer light forms a sort of yellow pool, a void in the middle area that spreads to the surrounding objects (little Jean's clothes and hat, for example), saturating and dissolving them, exactly like the light in *Women in the Garden*. And then there is the astonishing *Marine View – Sunset* (1874, Philadelphia Museum of Art), a little known work that deserves to be ranked among the greatest paintings of the century with its spectacular, explosive sky rendered by intermittent flashes of red, yellow and purple. Another interesting work is *The Basin at Argenteuil* (1872), with that longitudinal sequence of light and shadow, the row of trees at left being used as a pretext to create alternations of green that are scaled in exact perspective. Monet's skies are the most varied and poetic, the most daring and convincing, in Impressionist painting. We have already seen the dream-like sky in *Marine View – Sunset*. But there is also a magnificent sky in *Spring* (or, according to some critics, *Summer*) at the Neue Nationalgalerie in Berlin (1874), in which there are several gradations of one single hue, blue, with vaporous shadows of light haze suspended over a green and yellow band that oscillates between the idea of a meadow and that of a corn field. The female figure immersed in the grass, whether reading or walking, is one of the recurring subjects in this phase. We find it again in the celebrated *Poppies, near Argenteuil* (1873) and *Woman with*

a Parasol – Mme Monet and Her Son (1873 or 1875), which anticipates the thematic, compositional and stylistic structure of two other famous paintings with the same theme produced in 1888.

Much has been said about Monet's use of the *equisse*, *pochade* and *étude* (sketches and studies), which he created as finished works with the magnitude, both artistic and physical, of an oil painting. In my opinion this is a rather misleading oversimplification. It is beyond argument that the traditional sketch, as a method for taking notes in painting, is for the most part a vehicle for the artist's first sensations and reactions, that is, his visual impressions. But Impressionism as such would have been of little value indeed had it contented itself with systematically using and amplifying this procedure. In Monet we note a tendency to do away with details, to shade and often eliminate the line, to draw by means of dabs of colour. The so-called impression, however, is in his canvases a solid, precise, well-constructed phenomenon. By its very nature the sketch is a rapid representation. Monet's painting can be deceptive: he evokes fleeting, immediate sensations, but the works are executed with well-gauged refinement and after a good deal of careful study. At times the desired effect calls for more work than the smooth, classical-type rendition. Take such works as *Railway Bridge at Argenteuil* (1874) or *Pleasure Boats at Argenteuil* (1875): here the preciseness of perception and depth of feeling are so pronounced that they make us forget the ephemeral nature of the lines and the dabs of colour, as well as any alleged superficiality. This artist's painting is anything but rapid and sketchy;

his meditation upon the image – inwardly immediate and spontaneous but then recreated with the utmost technical-pictorial insight and knowledge – is intense and protracted.

As Michel Butor has clearly pointed out, Monet's works are complex and boldly constructed; he refers not only to *The River*, but also to the strange portrait *Mme Monet in Japanese Costume* (1875), which is related to Manet's *Woman with Fans* (*La dame aux éventails*). Monet takes up Manet's theme, but reshapes it in a totally different manner, lending special value to the two-dimensional motif of the fan. The fascination of the fan lies in its being a sort of picture within a picture, a small area of "pure painting" in the guise of a represented object. Then Butor points out the startling effect achieved – on the level of simulation – by the juxtaposition of Camille's face (which is supposedly "real") and the fierce countenance of the samurai (which is openly "fictitious" as it is painted or embroidered on to the robe on the woman's buttocks). In short, there is a first level of fiction which Monet ironically represents as less convincing than the second level, the duplicated fiction. The painting thus pokes fun at the spectator by creating another, more interior painting, the "painting on cloth" of the samurai on Camille's robe (and buttocks), as well as the women and landscapes on the decorative fans on the wall and floor.

The structural ambiguity created by these two faces, the real one and the false one (which is more vivid than the real face), is generally reflected in the linguistic ambiguity established between the painting of reality and the painting on the fan in Camille's hand, between the

picture of the world and the picture within a picture. The figure on the fan is opened and closed, it reveals itself and disappears; the fan was a popular visual device with the Symbolists as the emblem of intermittence, pulsation and transience. What surprises one in this painting is the unusually illusory nature Monet lends to the representation – especially the Japanese robe, which is as precious and concrete as the velvet in a Jan van Eyck painting. But this is nothing more than further proof of the "constructive" quality of Monet's art, which always aimed at finding that which painters must forget in order to exist: the depth of the canvas. Thus, besides the tension which runs parallel to the surface between the upper and lower areas, between Camille's face and the samurai, there is also a tension between the apparent depth of the canvas and the depth of the subject.

The year 1876 also witnessed the creation of one of Monet's few cityscapes: *The Tuileries*, now in the Musée Marmottan in Paris. This work, which was preceded by a sketch with the same title kept in the Musée d'Orsay, is a view of the famous garden of the Louvre as seen from the Palais du Louvre. Monet used the aerial view device repeatedly for his Parisian cityscapes (in the *Quai du Louvre*, also seen from a window of the same palace, and in *The Garden of the Princess* and *Saint-Germain l'Auxerrois*, all done in 1866, as well as in the two versions of *Boulevard des Capucines*, painted in 1873), almost as if he were able to conceive the city only as an open space seen from above and hence in the form of a panorama. Monet's sensibility calls for broad horizons, natural open spaces that serve as springboards for his

pictorial eye, clearings and woods like those he painted in 1877 at Montgeron near the castle of his new friends, Ernest and Alice Hoschedé (*Pond at Montgeron* and *Rose Beds in the Hoschedés' Garden at Montgeron*). The splendid series of the Saint-Lazare railway station are, in their own way, also panoramas, though they are not viewed from above. Some of these canvases were begun at the end of 1876, after Monet had received permission to paint in the station and railroad yard, but they all bear the date 1877. Some of the most interesting aspects of these paintings (besides the fact that they are the first example of a vast, "programmatic" cycle in his oeuvre) are as follows: his drastic and by now definitive predilection for vague, vaporous subjects, visually almost illegible and difficult to render pictorially – a predilection that has nothing whatsoever to do with his love for sketches; the resumption of the fog motif, which he had already rendered four years earlier in *Impression, Sunrise* and which was undoubtedly connected to his study of Turner's art; his stylistic and philosophical homage to one of Turner's most famous works, *Rain, Steam and Speed* (1844, National Gallery, London); and lastly, his interest in modern life, which had changed so drastically through technological innovations. All these aspects are closely related. Monet's "impressionist" language is totally alien to the superficiality and frivolity some critics have attributed to him, because it is a language that springs from his conscious, utterly modern realization of the impasse of representation – that is, the difficulty in representing a world less and less inclined to rigid labelling or classification.

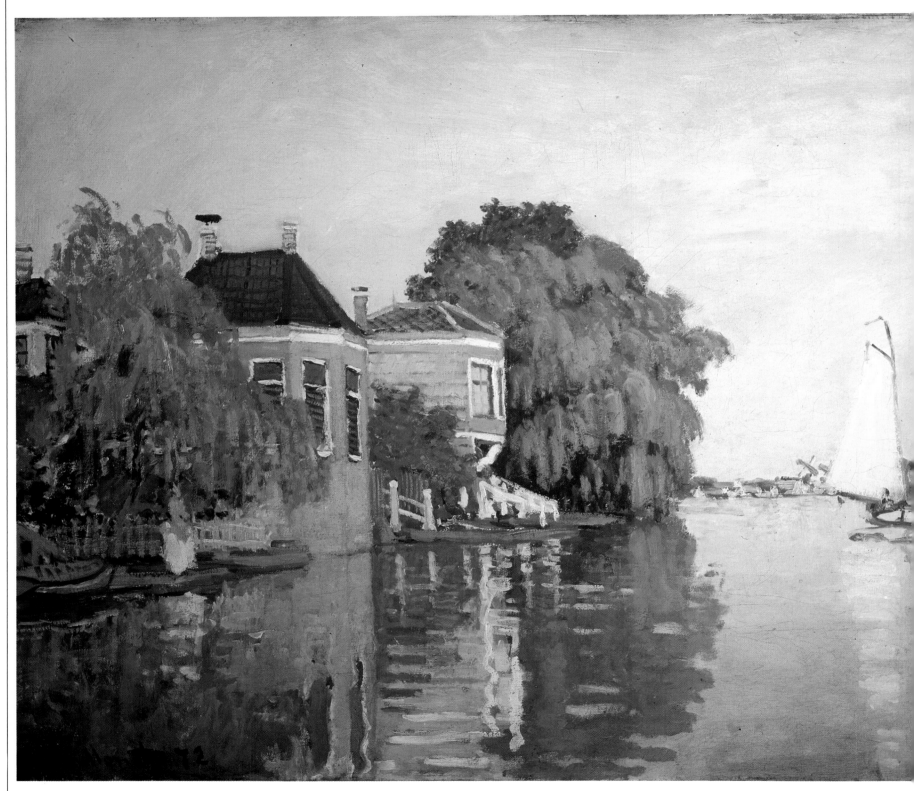

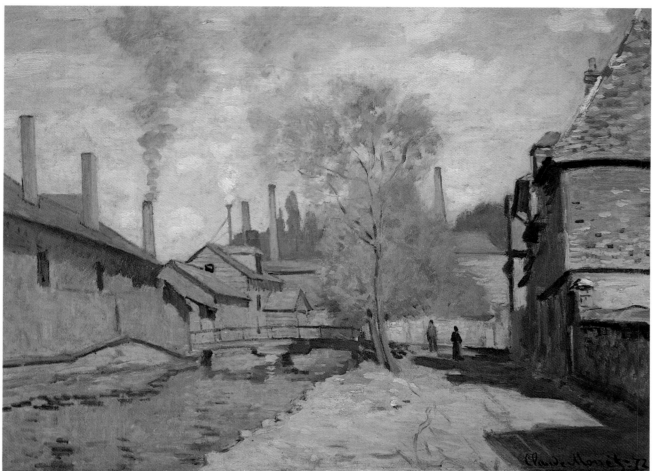

Left:
Landscape near
Zaandam,
*Zaandam, 1872; oil
on canvas; 44 × 66
cm (17¹⁵⁄₁₆ × 26⅛ in);
signed and dated;*
Metropolitan
Museum of Art,
New York. *The
style employed
here, with thick,
vibrant brush
strokes on broad
and luminous
backdrops, heralds*
that of Regatta at
Argenteuil *and
other magnificent
canvases painted in
the mid 1870s. The
fact that Monet
returned to
Zaandam after his
first 1871 sojourn
confirms the
important role
played by the
Netherlands
experience in the
growth of his art.*

Above: The Robec
Stream, Rouen,
*Rouen, 1872; oil on
canvas; 50 × 65 cm
(19½ × 25 in);
signed and dated;
Musée d'Orsay,
Paris.*

96

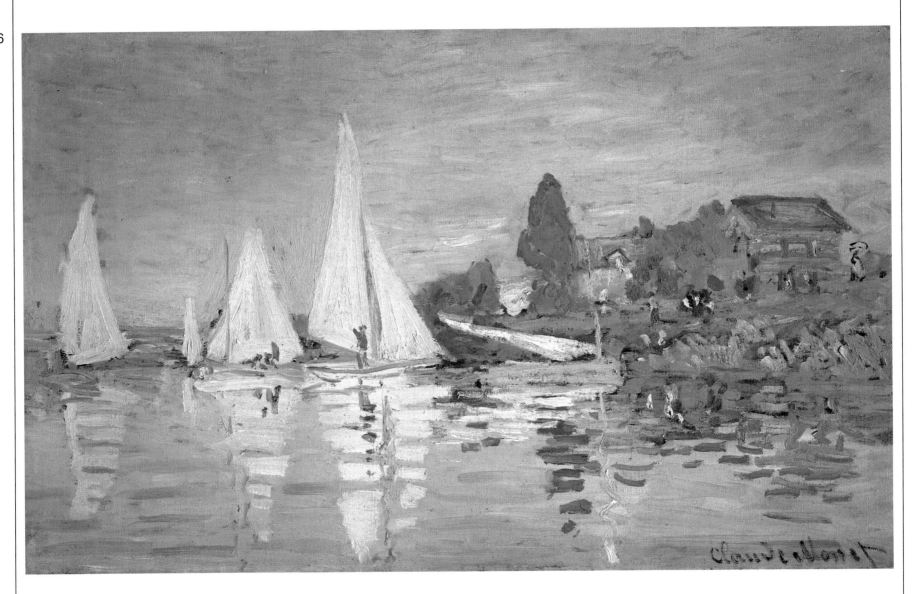

Above: Regatta at
Argenteuil,
*Argenteuil, summer
1872; oil on canvas;
48 × 73 cm
(18¼ in × 28¼ in);
signed; Musée
d'Orsay, Paris.*

Opposite above:
Mme Monet with a
Friend in the
Garden,
*Argenteuil (?),
c. 1872;
oil on canvas;
51.5 × 66 cm
(20 × 25¼ in);
signed; Private
Collection.*

Opposite below:
Unloading Coal,
*Paris (?); oil on
canvas; 55 × 66 cm
(21⅛ × 25 in);
signed and dated;
Private Collection,
Paris.*

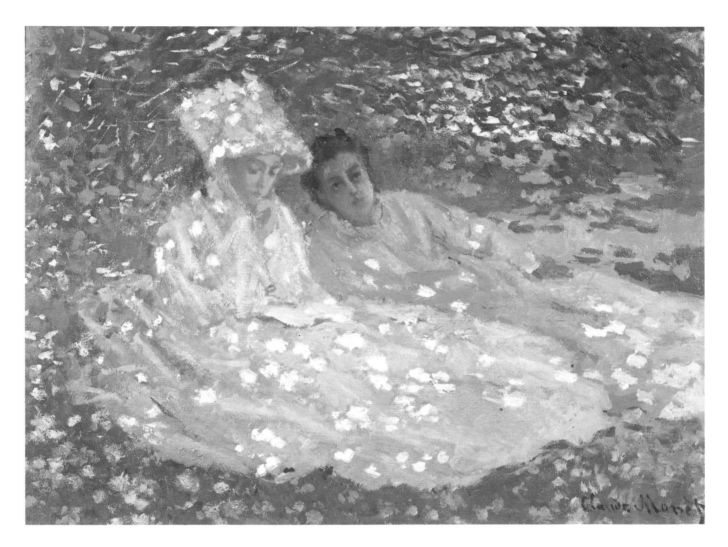

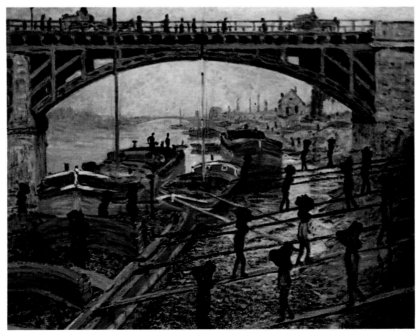

98

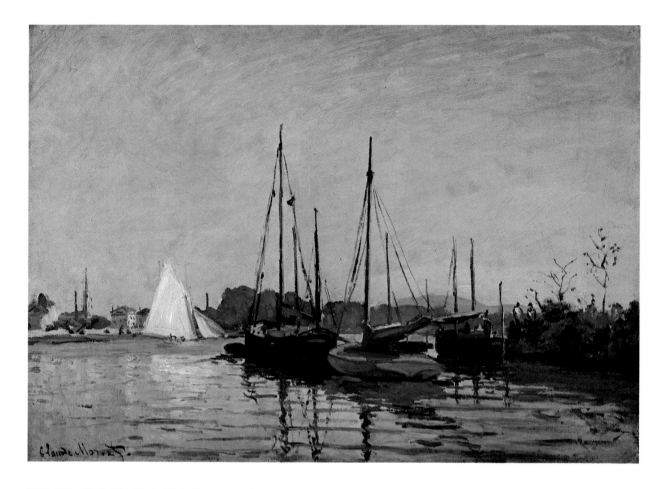

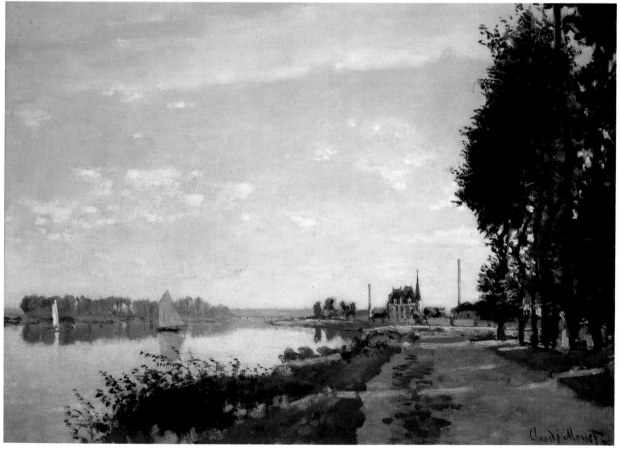

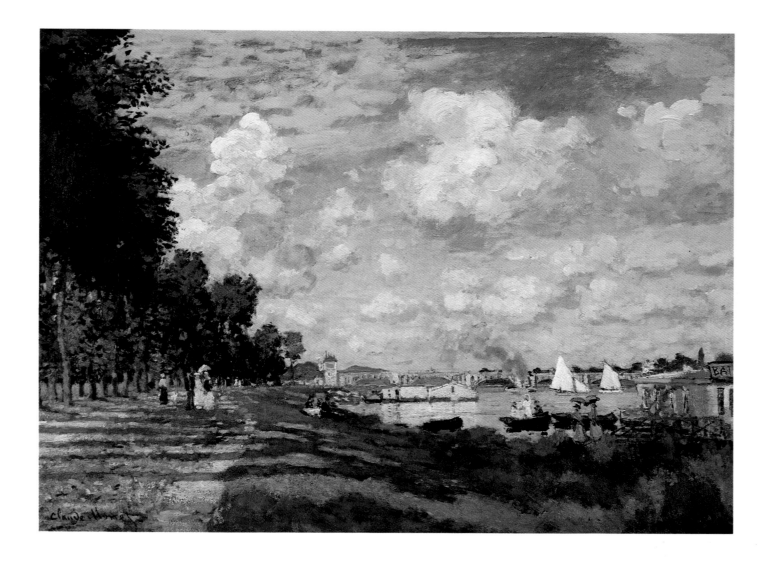

Opposite above:
Pleasure Boats at
Argenteuil,
Argenteuil,
c. 1872; oil on
canvas; 49 × 65 cm
(19 × 25 in);
signed; Musée
d'Orsay, Paris.

Opposite below:
Argenteuil,
*Argenteuil, summer
1872; oil on canvas;
50.4 × 65.2 cm
(19⅞ × 25⅝ in);
signed; National
Gallery of Art,
Washington.*

Above: The Basin
at Argenteuil,
*Argenteuil, summer
1872 (?); oil on
canvas; 60 × 80 cm
(23¼ × 31 in);
signed; Musée
d'Orsay, Paris. This
painting, like the*

*one opposite below,
is clearly articulated
in horizontal areas
with vertical
elements; here the
luminosity is more
marked.*

100

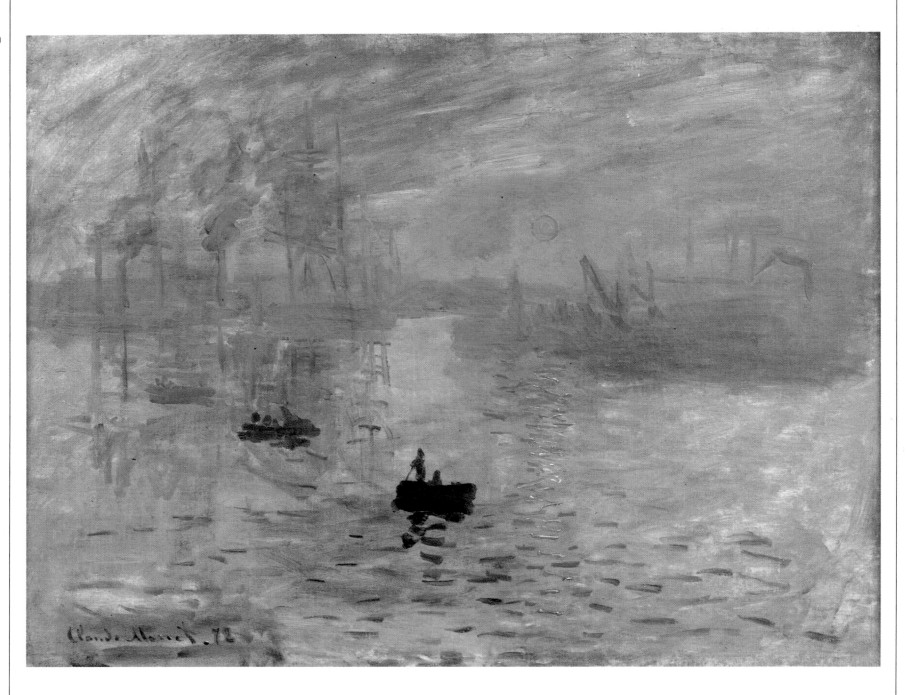

Impression,
Sunrise, *Le Havre,*
1872; oil on canvas;
48 × 63 cm
(18¾ × 24½ in);
signed and dated;

Musée Marmottan,
Paris. Despite the
date on the
painting, some
critics feel it was
produced in 1873.

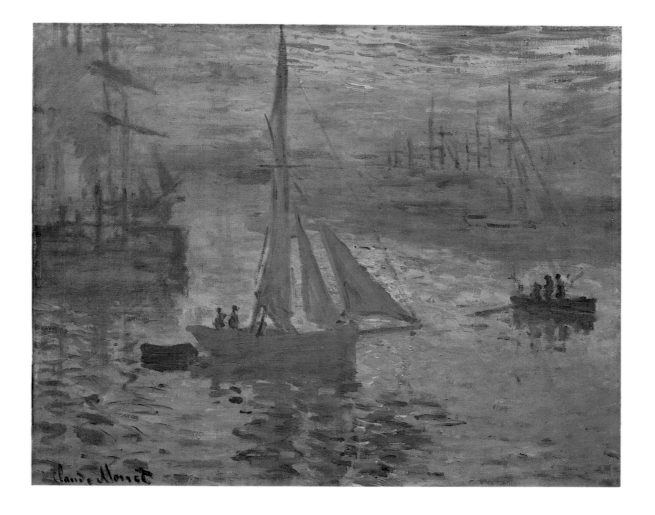

Sunrise, Seascape, (19 × 23¼ in);
Le Havre, 1873 (?); signed; Private
oil on canvas; Collection, Paris.
49 × 60 cm

102

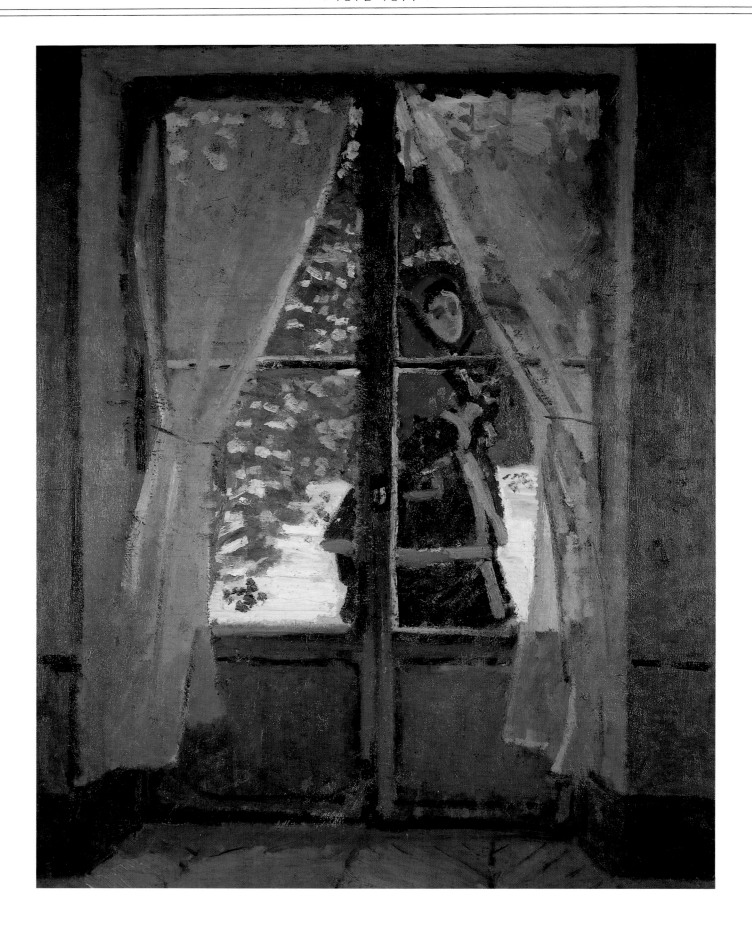

Above: Mme Monet
in a Red Cape,
Argenteuil, 1873;
oil on canvas;
100 × 80 cm
(39 × 31 in);
Museum of Art,
Cleveland.

Opposite: Camille
Monet at the
Window,
Argenteuil, June
1873; oil on canvas;
60 × 49 cm
(23¼ × 19 in);
signed; Private
Collection.

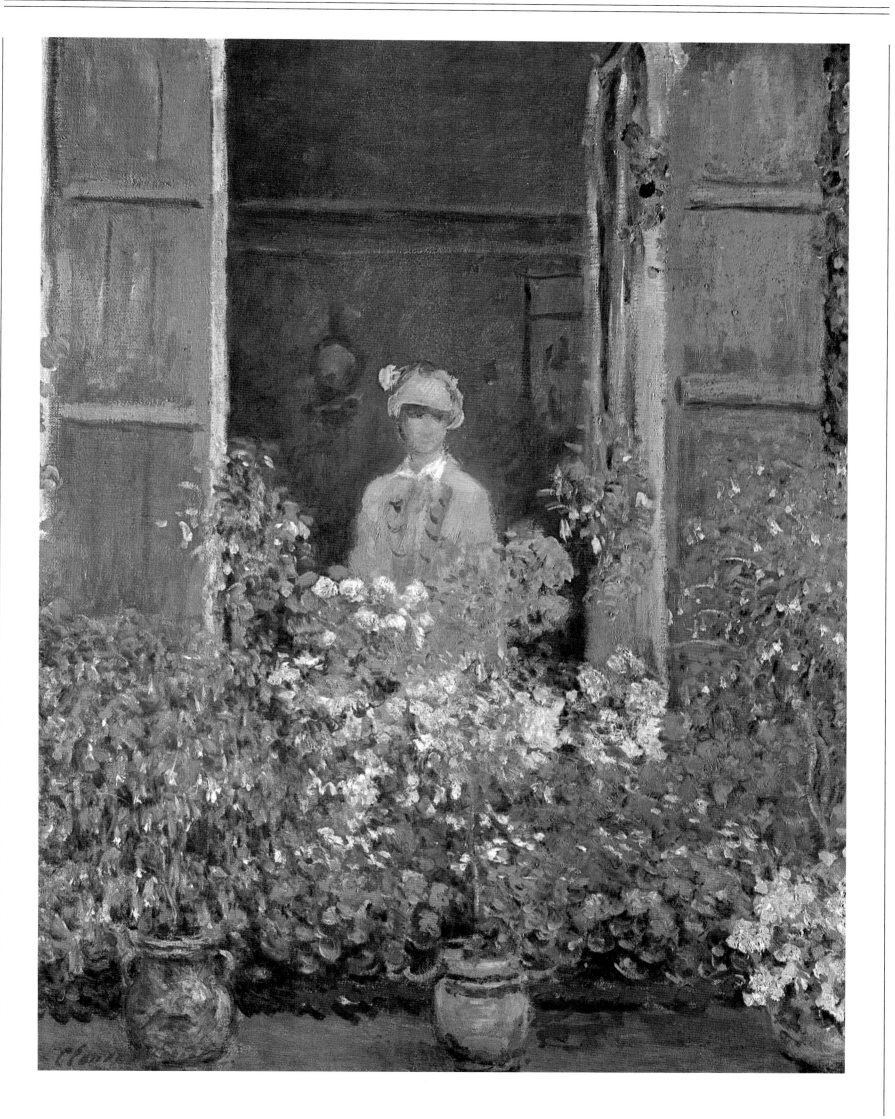

104

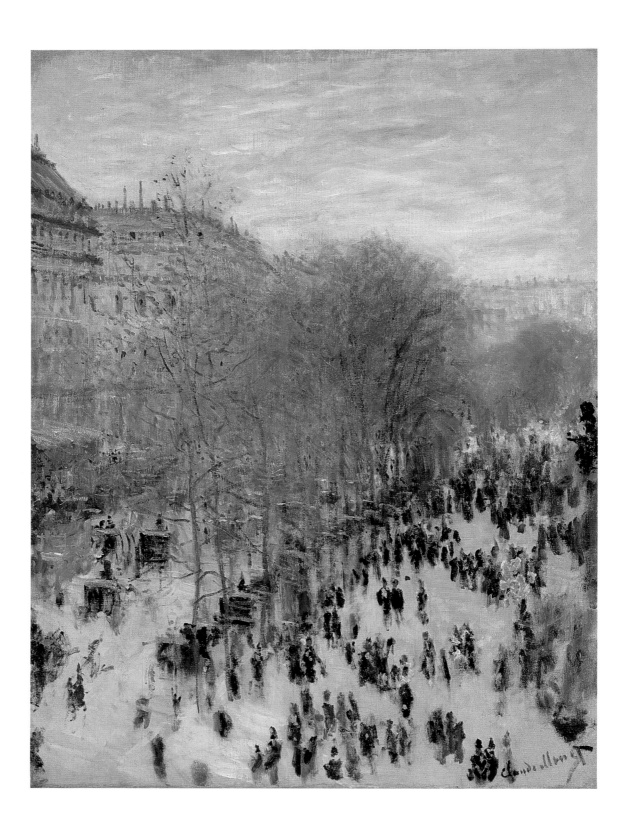

Boulevard des Capucines, *Paris,* February 1873; oil on canvas; 79 × 60 cm *(31½ × 23⅜ in);* *signed;* *Nelson-Atkins* *Museum of Art,* *Kansas City.*

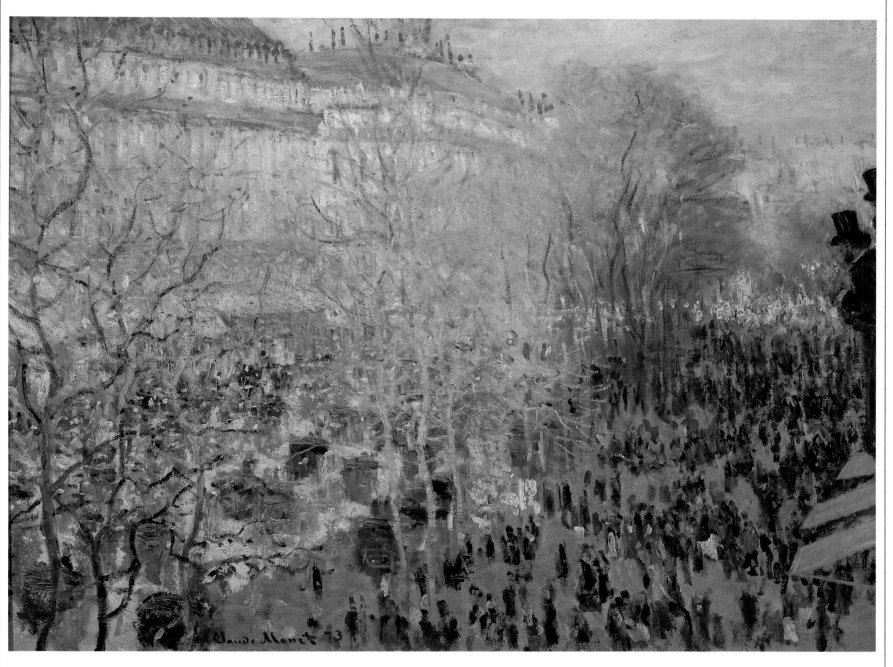

Boulevard des Capucines, *Paris, February 1873; oil on canvas; 60 × 80 cm (23¼ × 31 in); signed and dated;* *Pushkin Museum, Moscow. The painting in also known by another title:* Carnival at the Boulevard des Capucines.

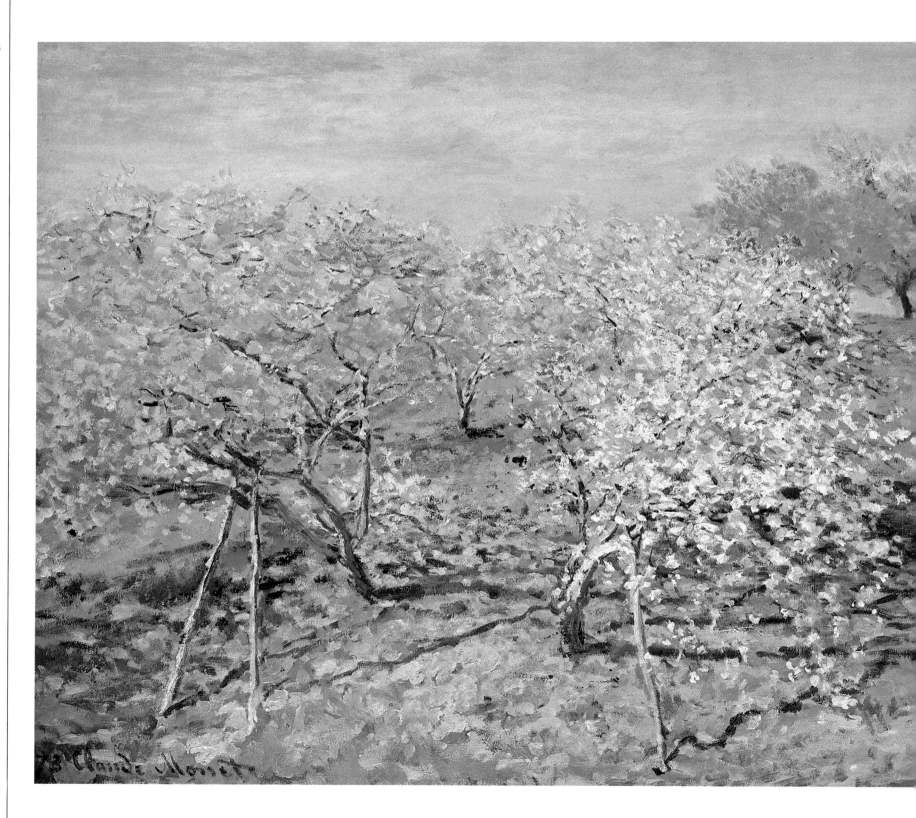

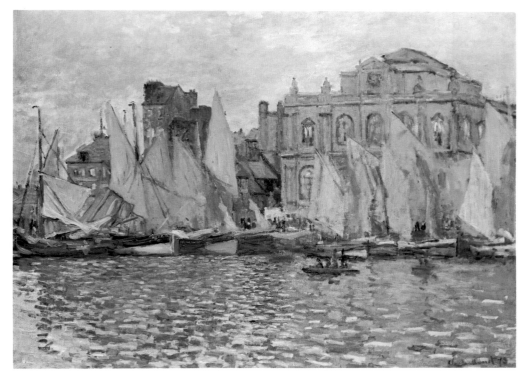

Left: Apple Trees in Bloom, *environs of Argenteuil, spring 1873; oil on canvas; 61 × 100 cm (23¼ × 39 in); signed and dated; Metropolitan Museum of Art, New York. This painting introduces a manner of* observing nature – *that is, of transposing its appearance on to the canvas – that Monet was to develop above all after 1880: a sort of instinctive, empirical "chromatic divisionism."*

Above: The Harbour, Le Havre, Le Havre, *1873; oil on canvas; 73.5 × 99 cm (29 × 39 in); Private Collection.*

108

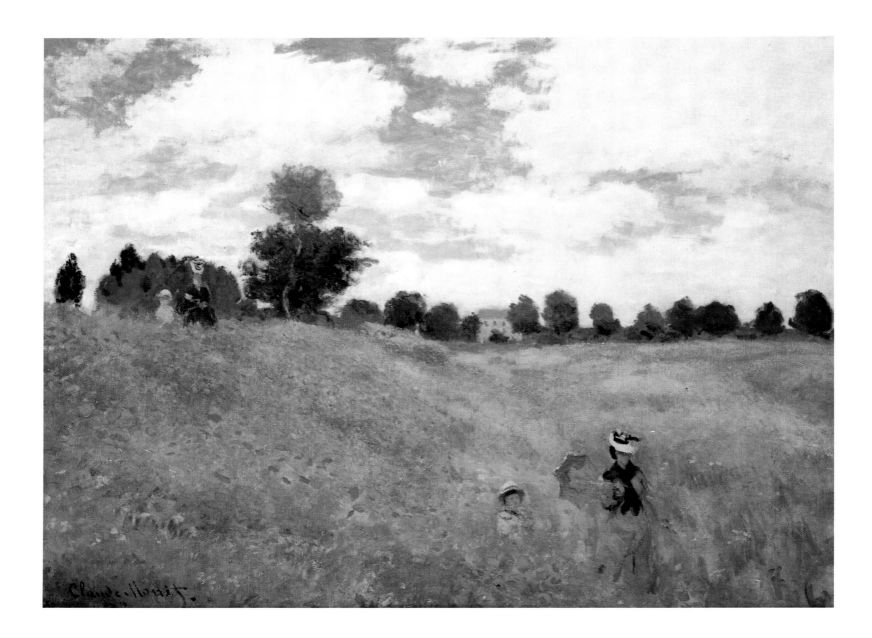

Above: Poppies, near Argenteuil, *Argenteuil, summer 1873; oil on canvas; 50 × 65 cm; (19½ × 25 in); signed and dated; Musée d'Orsay, Paris. The figures portrayed are Camille Monet and her son Jean.*

Opposite: Woman with a Parasol – Mme Monet and Her Son, *Etretat (?), summer 1873 (?); oil on canvas; 100 × 81 cm (39⅜ × 31⅞ in); signed; National Gallery of Art, Washington.*

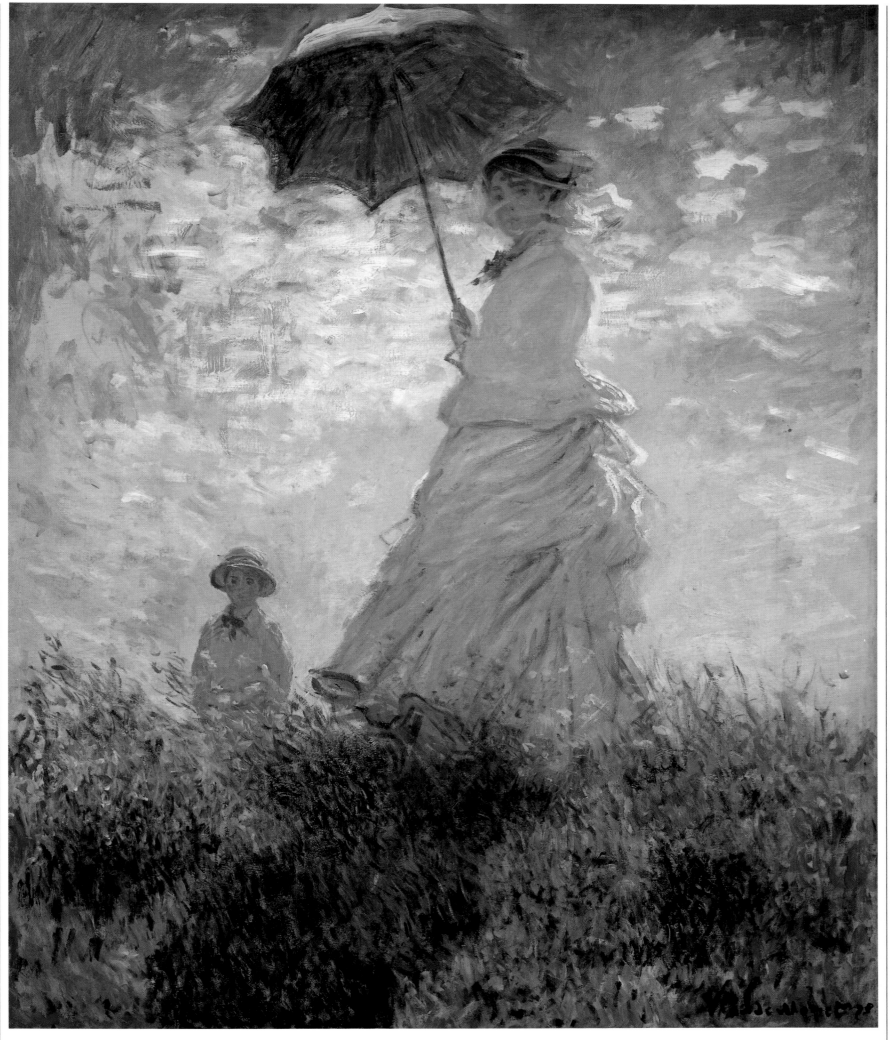

110

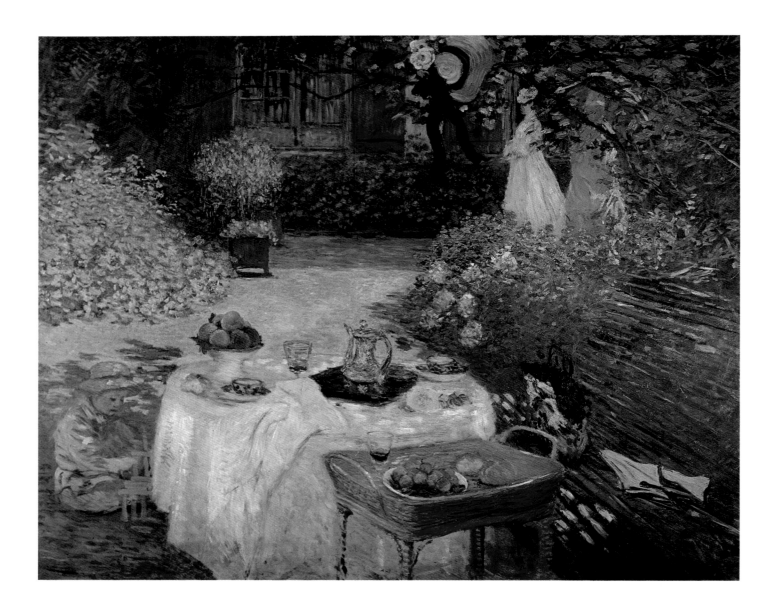

The Luncheon, *1873; oil on canvas;*
Decorative Panel *162 × 203 cm*
(*or* Monet's Garden *(63 × 79 in);*
at Argenteuil), *signed; Musée*
Argenteuil, summer *d'Orsay, Paris.*

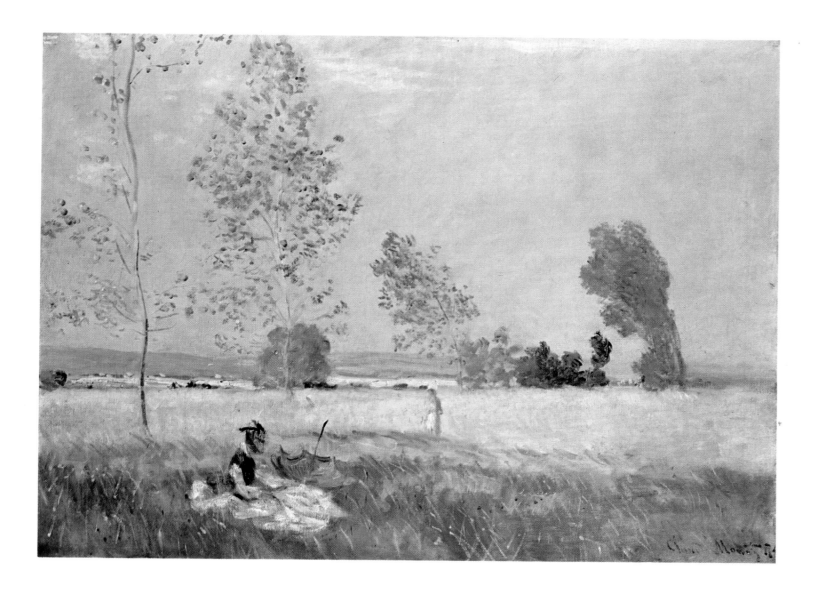

Spring, *environs of*
Argenteuil, June
1874; oil on canvas;
57 × 80 cm

(22 × 31 in); signed
and dated; Neue
Nationalgalerie,
Berlin.

112

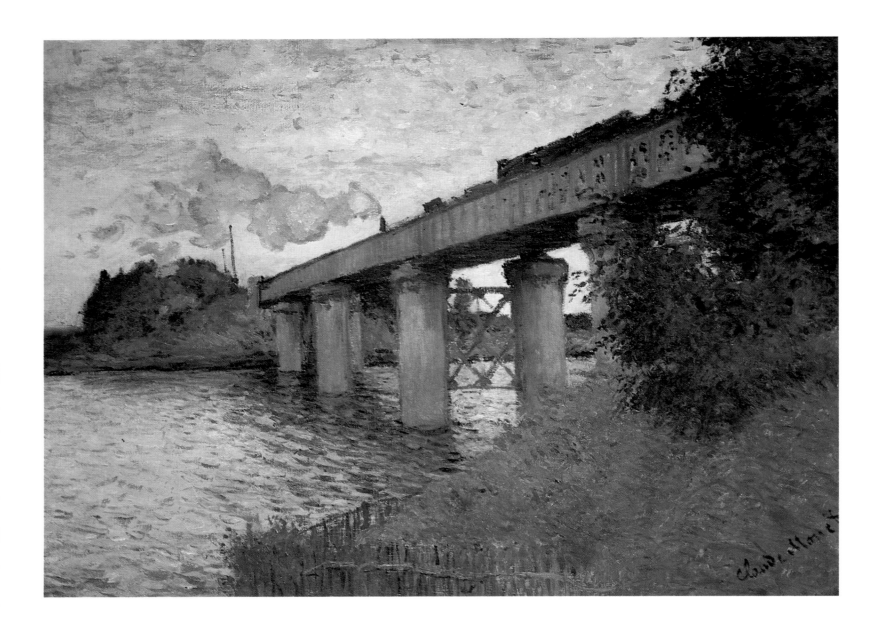

Above: Railway
Bridge at
Argenteuil,
Argenteuil, 1874;
oil on canvas;
55 × 72 cm
(21¼ × 28 in);
signed;
Musée d'Orsay,
Paris.

Opposite above:
The Bridge at
Argenteuil,
Argenteuil, 1874;
oil on canvas;
60 × 80 cm
(23¼ × 31 in);
signed and dated;
Musée d'Orsay,
Paris.

Opposite below:
The Barks; Regatta
at Argenteuil,
Argenteuil, summer
1874;
oil on canvas;
60 × 100 cm
(23¼ × 39 in);
signed; Musée
d'Orsay, Paris.

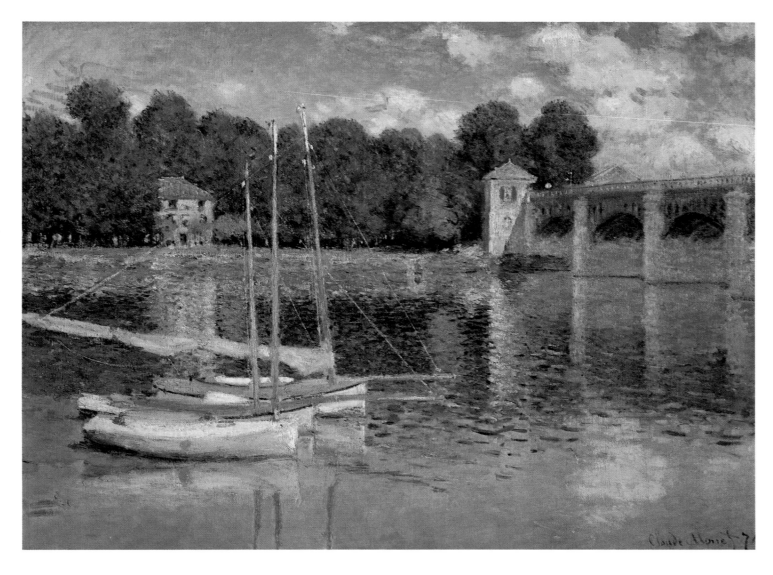

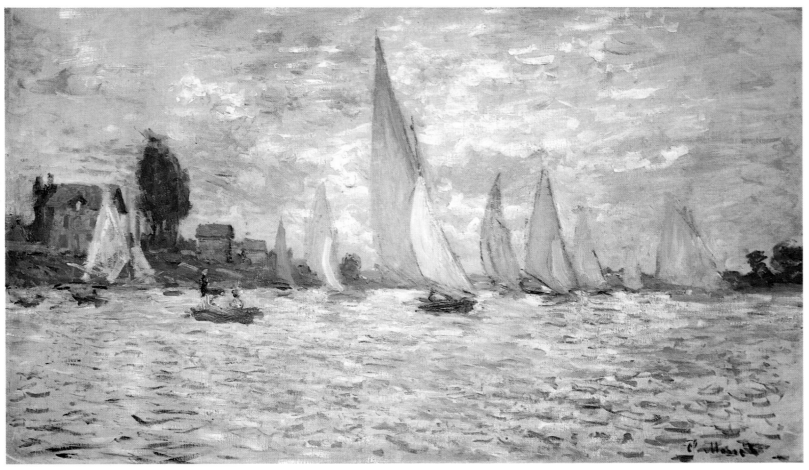

114

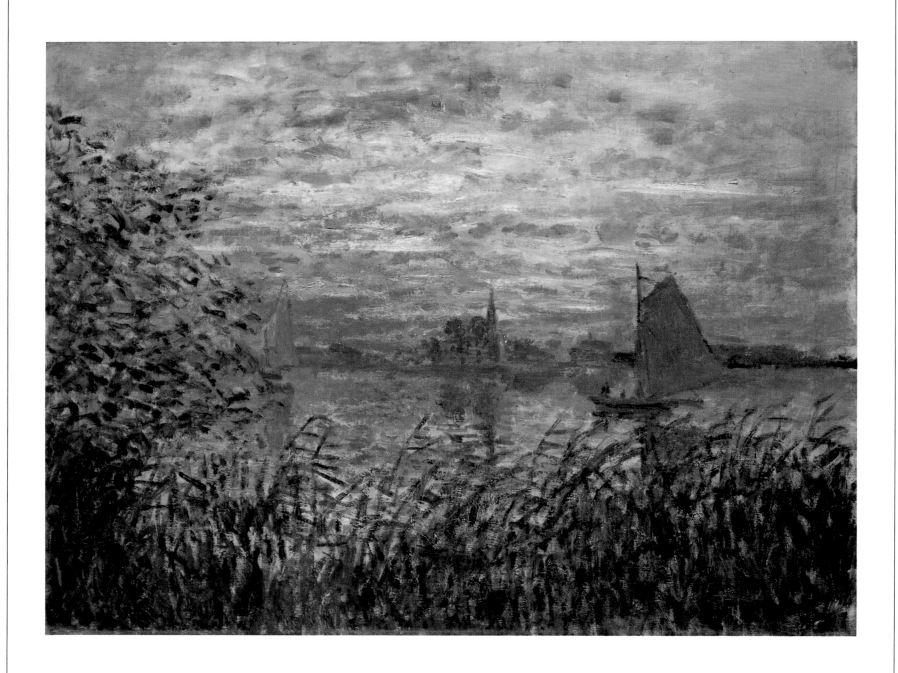

Marine View –
Sunset, *environs of
Argenteuil, 1874;
oil on canvas;*

*50 × 65 cm
(19½ × 25 in);
Museum of Art,
Philadelphia.*

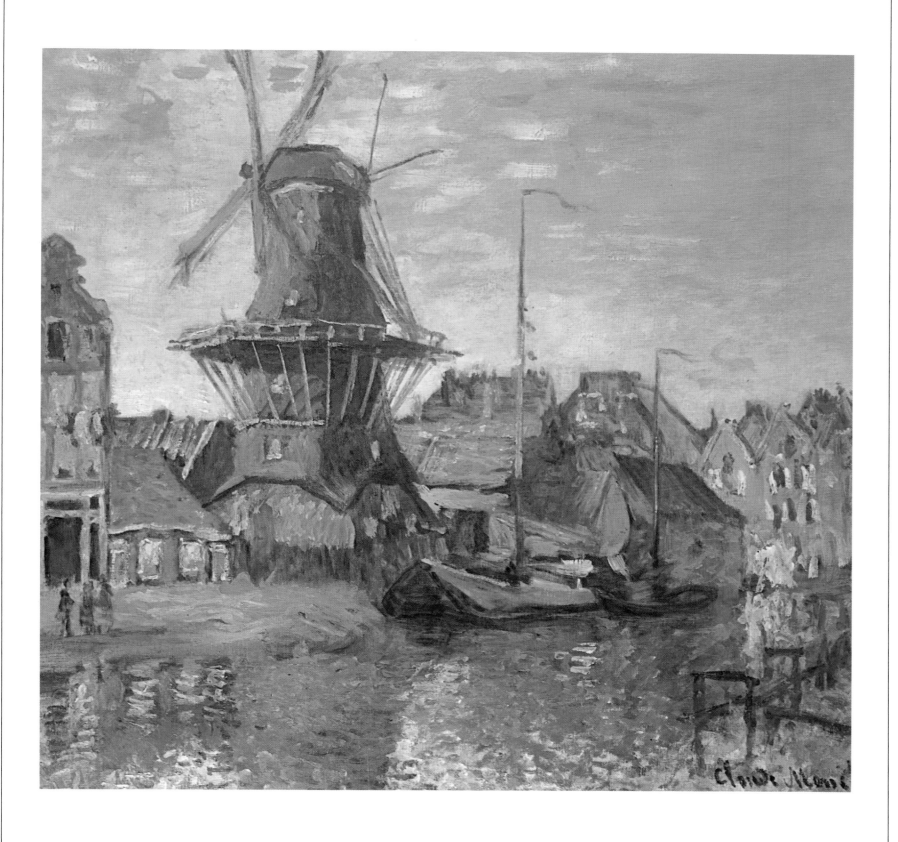

Windmill at
Amsterdam,
Amsterdam, 1874;
oil on canvas;
55 × 65 cm
(21¼ × 25 in);
signed; Private
Collection. In the
opinion of some art
historians, this
painting, as well as
the one on page
116, was executed
in 1872.

116

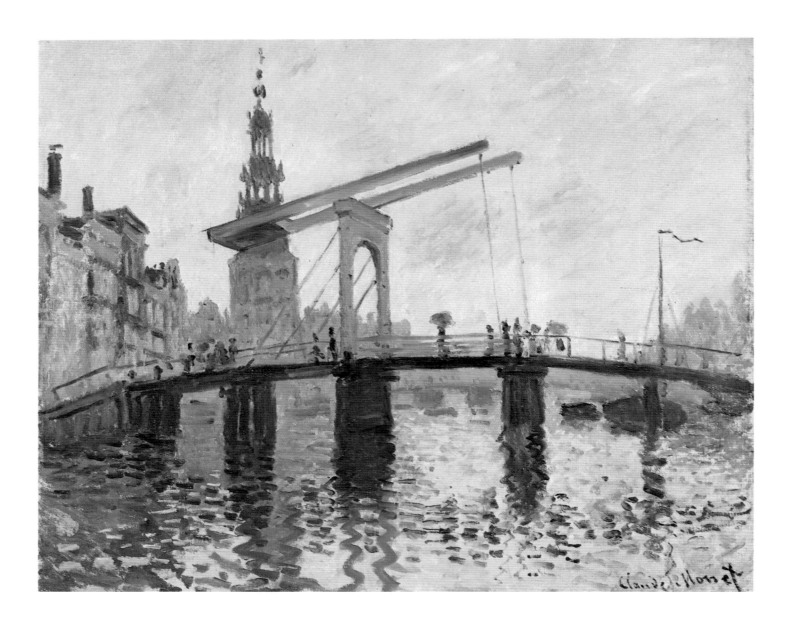

The Drawbridge at
Amsterdam,
Amsterdam, 1874;
oil on canvas;
53 × 63.5 cm

(20½ × 24½ in);
signed; Shelburne
Museum, Shelburne
(Vermont).

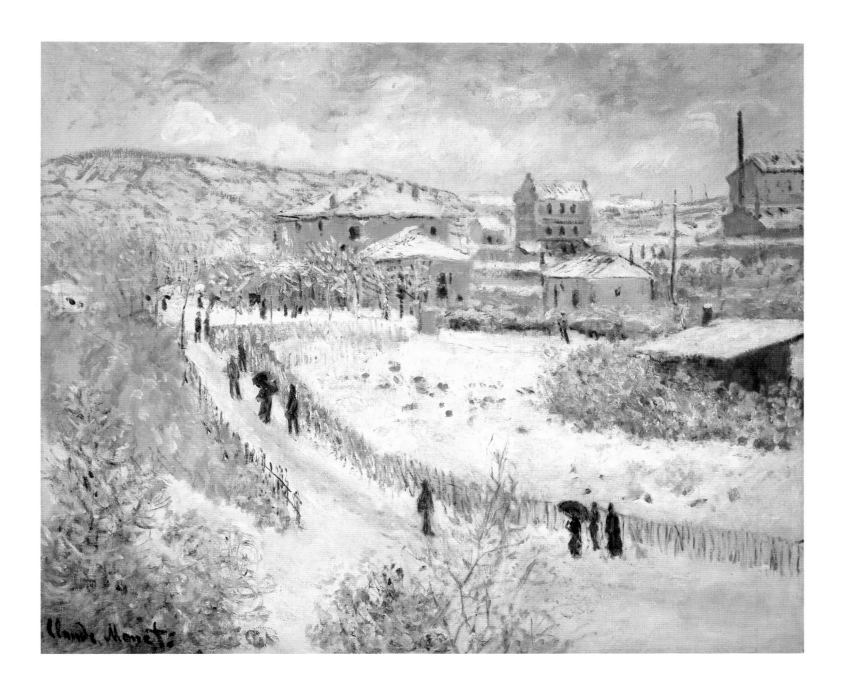

View of Argenteuil,
Snow, *Argenteuil,
January or
February 1875;
oil on canvas;
54.6 × 65.1 cm
*(21 × 25 in);
signed;
Nelson-Atkins
Museum,
Kansas City.*

118

The Tuileries;
Study, *Paris, 1875;*
oil on canvas;
50 × 75 cm
(19½ × 29 in);
signed and dated;
Musée d'Orsay,

Paris. Some critics
consider this a
study for the
painting of the
Tuileries garden
reproduced
on page 123.

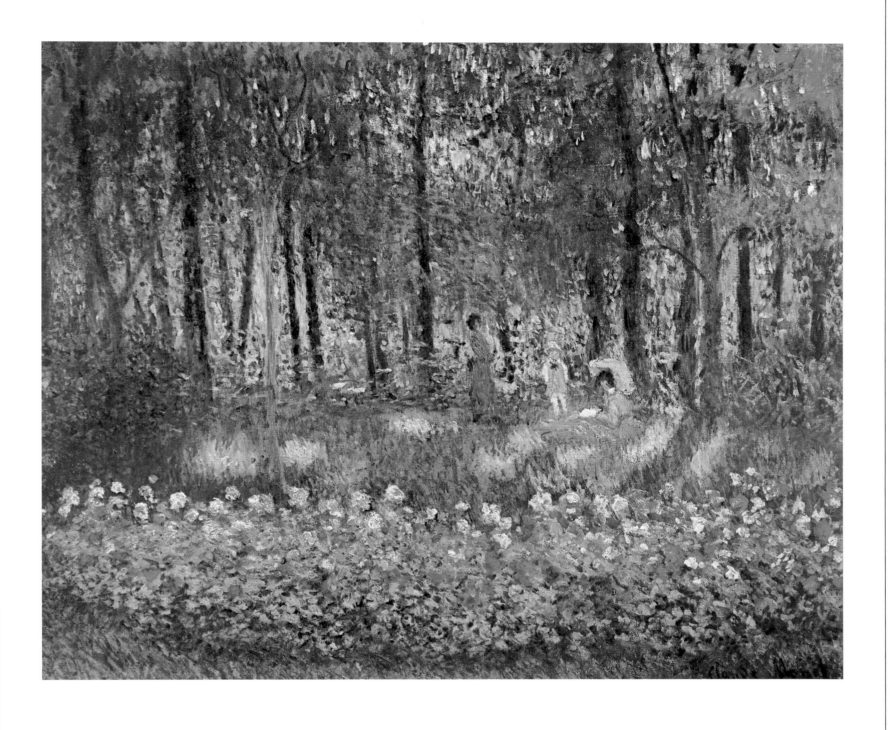

The Monet Family
in Their Garden at
Argenteuil,
*Argenteuil, spring
1875; oil on canvas;*
*61 × 80 cm
(23¼ × 31 in);
signed; Private
Collection.*

120

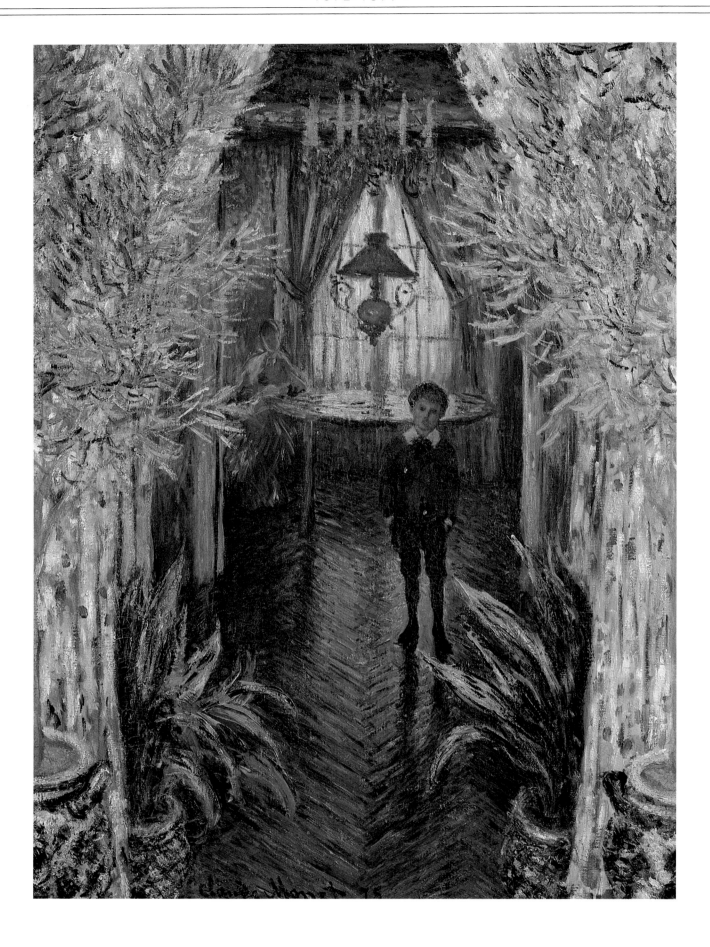

Corner of an
Apartment,
Argenteuil, 1875;
oil on canvas;
81 × 60 cm

(31½ × 23¼ in);
signed and dated;
Musée d'Orsay,
Paris.

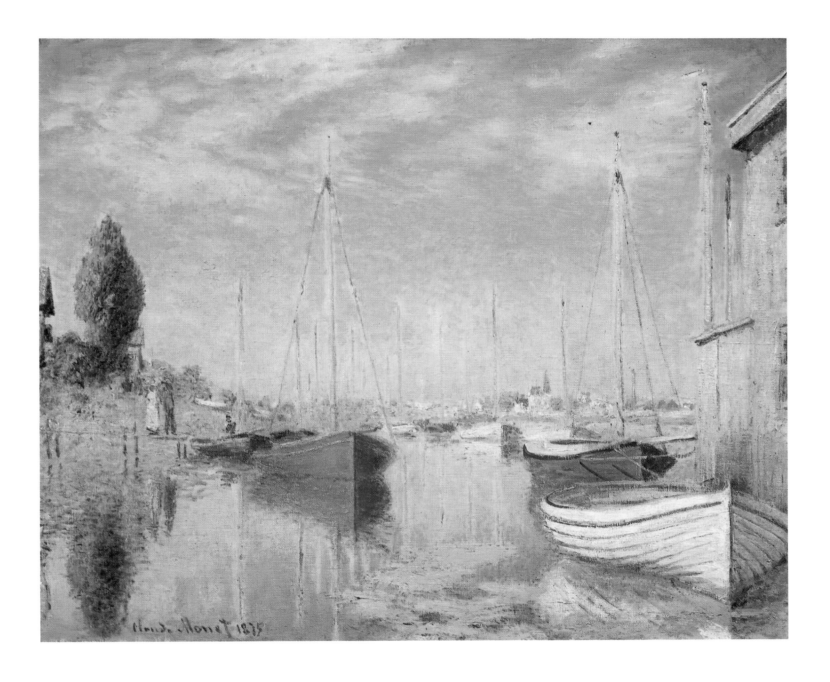

Pleasure Boats at
Argenteuil,
*Argenteuil, autumn
1875; oil on canvas;
54 × 65 cm
(21 × 25 in);
Private Collection.*

*There are two other
versions of this
painting that have
slightly "staggered"
viewpoints and
somewhat different
objects.*

122

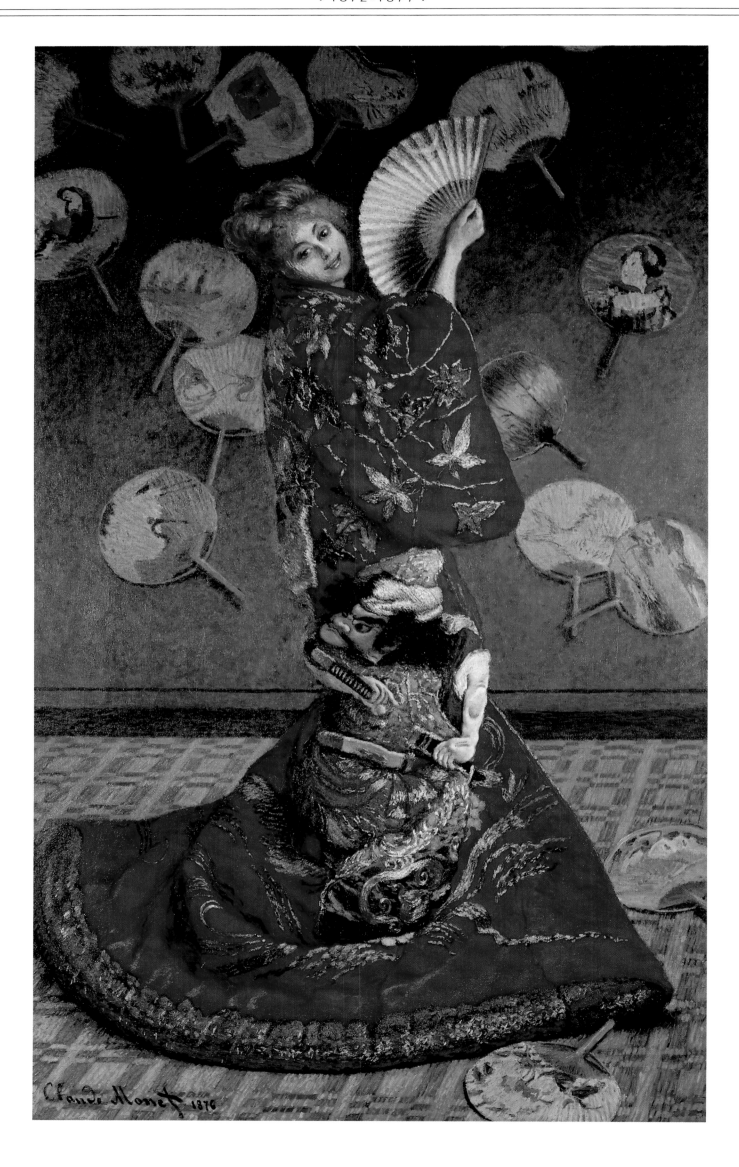

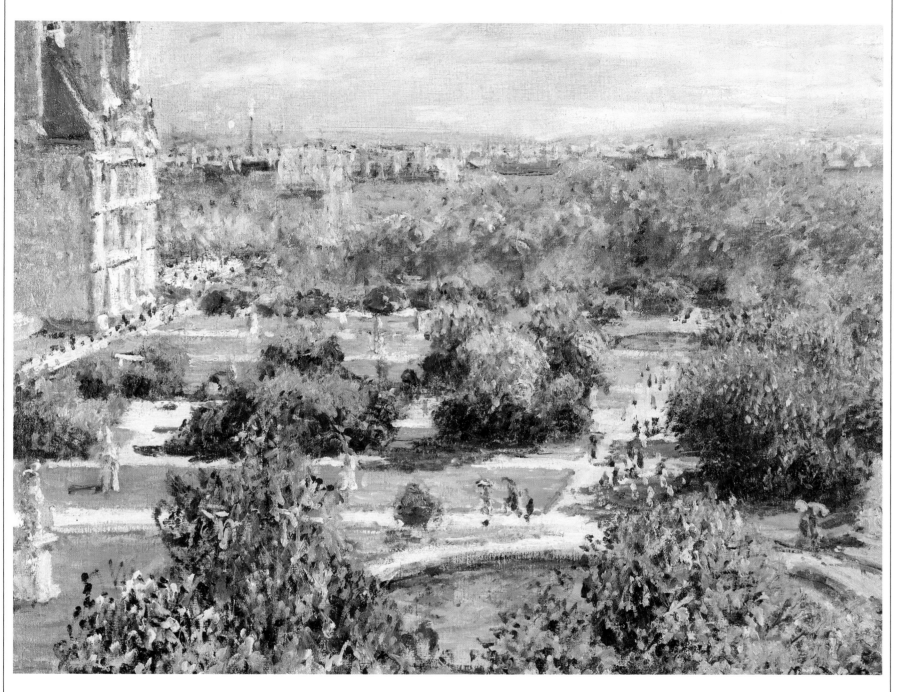

Opposite: Mme
Monet in Japanese
Costume, *Paris (?),*
1876; oil on canvas;
231 × 142 cm
(90 × 55 in); signed
and dated; Museum
of Fine Arts,
Boston. Some
scholars think this
work was executed
in 1875.

Above: The
Tuileries, *Paris,*
spring 1876; oil on
canvas; 53 × 72 cm
(20 ½ × 28 in);
signed and dated;
Musée Marmottan,
Paris. Despite the
contrast between
the small size of the
canvas and the
panoramic view,

this work cannot be
considered a study
because it bears
Monet's signature
and date.

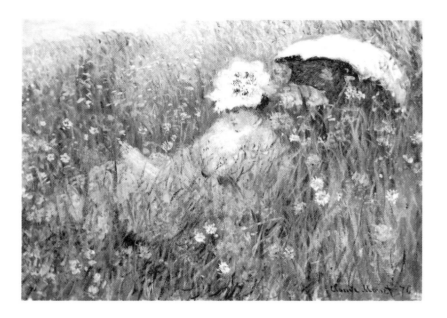

Left: Parc Monceau, Paris, *Paris, 1876; oil on canvas; 60 × 81 cm (23¼ × 31½ in); signed and dated; Metropolitan Museum of Art, New York. The light rains down through the foliage* of the trees, creating a strange, alienating optical effect that dazzles and intoxicates the viewer. Monet was searching for unconventional and hence disquieting means of "seeing" external reality.

Above: In the Meadow, Argenteuil (?), *spring 1876; oil on canvas; 60 × 81 cm (23¼ × 31½ in); signed and dated; Private Collection.*

126

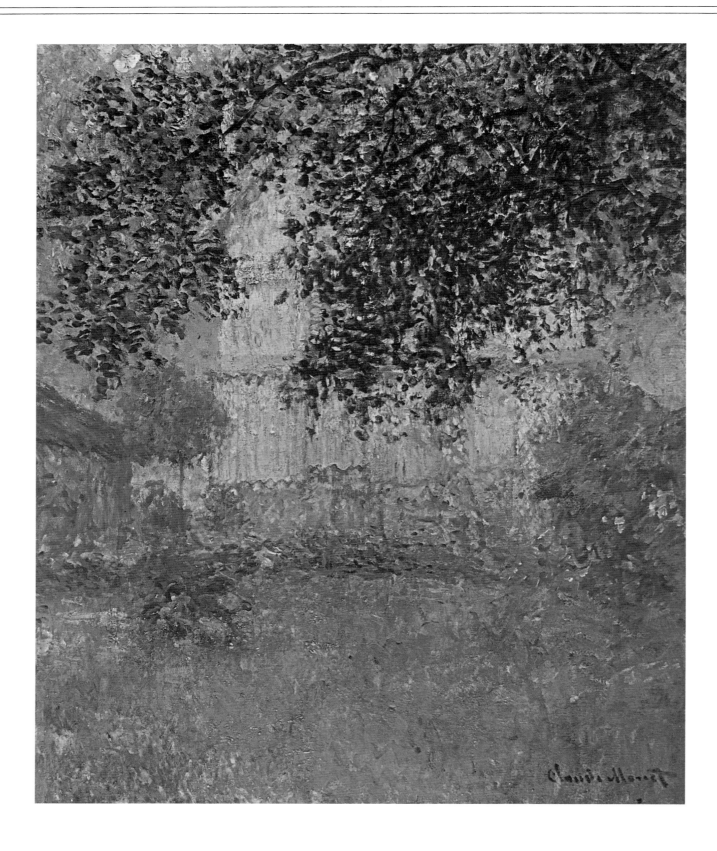

Above: Monet's House at Argenteuil, *Argenteuil, 1876, oil on canvas; signed; Private Collection.*

Opposite above: The Artist's Studio Boat, *Argenteuil, 1876; oil on canvas; 54 × 65 cm (21 × 25 in); signed; Musée d'Art et d'Histoire, Neuchâtel.*

Opposite below: The Turkeys, *Château of Rottembourg at Montgeron, 1876-77; oil on canvas; 144 × 172 cm (56 × 67 in); signed and dated (1877); Musée d'Orsay, Paris. This work was certainly begun in the late summer of 1876 during Monet's first sojourn at the Hoschedés' château at Montgeron, and was probably finished or touched up in the studio the following year, in any case before the third Impressionist show in April 1877, where it was exhibited.*

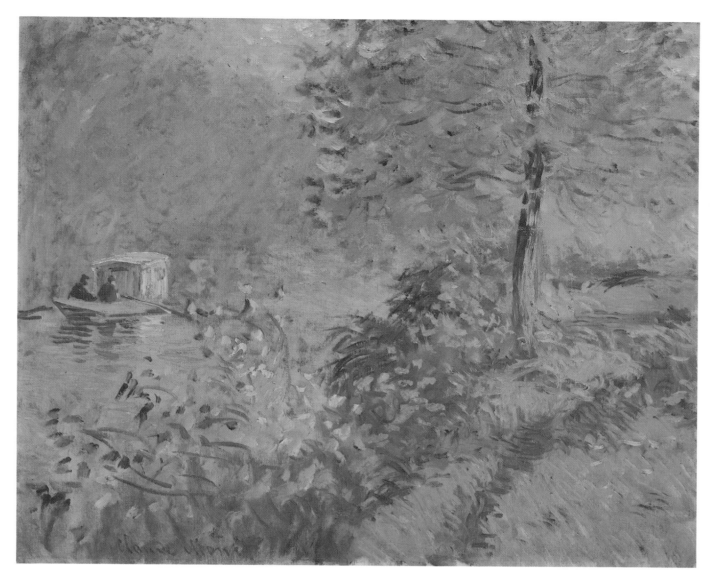

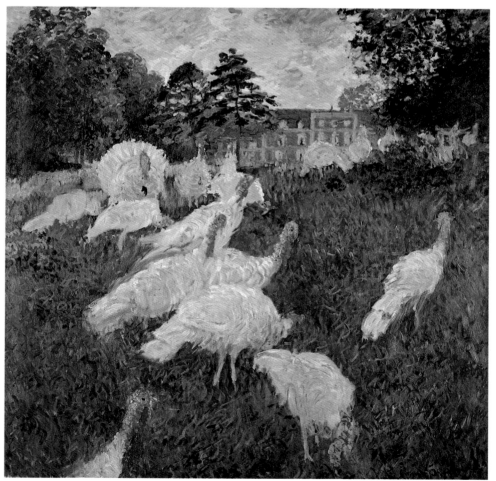

Rose Beds in the
Hoschedés' Garden
at Montgeron,
Montgeron,
summer 1877 (?);
oil on canvas;
172 × 192 cm
(67 × 74¼ in);
signed; The
Hermitage

Museum, St.
Petersburg. Usually
dated at 1877, this
work may have
been painted during
the summer of
1876. The same is
true of the painting
reproduced
on page 129.

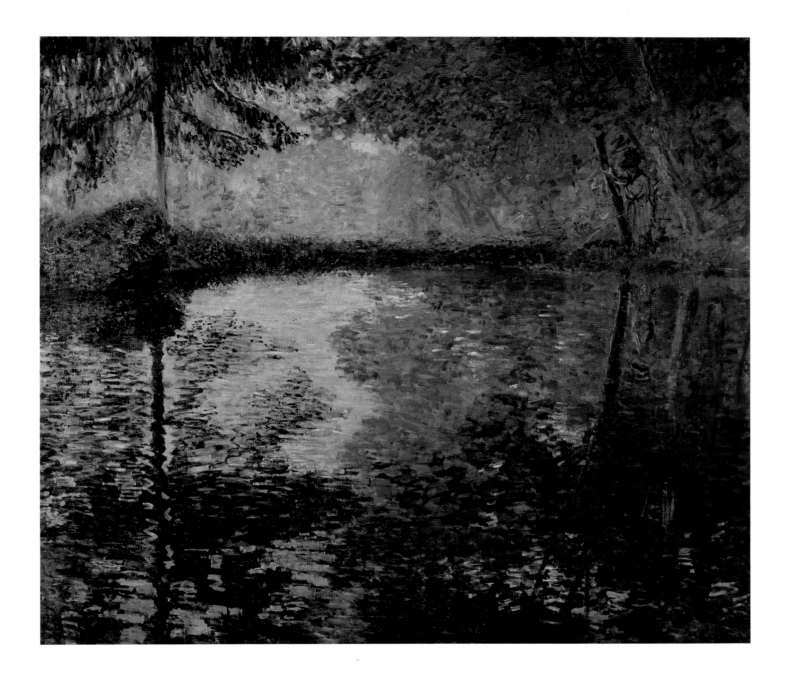

Pond at
Montgeron,
*Château of
Rottembourg at
Montgeron,
summer 1877 (?);
oil on canvas;*

*172 × 193 cm
(67 × 75 in);
signed; The
Hermitage
Museum, St.
Petersburg.*

130

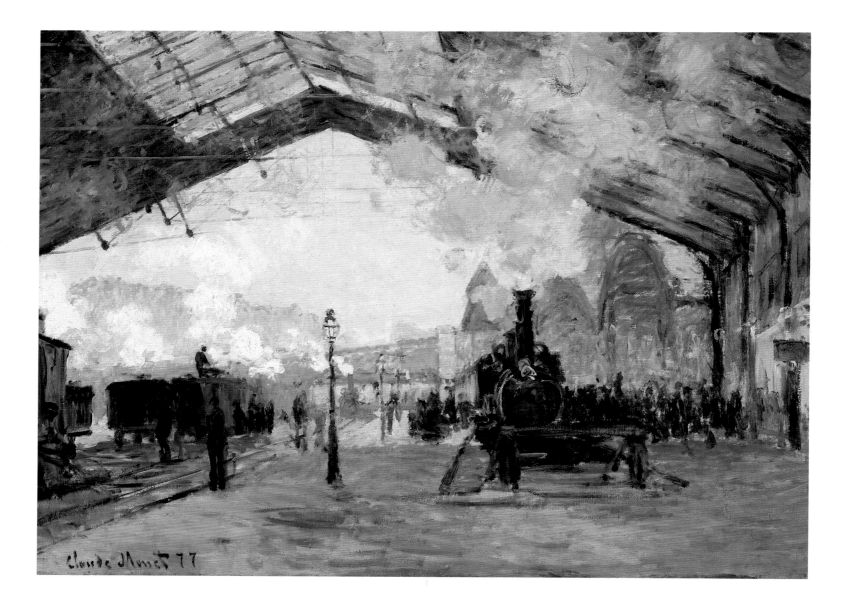

Above: The Gare
Saint-Lazare, *Paris,*
winter 1876-77;
oil on canvas;
60 × 80 cm
(23¼ × 31 in);
signed and dated
(1877); The Art
Institute, Chicago.

Opposite above:
The Pont de
l'Europe, Gare
Saint-Lazare, *Paris,*
winter 1876-77;
oil on canvas;
64 × 80 cm
(24¼ × 31 in);
signed and dated
(1877); Musée
Marmottan, Paris.

Opposite below:
The Gare
Saint-Lazare, *Paris,*
winter 1876-77;
oil on canvas;
82 × 100 cm
(31¼ × 39 in);
signed and dated
(1877); Fogg Art
Museum,
Cambridge (Mass.).

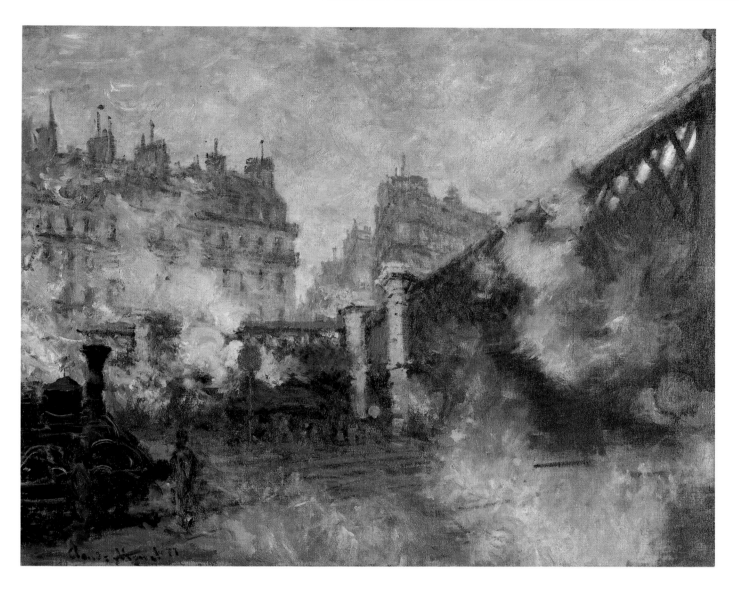

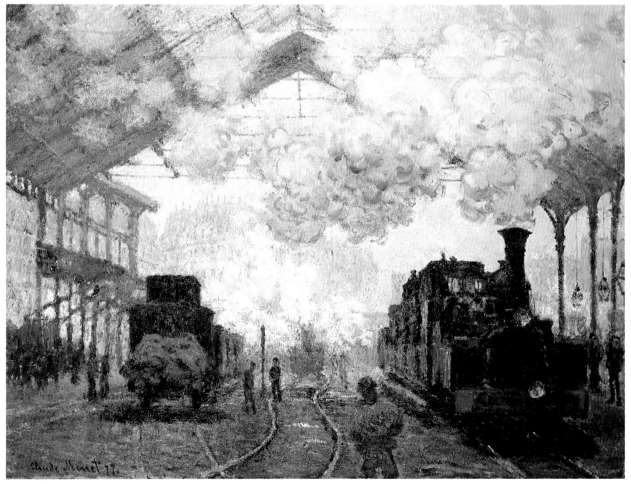

Matter and colour

The two versions of *Rue Montorgueil, Festival of June 30, 1878*, which is on the heels of the meaningful experience of the *Gare Saint-Lazare* cycle, reveal Monet's determination to plumb the depths of the pictorial potential of decidedly provocative, almost unrepresentable, subjects: the smoke "filled with noise" and the hustle and bustle of the station; the "chromatic uproar" and total confusion of the street decked with flags on a national holiday. Here Monet anticipates some of the typical features of the Fauve works (early twentieth-century paintings of the streets of Paris by artists such as Marquet or Dufy, who were also fascinated by the vitality of festivals). But at the same time he introduces a totally personal interpretation of the theme that was destined to become a constant one, a leitmotif, in his oeuvre. The canvas is the place in which one reckons with the difficulties of perception, the psychological and philosophical contradictions of art – if for no other reason than because the painted surface is something that can only be led back to the vision that generated it in a problematical way. In the case of the rue Montorgueil paintings, there are at least three factors on which this paradox hinges: first of all, the flags are at once an object of our vision and something that obstructs our vision (since they conceal the normal perspective of the street); then they refer to elements the visual arts cannot describe – the noisy merrymaking, the music, the smells of the street; lastly, the flags, like the fans in *Mme Monet in Japanese Costume*, are "pictorial" elements in themselves, pictures within a picture, canvases convered with colours. In the artist's hands, the flags are immediately transformed

into something implicitly linguistic: a metaphor of the painting that contains them or coincides with them.

The *Rue Montorgueil* paintings, like most of Monet's cityscapes, depend on an elevated viewpoint: "I really liked the flags. At the first national holiday, 30 June, I walked down rue Montorgueil with my easel and paints. The street was decked with flags, but was swarming with people. I espied a balcony, went up the stairs and asked permission to paint there." It would be interesting to know how much Monet's need to "see from on high" was related to Degas's ideas on the angle of the picture, since around 1878 this artist was accentuating his tendency to choose unusual viewpoints, almost always from above to below, in his paintings of ballet dancers or his portraits. The critic William Seitz declared that in the two rue Montorgueil works: "both the motif and the style are projected into the future, toward van Gogh's *July 14*, towards the highly subjective streets of the Fauves and Futurists, towards the New York views by John Marin and Mark Tobey. Few works so efficaciously bear witness to the dynamism of Impressionism."

A more graphic style that seeks an elegance wholly interior to the theme, is to be found in *Parisians Enjoying the Parc Monceau* (1878), which recalls the contemporaneous works of Degas or Renoir and, moving in a different direction, also of certain Expressionist works painted around 1915. *Poppy Field near Vétheuil* (1878) on the other hand reconfirms Monet's urge to conceive the surface of his paintings as a complex symphony of chromatic stimuli; the broad bicoloured area with its green base dotted with red that is the subject

of this work is, in my opinion, worthy to stand alongside the experiments Seurat and the *pointillistes* would make a few years later. Even more audacious (and equally "symphonic") is the presence of white in *Road to Vétheuil, Winter* (1879), in which the paint is applied in thick, compact, pasty smudges, veritable daubs of colour, like calligraphic signs made by a small child experimenting with the alphabet. This painting is astonishing, and to appreciate its modernity we need only isolate a detail of the "hill" on the left – forgetting for the moment the literal sense of the representation, which in more than one way is misleading – to highlight its purely artistic value. In this way the close relation of Monet's art to the future sensibility of action painting would be clearly established.

On the inner, poetic plane the above-mentioned landscape and the magnificent cycle painted between Vétheuil and Lavacourt during the winter of 1879-80 present many obvious affinities. At least four masterpieces must be mentioned in this context: *Vétheuil in the Fog*, a bluish, phantasmagoric work built upon series of transparencies rather than on concrete realities, on the dazzling watery effects and subdued melancholy that can be recognized only by those familiar with the visual tricks sometimes played by fog in the dead of winter on rivers and lagoons. Then there is *Break-up of the Ice, Lavacourt*, which takes up a theme dear to the Romantics (one has only to think of Caspar David Friedrich's *Wreck of the "Hope"*) by dwelling on the physical marvel of white sheets of ice drifting along a flooded river. This prodigy of nature is interpreted by Michel Butor as the

moment in which "the entire metaphor of painting is unveiled [...] the moment in which the dense surface of the river, its crust, comes apart, thus revealing upside-down glimpses of the trees on the shore." The third masterpiece is *Hoarfrost, near Vétheuil*, a magical work in pink, violet and blue, a marvellous, intensely spiritual painting that is nevertheless in keeping with Monet's "secular" aspirations. Lastly, there is *Ice Thawing on the Seine* (or *Ice Floes near Vétheuil*), with a beautiful mirror-like connection between the sky that is clearing and the water that is becoming fluid again after the terrible winter cold – almost like a subdued cry of hope.

We must not overlook the intimate link between these four paintings – consecrated to silence and frost, to the blinding of the eye and consciousness – and Monet's particular psychological state in this difficult phase of his life: he had just lost his cherished wife Camille, whose death throes are represented in *Camille on Her Death Bed* (1879), and this had deeply affected him. Once again his work, which in the paintings of the thaw displays a certain aura of tragedy, convinces us that the rather common critical evaluation of Monet as a "happy, light" painter inclined to produce a carefree, banal and worldly interpretation of art, is ridiculous. In 1880 Monet painted the landscape *Vétheuil in Summer*, now at the Metropolitan Museum of Art, New York. Unlike his youthful works of the Seine, this rendition does not offer a brilliant and faithful mirror image of the town on the river, but rather seems to retain only something like a spectral memory of it, like a pain-filled shroud... And in fact

the town itself, the houses, trees and church, even in the "real" version (that is, the town not reflected in the water) seem to be ruffling in the wind, unsettled, struck and bewildered, perhaps out of focus, plunged in an atmosphere of utter sadness. *Snow Effect at Lavacourt* (1881) represents a return to the aesthetic of the cold which in a pictorial sense is tantamount to an aesthetic of the colour white. The canvas is divided into four areas. A large whitish-blue spot in the lower part, furrowed by leaden waves and rents, by violet-blue brush strokes, makes up the snow-clad earth in the foreground, which is slightly convex. In the upper part opposite, in an almost specular area, the sky is rendered through a light blue-yellowish, almost homogeneous, zone that is barely brightened below: a rather sickly, bilious sky, heavy with snow. In the middle, separating these two areas, there is a strange pink spot on the left – threaded with red, purple and brown – which is a sun-kissed hill; on the right is the little section (the only one to be really worked on and which is rich in detail) that depicts the houses, which are foreshortened. This is a collage composition that is quite successful in its rendering of emotion and in its organic quality. With *Church at Varengeville, Cloudy Weather* (1882) we are at opposite poles. Here the view, though also structured in areas, is uniform; it is as if a single, solid atmospheric sheath enveloped the landscape to transform the grass, bushes, pines and sea into a sole, opaque, resistant substance. This work marks the beginning of a brief cycle of seascapes viewed from above on the coast near Varengeville. Among these, mention must be made of *The*

Custom Officer's Cabin at Varengeville (1882; Museum Boymans-van Beuningen, Rotterdam), a work of an almost unreal luminosity, with a sea that is a mass of ever changing colours, reflections, dazzling light, and with a cliff that contains the most varied palette ever seen, while consisting of only one blinding colour. Wittgenstein's works come to mind in this context: "The difficulties we perceive when meditating on the nature of colours and which Goethe wanted to tackle in his *Zur Farbenlehre* [his studies on colour theory] are already innate in the indeterminateness of our concept of equality among colours." The most historically significant work painted in 1882 is *Spring* (Lyons Musée des Beaux-Arts). Above all it shows a flowery tree without leaves that takes up the entire right half of the canvas; then, below, is the green, white and yellow grass; and further on, forming a horizontal median band, is the brown of the plain interrupted by a river; above we see a violet-blue sky stained with the white spots of the clouds. According to Francesco Arcangeli – who underscores the arabesque motif of the branches as a symptom of a crisis in Impressionism – this work was important for the development of van Gogh's painting, which employed a similar accentuation of line and of the graphic-decorative aspect. Arcangeli asserts that Monet here takes on, and partially anticipates, the new sensibility promoted by the then emerging Symbolist movement: "A painting like this already marks a decreasing faith in sensation on Monet's part [...] He never abandoned sensation, but now he begins almost to try to modify its concept and practice." And in a more

general sense: "With the exception of Cézanne, he is the first to initiate a turning point that will involve everyone: it will concern van Gogh and Seurat, as well as the styles of Renoir, Pissarro and Sisley." "[Monet], once again chronologically ahead of time – not only materially but creatively as well – sets into motion the crisis of Impressionist culture." The series of seascapes at Etretat, which were Monet's most interesting artistic experience in the 1880s, is articulated in two fundamental stages: the first was in 1883 and includes works such as *Etretat, Rough Sea, Etretat,* and *The Manneport, Etretat, I.* These paintings reveal great stylistic maturity and an impressive technical command. The way in which Monet handles colour – his daubing brush strokes, his highly gestural line in the waves of *Etretat, Rough Sea* or in the rendering of the rocks in *Manneport* or, lastly, in the succession of little boats in *Etretat* with those curls and streaks, those dense strokes made with the palette knife – is certainly no less effective than van Gogh's technique, at least externally; although not as expressively dramatic, it is equally interesting on an aesthetic and formal plane. In a sort of harmony in ochre, *Etretat, Rough Sea* shows the famous falaise (cliff) d'Aval rendered in the form of a geological architecture with an infinite number of tiny horizontal slashes that alternate various hues of brown and grey; below this is a creamy white and sulphureous sea saturated with deep blue only in the distant horizon (but this is an almost imperceptible change smothered, as it were, by the leaden sky). The very same sea is rendered in *Manneport, Etretat, I* with a mixture of Prussian blue

and black in the sunset light which, passing through the arch of the cliff, splits it into two clearly distinct areas, almost as if it consisted of two different substances. Monet's career is also marked by less brilliant periods that lack inspiration. We have seen that there are periods of unevenness in his artistic development, which is characterized by moments of creative sterility followed by bursts of inventive vitality. So it certainly cannot be said that the canvases he produced in Liguria, Italy in 1884 attain the lyrical balance and beauty of the Etretat paintings. *Lemon Trees at Bordighera*, with its riot of colours, is a good painting, but it appears at once excessive and too moderate, lacking the tension that usually saves Monet from the imminent risk of being a slightly careless artist. And yet even works such as this, or *The Castle at Dolce Acqua* or *The Valley of Sasso at Bordighera*, are worthy of respect, if only because they poetically reflect that "cult of place" Marcel Proust was so fond of. In his critical essays (1897-1904) Proust comments that Monet's paintings, among other things, "reveal to us in equal measure the celestial nourishment our imagination can find in things: the waterways studded with islands in those idle afternoon hours in which the water is white and deep blue from the clouds and sky, green with the plants and meadows, pink with the already descending rays of light on the tree trunks, and in the darkness illuminated by the red glow of the bushes and gardens where large dahlias grow."

134

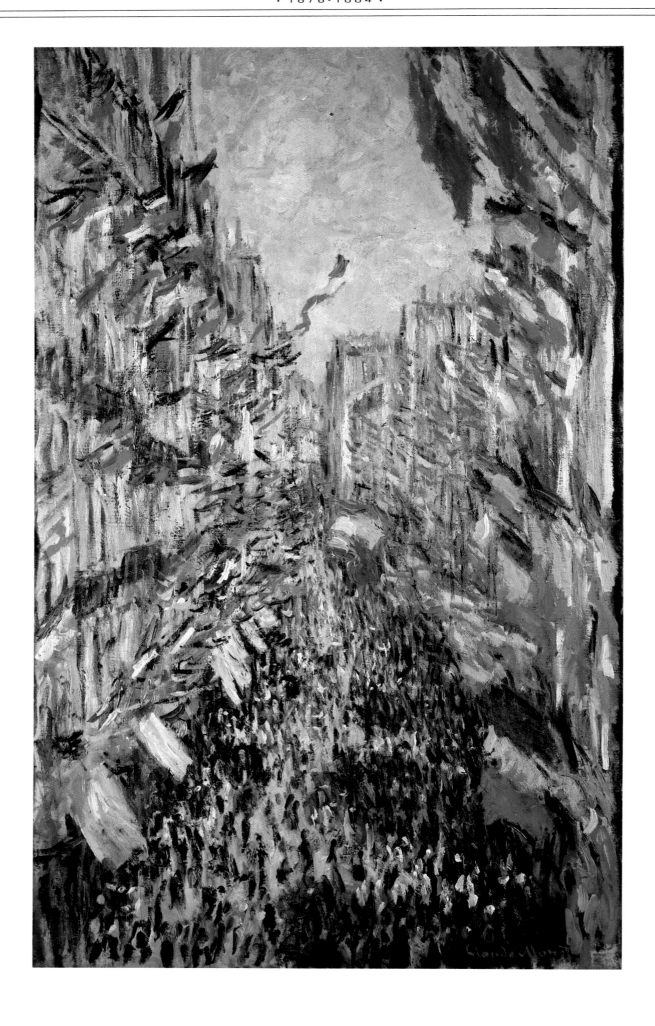

Rue Montorgueil,
Festival of June 30
1878, *Paris,*
oil on canvas;

81 × 50.5 cm
(31½ × 19½ in);
signed; Musée
d'Orsay, Paris.

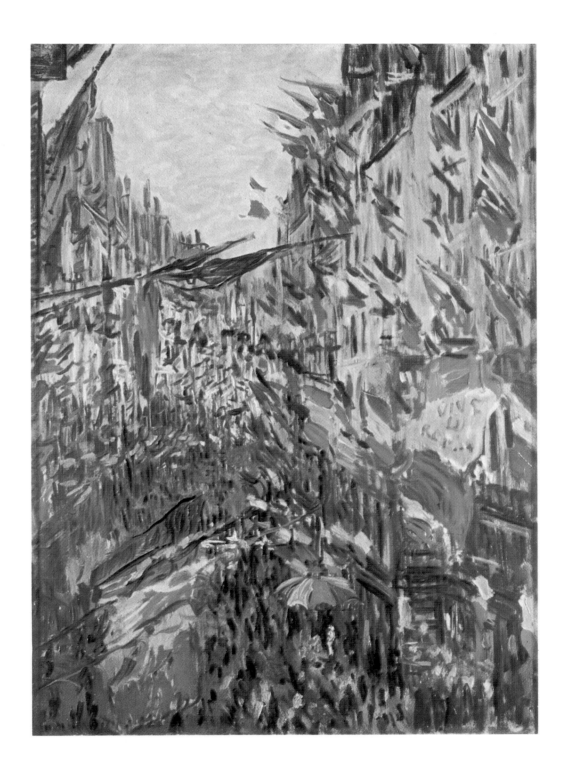

Rue Montorgueil canvas; 76 × 52 cm
Decked out with (29½ × 20 in);
Flags, *Paris, 30* signed; *Musée des*
June 1878; oil on *Beaux-Arts, Rouen.*

136

Above: The Banks
of the Seine,
Courbevoie,
summer 1878; oil
on canvas;
52 × 63 cm
(20 × 24½ in);
signed and dated;
Musée Marmottan,
Paris.

Opposite: Parisians
Enjoying the Parc
Monceau, *Paris,*
spring 1878; oil on
canvas; 70 × 55 cm
(27 × 21¼ in);
signed and dated;
Metropolitan
Museum of Art,
New York.

138

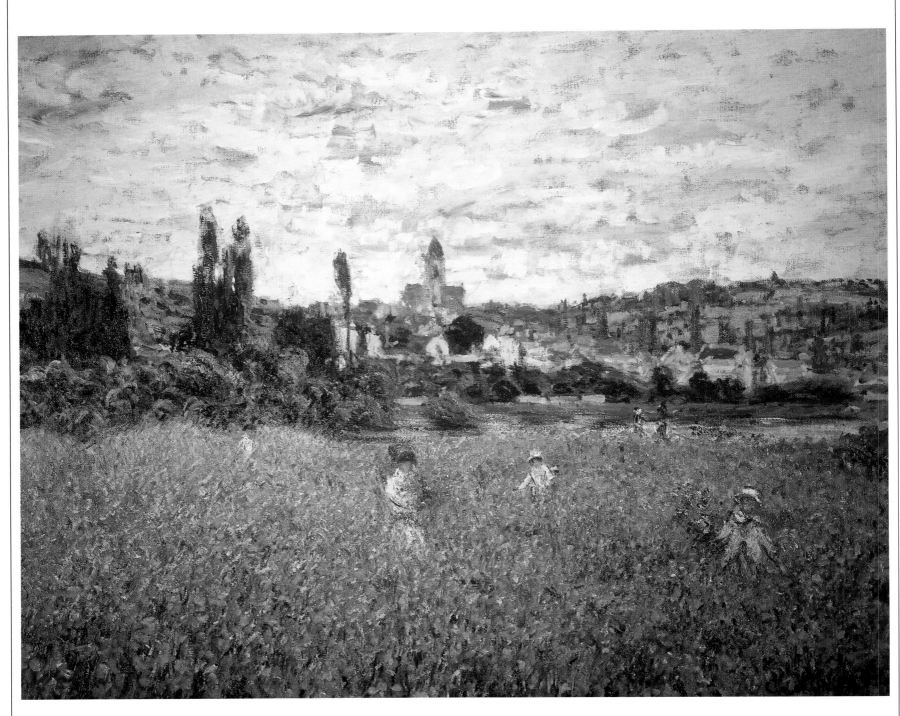

Poppy Field near
Vétheuil, *environs*
of Vétheuil, June
1878; oil on canvas;
70 × 90 cm
(27 × 35 in);
signed (?); Bührle
Collection, Zurich.

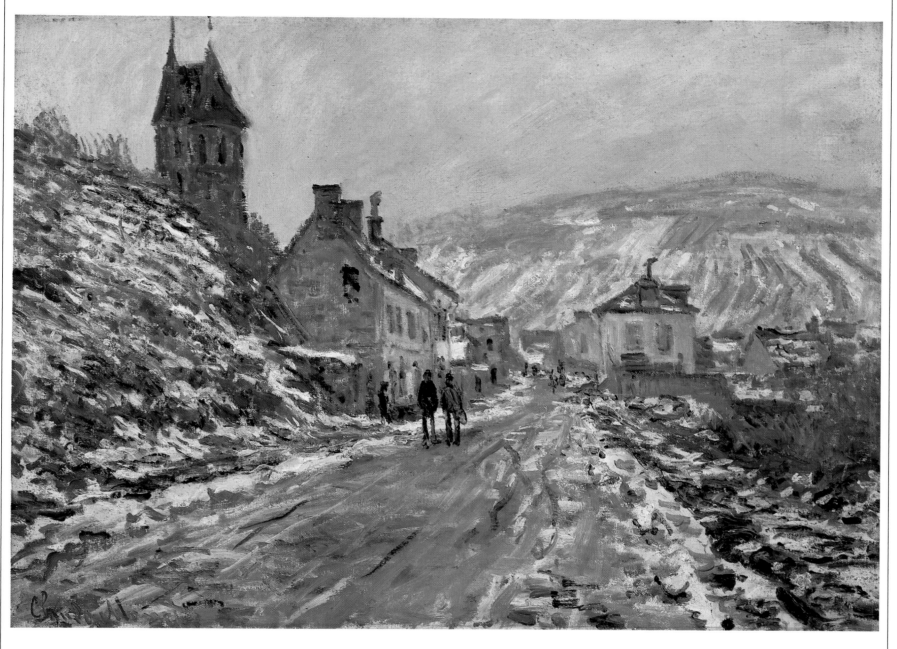

The Road to
Vétheuil, Winter,
Vétheuil, January
or February 1879;
oil on canvas;
53 × 72 cm
(20½ × 28 in);
signed;
Konstmuseum,
Göteborg.

140

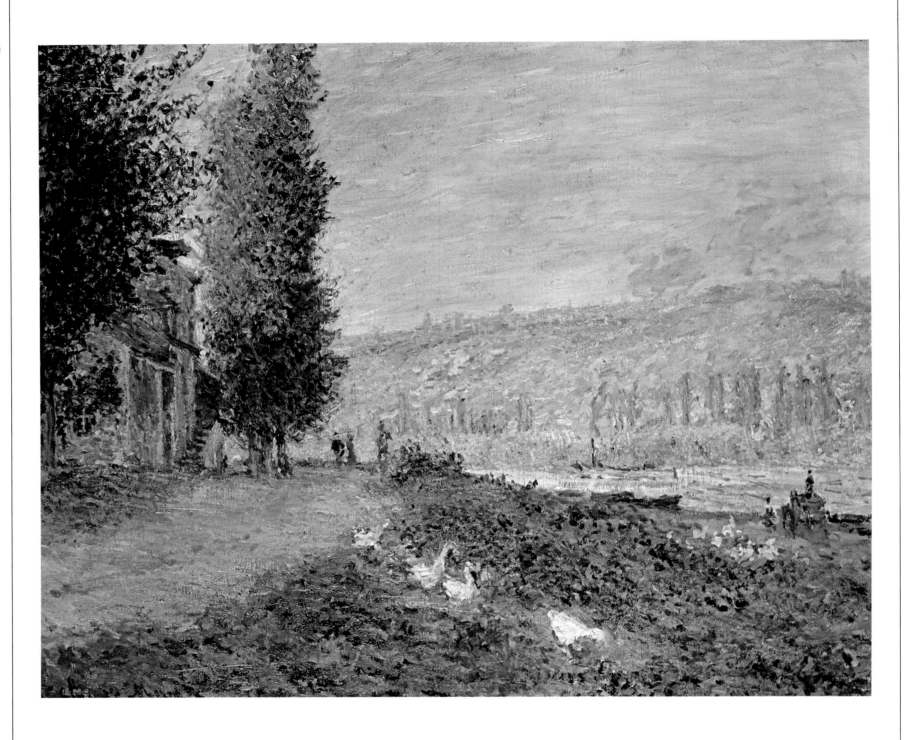

The Banks of the 66×80 cm
Seine, Lavacourt, $(25\frac{1}{4} \times 31$ in);
Lavacourt (near *signed;*
Vétheuil), 1879; *Gemäldegalerie,*
oil on canvas; *Dresden.*

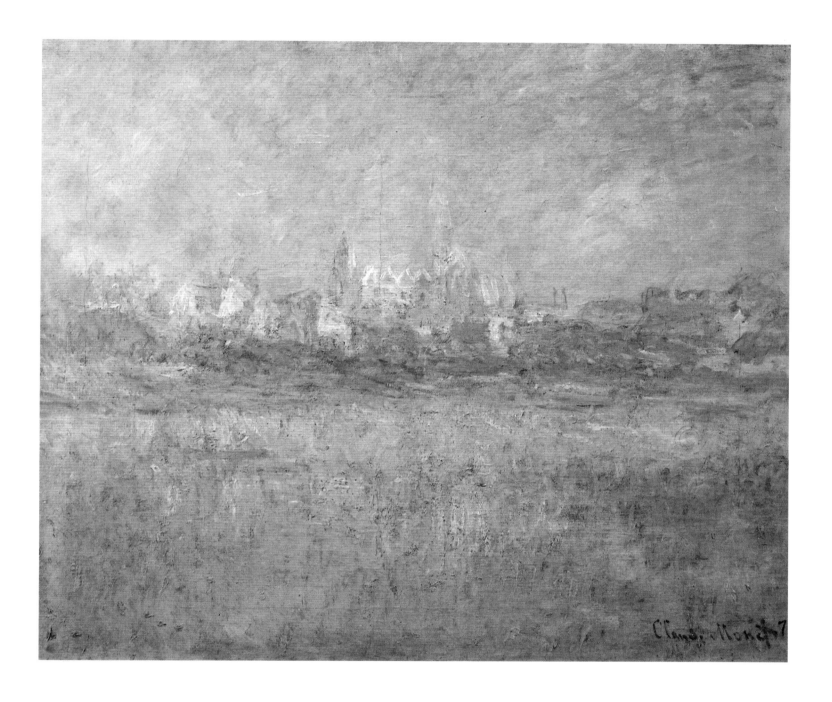

Vétheuil in the Fog, *Vétheuil, 1879; oil on canvas; 60 × 71 cm (23¼ × 27½ in); signed and dated; Musée Marmottan, Paris. Monet dated this painting at 1879, but it is difficult to* determine whether it was actually painted in the winter of 1878-79, like the work reproduced on page 139, or during the following winter (1879-80), like the "ice floe" series.

142

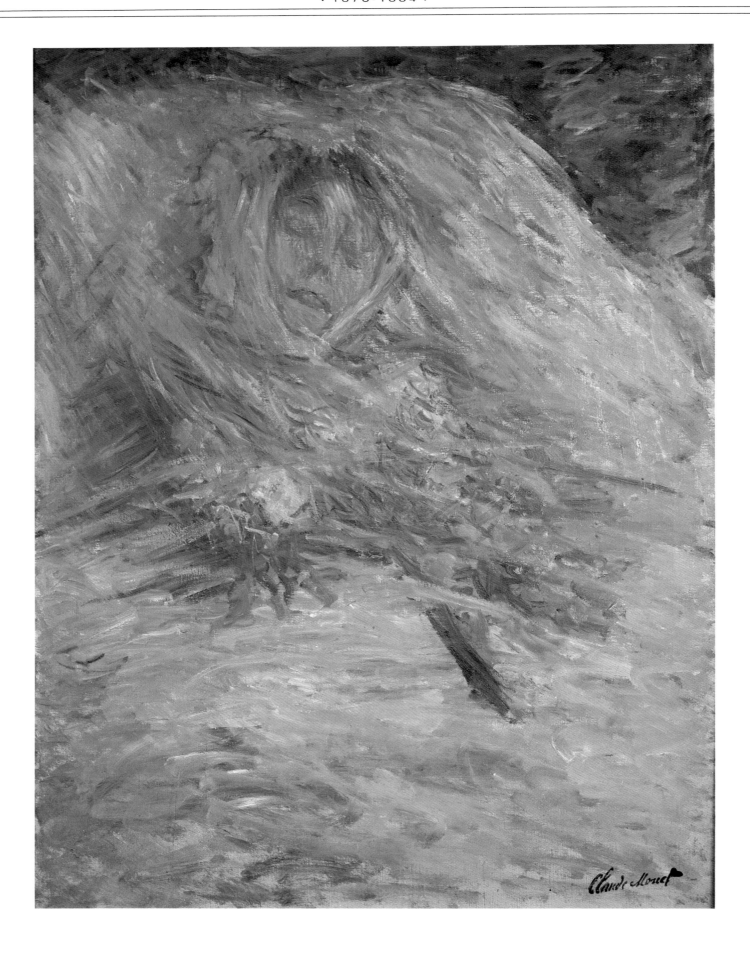

Camille on Her
Death Bed,
*Vétheuil, September
1879; oil on canvas;*
92 × 70 cm
(35¼ × 27 in);
*Musée
d'Orsay, Paris.*

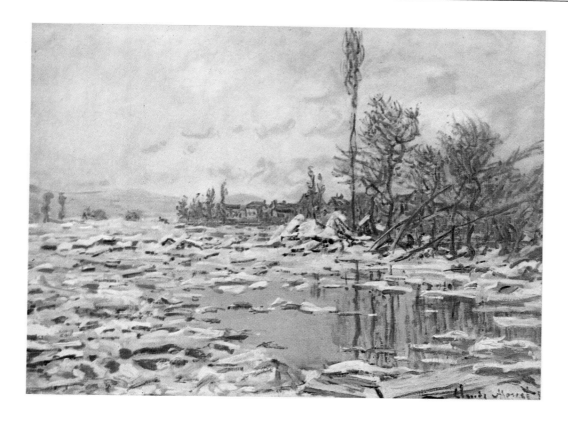

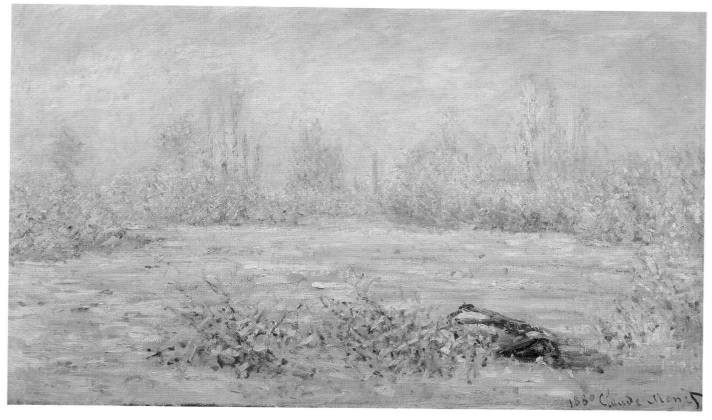

Above: Break-up of the Ice, Lavacourt, *Lavacourt (near Vétheuil), January 1880; oil on canvas; 68 × 90 cm (26½ × 35 in); signed and dated; Museu Gulbenkian, Lisbon.*

Below: Hoarfrost, near Vétheuil, *environs of Vétheuil, January or February 1880; oil on canvas; 60 × 100 cm (23¼ × 39 in); signed and dated; Musée d'Orsay, Paris.*

144

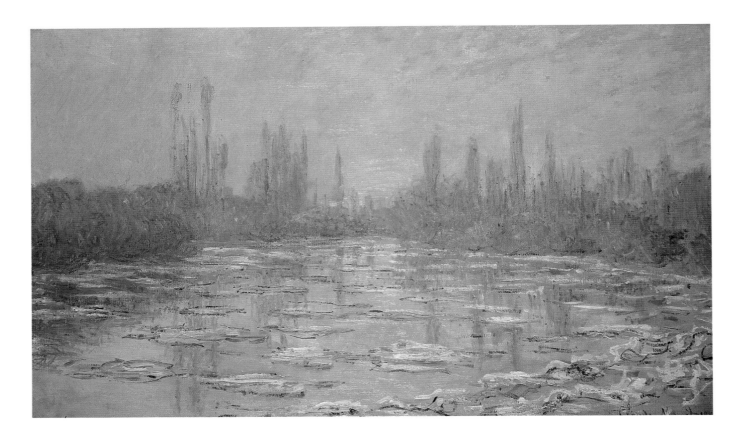

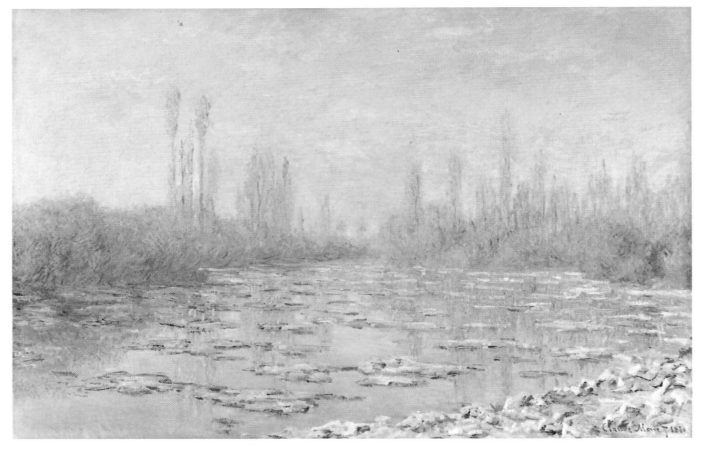

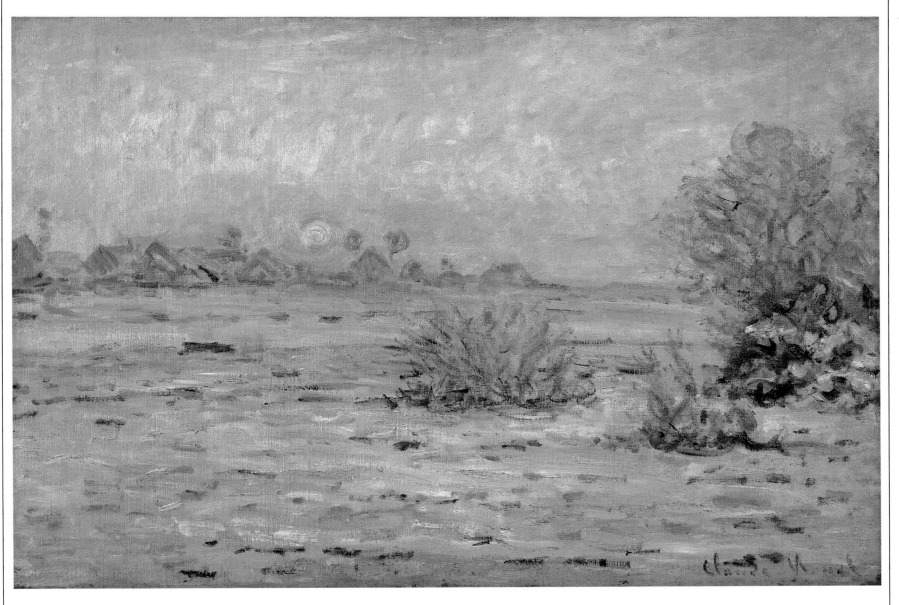

Opposite above: Ice Thawing on the Seine *(or* Ice Floes near Vétheuil*), environs of Vétheuil, January 1880; oil on canvas; 60 × 100 cm (23¼ × 39 in); signed and dated; Musée d'Orsay, Paris.*

Opposite below: Ice Floes, *environs of Vétheuil, January 1880; oil on canvas; 97 × 150.5 cm (37¼ × 58½ in); signed and dated; Shelburne Museum, Shelburne (Vermont).*

Above: Snow-covered Landscape, Dusk, *environs of Vétheuil, January or February 1880; oil on canvas 81 × 55 cm (31½ × 21¼ in); signed; Musée des Beaux-Arts André Malraux, Le Havre.*

146

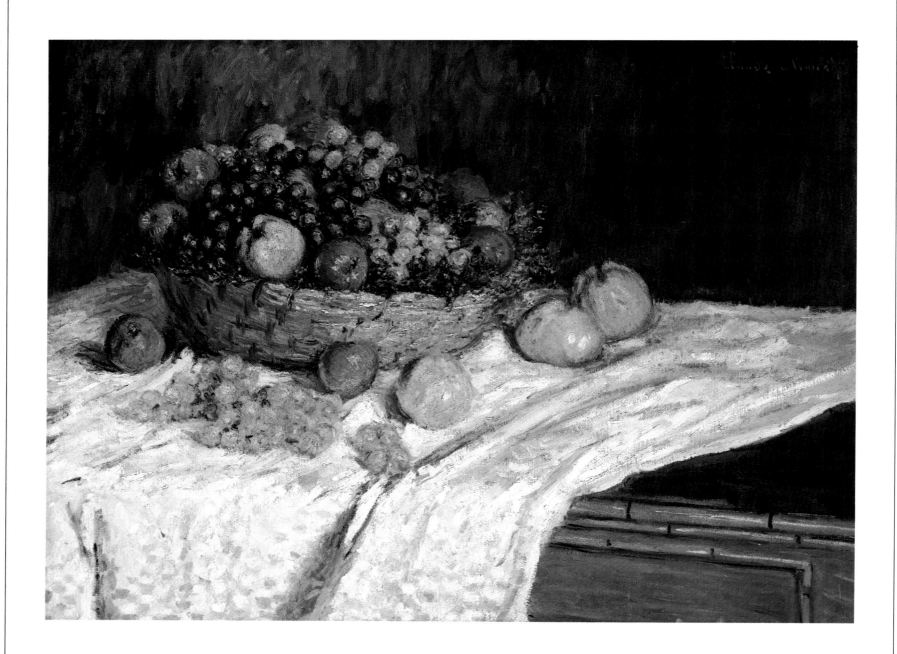

Above: Apples and Grapes, *Vétheuil (?), 1880; oil on canvas; 70 × 92 cm (27 × 35¼ in); Metropolitan Museum of Art, New York.*

Opposite: Path in the Ile Saint-Martin, Vétheuil, *environs of Vétheuil, 1880; oil on canvas; 80 × 62 cm (31 × 24 in); signed and dated; Metropolitan Museum of Art, New York.*

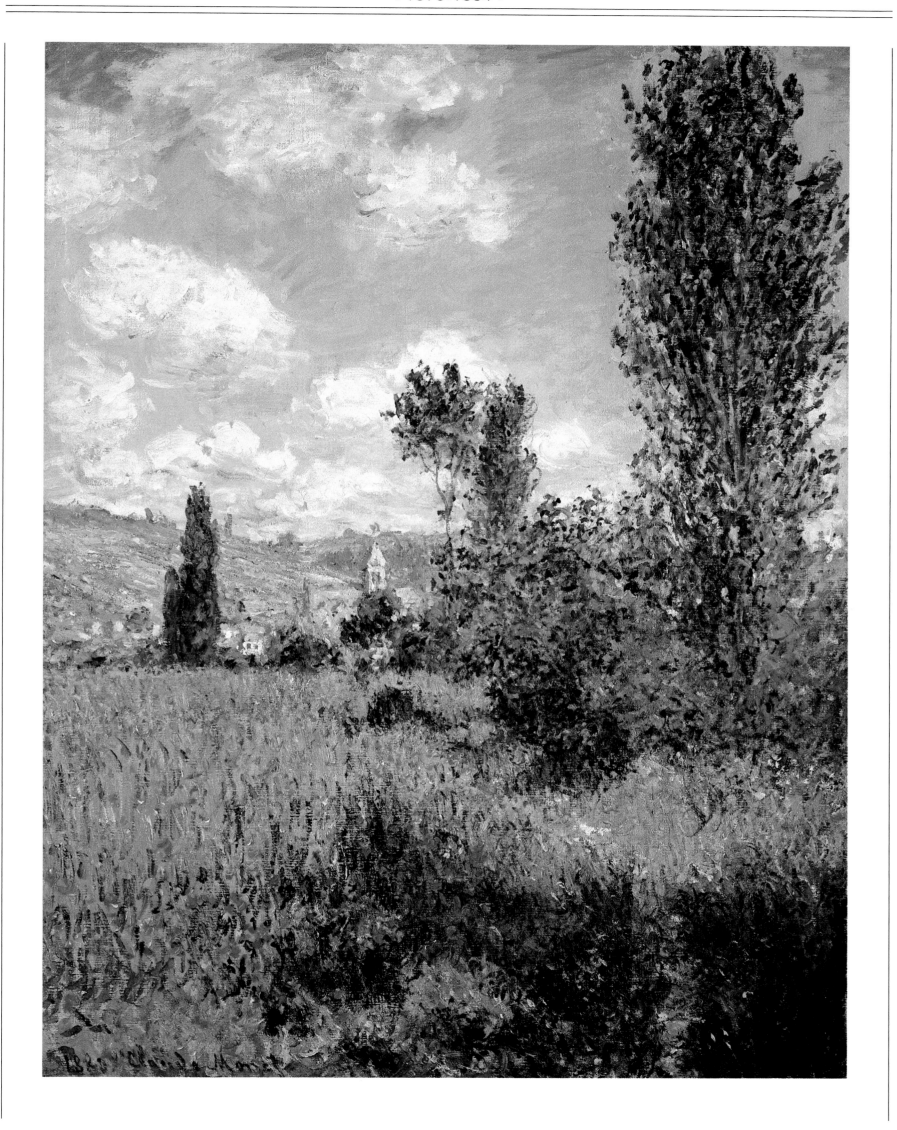

148

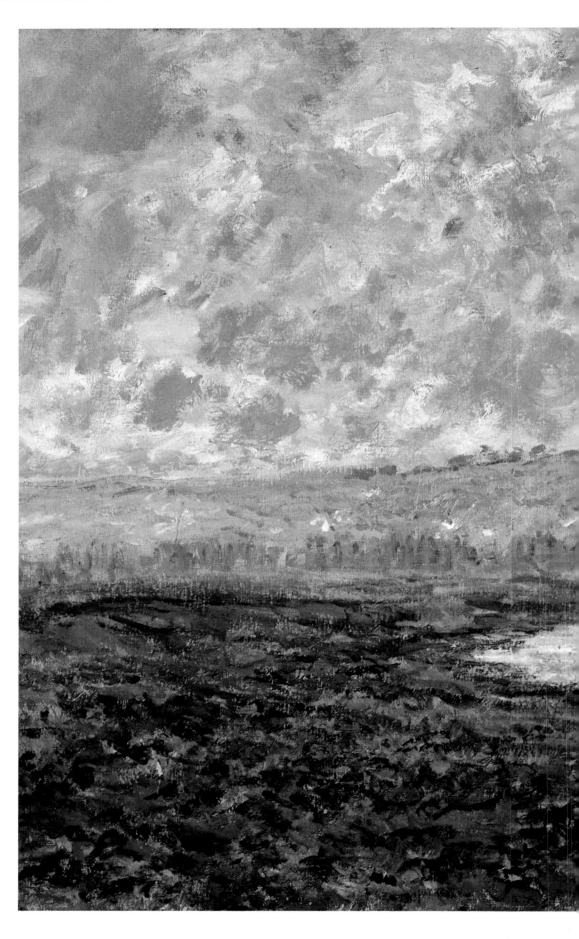

The Seine at Vétheuil, *environs of Vétheuil, spring 1880; oil on canvas; 62 × 102 cm (24 × 39⅞ in); signed and dated; Metropolitan Museum of Art, New York. The entire Vétheuil period is characterized by a deep and touching* melancholic quality *that is all the more noticeable because of the contrast with the preceding joyful period at Argenteuil (1872-1876). If Camille's death plays a role here, this painting is a noteworthy example of the artistic transposition of mourning.*

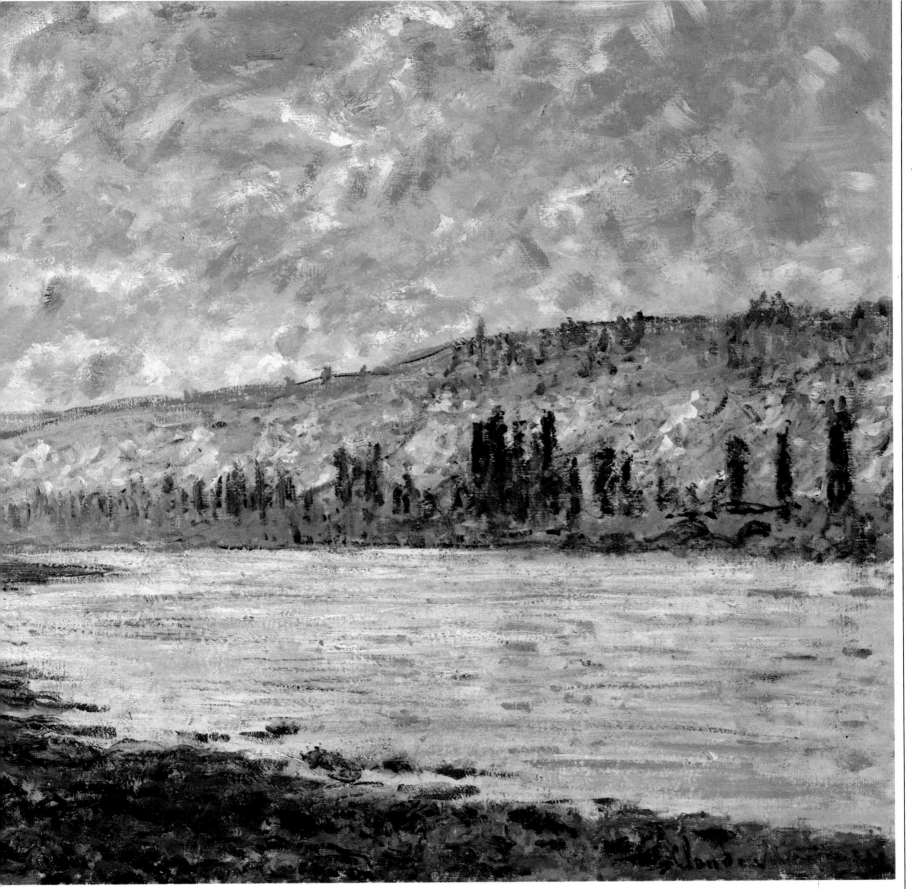

150

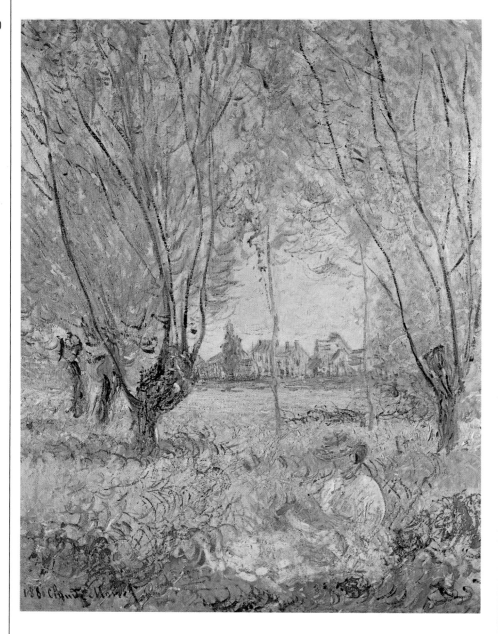

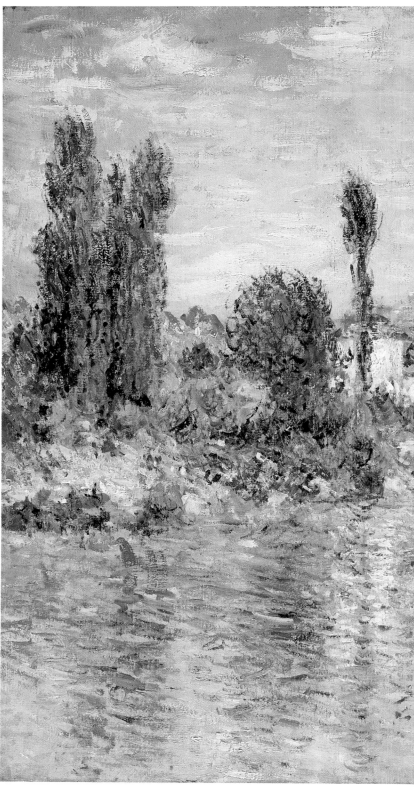

Above: Woman Seated under the Willows, *Vétheuil,* summer 1880; oil on canvas; 81.1 × 60 cm (31⅞ × 23⅝ in); signed and dated; National Gallery of Art, Washington.

This work is sometimes erroneously entitled Mme Monet Seated under the Willows, *but Camille had died about a year earlier.*

Right: Vétheuil in Summer, *Vétheuil, June or July 1880;* oil on canvas; 65 × 100 cm (25 × 39 in); signed and dated; Metropolitan Museum of Art, New York.

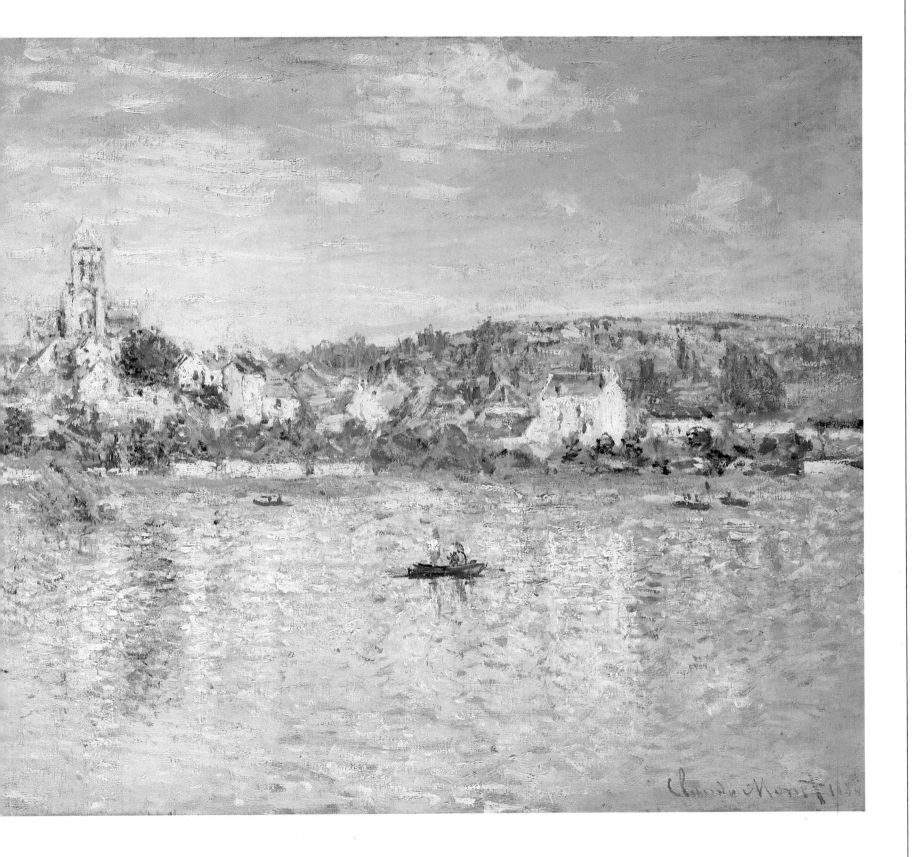

152

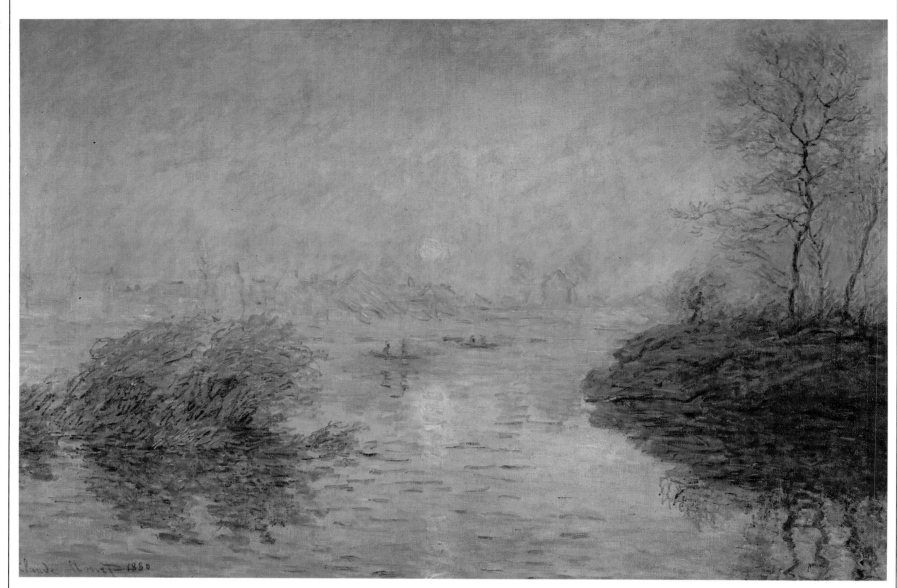

Above: Sunset at Lavacourt, *Lavacourt (near Vétheuil), autumn 1880; oil on canvas; 101 × 150 cm (39½ × 58½ in); signed and dated; Musée du Petit Palais, Paris.*

Opposite: Snow Effect at Lavacourt, *Lavacourt (near Vétheuil), January or February 1881; oil on canvas; 59 × 81 cm (23 × 31½ in); signed and dated; The National Gallery, London.*

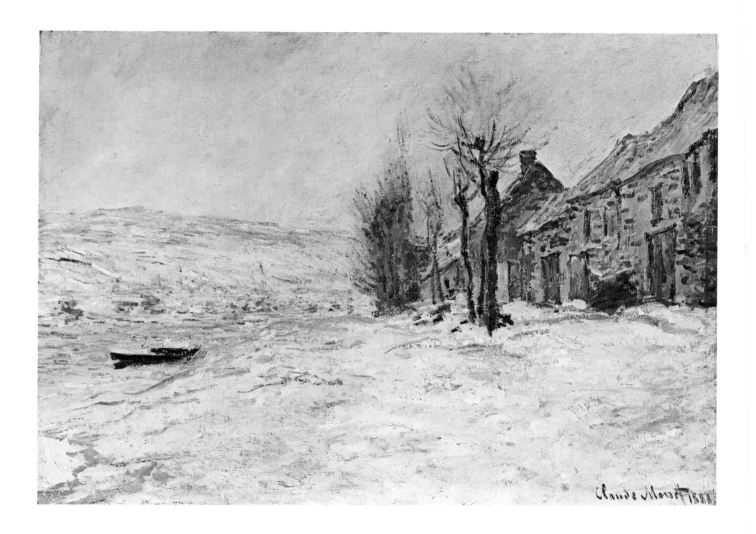

Page 154:
Sunflowers,
Vétheuil (?),
summer 1881; oil
on canvas;
100 × 81 cm
(39 × 31½ in);
signed and dated;
Metropolitan
Museum of Art,
New York.

Page 155:
Chrysanthemums,
Paris, autumn 1882;
oil on canvas;
102 × 84 cm
(39¼ × 32¼ in);
signed and dated;
Metropolitan
Museum of Art,
New York.

154

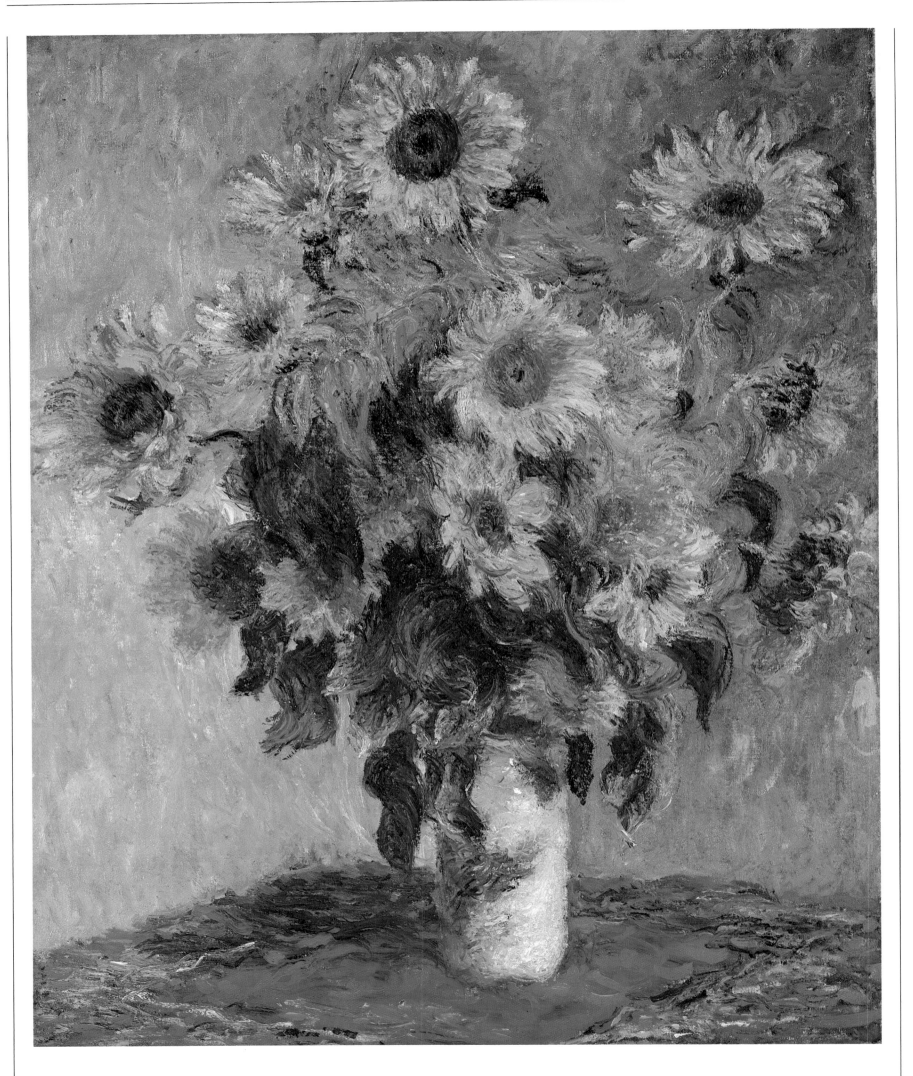

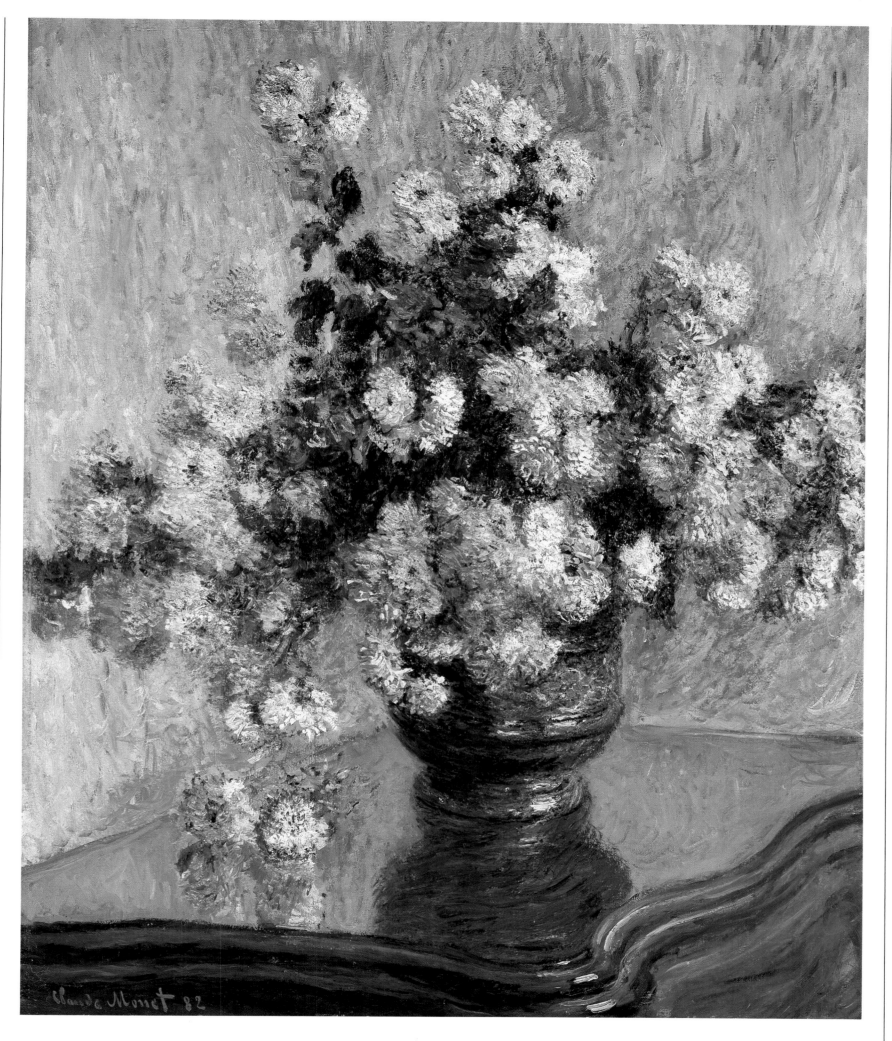
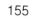

156

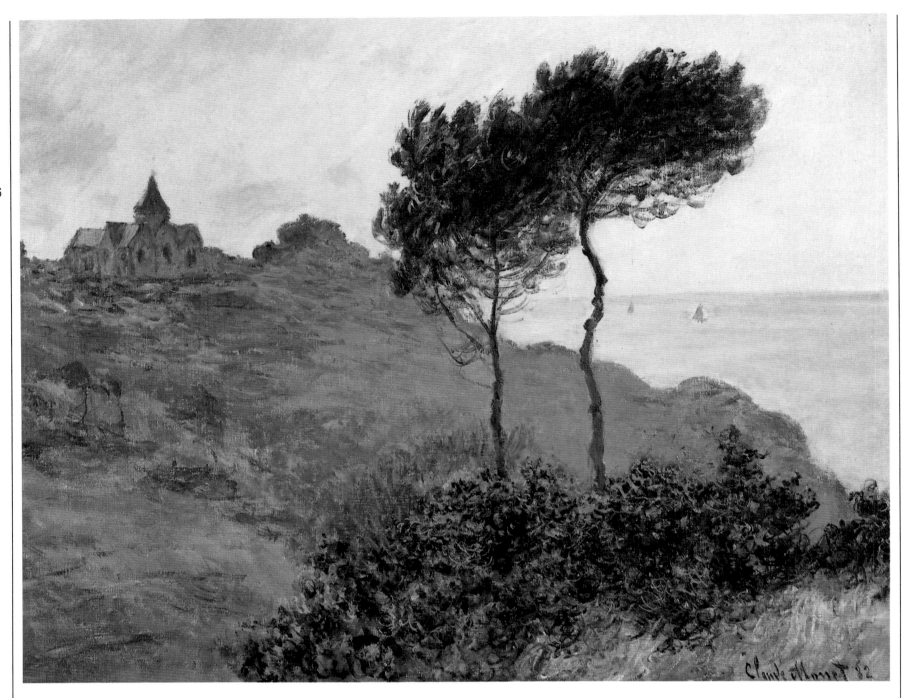

157

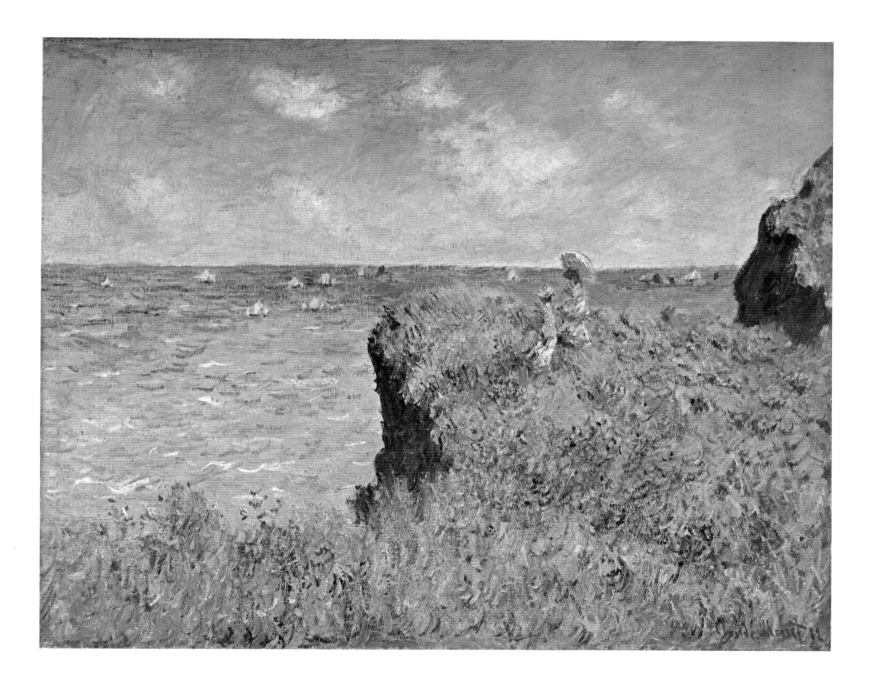

Opposite above:
Church at
Varengeville,
Cloudy Weather (or
Church on the
Cliff, Varengeville),
*Varengeville,
April-May 1882; oil
on canvas; 65 × 81
cm (25 × 31½ in);*

*signed and dated;
The J.B. Speed Art
Museum,
Louisville.*

Opposite below:
The Church at
Varengeville,
*Varengeville,
April-May 1882;
pencil on paper;
32 × 42 cm
(12¼ × 16 in);
signed; Private
Collection, Paris.*

Above: The Cliff
Walk, Pourville,
*environs of
Varengeville,
April-May 1882; oil
on canvas; 65 × 81
cm (25 × 31½ in);
signed and dated;
The Art Institute,
Chicago.*

158

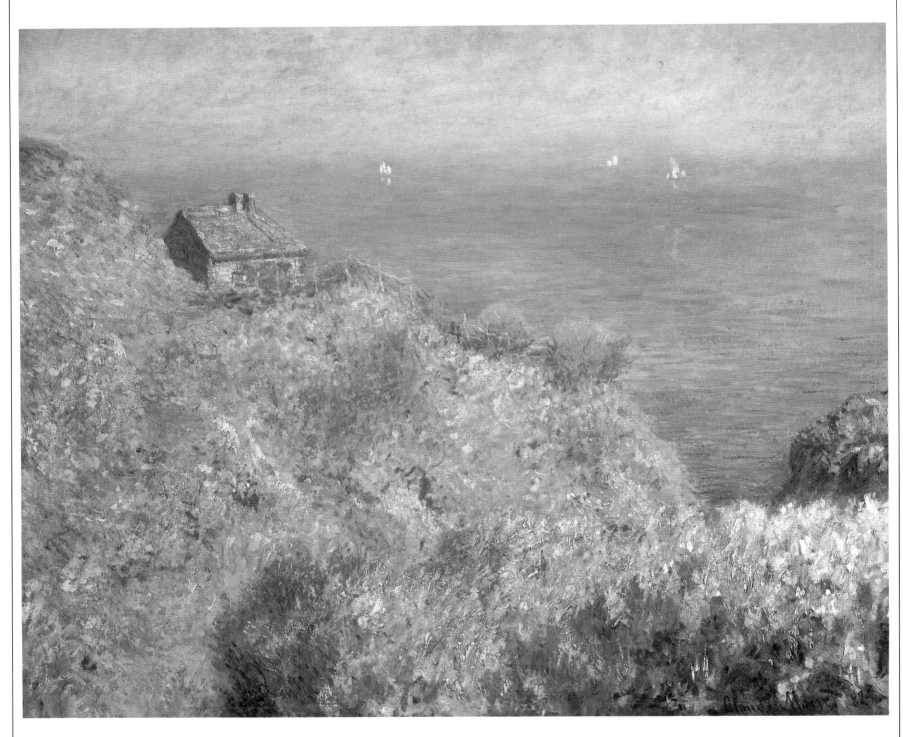

The Custom
Officer's Cabin at
Varengeville,
Varengeville,
April-May 1882; oil
on canvas; 60 × 78
cm (23¼ × 30¼ in);
signed and dated;
Museum
Boymans-van
Beuningen,
Rotterdam.

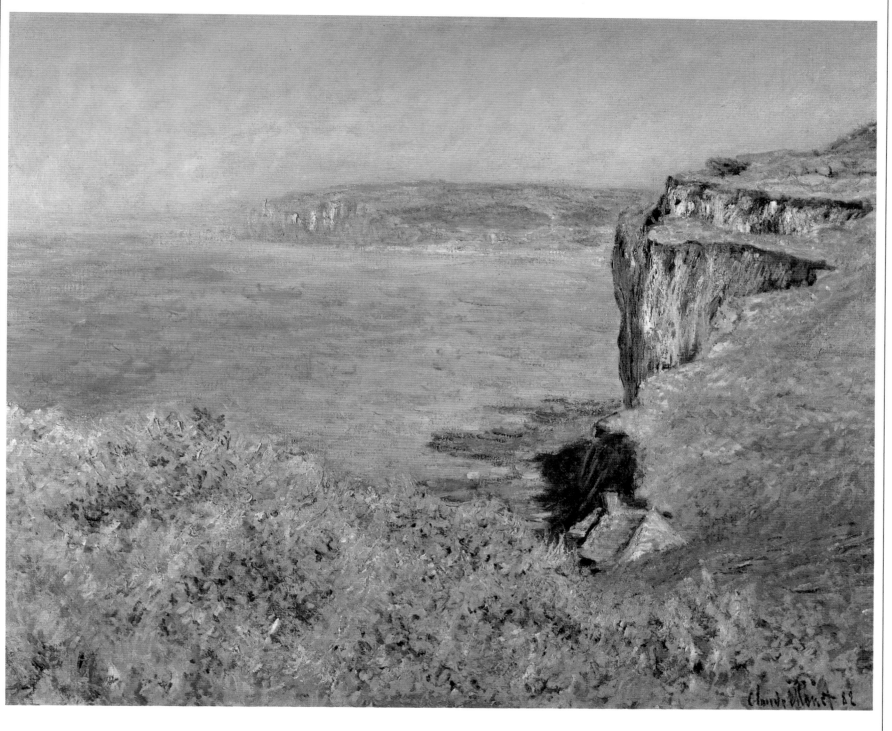

Cliff at Varengeville, environs of Varengeville, April-May 1882; oil on canvas; 65 × 81 cm (25 × 31½ in); signed and dated; Private Collection, London.

160

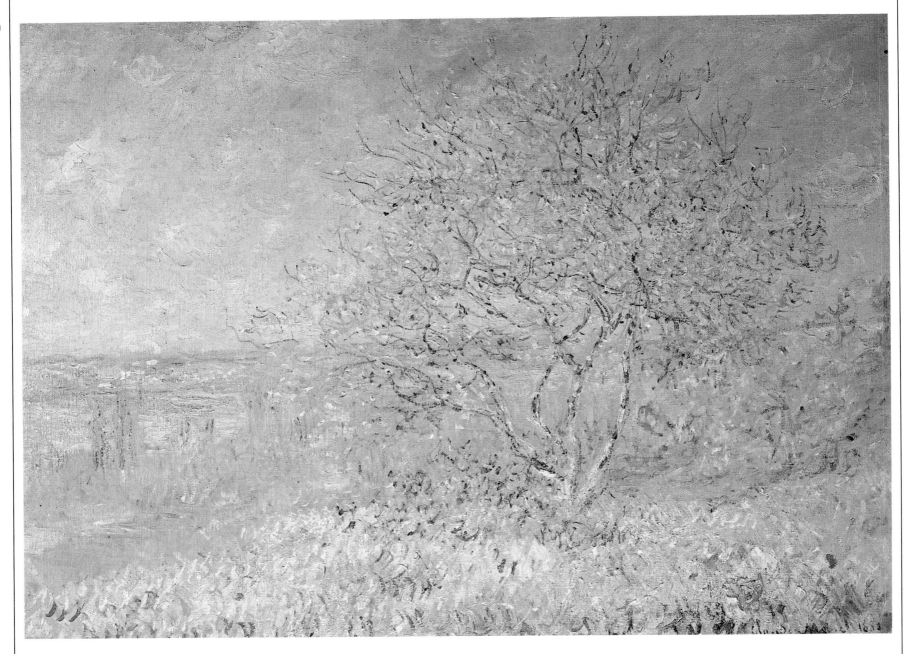

Spring, *Poissy (?),*
May 1882; oil on
canvas; 60 × 79 cm
(23¼ × 30¾ in);
signed and dated;
Musée des
Beaux-Arts, Lyons.
Though this work
bears the autograph
date of 1882, for
vague stylistic
considerations some
critics think it was
done at Vétheuil
two years earlier.

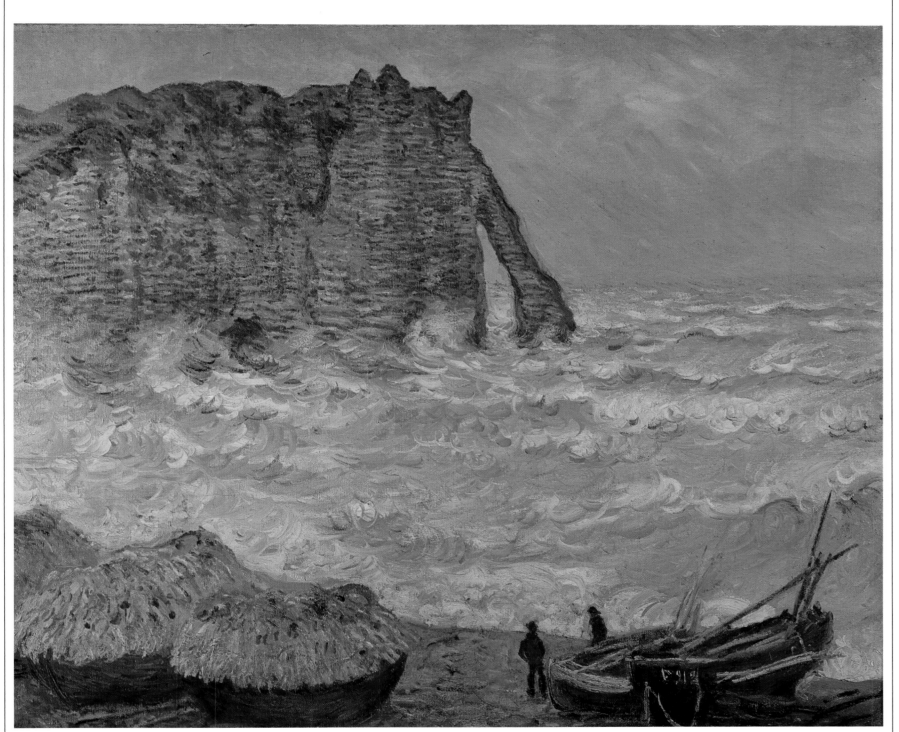

Etretat, Rough Sea,
Etretat,
January-February
1883; oil on canvas;
80 × 100 cm
(31 × 39 in);
Musée des
Beaux-Arts, Lyons.

162

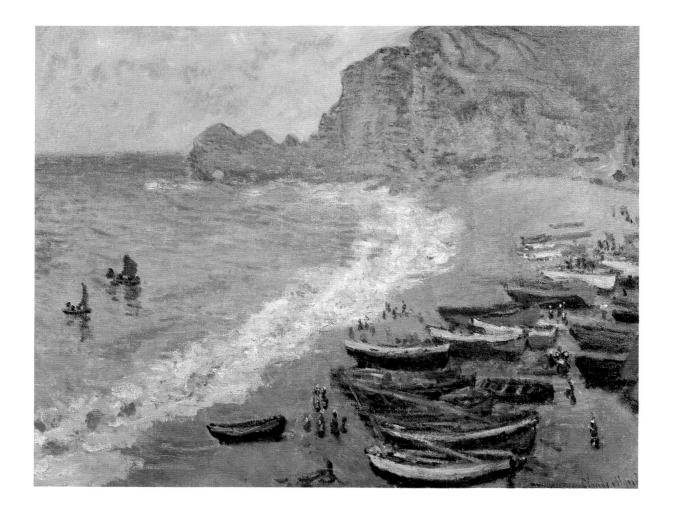

Etretat, *Etretat,* *(25¼ × 31½ in);*
January-February, *signed and dated;*
1883; oil on canvas; *Musée d'Orsay,*
66 × 81 cm *Paris.*

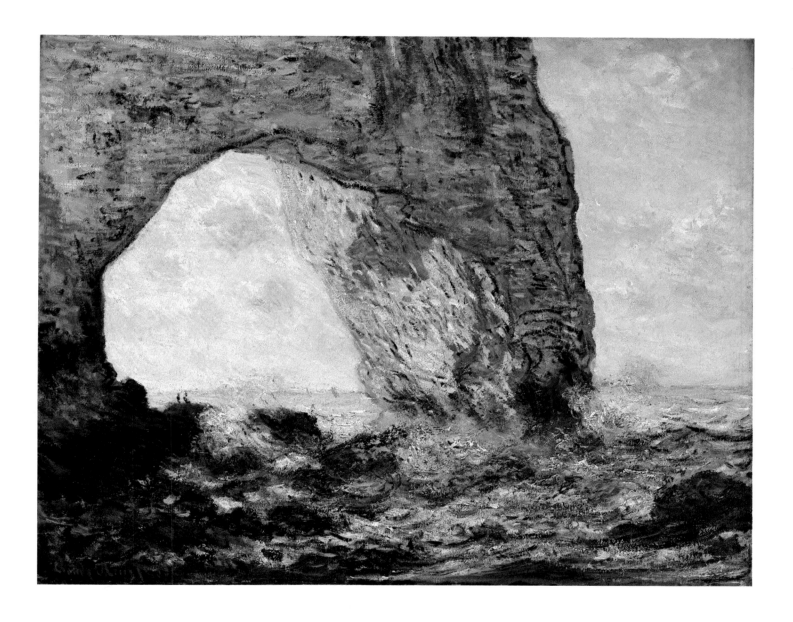

The Manneporte,
Etretat, I, *Etretat,*
January-February
1883; oil on canvas;
65 × 81 cm
(25 × 31½ in);
signed and dated;
Metropolitan
Museum of Art,
New York.

164

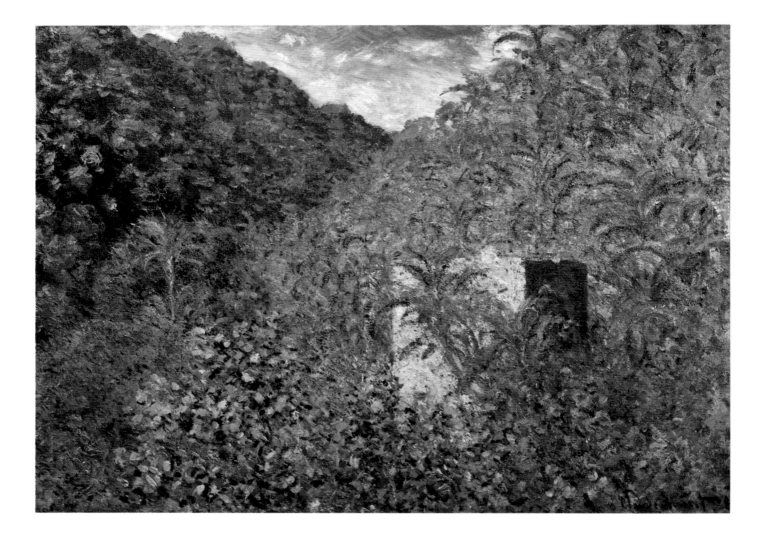

Above: Valley of Sasso, Bordighera, *environs of Bordighera, February-April 1884; oil on canvas; 65 × 92 cm (25 × 35¼ in); signed and dated;* Private Collection.

Opposite: Lemon Trees at Bordighera, *Bordighera, February-April 1884; oil on canvas; 73 × 60 cm (28¼ × 23¼ in); signed and dated;* Ny Carlsberg Glyptotek, Copenhagen.

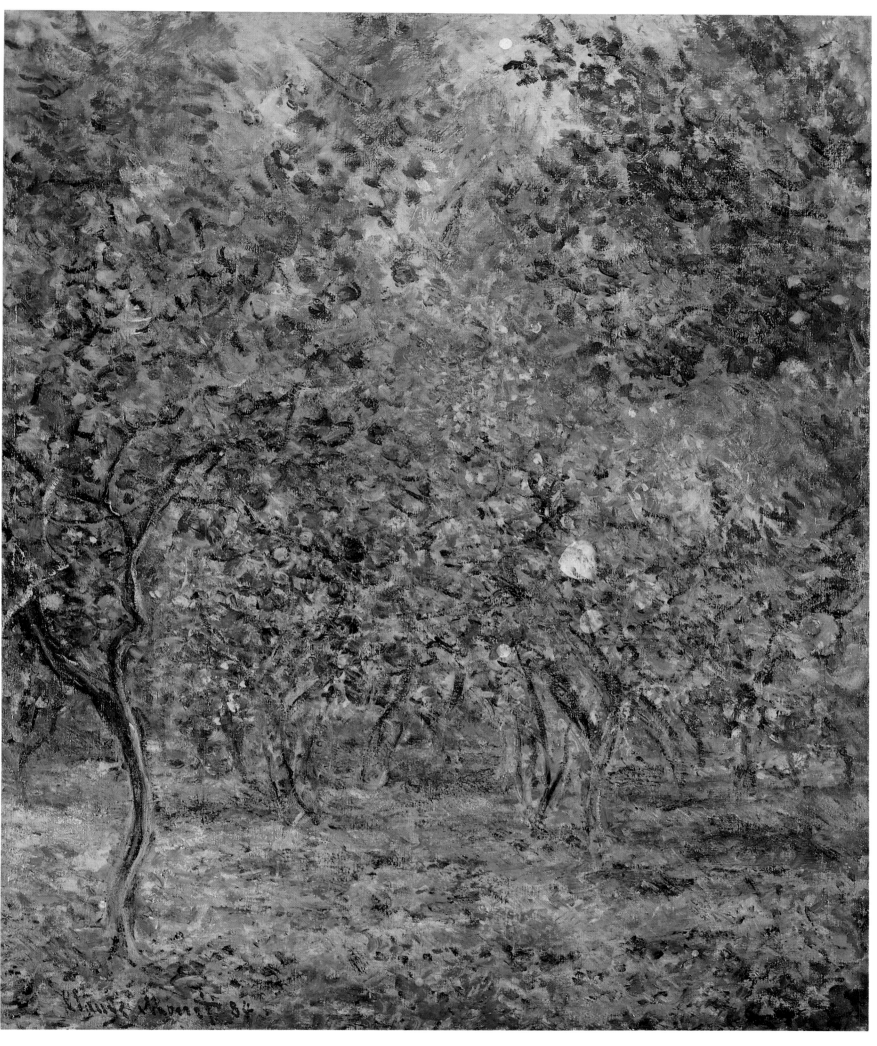

166

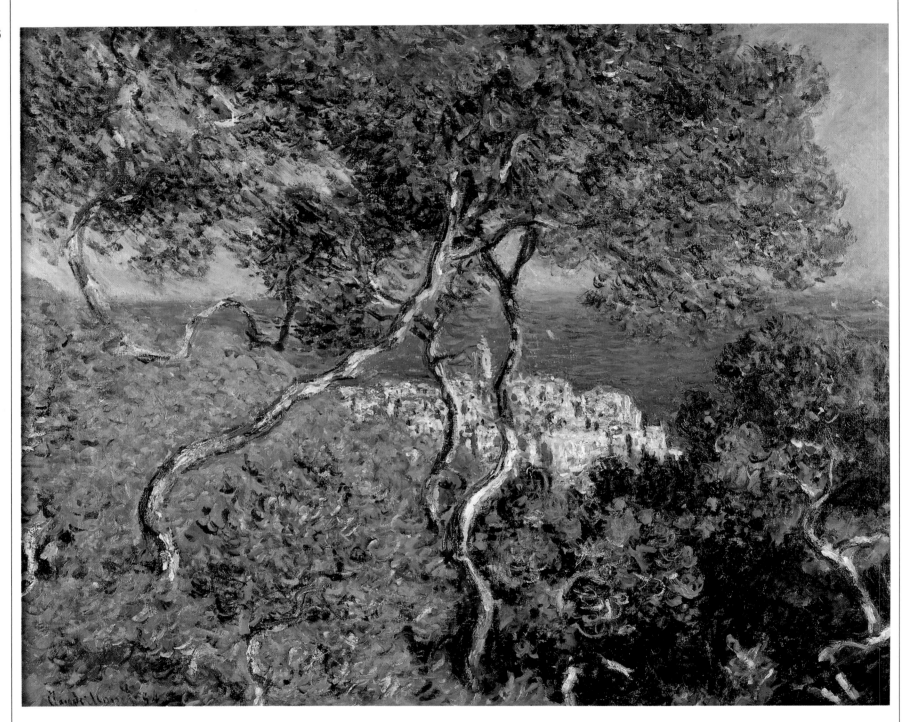

Above: Bordighera, *Bordighera, February-April 1884; oil on canvas; 64 × 81 cm (24¼ × 31½ in); signed and dated; The Art Institute, Chicago.*

Opposite: The Castle at Dolce Acqua, *environs of Bordighera, February-April 1884; oil on canvas; 92 × 73 cm (35¼ × 28¼ in); signed; Musée Marmottan, Paris.*

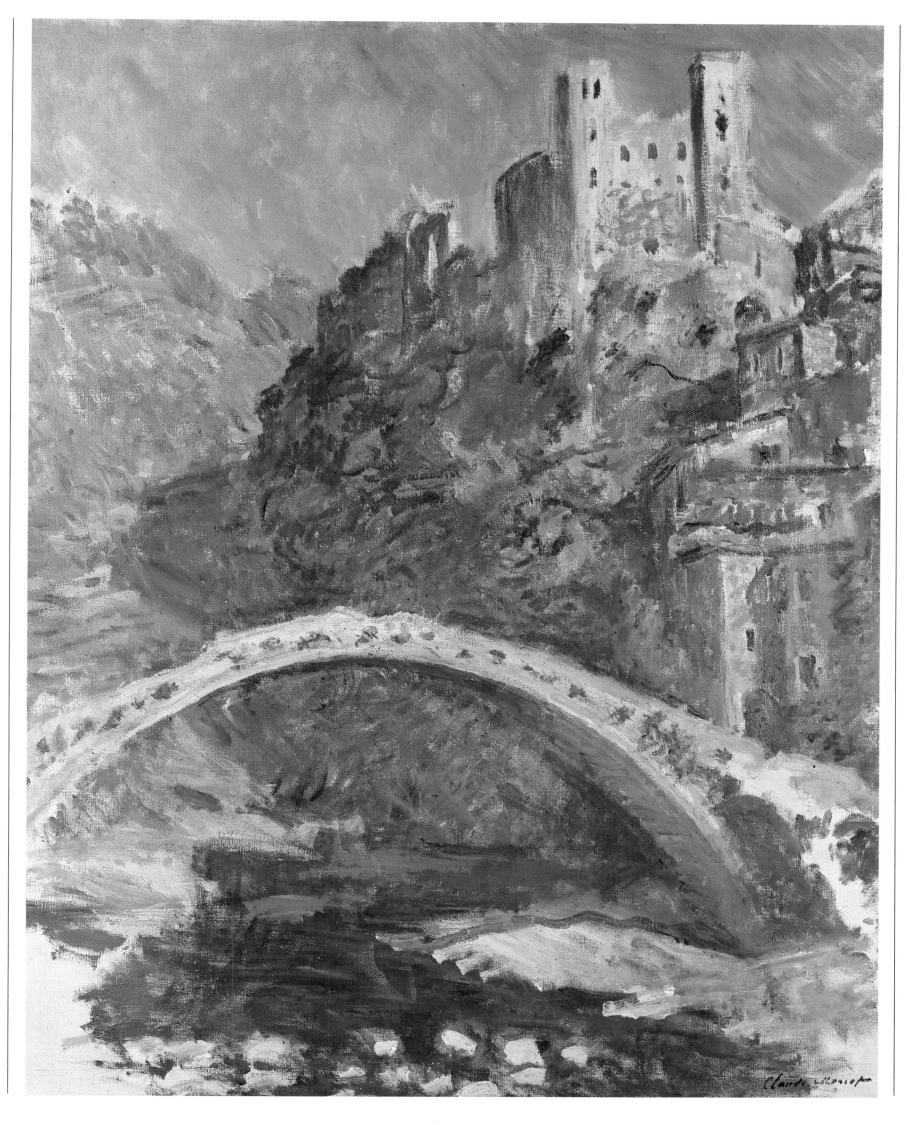

Late luminism

Monet painted views of the sea at Etretat, on the coast of Normandy, in four distinct periods; in 1868-69, when he was a guest of the art collector Gaudibert, then in January-February 1883, again in December 1885, and lastly in September 1886. The works he produced during the last two sojourns make up a very important unitary group which virtually marks his second great experiment with series painting after the Saint-Lazare railway station cycle. However, we should bear in mind that these are not pictorial or chromatic variations on a single, repeated theme (as was the case with the *Gare Saint-Lazare* paintings and, with some exceptions, with his future cycles such as the so-called hay stacks, Rouen cathedral, the Thames, etc.); rather they are a sort of free wandering through the theme, and their coherence is more a question of stylistic approach than the mere repetition of a motif. In other words, it is first of all the homogeneous expression, the uniform poetic tonality of these works that create the sense of a series (despite the fact that Monet painted several faithful renditions of certain subjects or viewpoints, for example in *Rocks at Belle-Île* or *The Manneporte, Etretat, High Tide*).

In any case the 1880s reveal a painter inclined to choose his subjects with almost obsessive care. He was not interested indiscriminately by whatever his eye came across (as were the Realists, many Impressionists and Monet himself in his early period). Now he adopted a critical attitude and addressed the problem of what one should paint. His statement "One must paint as much as one can, in any way one can, without being afraid of producing bad painting" can be considered a sort of motto, yet it holds true only in so far as it concerns *how* one

should paint, while as to *what* should be painted Monet became more and more selective as he gained in experience, going so far as to tackle a certain landscape only because of the value it took on from the point of view of the work. Therefore the theme becomes expedient to the objective set by the artist; and this objective will never coincide with rendering the theme in a convincing, surprising or lyrical manner, because this would create a vicious circle. For Monet the artistic purpose lies wholly within the physical dimension of the canvas; it is the result of a surface covered with colour and of the pictorial facts that issue from that surface. If attaining this objective entails the preliminary existence of a real subject, a panorama, a totality of three-dimensional objects, in other words a "vision," then Monet, with absolute consistency, considers the act of choosing essential. One theme cannot be the equivalent of another one, since the definitive quality of the painting, the system of emotions produced, depend on the theme. When the painting begins to move away from being a faithful mirror of reality, that reality (which lies at the source of the painting) ceases to be neutral and replaceable. The knotty problem posed by this paradox was unravelled only when painting became fully self-sufficient around 1915. Although he was still quite active at that time, Monet was able to participate in that evolution only to limited degree; because of his now distant nineteenth-century origins his artistic endeavours took him only as far as the delicate relationship between the work and its model, a relationship which, among other things, viewed the model as already prefiguring the painting.

By carefully considering the Etretat series we can see how *The Manneporte, Etretat, High Tide*

reveals that Monet has done away with the effects of descriptive realism. Strictly speaking, the 1883 version of the same subject (at the Metropolitan Museum of Art, New York) was not realistic either. But now, two years later, the evolution in Monet's style led him farther and farther away from the norms of traditional imitation. This is quite evident in the 1886 version of *The Manneporte, Etretat, II*, also at the Metropolitan Museum. Here the colour appears to be broken up into its components. Irregular little blotches (white, deep blue and green) are combined to form the surface of the water, which towards the horizon is transformed into a compact greenish band; other equally thick brush-strokes create the "combed" effect of the rock face: sienna, silver-grey, violet, brick red, and then bright red (in a chaotic mass) in the upper part of the arch. The reflection of the rock in the sea is a masterstroke: Monet interprets it as the osmosis of the two blocks of pictorial tissue, so that each transfers a part of its hues to the other. The sky on the other hand is more lifelike, but its blue is tinged with pink and orange – delightful inflorescences of bright light that describe clouds and sunset in a new way.

Similar, enchanting paintings were also executed during the previous year; for example *The Cliffs at Etretat* (1885, The Sterling and Francine Clark Art Institute, Williamstown). This is a view of another magical site along the coast which Monet sought to sculpt against the atmosphere around the hour of sunset. The needle rock, cut in two by shadow, radiates astonishingly beautiful blue and reddish light. This work gives one the sensation of a strange blend of chromatic invention and optical, almost photographic, truth. A principle of realism underlies this painting, something that can be

understood more clearly by comparing it to the 1886 version with the same title. The contrast between the two works is quite strong. In the 1885 painting the needle rises up imposingly to the left of the cliff and the arch, here only partly represented, that is called the Porte d'Aval; in the 1886 painting, on the other hand, the needle is seen through the Porte itself which, in the perspective effect, forms a sort of capsule or ideal container for the needle. Monet seems to have sought a vital, complementary relationship between the "void" of the arch and the "fullness" of the needle. The immobile vision of the 1885 work, which is so solemn, crystalline and serene, contrasts sharply with the surreal, convulsive character of the 1886 painting, which seems to be pathologically unstable and visually precarious: it is almost as if we were witnessing the emergence of the earth from the sea, or the moment preceding a volcanic explosion amidst sulphureous reverberations, just before the needle, the cliff and the very Etretat landscape sink into the sea in one movement.

The rhetorical character of these paintings, wavering between narrative and pure painting, makes use of the new technical capacity Monet had just acquired which, with slight adjustments, would be gradually perfected up to the high point of the following decade. The poetry and expressive power that permeate the entire Normandy coast cycle could not be understood if this technical progress were not correctly appraised. Francesco Arcangeli, in speaking of *Rocks at Belle-Île*, interprets these formal innovations as the result of a new psychology of the image related to Monet's move beyond Impressionism: "This perception, this impression has become something on which the painter deeply meditates [...] the

expression of a powerfully dramatic state". And again: "The concept of impression, of sensation, grows more deeply in him and ends up embracing something universal."

There is no question about the universal significance of the paintings of cliffs and rocks whose impervious walls are being lashed by waves with a cataclysmic force that shatters them into a rain of opaque reflections, chromatic splinters and sharp blades. This significance exists, if for no other reason than the fact that these works suggest a spiritual suffering that could not have been expressed in any other way. *Storm, Coast of Belle-Île* (1886, Musée d'Orsay) is a work of rare dramatic power that hinges on the oneiric transfiguration of the sea into a milky brown and pinkish liquid perfectly in harmony with the colour of the rocks. Referring to these visions, as well as to the 1887 painting *Pink Boat*, Michel Butor underscores "the formations of drops, froth, vapour – all phenomena that will be accompanied by smells and noises the memory of which will come to mind exactly to the degree to which the painter succeeds in maintaining the dynamism of those thick surfaces".

Pink Boat, which depicts two girls learning how to row, has an interesting viewpoint: the boat is moving to the right, leaving the actual space of the canvas; and the canvas in this sense is only a tiny part of the river (algae, water, leaves): the whole is a dark green flowing mane of wavy brush-strokes with neither beginning nor end, without a bottom or a surface, a continuous mass contrasted only by the colour of the girls' clothes and the sculling boat. This is perhaps the most obvious harbinger of the space without dimension in which the *Water Lilies* would later emerge.

Monet declared: "I'm trying to do the impossible: grass moving under black water". This is a moving lament that illustrates the contradictory situation and the pursuit of something which by definition is utopian created by the poet's true vocation. Other works of this period are perhaps less "impossible," to use Monet's own term, but are still difficult: *The Boat at Giverny, Antibes Seen from La Salis, The Sea near Antibes*, and *Juan-les-Pins*. These paintings betray the need to tackle the unrepresentability of instantaneous emotions which, as Proust would later say, are difficult to describe but are psychologically "absolute." In the 1888 landscapes of the Côte d'Azur we can also note the developments in that style influenced by Divisionism to which Monet often turned with excellent results. *Juan-les-Pins* in particular, with its unmistakable imprint, is in my opinion a magnificent work, worthy to compete with some of the works that would be painted by Bonnard, Derain, Vlaminck or Braque between 1900 and 1907. And yet even this period, so filled with novelties and ingenious discoveries, contains low points and breaks in tension. Two examples of this are the famous works in the Musée d'Orsay entitled *Woman with a Parasol*, which take up a subject from 1873 (or 1875) (*Woman with a Parasol – Mme Monet and Her Son*) and re-work it too faithfully. It is as if Monet felt the need, every so often, to retrace his steps, to relive, as far as possible, the experiences of his youth. More in line with his modernity is the series given over to the Creuse, a little river flowing in the valley near Fresselines, where Monet was invited in 1889 by Maurice Rollinat. What strikes one in these works is the stiffness of the composition, which is based on the one hand on a few blocks

with somber tones and overbrilliant tones on the other. Equally surprising is the difference between one version and the other, the succession of colour schemes that culminate in the hallucinatory effects of *Valley of the Creuse, Evening Effect*. Here we can see, in that pink and orange which represent the river and the sky, so bold that they smack almost of pop art, the extent of what Monet is capable of doing with nature without ever being either banal or gratuitous.

In the long series of *Hay Stacks* (1889-91) we find an analogous capacity to treat colour variations in relation to light although this is also a simple pretext for setting off the blaze of reds, violets and pinks; the difference being that here, for the first time, Monet makes systematic use of atmospheric conditions. His pictorial language was beginning to take into account the weather conditions and the hour of day no longer as merely incidental, albeit fundamental, factors in the subject, but as self-sufficient pivotal points of the work. The real subject is thus not the stack in itself together with the surrounding field and the hill in the background, but, more crucially, the season and the hour in which it is painted. It is not surprising, therefore, that Monet scrupulously notes the weather conditions, time of day and season and then uses this information as part of the title. The concept of series thus acquires a new, all-embracing meaning that is far removed from an obvious repetition of a subject dear to the artist. The series implicitly replaces the singularity of the visual rectangle with a new principle, that of the total work, expanded like a polyptych to take in a plurality of representations. The canvases with the stacks of grain must indeed be viewed in a multiple sense; that is, they should be seen all together, in one simultaneous act of

perception. This would allow the viewer to grasp the salient feature, which makes them masterpieces of modern art, namely the element of diversity on which their meaning is based. This, together with the unlimited expressive faculties of the colour, are exactly what Monet wants us to grasp. The attention Kandinsky paid to the *Hay Stacks* was crucial for his artistic growth (the 1895 version was in the Morosov collection in Moscow, and is now in the Pushkin Museum). Kandinsky understood the full potential of colour and took this as a starting point for that revolution of the creative process that would later make him the father of abstract painting. Compared to the hay stack series, the series of poplars (painted in 1891) tends more towards an almost architectural construction, a characteristic that brings it remarkably close to Mondrian's aesthetic. As in Mondrian, the poplars series contains great self-assurance in interpreting, and sometimes enhancing, the subject over and above the value or place this subject has in the real world. Thus we have those amazing manifold perspective angles (converging, diverging, specular, parallel, crossed) on the basis of which the rows of poplars are arranged like so many models posing for the artist. Equally astonishing is the importance taken on, in these ceremonial sequences, by the masses of leaves, which are cut through by a system of light variations that seem to aim at producing a mechanical and potentially infinite proliferation of creative possibilities that are rudimentary, but absolutely new in painting.

170

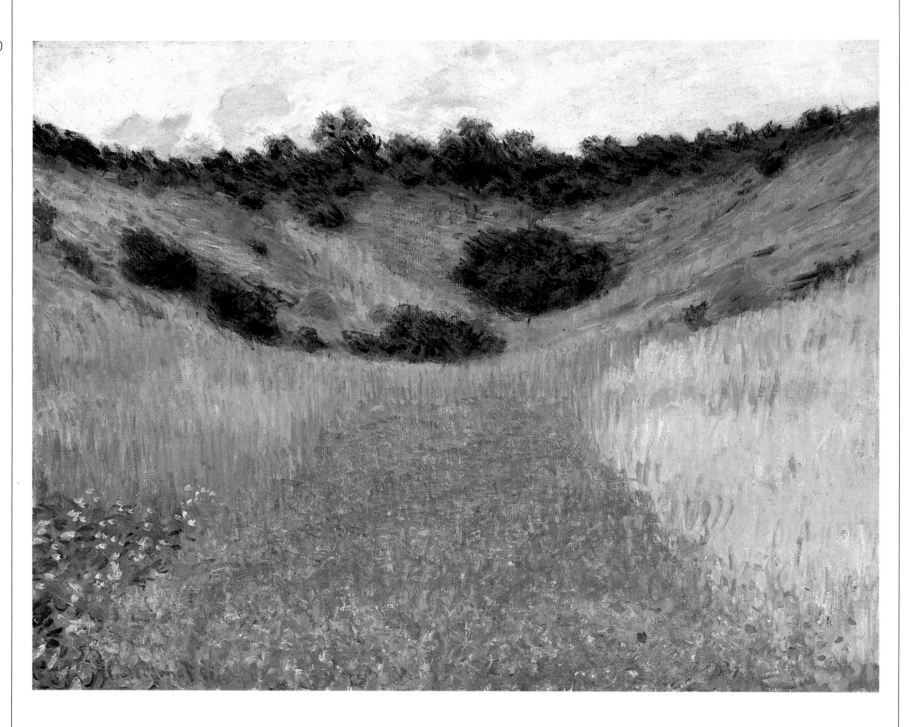

Above: Poppy Field
near Giverny,
*environs of
Giverny, June 1885;
oil on canvas;
67 × 83 cm
(26 × 32 in);
signed and dated;
Museum of Fine
Arts, Boston.*

Opposite above:
The Manneporte,
Etretat, High Tide,
*Etretat, December
1885; oil on canvas;
65 × 81 cm
(25 × 31½ in);
Private Collection.*

Opposite below:
Boats at Winter
Quarters at Etretat,
*Etretat, December
1885; oil on canvas;
65 × 81 cm
(25 × 31½ in);
signed; The Art
Institute, Chicago.*

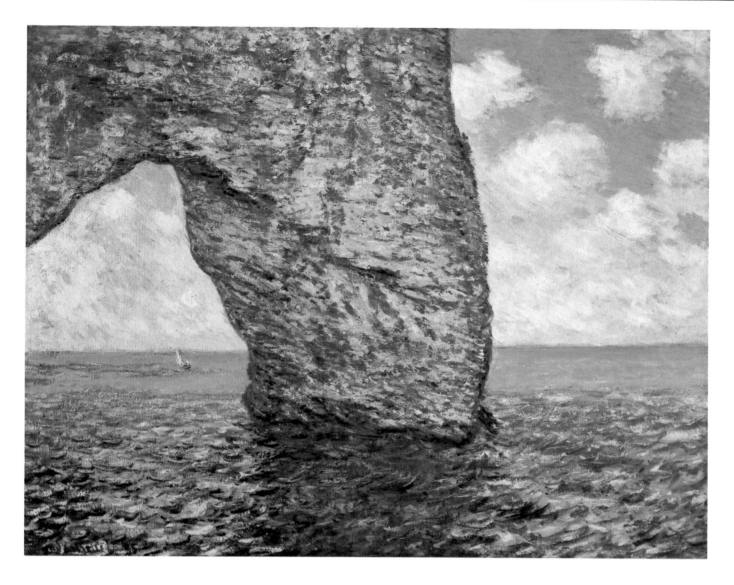

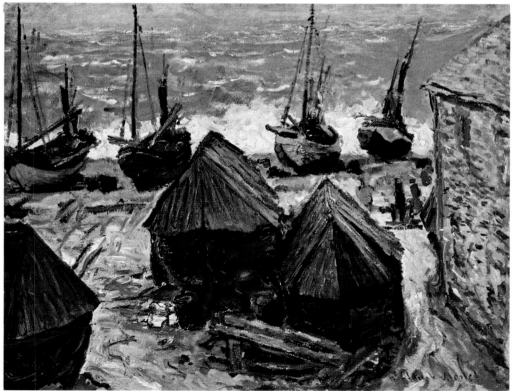

172

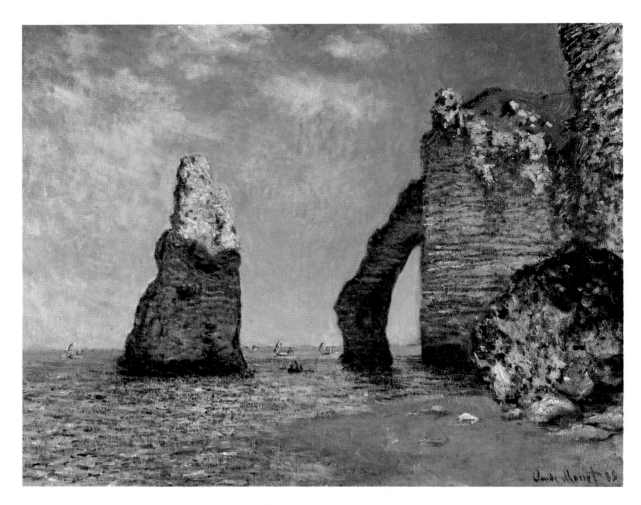

The Cliffs at
Etretat, *environs of*
Etretat, December
1885; oil on canvas; *Francine Clark Art* *photograph of the*

65×81 cm
(25 × 31½ in);
Sterling and

Institute,
Williamstown
(Mass.). Above is a

same site taken
around 1900.

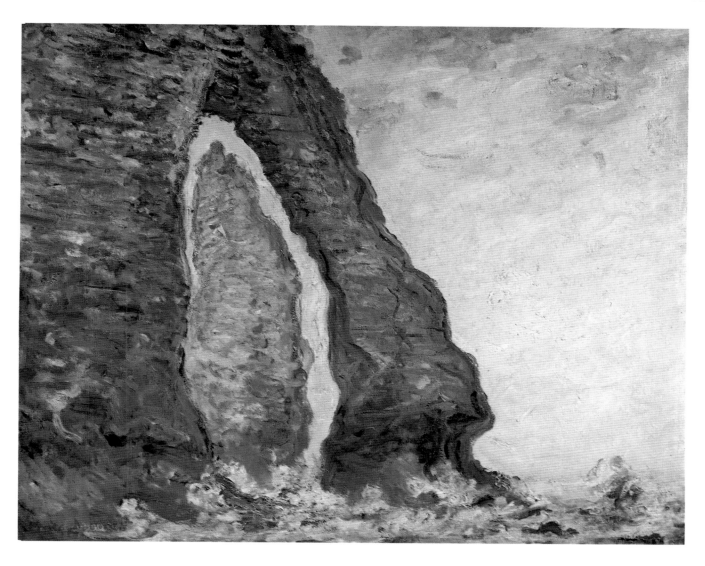

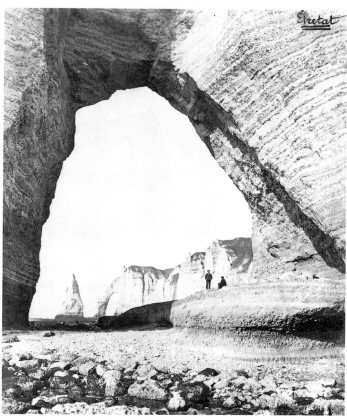

Cliffs at Etretat, environs of Etretat, September 1886; oil on canvas; 73 × 92 cm (28¾ × 35¾ in); signed; Private Collection. A 1900 photograph shows the Porte d'Aval and the "Needle" seen through the Manneporte, which is a few kilometers away.

174

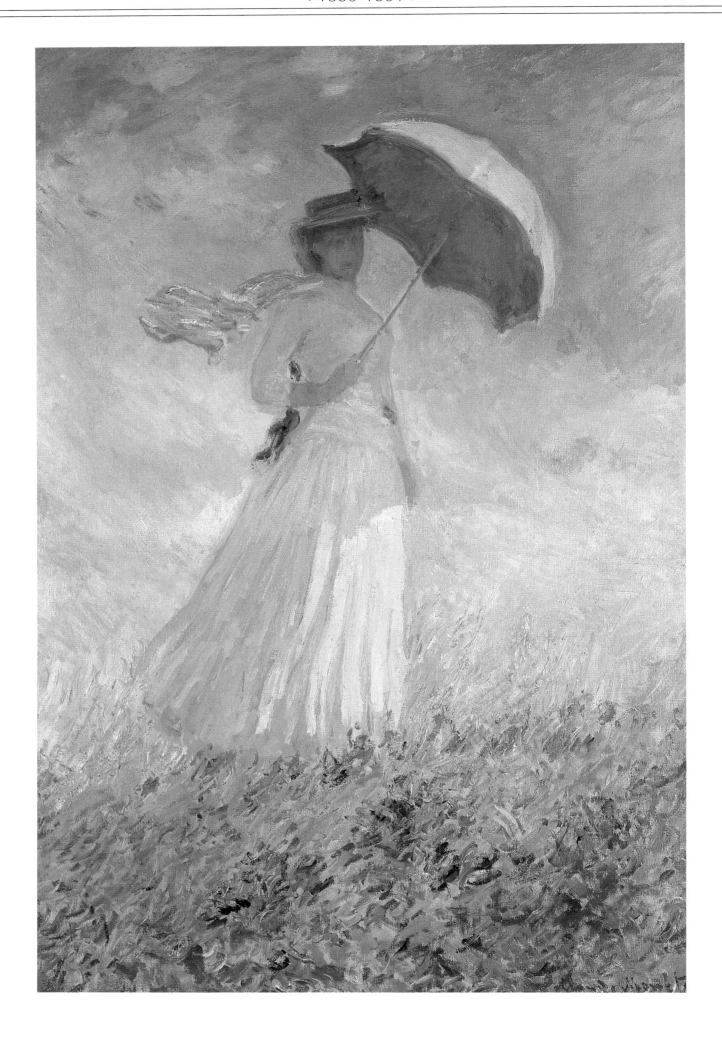

Woman with a
Parasol Turned
towards the Right,
environs of Etretat,
September 1886; oil *on canvas;*
131 × 88 cm
(51 × 34 in); signed
and dated; Musée
d'Orsay, Paris.

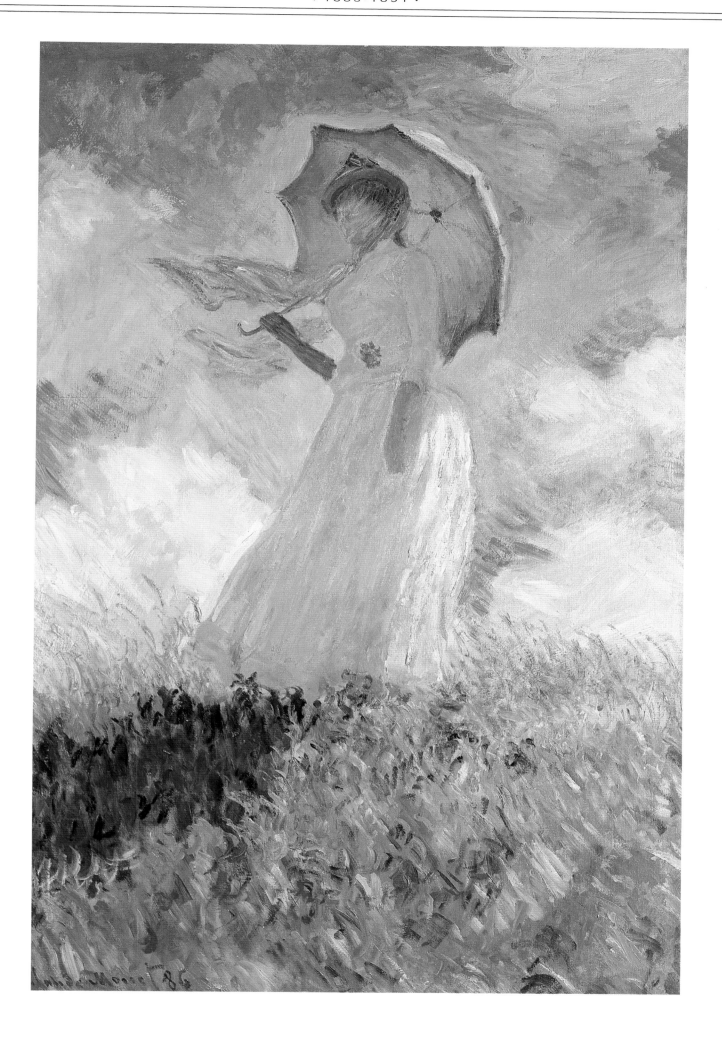

Woman with a
Parasol Turned
towards the Left,
environs of Etretat,
September 1886; oil
on canvas;
131 × 88 cm
(51 × 34 in); signed
and dated; Musée
d'Orsay, Paris.

176

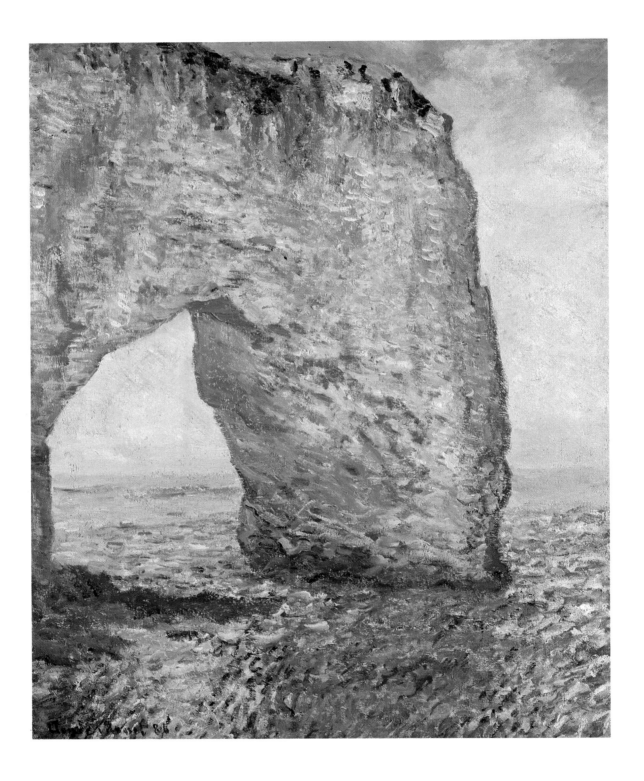

The Manneporte,
Etretat, II, *Etretat,*
September 1886; oil
on canvas;
81 × 65 cm

(31½ × 25 in);
signed and dated;
Metropolitan
Museum of Art,
New York.

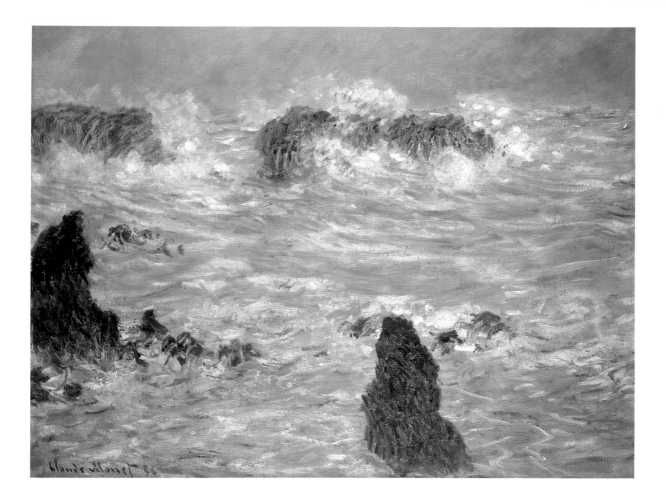

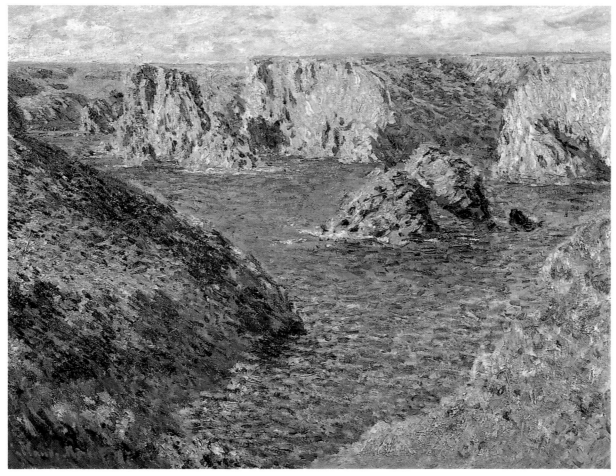

Above: Storm, Coast of Belle-Île, *environs of Etretat, September 1886; oil on canvas; 64 × 81 cm (24¼ × 31½ in);* *signed and dated; Musée d'Orsay, Paris.*

Below: Port-Domois, Belle-Île, *environs of Etretat, September 1886; oil on canvas;* *65 × 81 cm (25 × 31½ in); signed and dated; Yale University Art Gallery, New Haven.*

178

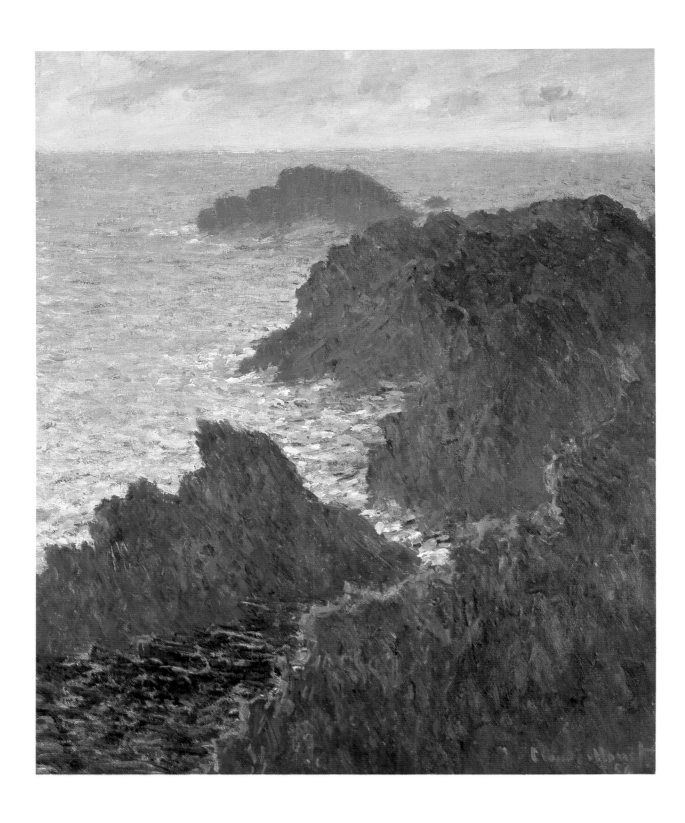

Above: Rocks at Belle-Île, *environs of Etretat,* September 1886; oil on canvas; 72.5 × 58.5 cm (28 × 22¼ in); signed and dated; Art Museum, Saint Louis.

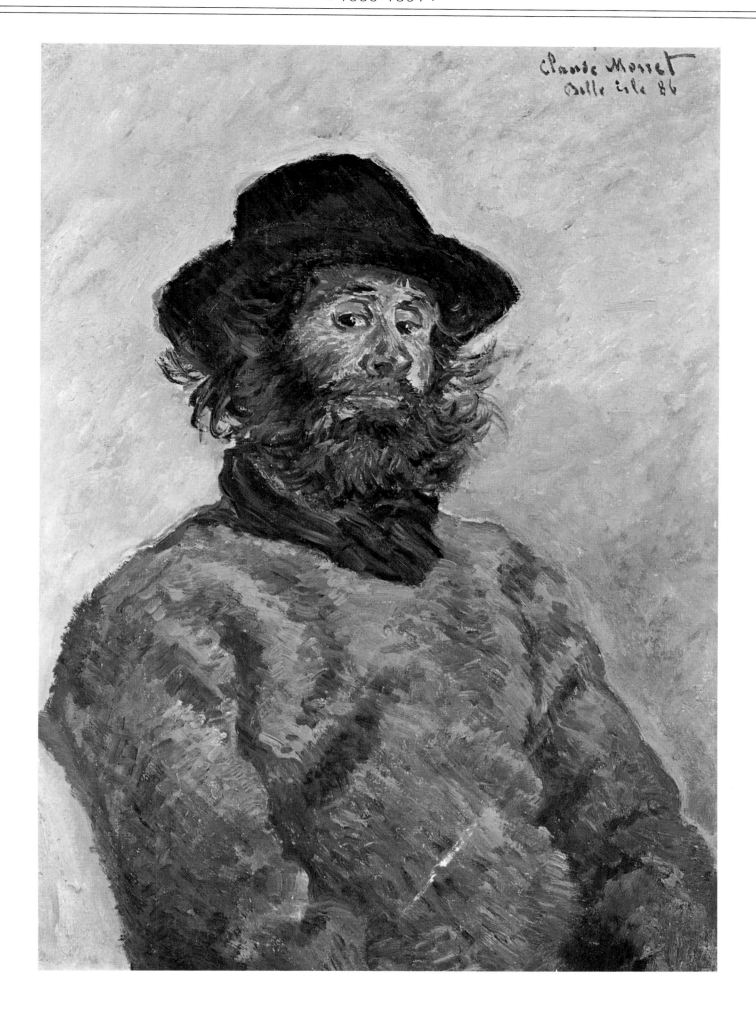

Poly, Fisherman at 74 × 53 cm
Kervillaouen, (28¼ × 20½ in);
environs of Etretat, signed and dated;
September 1886; Musée Marmottan,
oil on canvas; Paris.

180

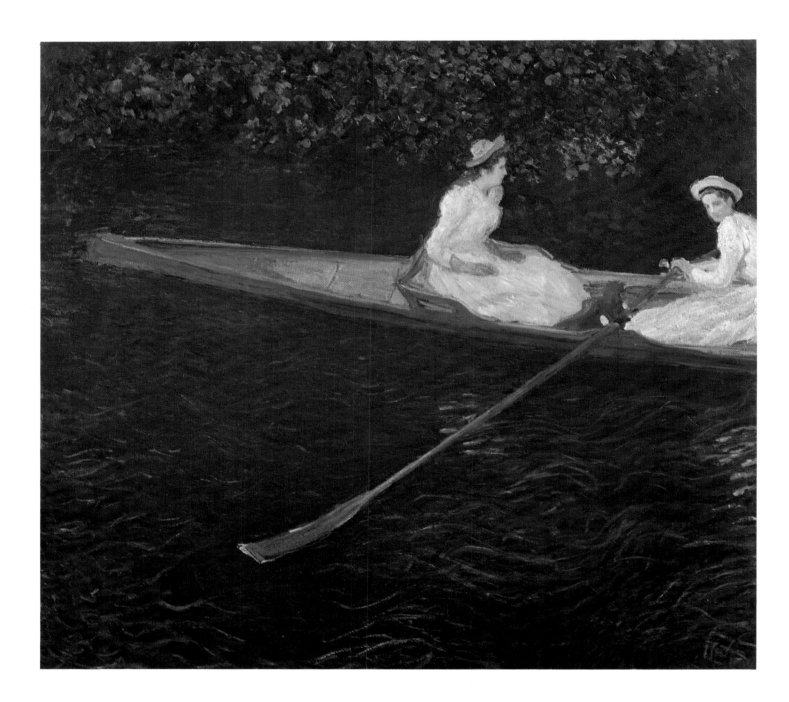

Above: Pink Boat, *environs of Giverny, summer 1887; oil on canvas; 133 × 145 cm (51¼ × 56½ in); Museu de Arte, São Paolo.*

Opposite above: The Boat at Giverny, *environs of Giverny, summer 1887; oil on canvas; 98 × 131 cm (38 × 50¾ in); signed; Musée d'Orsay, Paris.*

Opposite below: The Blue Boat, *environs of Giverny, summer 1887; oil on canvas; 109 × 129 cm (42½ × 50 in); Thyssen-Bornemisza Collection, Lugano.*

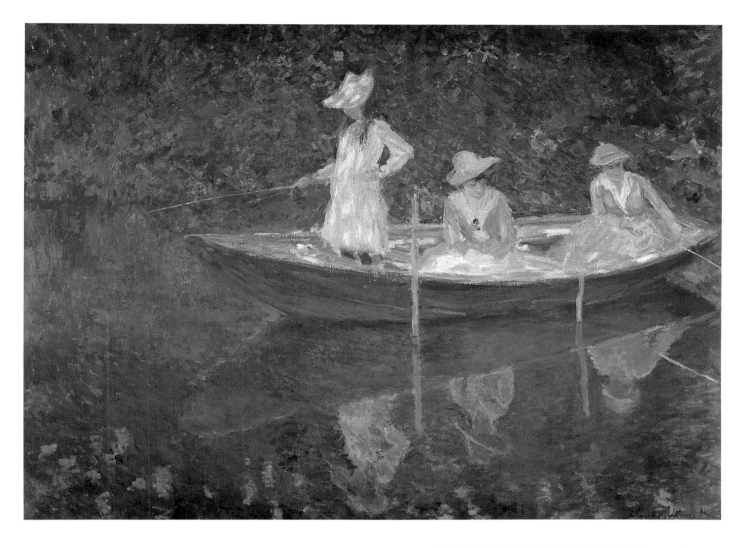

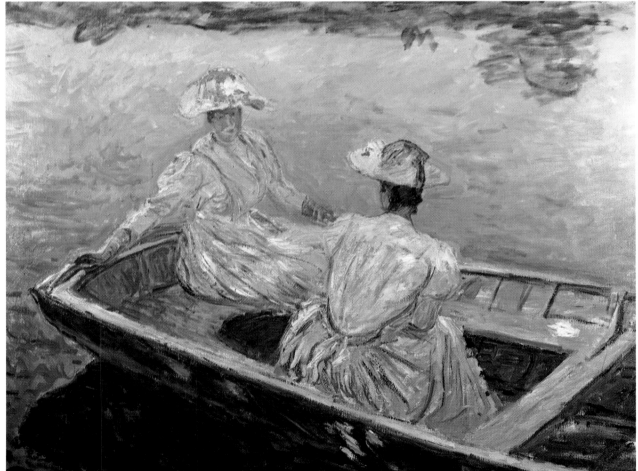

182

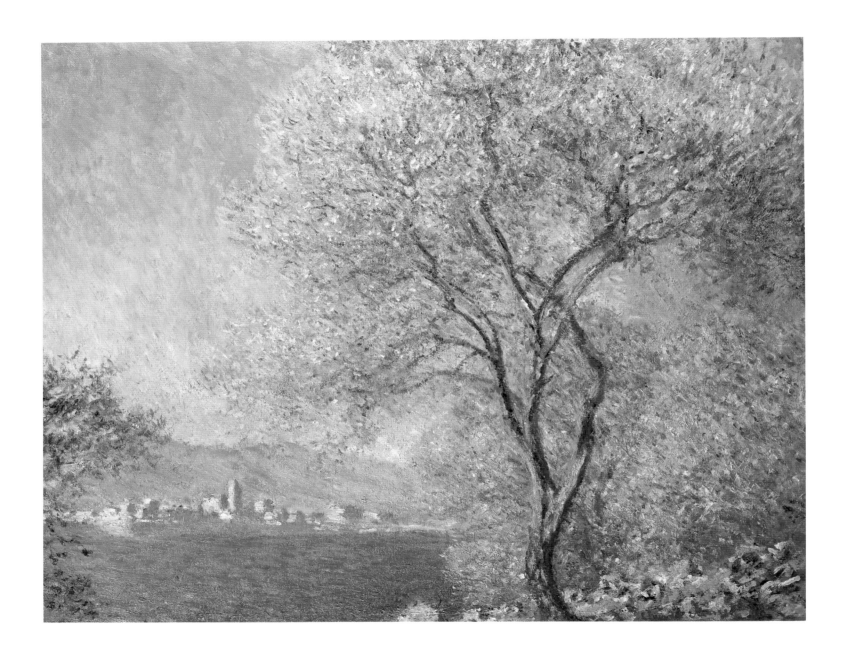

Antibes Seen from
La Salis, *Antibes,*
January-April 1888;
oil on canvas;

65 × 92 cm
(25 × 35¼ in);
signed; Museum of
Art, Toledo.

183

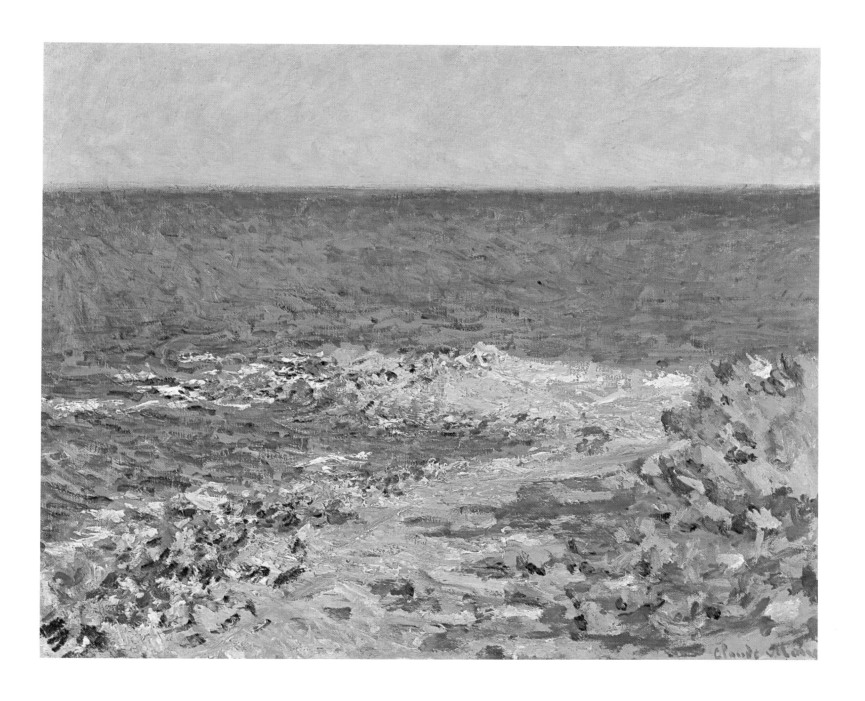

The Sea near *60 × 70 cm*
Antibes, *environs* *(23¼ × 27 in);*
of Antibes, *signed; Private*
January-April 1888; *Collection.*
oil on canvas;

184

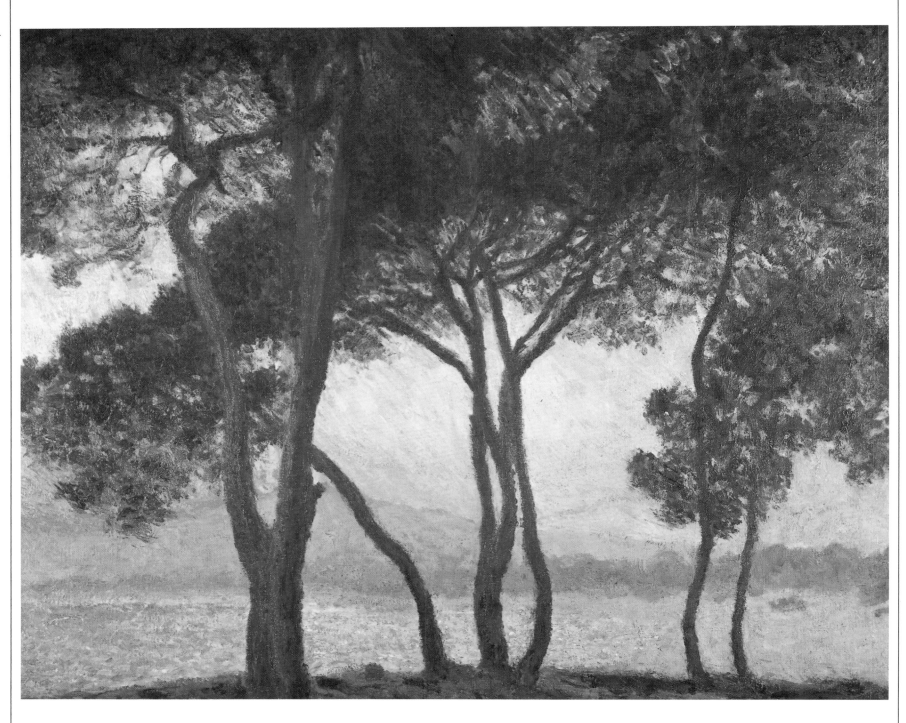

Juan-les-Pins, *oil on canvas;*
environs of *73 × 92 cm*
Antibes, *(28¼ × 35¼ in);*
January-April 1888; *Private Collection.*

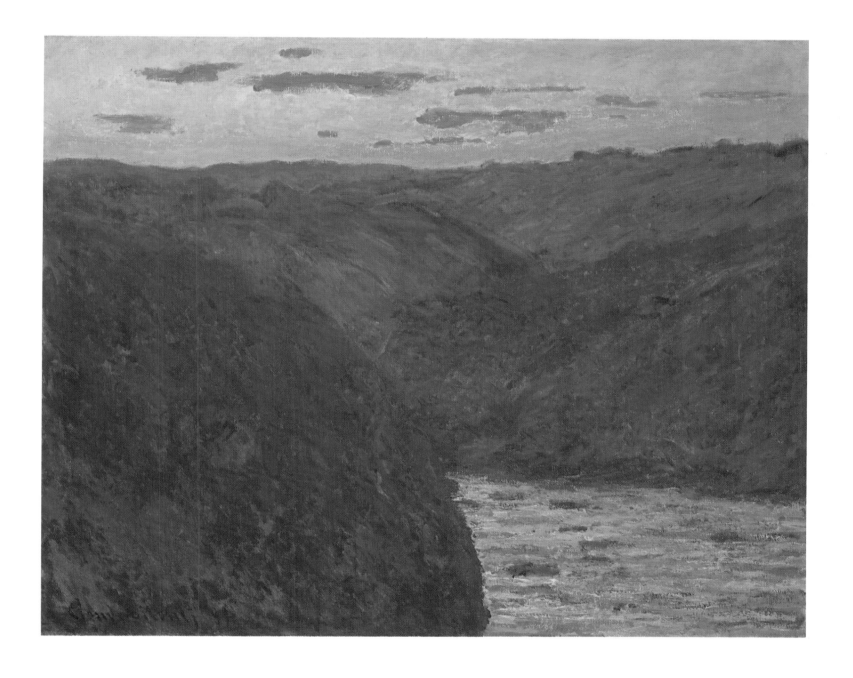

Valley of the Creuse
(Afternoon Effect),
Fresselines,
March-April 1889;
oil on canvas;

73 × 93 cm
(28¼ × 36 in);
signed and dated;
Private Collection.

186

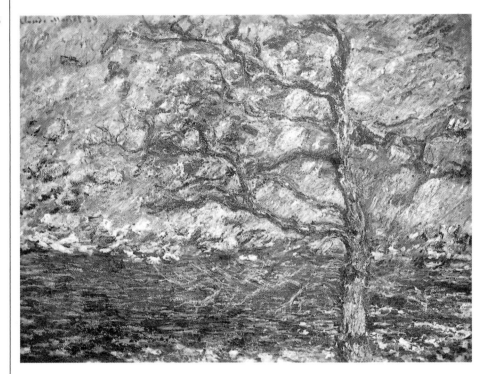

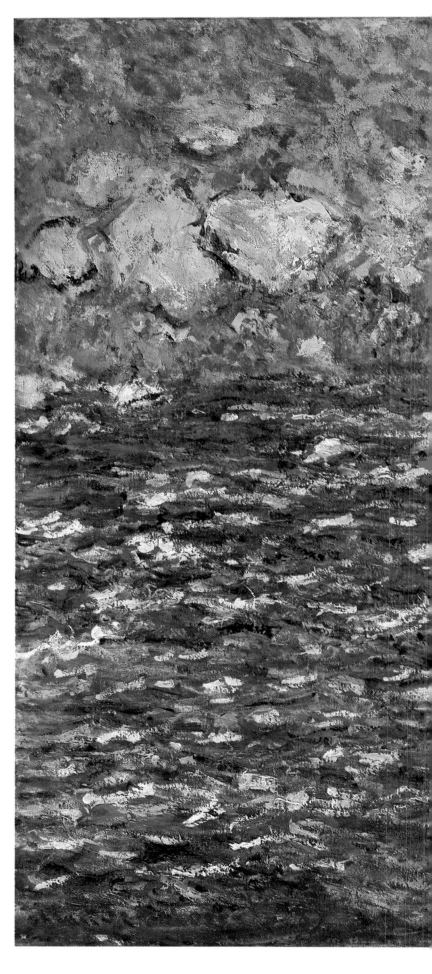

Above: The Old Tree at Fresselines, *Fresselines, March-April 1889; oil on canvas; 81 × 100 cm (31½ × 39 in); Private Collection, Paris (stolen during the Second World War).*

Right: Rapids on the Petite Creuse at Fresselines, *Fresselines, March-April 1889; oil on canvas; 65 × 92 cm (25 × 35¼ in); signed and dated; Metropolitan Museum of Art, New York. The little rapids of Creuse, with its craggy precipices* and desolate hollows, had fascinated Monet in January 1889 when he was a guest of his musician friend Maurice Rollinat. Two months later Monet returned, settling at the nearby village of Verit, with the aim of painting the Creuse valley.

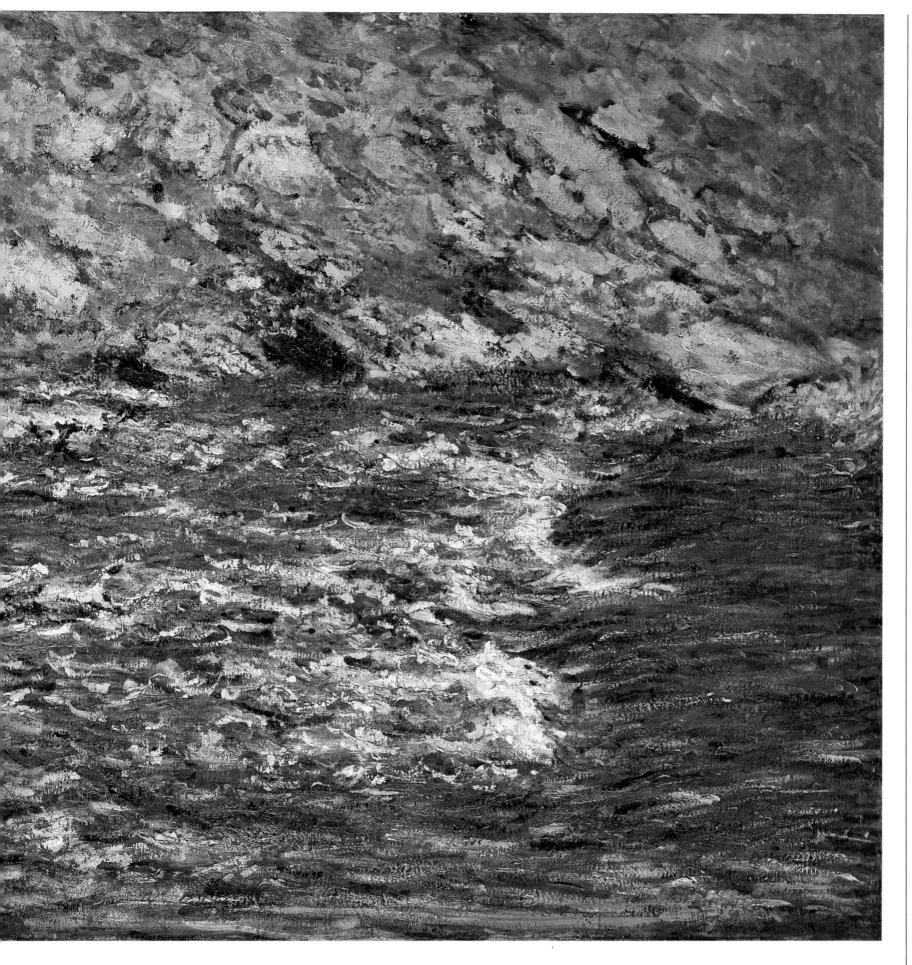

188

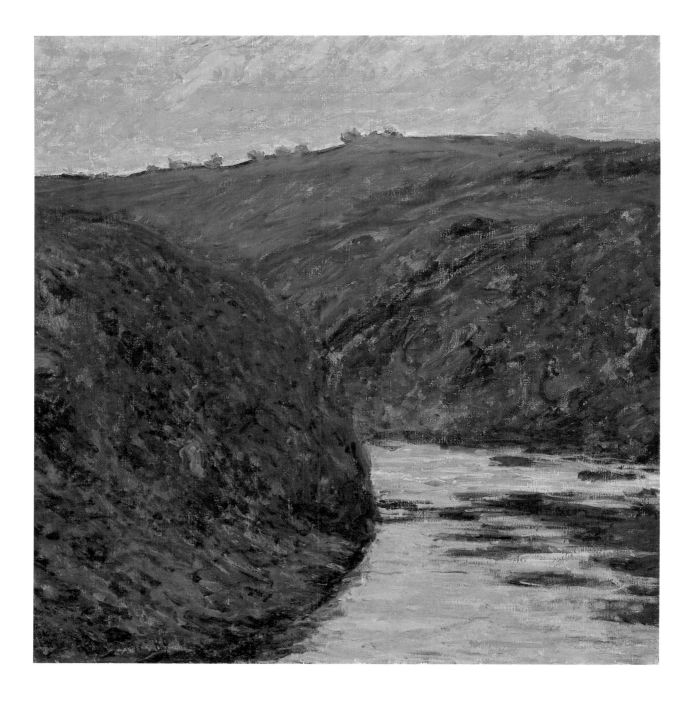

Valley of the Creuse
(Evening Effect),
Fresselines,
March-April 1889;
oil on canvas;

74 × 70 cm (28¼
in × 27 in); signed
and dated; Musée
d'Unterlinden,
Colmar.

189

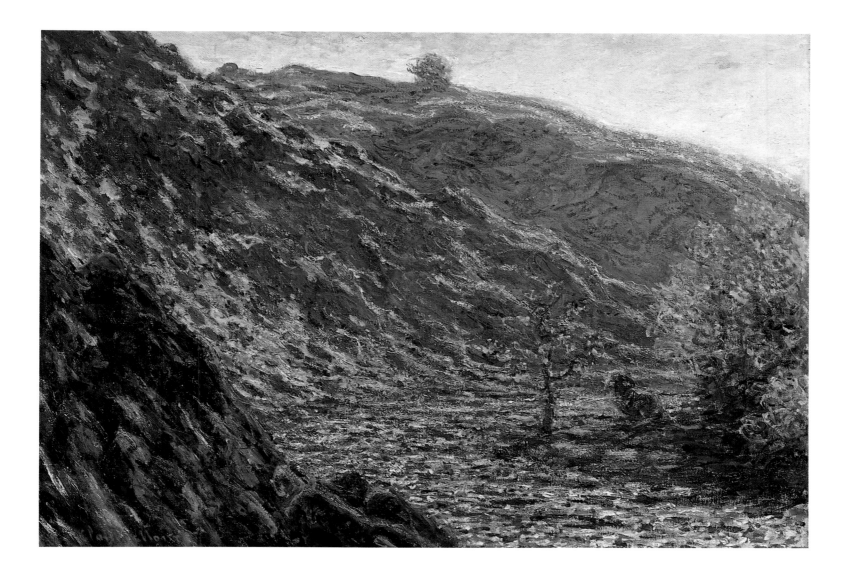

The Petite Creuse, *(25¼ × 35¼ in);*
Fresselines, *signed and dated;*
March-April 1889; *The Art Institute,*
oil on canvas; *Chicago.*
66 × 92 cm

190

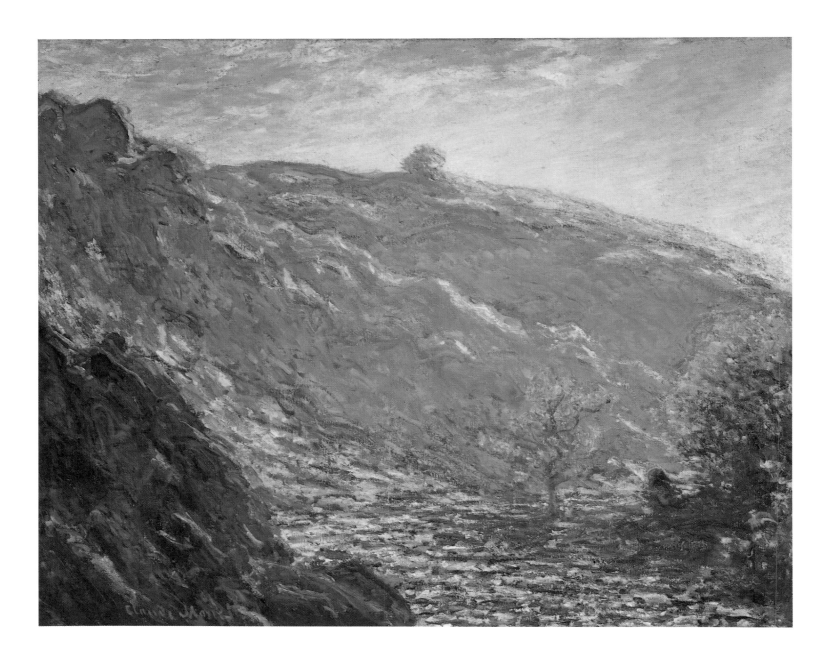

Above: The Petite
Creuse (Sunlight),
Fresselines,
March-April 1889;
oil on canvas;
73 × 92 cm
(28¼ × 35¼ in);
signed; Private
Collection.

Opposite: Study of
Rocks; Creuse,
Fresselines,
March-April 1889;
oil on canvas;
72 × 91 cm
(27¼ × 35¼ in);
signed and dated;
H.M. Queen
Elizabeth, The
Queen Mother,
London.

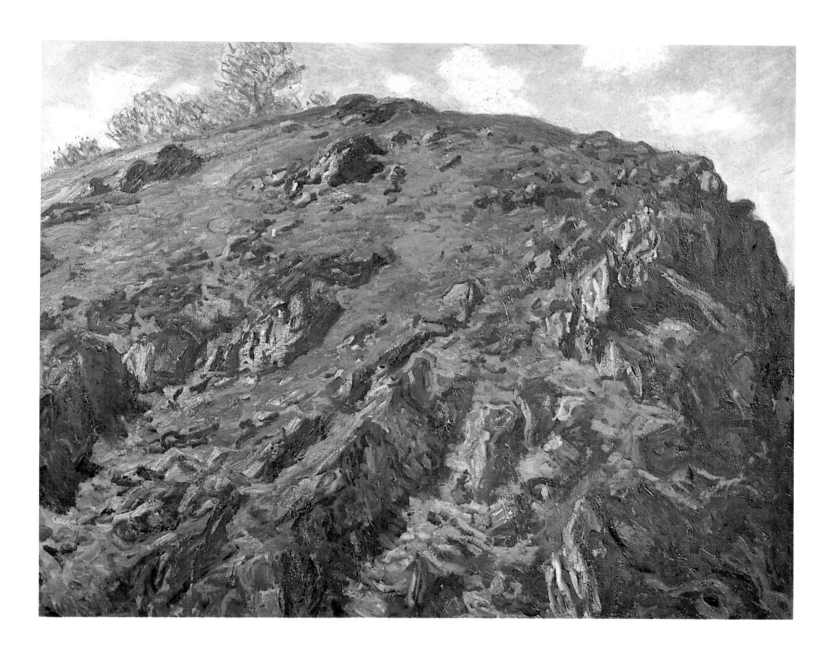

Page 192 above: Hay Stacks (Morning Effect), *environs of Giverny, 1889; oil on canvas; 65 × 93 cm (25 × 36 in); signed and dated; Private Collection.*

Page 192 below: Hay Stacks (End of Summer), *environs of Giverny, 1890-91; oil on canvas; 59 × 85 cm (23 × 33 in); signed and dated (1891); The Art Institute, Chicago.*

Page 193 above: Hay Stacks (End of Day, Autumn), *environs of Giverny, 1890-91; oil on canvas; 66 × 88 cm (25¼ × 34 in); signed and dated (1891); The Art Institute, Chicago.*

Page 193 below: Hay Stacks (Sunset, Snow Effect), *environs of Giverny, 1890-91; oil on canvas; 63 × 100 cm (24½ × 39 in); signed and dated (1891); The Art Institute, Chicago.*

192

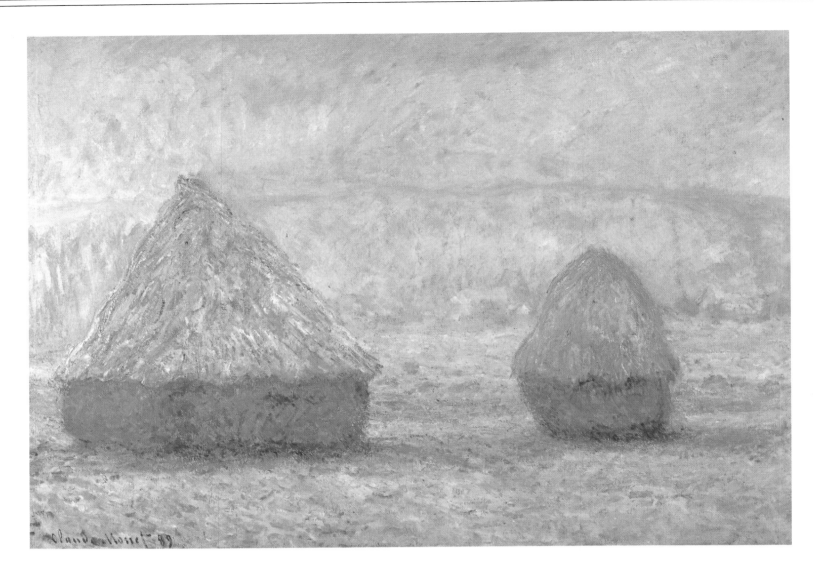

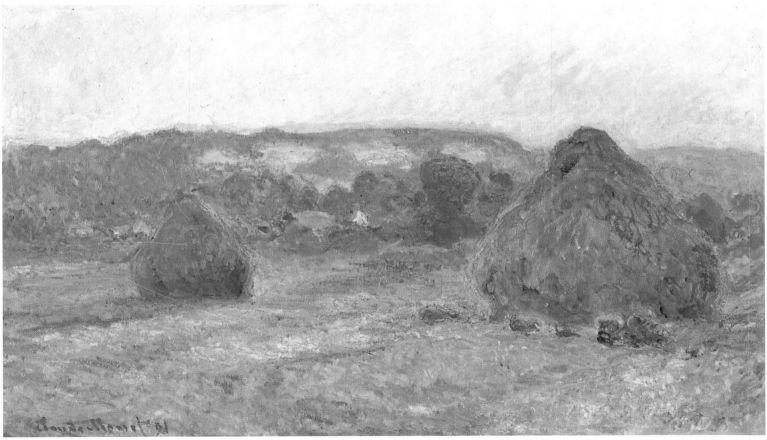

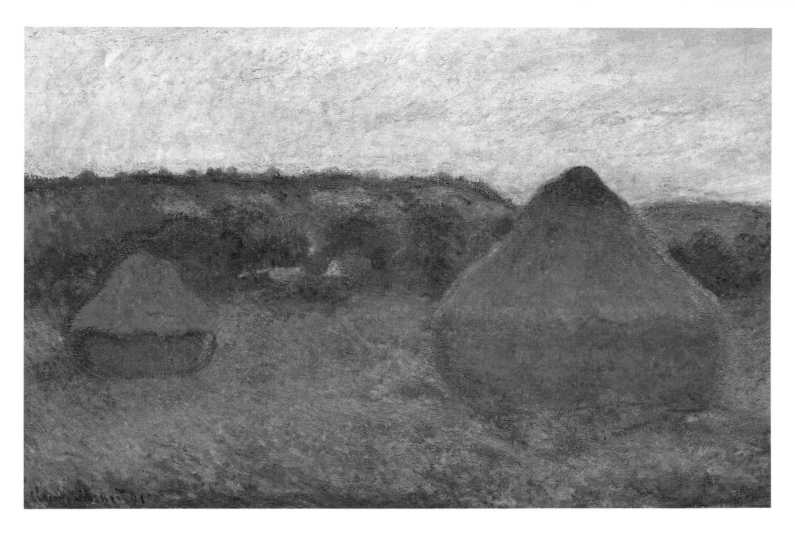

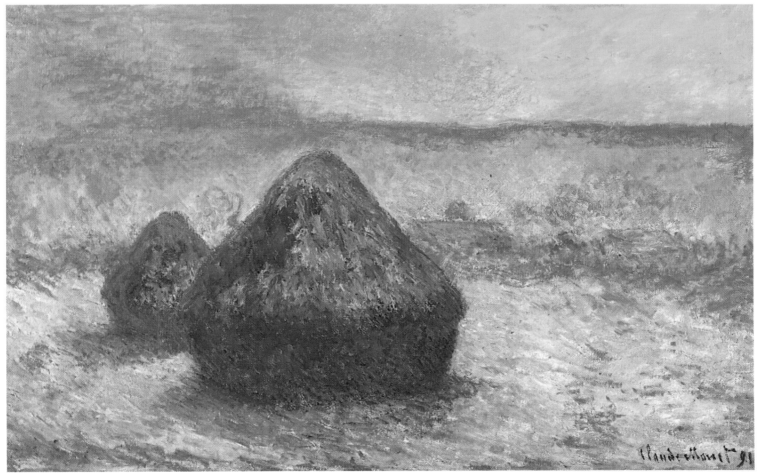

194

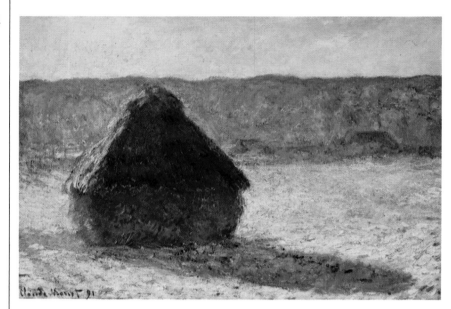

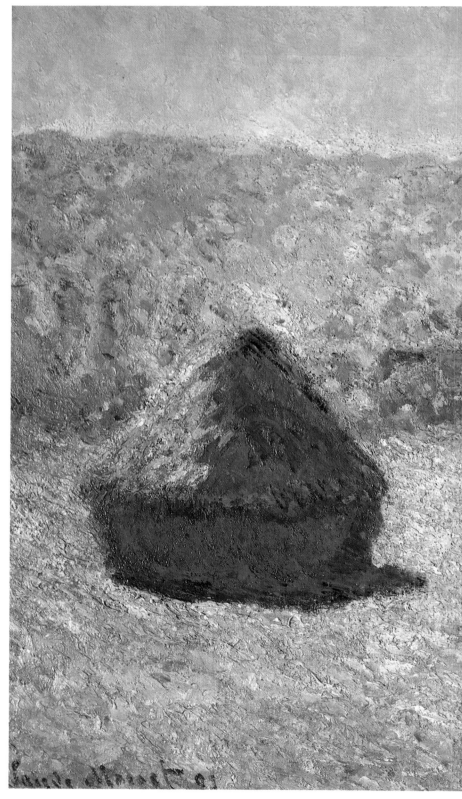

Above: Hay Stack (Snow Effect), *environs of Giverny, 1890-91; oil on canvas; 65 × 92 cm; signed and dated (1891); Museum of Fine Arts, Boston.*

Right: Hay Stacks (Late Summer, Morning Effect), *environs of Giverny, winter 1890-91; oil on canvas; 60.5 × 100.5 cm (23½ × 39 in); signed and dated (1891); Musée d'Orsay, Paris. Monet presumably began this work in September 1890. It is not clear why he finished almost all the "hay stacks" several months after starting to work on them. The season in which he began the works are in any case a part of the titles Monet gave to these paintings.*

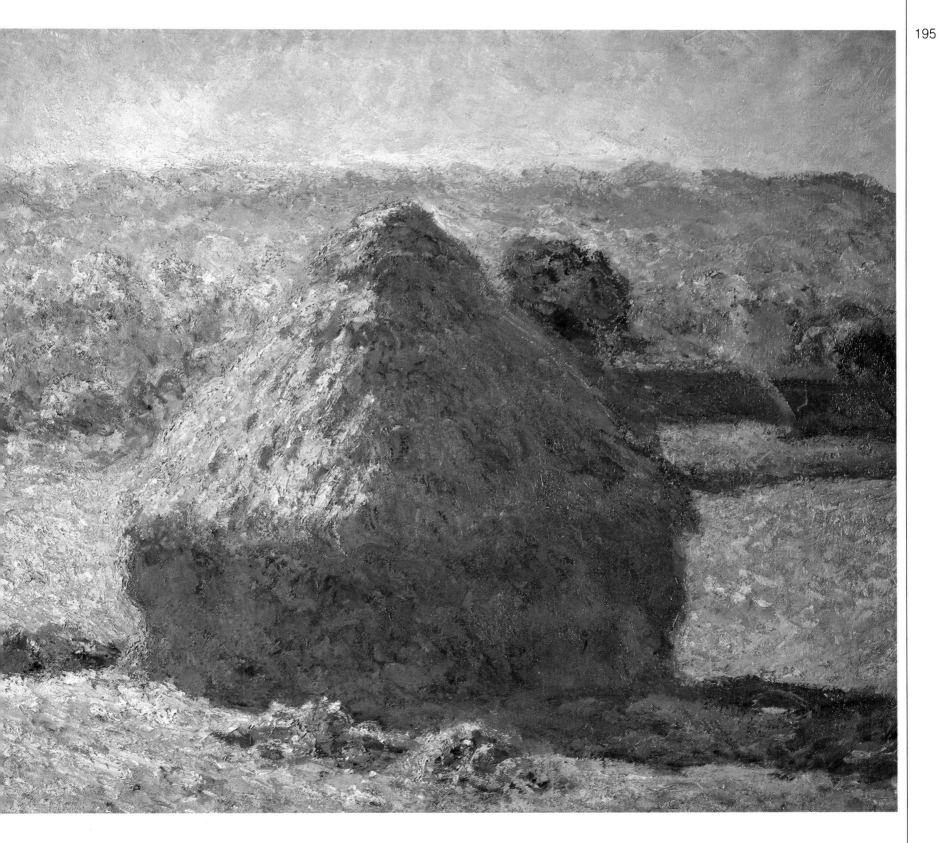

196

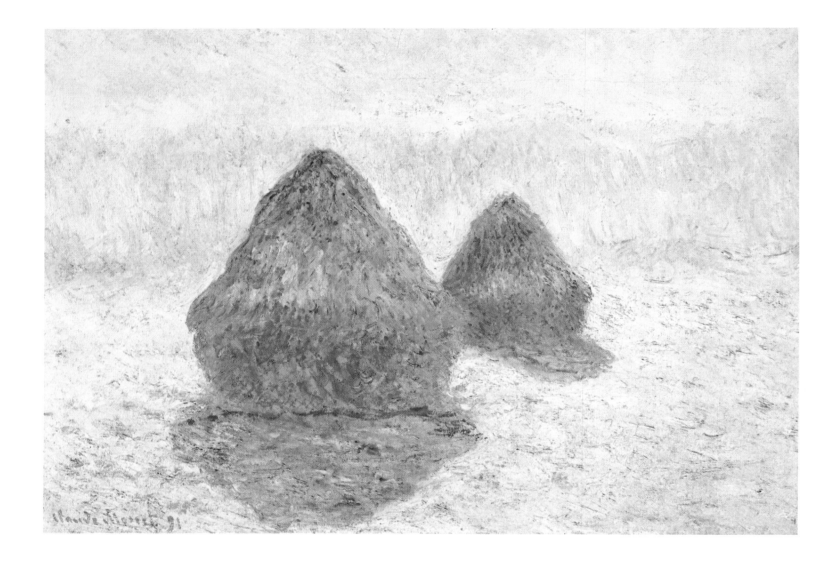

Hay Stacks
(Winter), *environs
of Giverny, winter
1890-91;
oil on canvas;
65 × 91 cm
*(25 × 35¼ in);
signed and dated
(1891);
Metropolitan
Museum of Art,
New York.*

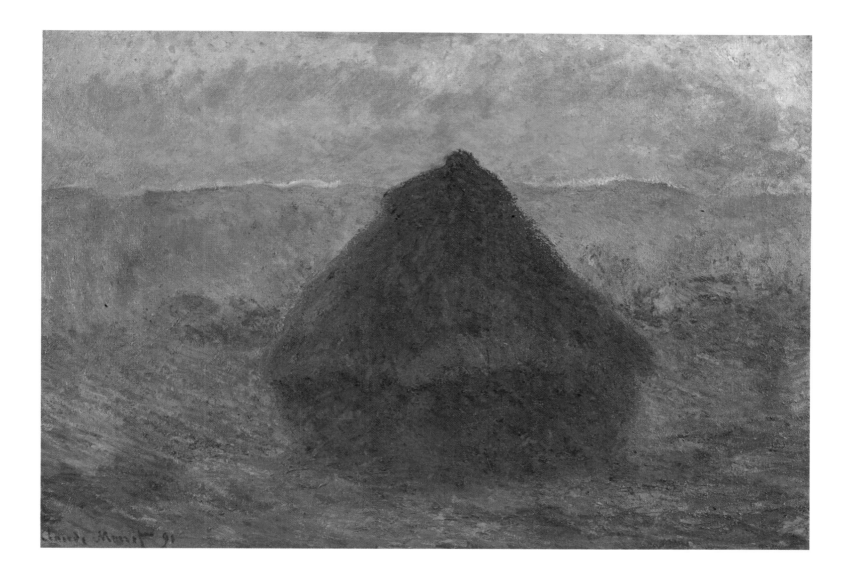

Hay Stack, *environs*
of Giverny,
1890-91; oil on
canvas; 65 × 92 cm
(25 × 35¼ in);
signed and dated
(1891); Collection
Pierre
Larock-Granoff,
Paris.

198

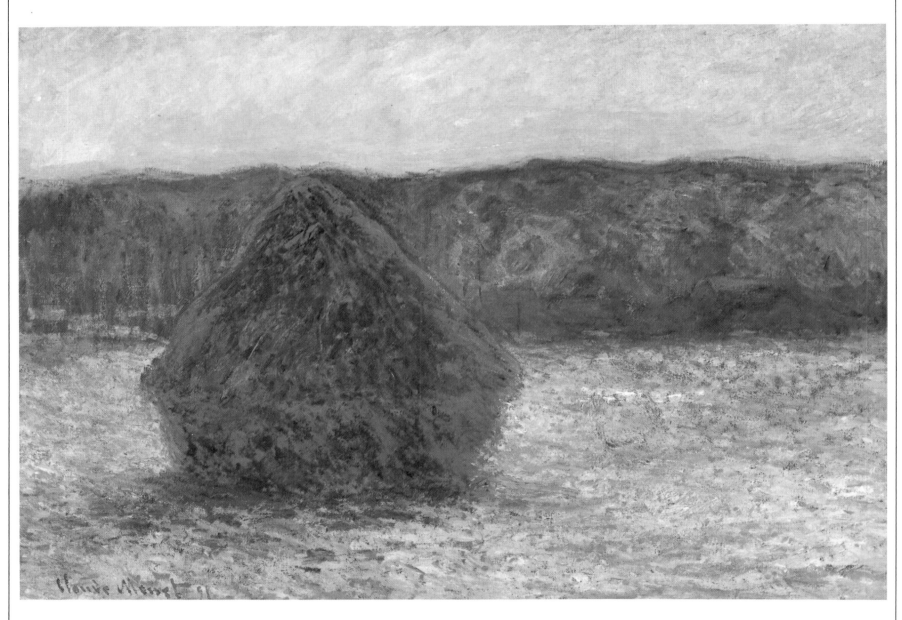

Hay Stack (Thaw, Sunset), *environs of Giverny, winter 1890-91;* oil on canvas; 65 × 92 cm (25 × 35¼ in); signed and dated (1891); The Art Institute, Chicago.

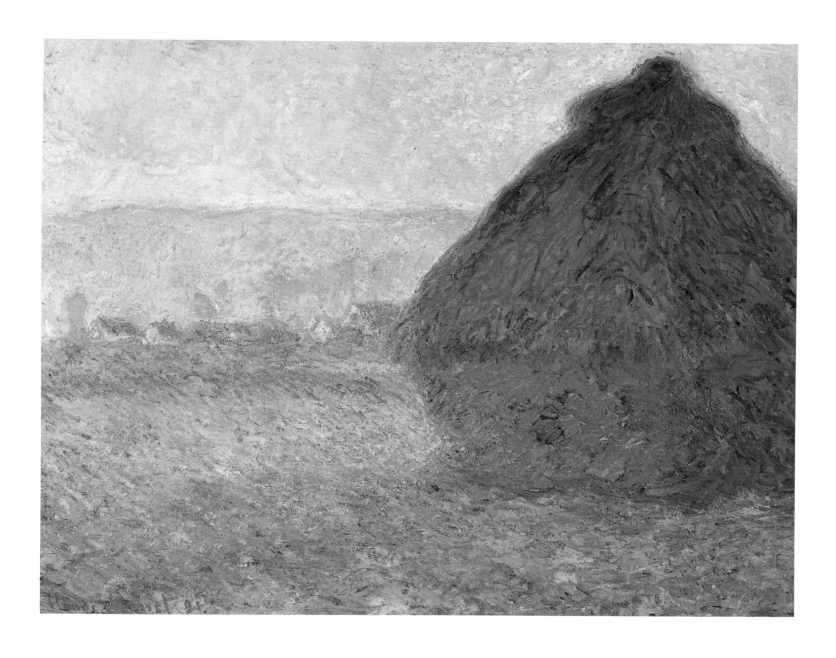

Hay Stack (Sunset), environs of Giverny, 1890-91; oil on canvas; 73 × 93 cm (28¼ × 36 in); signed and dated (1891); Museum of Fine Arts, Boston. This is another work which Monet presumably began in the autumn of 1890.

200

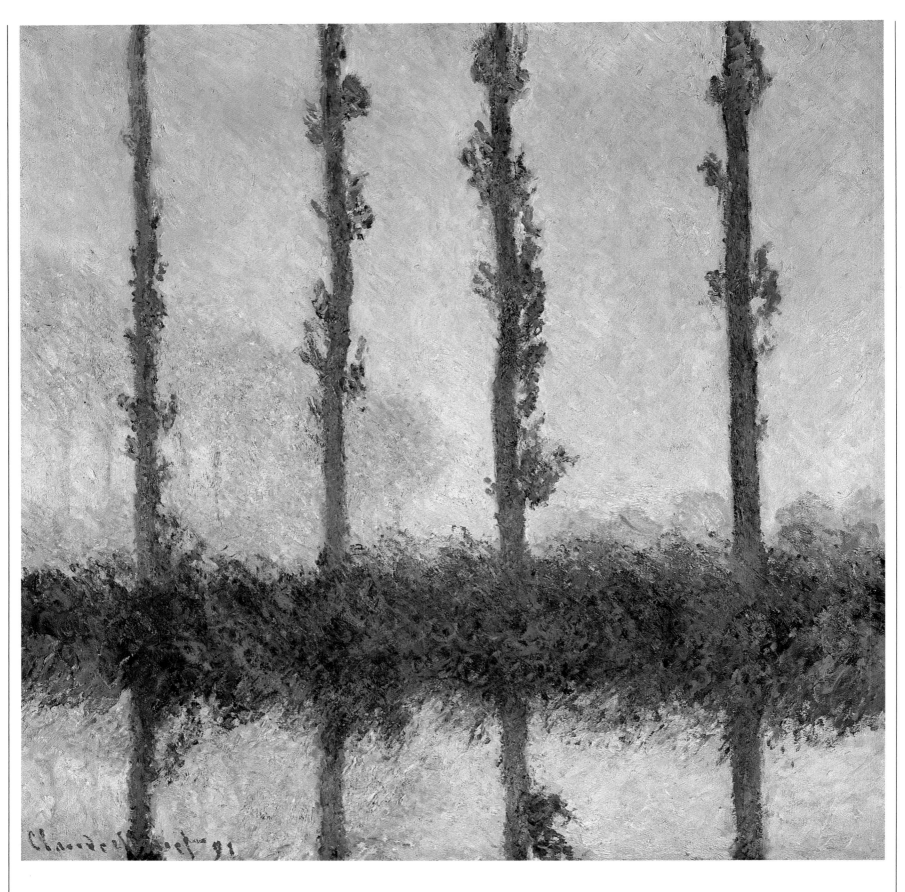

Poplars, *environs* *signed and dated;*
of Giverny, 1891; *Metropolitan*
oil on canvas; *Museum of Art,*
82 × 82 cm *New York.*
(31¼ × 31¼ in);

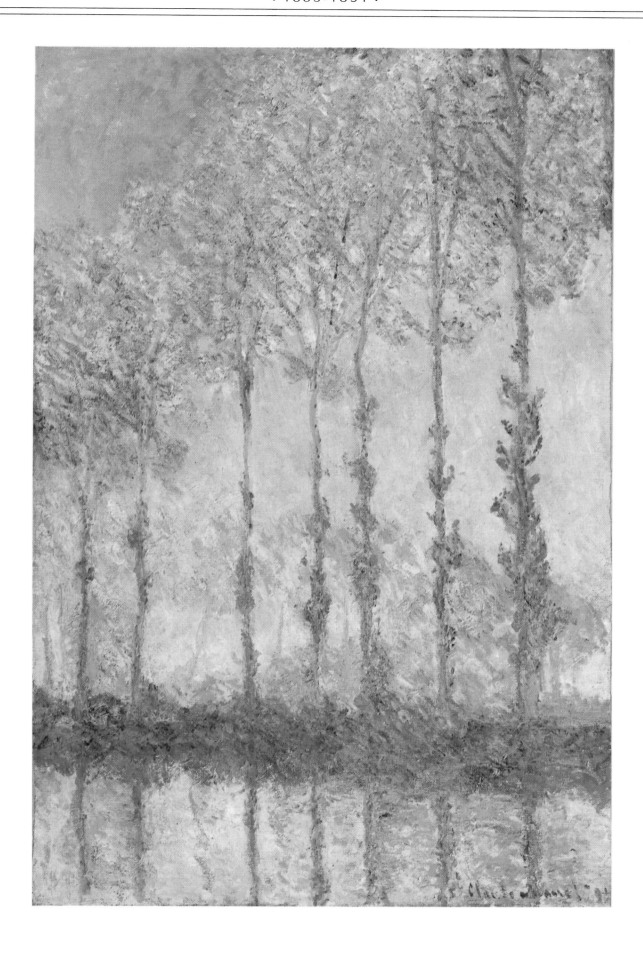

Poplars (Banks of
the Epte), *environs
of Giverny, 1891;
oil on canvas;
100 × 65 cm*
*(39 × 25 in); signed
and dated; Museum
of Art,
Philadelphia.*

202

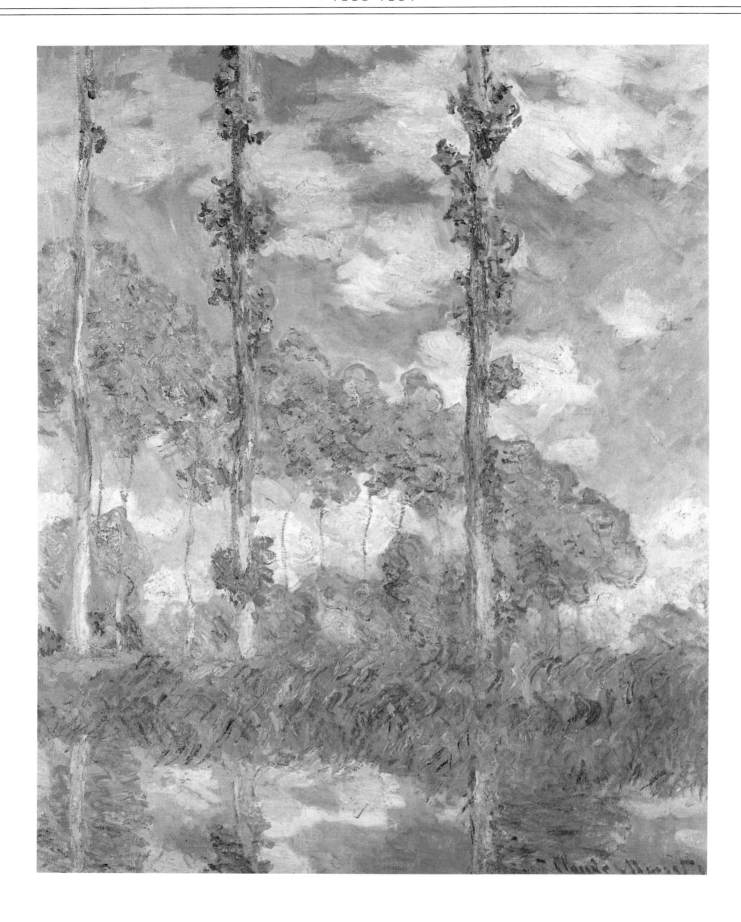

Poplars (Summer),
environs of
Giverny, 1891;
oil on canvas;
93 × 73 cm

(36 × 28¼ in);
signed and dated;
National Museum
of Western Art,
Tokyo.

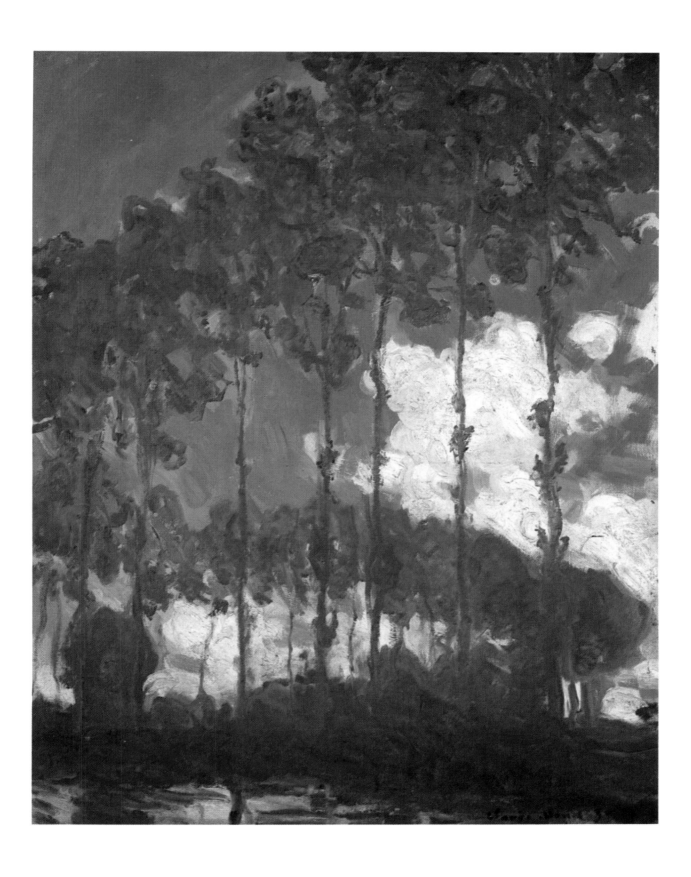

Poplars (Banks of the Epte), *environs of Giverny, 1891;* oil on canvas; 92 × 74 cm (35¼ × 28¾ in); *signed and dated (1890); Tate Gallery, London, Monet probably erroneously dated this work at 1890.*

204

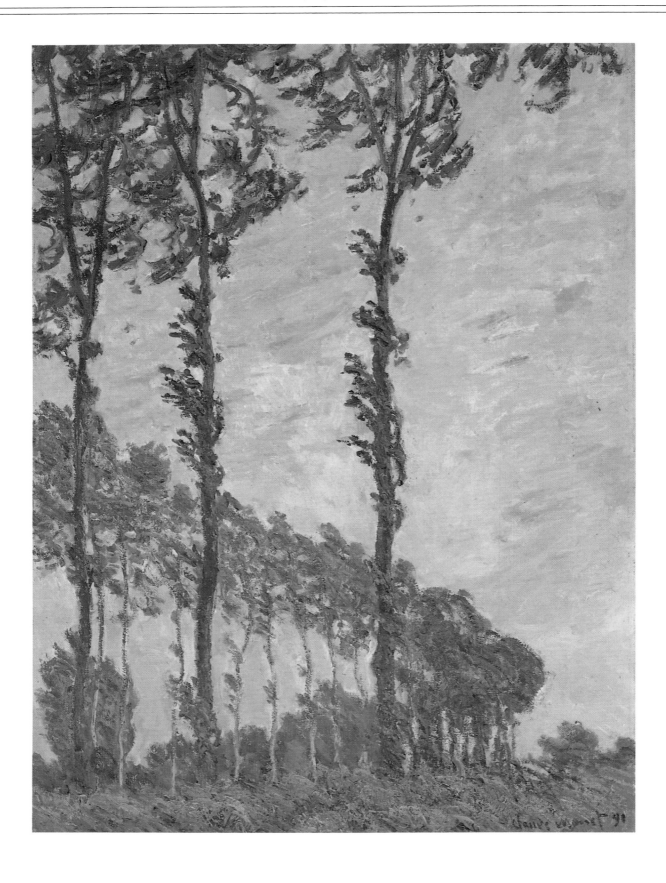

Poplars (Wind
Effect), *environs of
Giverny, 1891;
oil on canvas;
100 × 73 cm*

*(39 × 28¼ in);
signed and dated;
Durand-Ruel
Collection, Paris.*

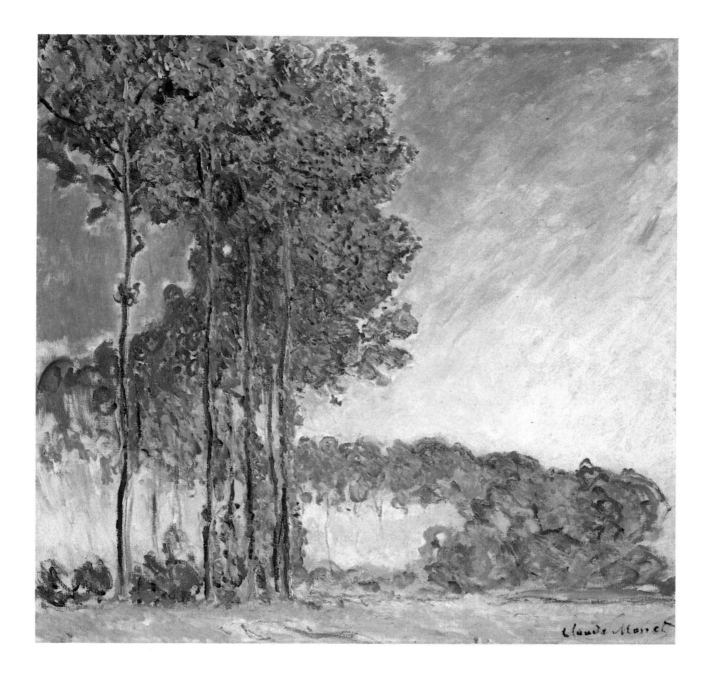

Poplars (View from
the Marsh),
*environs of
Giverny, 1891; oil
on canvas; 89 × 92*
*cm (34¼ × 35¼ in);
signed; Fitzwilliam
Museum,
Cambridge
(England).*

The obsession
with the subject

With the Rouen cathedral series, which began in 1892 and ended in 1894, another aspect of Monet's art comes to the fore: the tendency to solicit a dynamic type of reaction on the part of the viewer. The gesture of repetition, implicit in this series, multiplies the pictorial versions of the subject and therefore ends up dispelling it on the level of reality. Now there was such a variety of irreconcilable interpretations that corresponded to the same real subject that the theme as such lost all its pictorial significance. This means that if Monet carefully chose the subject to be painted, considering it in some way essential to the aims of the work, he was not merely offering a description of the subject or re-proposing it in painting, but was using it as a "pretext," as something which, in being transformed into an image, necessarily relinquishes its initial identity as a concrete object. Between one view of Rouen cathedral and the other – just as between one hay stack and another – there is a marked distance, a great difference in expressive potential, so much so that one should perhaps not even speak of a series. The theme no longer coincides with the objective-spatial reality from which the painting derived (the "cathedral"); it moves closer and closer to the immediacy of sensation, which is temporally defined ("morning effect," "harmony in brown," "sunset") and which the painter quite deliberately includes in the title. We do not appreciate reality per se, Monet seems to be saying, but the individual and unrepeatable moments of its penetration into us through the senses. Each approach, every moment of inner penetration on the part of the real by means of its image, generates another reality,

a different relationship between the self and the world. If that relationship is to be expressed in an artistic representation, it would be absurd to expect the painting to be faithful to anything more stable than the fugitive moment of perception. The cathedral, the hay stack, the river or cliff do not exist as such; what does exist are only the infinite repercussions of these objects as we perceive them at a given moment in time: each time in a certain way, with a certain light, and originating from a certain emotion. This in itself already involves a form of dynamism, since it makes the work something that fluctuates and takes on form again through our experience.

It is only logical, therefore, that Monet should go so far as to abolish the unitary "viewpoint." His late works, from the Rouen cathedral cycle on, no longer attach any importance to perspective and do not consider it indispensable to an interpretation of the painting. Not only do the views of Rouen cathedral have or indeed require a viewpoint; they also even invite us to move back and forth, closer to or farther from the painting; they exhort us to sum up the various interpretations we made from the different distances and viewpoints so as to reconstruct the image in a subjective manner on the basis of a synthesis of different perceptions. Thus the cathedral appears and disappears, becomes light and stone, and then a hole in the interior, and is then a vague form amidst the fog, a profile, a ghost, a shadow – and finally, nothing.

In this way Monet realized his old ideal of "painting as immersion." He succeeds in making us transform our interpretation of his works into a psychological penetration of the fluctuating space

of the surface. The canvas has finally rejected the principle of immobility and of contemplation in the classical and Renaissance sense of the term. Our view has changed from a facile convention to a complex response that is required of our consciousness: a "duel" the mind has with the visible in an effort to possess it. This challenge of the eye seeking the utopia of penetration comes up against, or is complicated by, the dream-like aquatic mirrors of the versions of *Ice Floes, Bennecourt* (1893), the varied and much more evolved revivals of the important ice floe series done in 1880. The mirror is certainly a fundamental metaphor in Monet's oeuvre. One might even go so far as to say that from the end of the 1860s on water provided him with the possibility of introducing a specular element, a glance that rebounds and, since it cannot penetrate the water, returns defeated to its starting point. The mirror's important role as a pictorial device in the history of Western art from van Eyck on is well known. Its glance is in a sense the emblem of the artist's glance. This "artist's glance" for Monet is not the usual vision whereby people are able to see the world, but a richer way of seeing that is characterized by the desire for immersion and the utopian quest for the impossible. These two poles are complementary: as the crisis of perception increases – that is, as the difficulty in considering the painting an interpretation of reality becomes clearer – the concrete depth of the canvas also increases. This can be understood readily in the versions of *Rouen Cathedral* at the Boston Museum of Fine Arts and the National Museum of Wales, for example. The specter of the visible (a common city square, the sunlit façade of a Gothic

building) becomes a Baroque conglomeration of lava flows, a geological formation, a web of stalagmites and stalagtites, almost the genesis of the world's very nervous system. The crisis of vision is manifested in the "false views" of *Mt. Kolsaas, Norway* (1894-95), in which the dark, compact effigy of the mountain occludes the virtual space and blocks the canvas into masses of white, grey and black pigment; these masses in turn divide the canvas into large areas, impose a depth upon it, and establish internal links with the surface, but no longer manage to connect the canvas with the object mentioned in the title.

Our perception of the created work is rendered difficult by those very same conditions of light and atmosphere that at the outset of Monet's career seemed to presage only great optical conquests. Note the tragic uniformity of substance and the mute wall of colour he uses to express atmospheric changes in *Cliffs at Pourville (Rain)* (1896). A similar blinding effect is produced in the 1896 versions of *The Custom Officer's Cabin at Varengeville*, known as *Gorge of the Petit Ailly, Varengeville*, which are so removed from the same views he executed in 1882. The viewpoint is identical, as Monet seems to have painted from the same rocky spur on the coast; but it is like seeing the views of the object on the one hand, and its X-rays on the other. The version at the Metropolitan Museum is rendered in green and violet, the one in the Fogg Art Museum in Cambridge, Mass. is cyclamen-coloured. In both works, but particularly in the second one, homogeneous blocks of colour predominate; they are initially related to perceptions of light that were then toned down to make way for more independent, abstract

chiaroscuro areas.
A remarkable step in the direction of the conceptualization of painting was taken with the *Morning on the Seine* series (1896-98). As often occurred in this period, the phases of this cycle range from almost miraculous descriptive works (the 1896 version at the Boston Museum of Fine Arts) to the subtle play of balance and the partial dissolution of the image (the 1897 version at the North Carolina Museum of Art), up to the truly formless 1898 version at the Tokyo National Museum of Western Art. Water takes on an important role in these works, rendered either as an element that gives full play to the rhetorical qualities of the painting or as a confused, implosive whirl of the very stuff of the subject. In the 1896 version the river bank cuts the canvas in two horizontally, dividing it almost into the true reality represented above and the fictitious reality mirrored below. If we could turn the canvas upside down we would see that it is quite difficult to distinguish between the two halves, as the second one is only slightly more blurred than the first.
In *Waterloo Bridge* (1900, Santa Barbara Museum of Art) Monet exploits the yellow fire that the sunlight generates on the Thames and merges in a single vision the suave violet touches in the North Carolina Museum version of *Morning on the Seine* and the inexhaustible maelstrom of brush-strokes in the Tokyo version. Monet's pictorial language is expressed in a zigzag course, at first shading the figural masses and then heightening them with vivid marks. In the many versions of *The Japanese Bridge, Giverny* painted between 1899 and 1900, this "plague" of colours holds

sway. The colour explodes in a myriad of strongly contrasting hues; and the vortex of petals, reeds and grass, as well as the intricate reflections in the liquid areas of the painting, serve as a valid pretext for the feverish slashes of the palette knife and brush. The chaos of perception once again becomes the chaos of nature. But this nature is special, for the artist-gardener conceived it with a particular aim in mind, letting it grow in the pond and on the banks in heaps of pictorial sensation. Here too Monet shows he cannot do without a model, even though his painting procedure moves towards the elimination of the relationship between painting and the world. Once again the artifice of variation – which by now no longer needs sources of light – contributes to the disappearance of the presumed truth of the subject in favour of the truth of the painting that becomes more and more solidly established.
One passes from the total green (a formless monochrome) of the London National Gallery version of the Japanese bridge to the blend of reds, lilac, yellows and violets in the Boston version, a vivid phantasmagoria that makes this latter work seem like a sort of machine capable of recreating the world. In *The Artist's Garden at Giverny* (1900) the chromatic transfiguration is so manifest as to make the title almost meaningless: is the artist's garden the actual site in which he cultivates flowers and plants, or is it rather the very seat of his creativity, the inner garden of his paintings and of the work bearing that title?
The views of the Thames (1903-4) are much more evocative, even magical. Of the series, one painting is particulary worthy of mention:

The Houses of Parliament (*Sunset*) (1904, Private Collection), which in the dissolution of the colour, especially in the two orange-reddish patches in the sky and river, expresses the power of a late masterpiece by Titian (his *Flaying of Marsyas*, for example). Seen at close range, these vast, throbbing works seem to narrate a bloody event, be it mythical or metaphysical – a dramatic gash of light in the heart of a gloomy day. Here, as in the other works of this series, the buildings in the background are rendered by a shadow with jagged upper outlines (the Gothic crenellation of the Houses of Parliament) that is a somber area in front of which the reverberations of sunlight sometimes flare with yellow by contrast (see the Musée d'Orsay version).
And as a sort of countermelody to the London fog we have the translucent 1908 views of Venice. A close examination of these works reveals that there is something rather unhappy in the *Palazzo Contarini, Venice* views dominated by a violet that immediately evokes an enveloping sense of mourning. *The Grand Canal, Venice,* although tinged with glittering pink effects over a delicate sky-blue harmony, is no less gloomy a work in the emotions it expresses. These are unquestionably beautiful paintings. Yet they bear the stamp of a kind of regression with respect to the direction Monet had been taking in the last twenty years, because they negate in part the abandonment of figurative art that makes Monet a truly twentieth-century artist. In order to understand, through comparison, where the problem of this regression lies, we should analyze the little 1907 series of *Water Lilies*, in which the new features he

introduces are clearly delineated. Although he plays, as always, on the singular nature of the subject, Monet here demonstrates his intention to conceive the canvas as a mere support for the unfolding of forms and colours, a sort of informal topographical map whose inner regions, which are more or less compact or fringed, refer only indirectly to the leaves or corollas of the water liles, to the water and plants. Indeed, only after a few minutes of observation does one realize that the large patches in the background (brown-reddish in one version, green-blue in another) are reflections on the pool and therefore stem presumably from the foliage of the surrounding trees. The part of the water that reflects the sky is, on the other hand, yellow in both paintings (although two different shades of yellow). This is not easy to note, because for the first time Monet uses an expedient he was never to abandon that allowed him to treat the painting surface as a miraculous mirror which reflects not nature, but the pure, formal intelligence of the artist and his need to confer space to space, to mark out boundaries, open or close off areas, separate and join. Monet virtually abolishes the horizon line; an optical axis moving from above to below frames the pool so as to make our vision plunge into its depths. All we can see is water, or better, what lives, grows, proliferates and is reflected in water. This solution to the problem of content and pictorial language at the same time was so compelling and effective that he no longer needed or wanted to modify it. From that time on, for Monet and his brush there would be only the pool, water lilies and reflections.

208

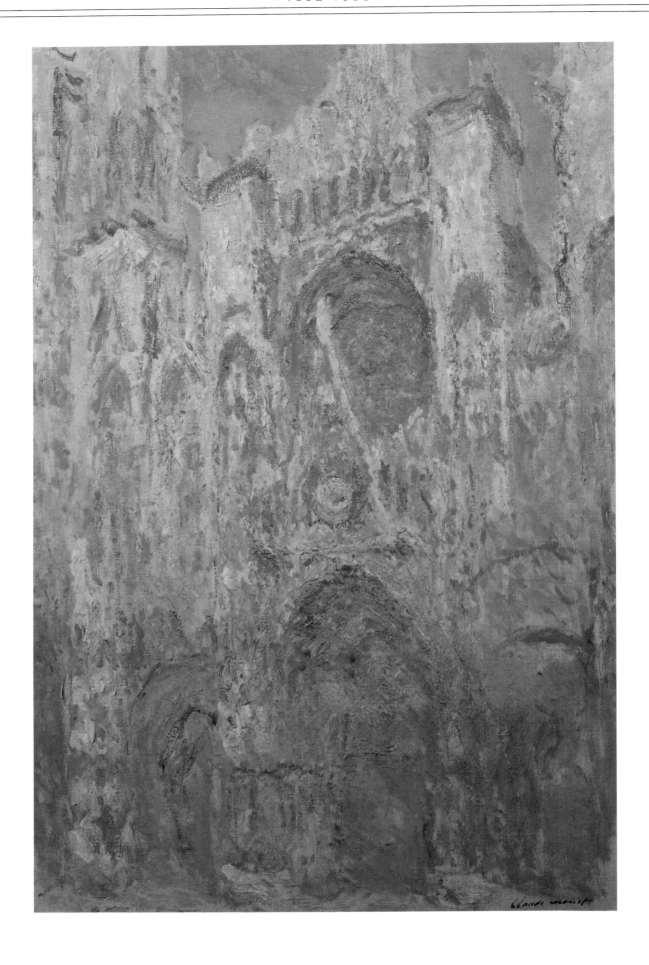

Rouen Cathedral, *100 × 65 cm*
Façade (Sunset), *(39 × 25 in);*
Rouen, 1892-94; oil *signed; Musée*
on canvas; *Marmottan, Paris.*

209

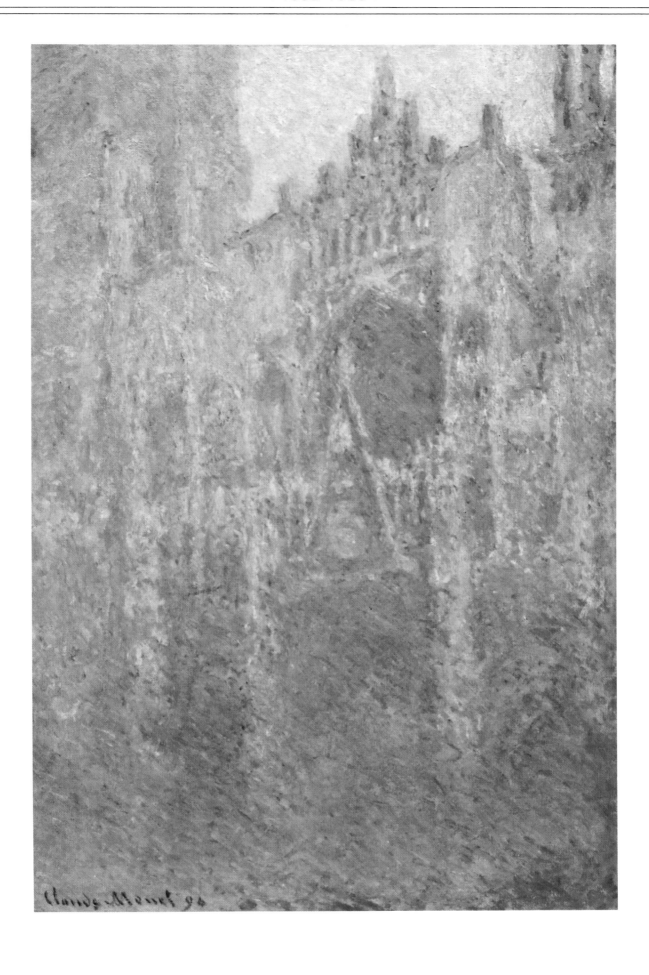

Rouen Cathedral,
Façade (Morning
Effect), *Rouen,
1892-94;
oil on canvas;*

*100 × 65 cm
(39 × 25 in); signed
and dated (1894);
Folkwang Museum,
Essen.*

210

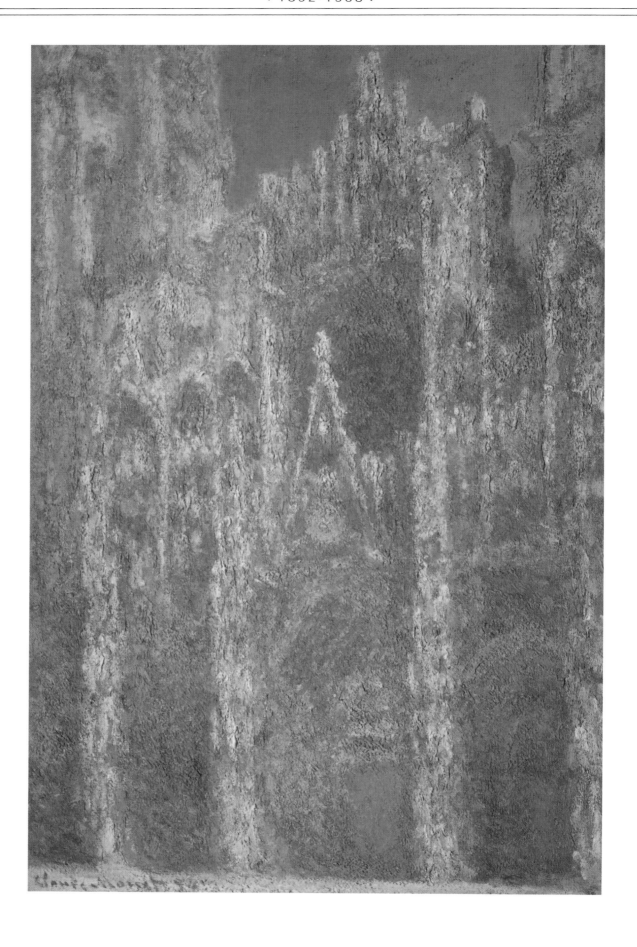

Rouen Cathedral,
Façade, *Rouen,
1892-94; oil on
canvas; 100 × 66
cm (39 × 25¼ in);
signed and dated*
*(1894); Museum of
Fine Arts, Boston.
A detail of this
painting is shown
on the opposite
page.*

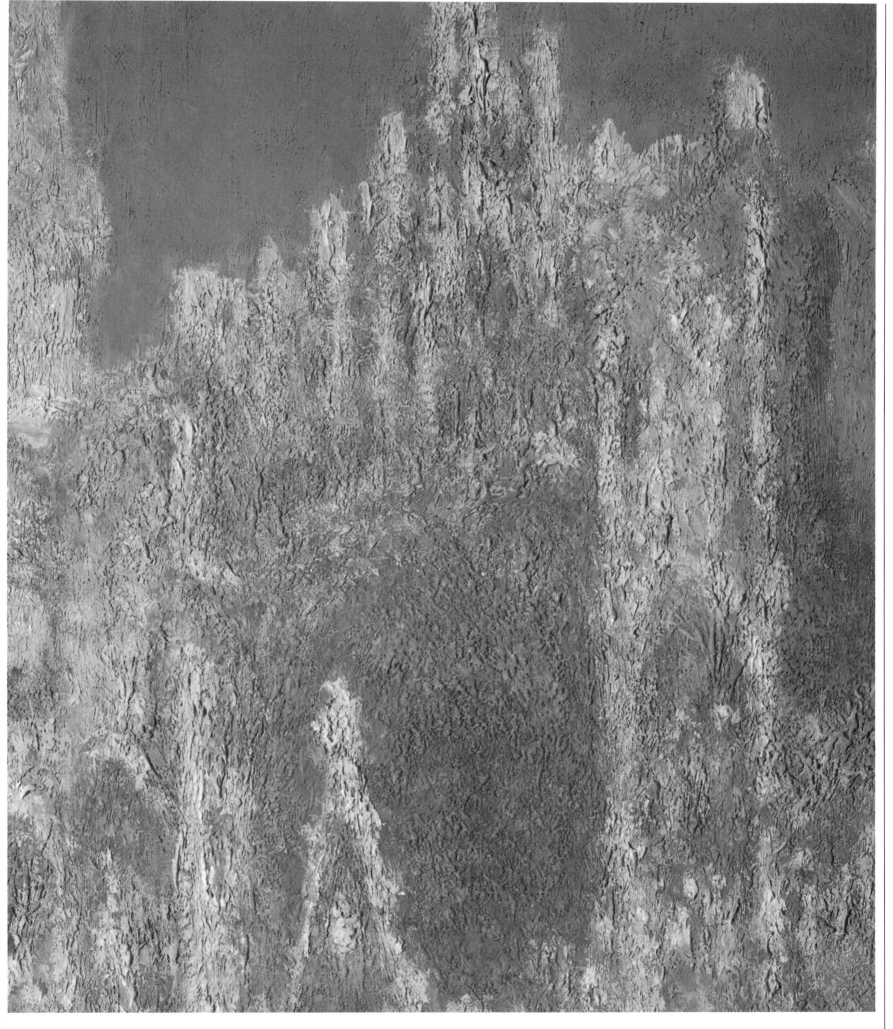

212

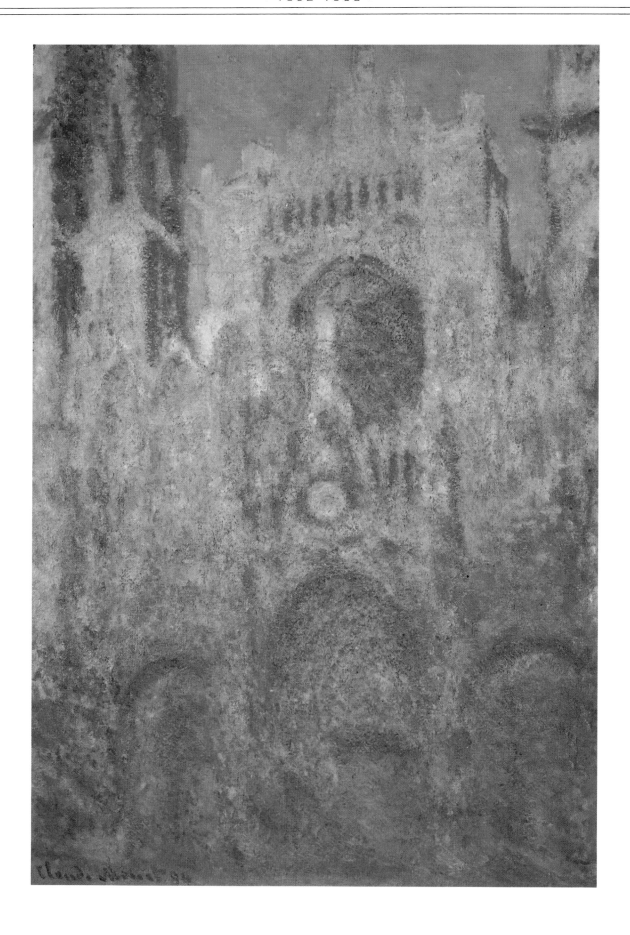

Rouen Cathedral, *(39 × 25 in);*
Façade, *Rouen,* *signed and dated*
1892-94; *(1894); National*
oil on canvas; *Museum of Wales,*
100 × 65 cm *Cardiff.*

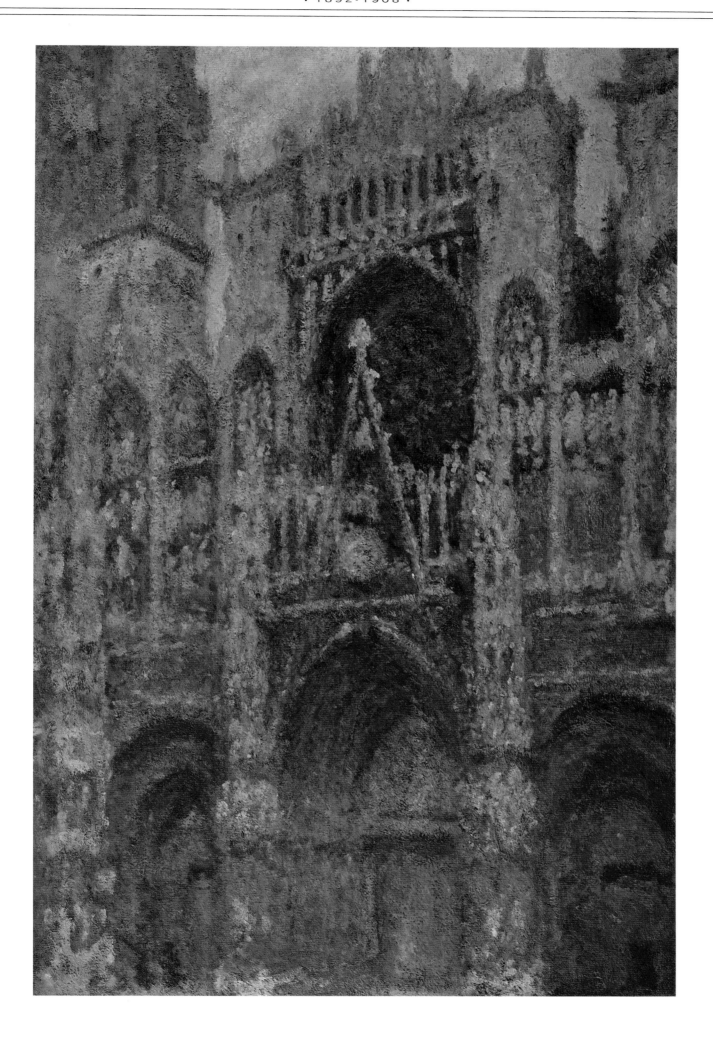

Rouen Cathedral, (39 × 25 in); signed
Façade (Grey Day), and dated (1894);
Rouen, 1892-94; Musée
oil on canvas; d'Orsay, Paris.
100 × 65 cm

214

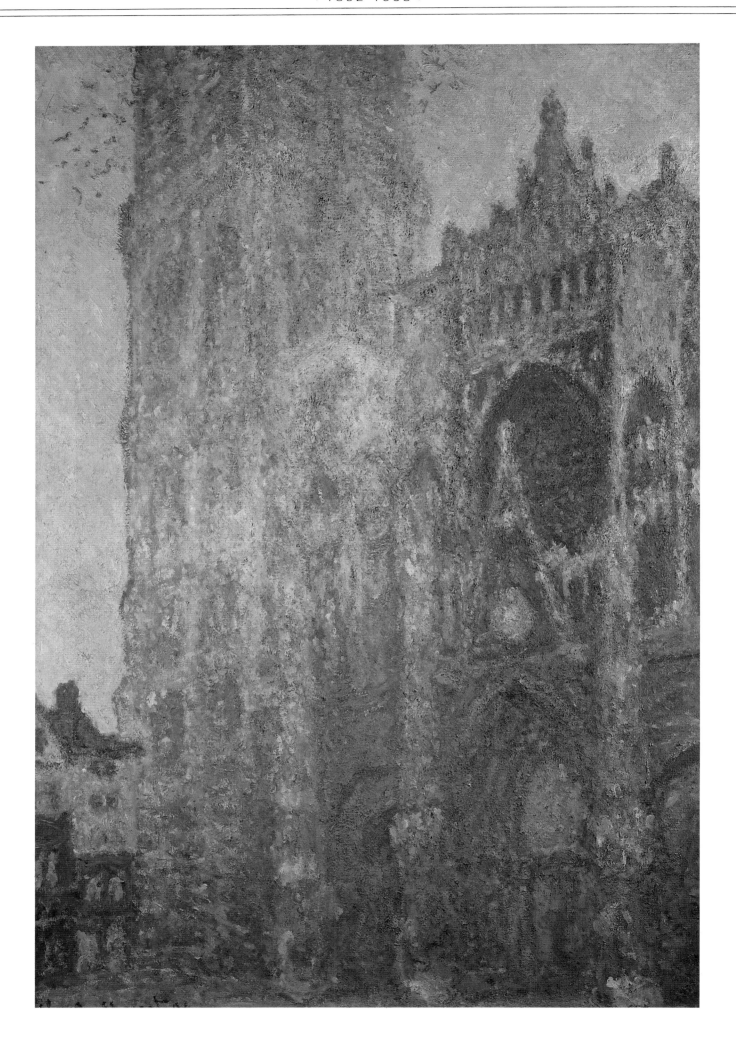

Rouen Cathedral,
Façade and Tower
(Morning Effect),
Rouen, 1892-94; oil
on canvas;
*106 × 75 cm
(41 × 29 in); signed
and dated (1894);
Musée d'Orsay,
Paris.*

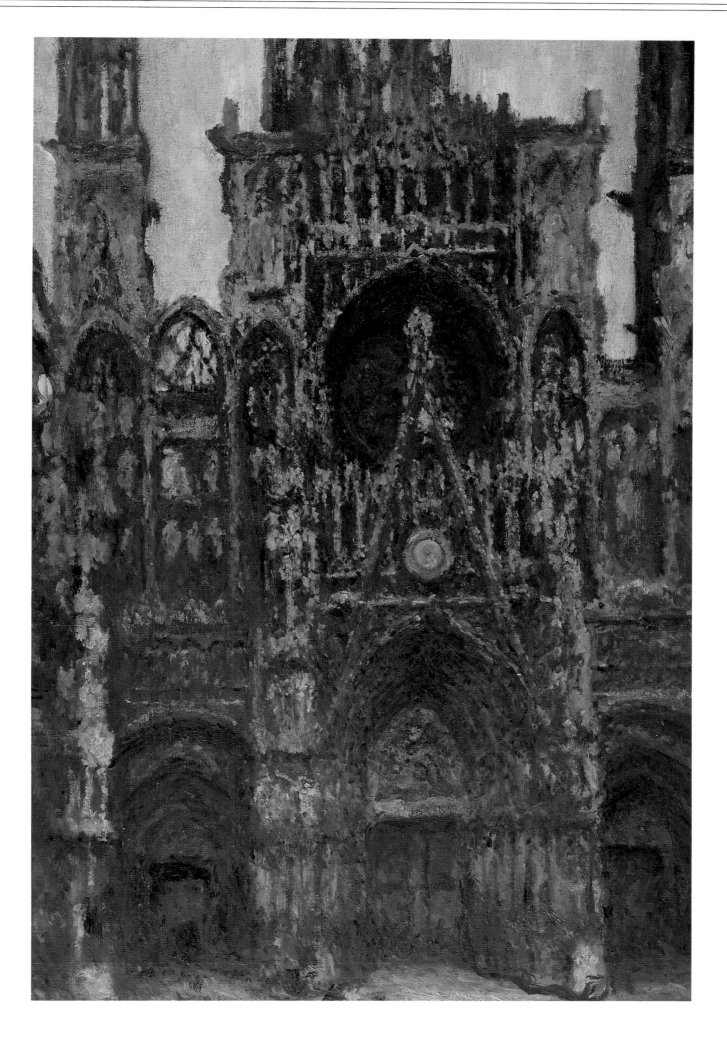

Rouen Cathedral, the Portal Seen Head-on (Harmony in Brown), *Rouen, 1892-94; oil on* *canvas; 107 × 73 cm (41¼ × 28¾ in); signed and dated (1894); Musée d'Orsay, Paris.*

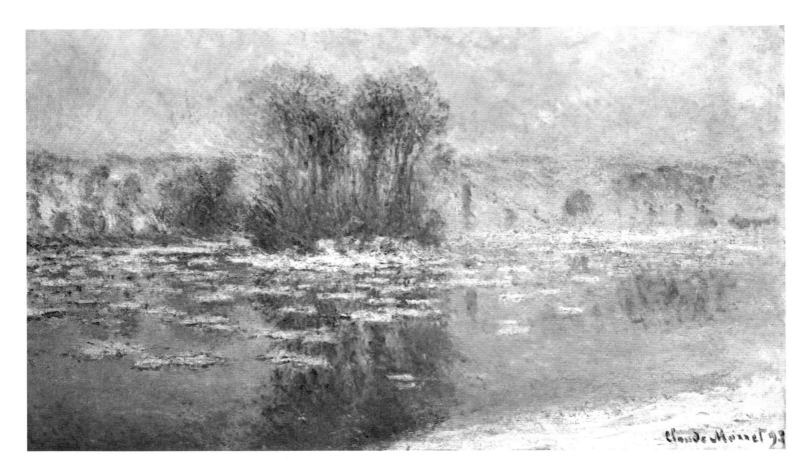

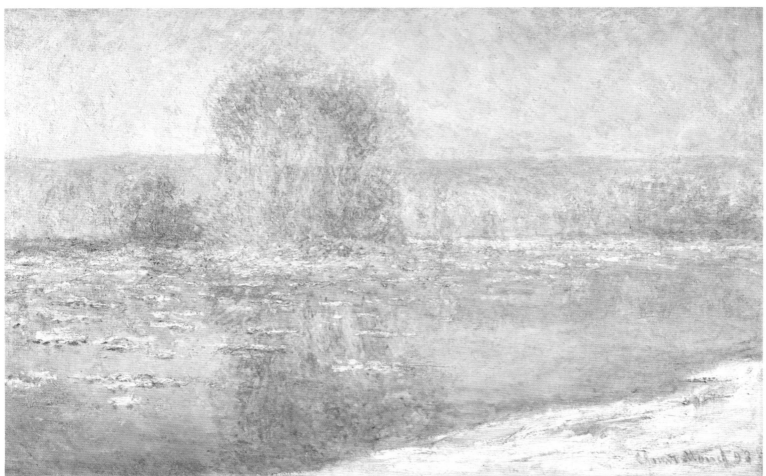

Above: Ice Floes (Bennecourt), *Bennecourt, February 1893; oil on canvas; 60 × 100 cm (23¼ × 39 in); signed and dated; Private Collection.*

Below: Ice Floes (Bennecourt), *Bennecourt, February 1893; oil on canvas; 65 × 100 cm (25 × 39 in); signed and dated; Private Collection.*

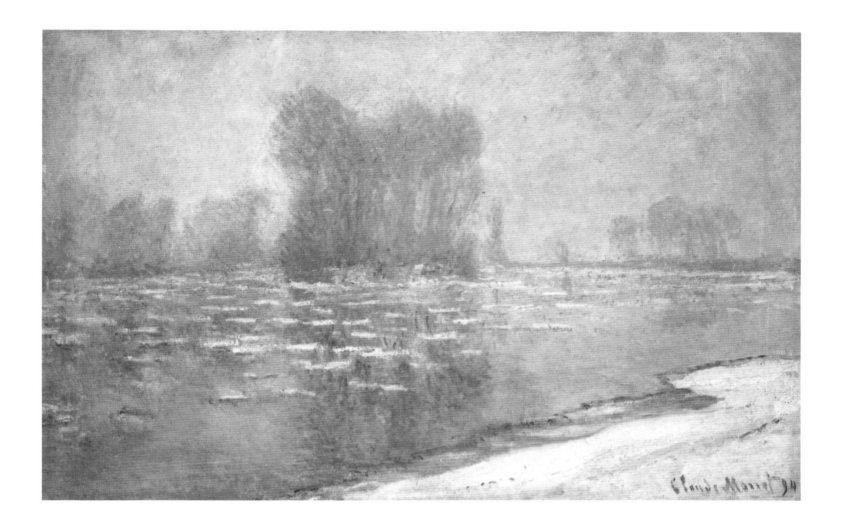

Ice Floes (Morning
Haze), *Bennecourt,*
February 1893; oil
on canvas;
66 × 100 cm
(25¼ × 39 in);
signed and dated
(1894); Museum of
Art, Philadelphia.
Monet must have
made a mistake in
the date.

218

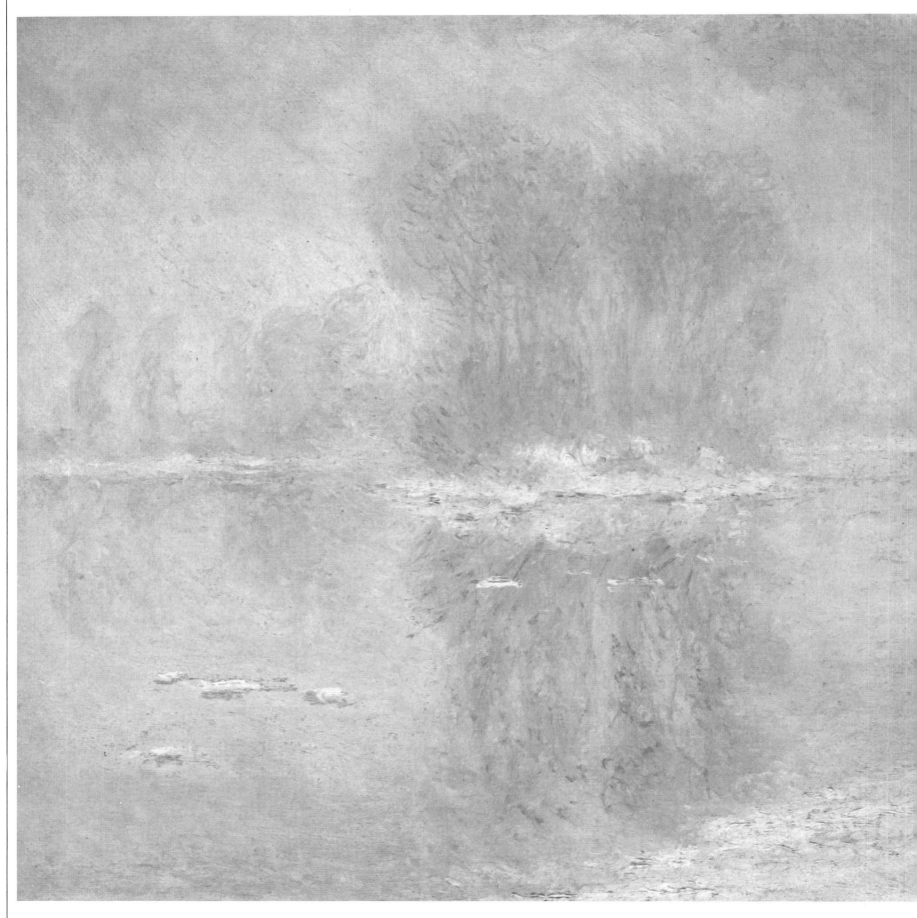

The Thaw,
Bennecourt,
February 1893; oil
on canvas;
65 × 100 cm
(25 × 39 in); signed
and dated;
Metropolitan
Museum of Art,
New York. The
brief Bennecourt
series takes up a
theme already
painted in the
winter of 1879-80, a
theme Monet was
fond of for
symbolic reasons,
among other things,
in that it allowed
him to represent the
recovery of the
mirroring capacity
of the water after
the frost and the
river returning to its
liquid and mutable
state, which is a
return to life after
the total, surreal
standstill of the
"white death."

220

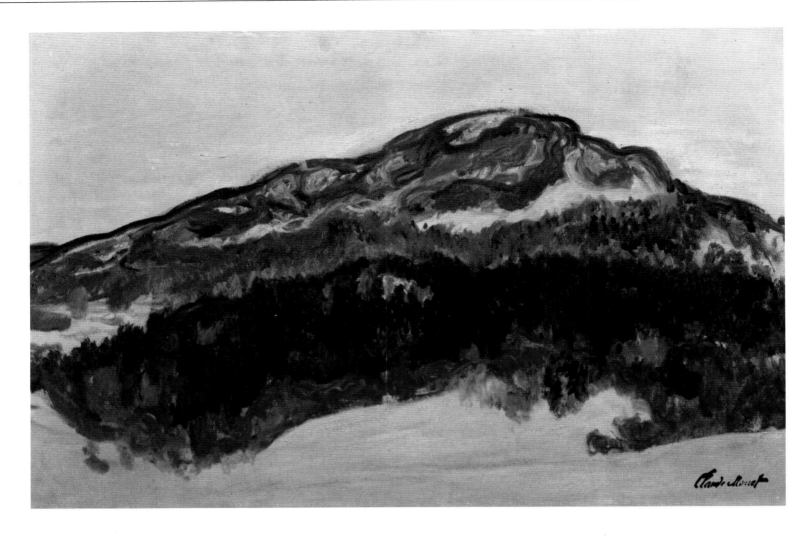

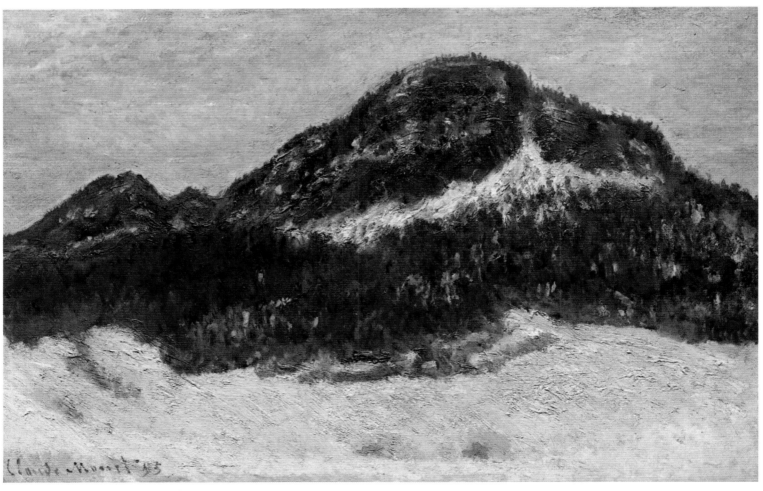

221

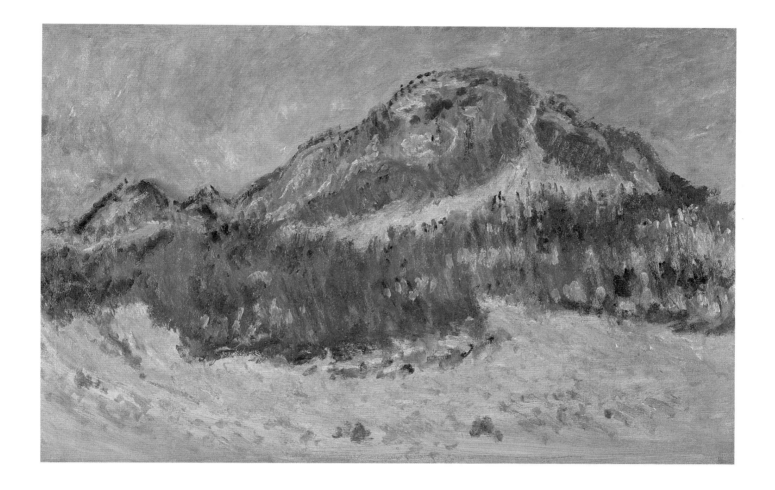

Opposite above:
Mount Kolsaas
(Norway),
*Sandviken (near
Oslo),
February-March
1895;
oil on canvas;
65 × 100 cm
(25 × 39 in);
signed; Musée
Marmottan, Paris.*

Opposite below:
Mount Kolsaas
(Norway),
*Sandviken (near
Oslo),
February-March
1895; oil on canvas;
65 × 100 cm
(25 × 39 in); signed
and dated; Private
Collection,
Chicago.*

Above: Mount
Kolsaas (Norway),
*Sandviken (near
Oslo),
February-March
1895; oil on canvas;
65 × 100 cm
(25 × 39 in);
Musée d'Orsay,
Paris.*

222

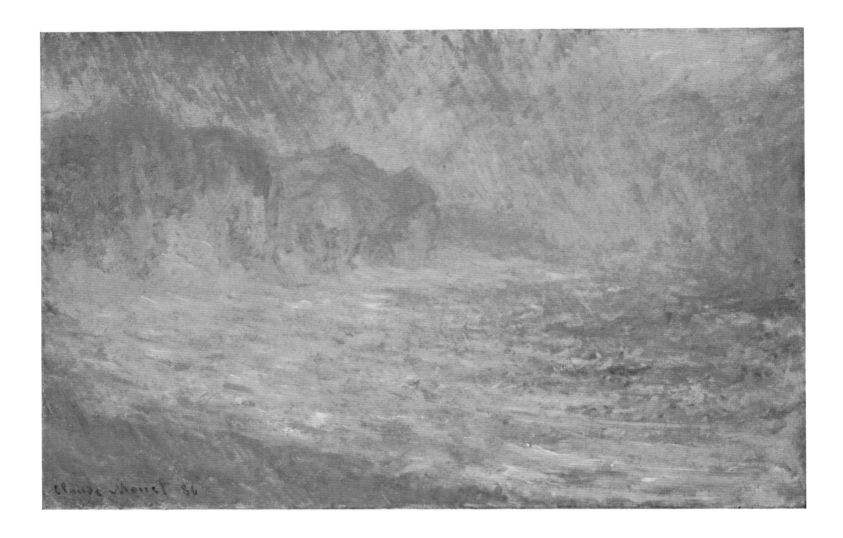

Above: Cliffs at
Pourville (Rain),
*Pourville, spring
1896; oil on canvas;
65 × 100 cm
(25 × 39 in); signed
and dated (1886);
Private Collection.
The date given by
Monet is incorrect
and probably due to
absent-mindedness.*

Opposite above:
Cliffs at Pourville
(Morning),
*Pourville, 1896-97;
oil on canvas;
65 × 99 cm
(25 × 38½ in);
signed and dated
(1897); Private
Collection. Monet
certainly began the
paintings
reproduced on this
page in the spring
of 1896.*

Opposite below:
Cliffs at Pourville
(Morning),
*Pourville, 1896-97;
oil on canvas;
66 × 101 cm
(25¼ × 39½ in);
signed and dated
(1897); Museum of
Fine Arts,
Montreal.*

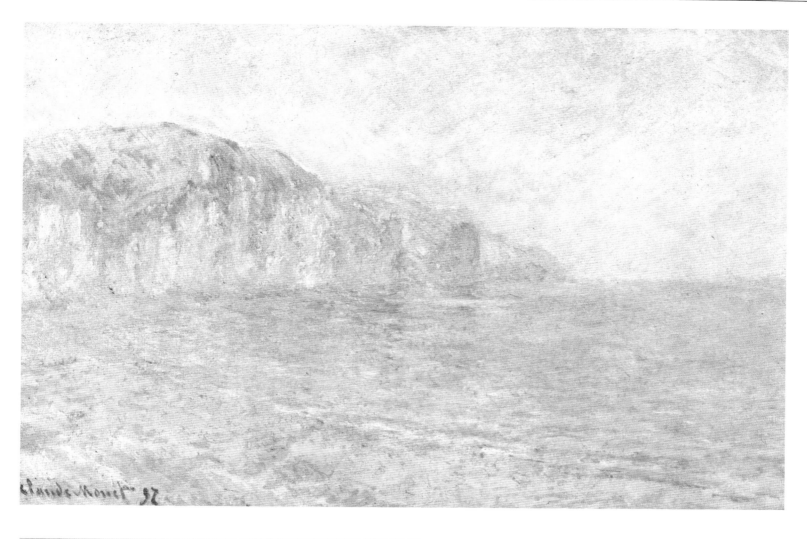

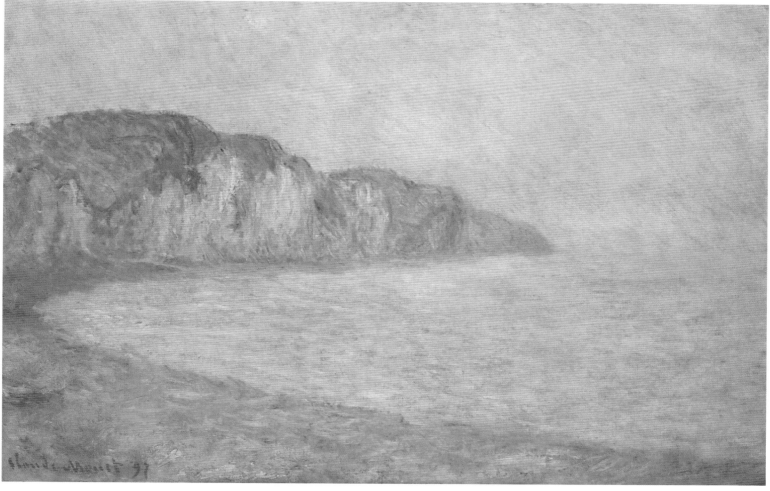

224

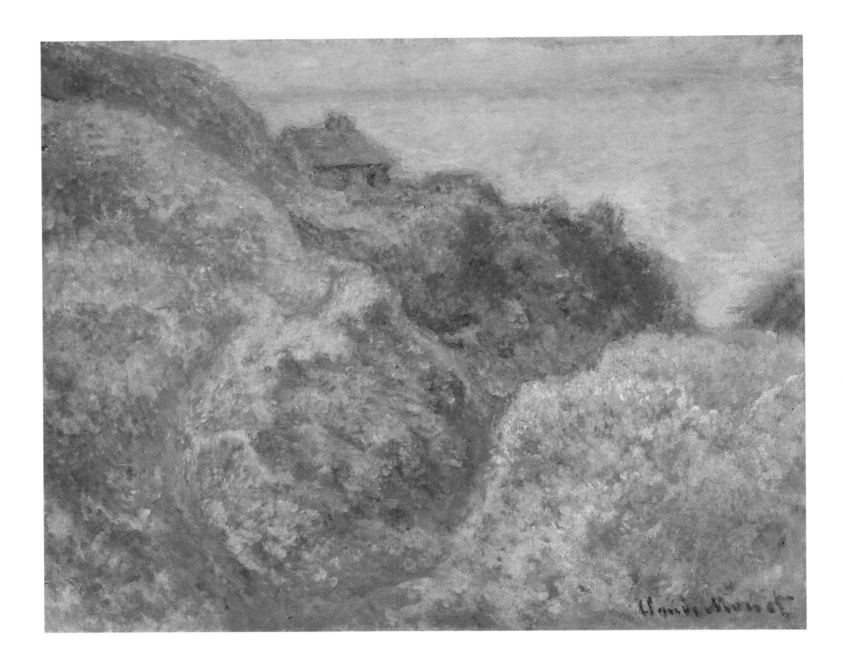

Gorge of the Petit (24⅛ × 31⅞ in);
Ailly (Varengeville), signed;
Varengeville, spring *Metropolitan*
1896; oil on canvas; *Museum of Art,*
64 × 81 cm *New York.*

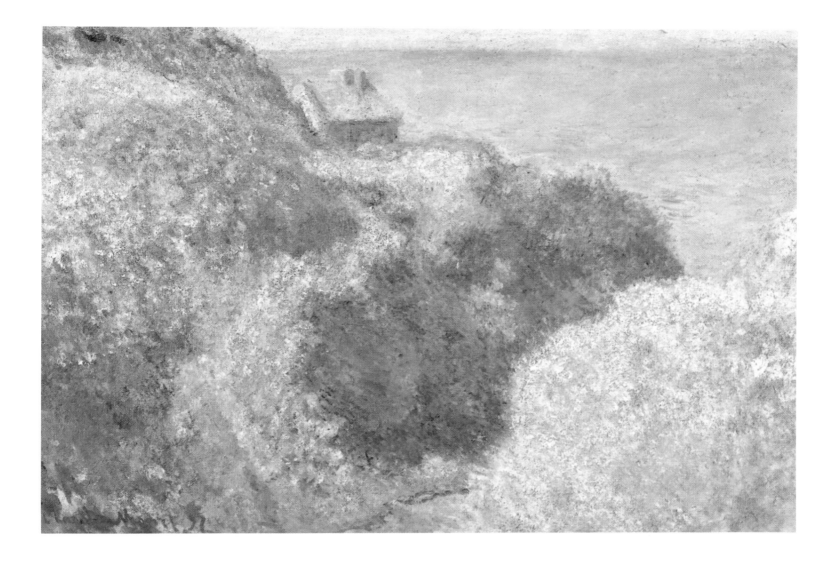

Gorge of the Petit
Ailly (Varengeville),
*Varengeville, spring
1896; oil on canvas;
65 × 92 cm*
*(25 × 35¾ in);
signed and dated
(1897); Fogg Art
Museum,
Cambridge (Mass.).*

226

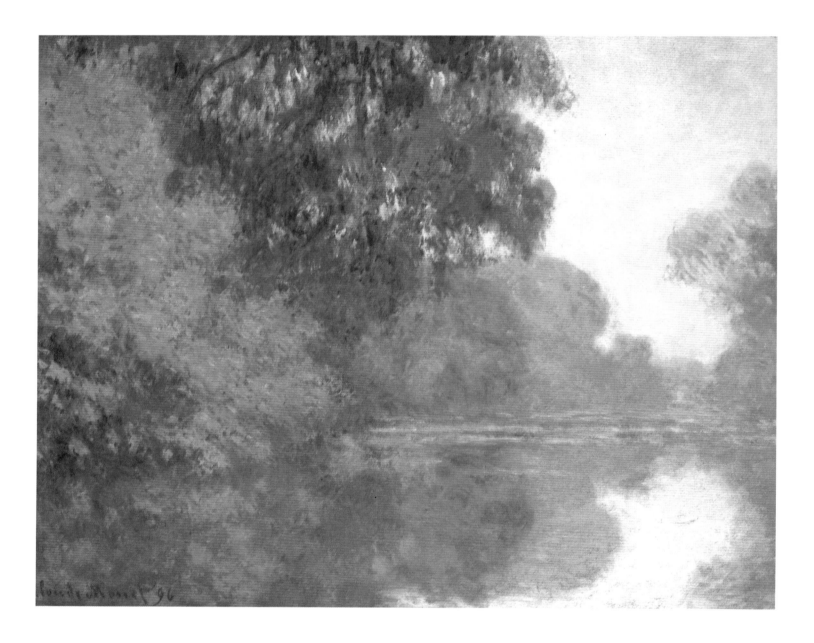

Morning on the
Seine, near
Giverny, *environs
of Giverny, 1896;
oil on canvas;*
74 × 93 cm
*(28¾ × 36 in);
signed and dated;
Museum of Fine
Arts, Boston.*

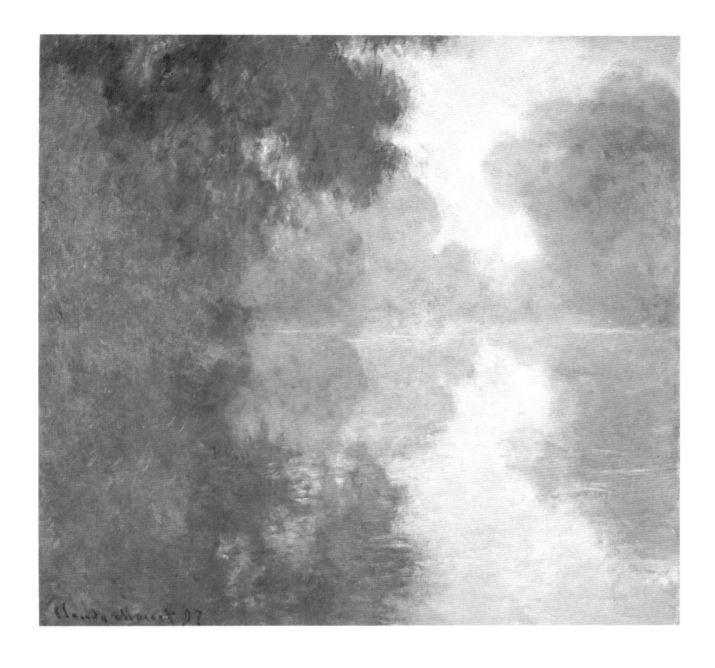

Morning on the
Seine, near Giverny
(Mist), *environs of
Giverny, 1896-97;
oil on canvas;
89 × 92 cm*

*(34¾ × 35¼ in);
signed and dated
(1897); North
Carolina Museum
of Art, Raleigh.*

228

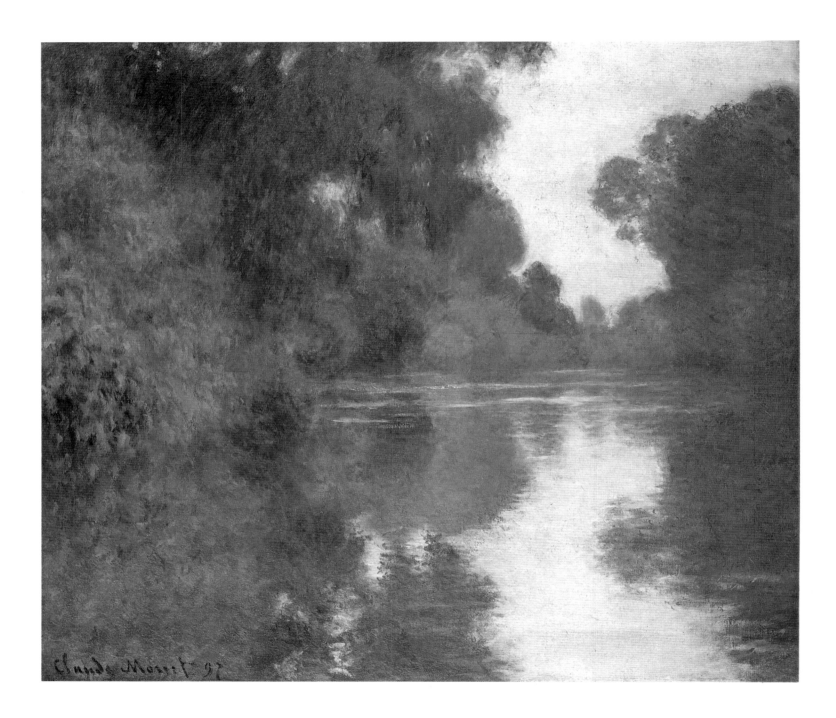

Morning on the
Seine, near
Giverny, *environs
of Giverny, 1897;
oil on canvas;*

*81 × 93 cm
(31½ × 36 in);
signed and dated;
Museum of Fine
Arts, Boston.*

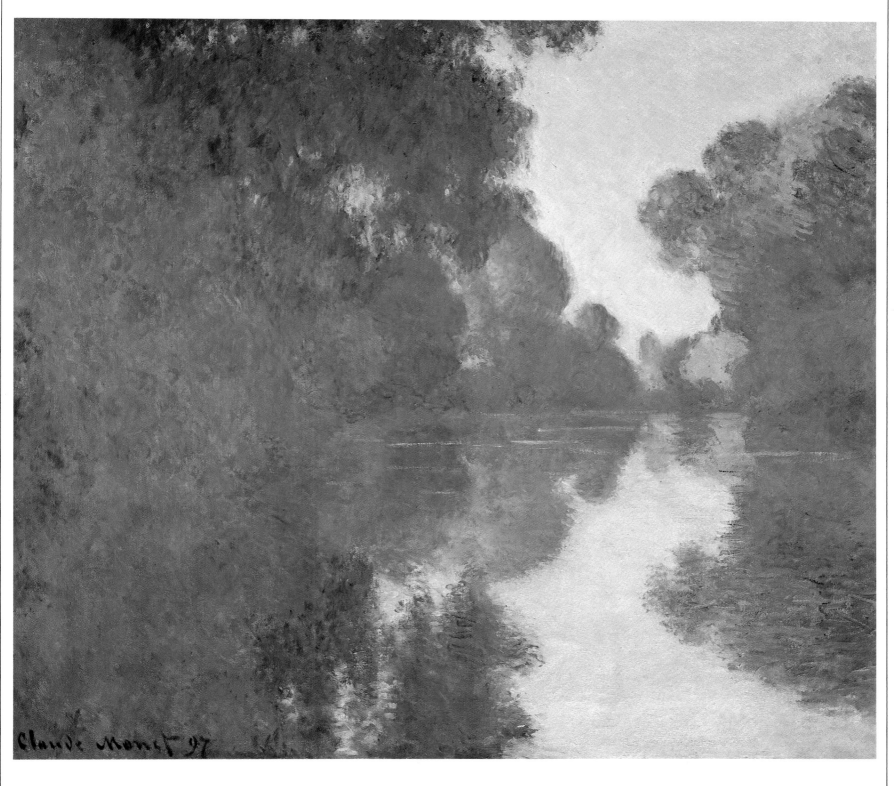

Morning on the
Seine, near
Giverny, *environs
of Giverny, 1897;
oil on canvas;
80 × 91 cm*

*(31 × 35¼ in);
signed and dated;
Metropolitan
Museum of Art,
New York.*

230

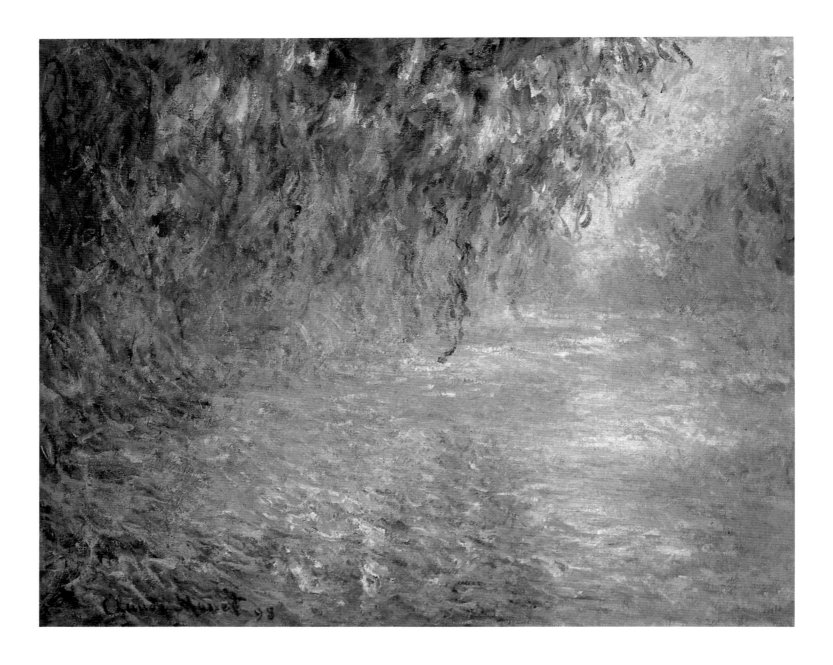

Morning on the
Seine, near
Giverny, *environs
of Giverny, 1898;
oil on canvas;
73 × 92 cm*

*(28¼ × 35¼ in);
signed and dated;
National Museum
of Western Art,
Tokyo.*

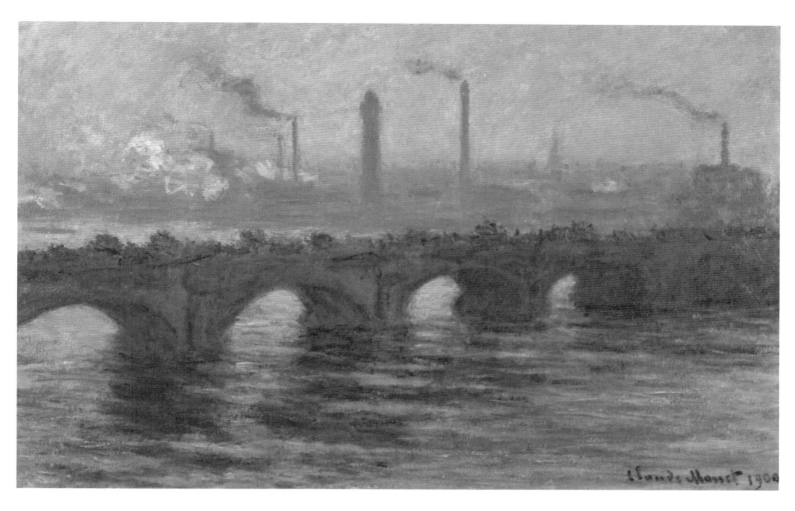

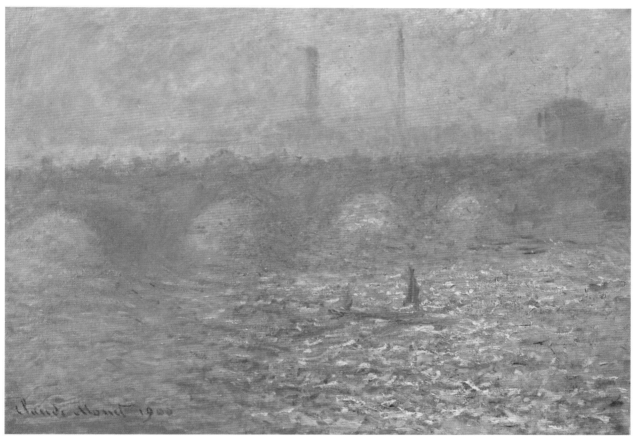

Above: Waterloo Bridge (Cloudy Day), *London, winter 1899-1900; oil on canvas; 64 × 93 cm* *(24¼ × 36 in); signed and dated (1900); The Hugh Lane Municipal Gallery of Modern Art, Dublin.*

Below: Waterloo Bridge, *London, winter 1899-1900; oil on canvas; 65 × 93 cm (25 × 36 in); signed* *and dated (1900); Museum of Art, Santa Barbara.*

232

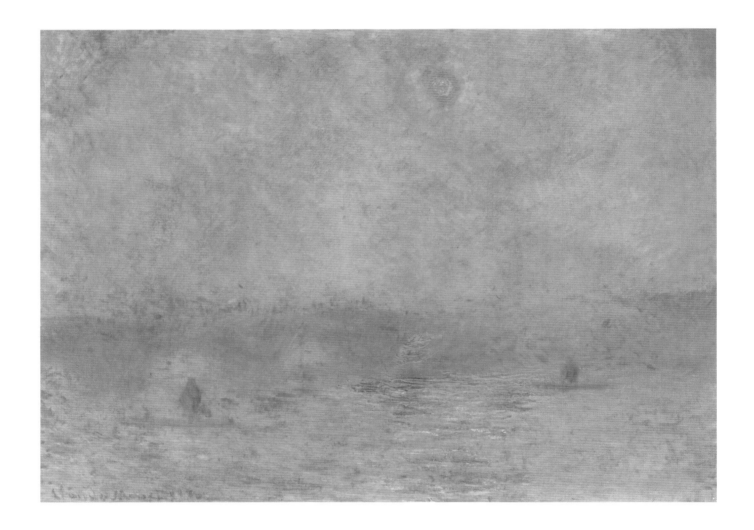

Waterloo Bridge
(Sun in the Fog),
*London, winter
1903-4; oil on
canvas; 73 × 100*
*cm (28¼ × 39 in);
signed and dated
(1903); Galerie
Nationale du
Canada, Ottawa.*

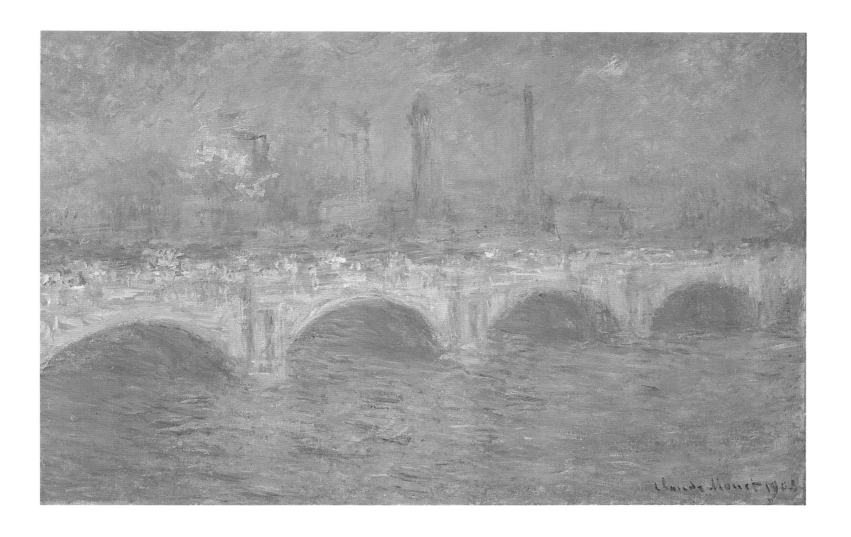

Waterloo Bridge, London (Sunlight Effect), *London, winter 1903-4; oil on canvas;* *64.5 × 100 cm (25 × 39 in); signed and dated (1903); Carnegie Museum of Art, Pittsburgh.*

234

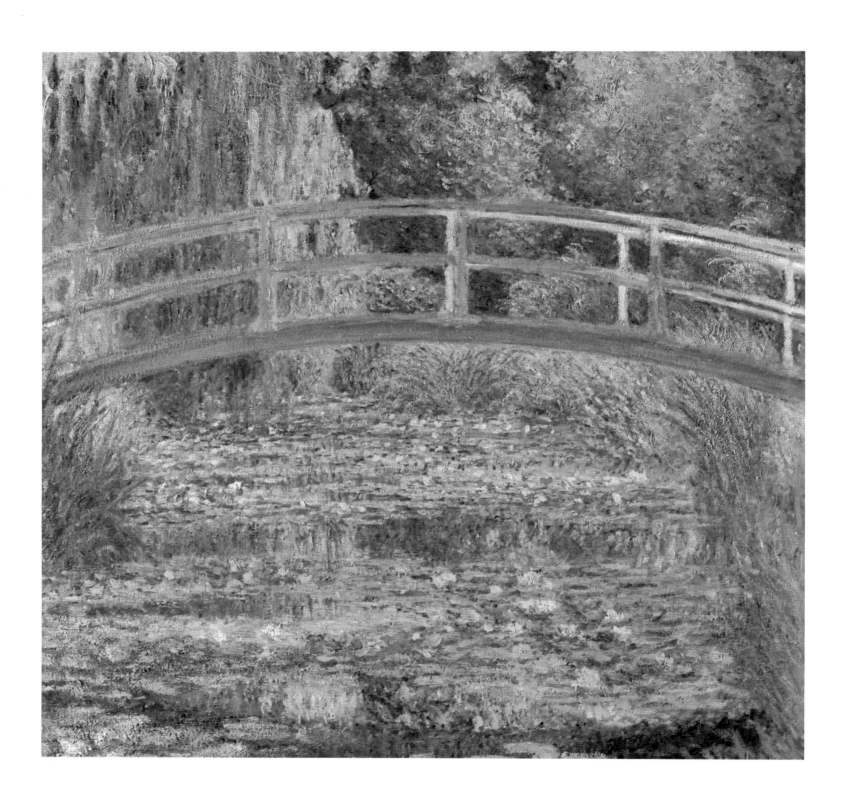

Above: The Water
Lily Pond
(Japanese Bridge),
*Giverny, autumn
1899; oil on canvas;
88 × 92 cm
(34 × 35¼); signed
and dated; The
National Gallery,
London.*

Opposite: The
Water Lily Pond
(Japanese Bridge),
*Giverny, autumn
1899; oil on canvas;
93 × 74 cm
(36 × 28¾ in);
signed and dated;
Metropolitan
Museum of Art,
New York.*

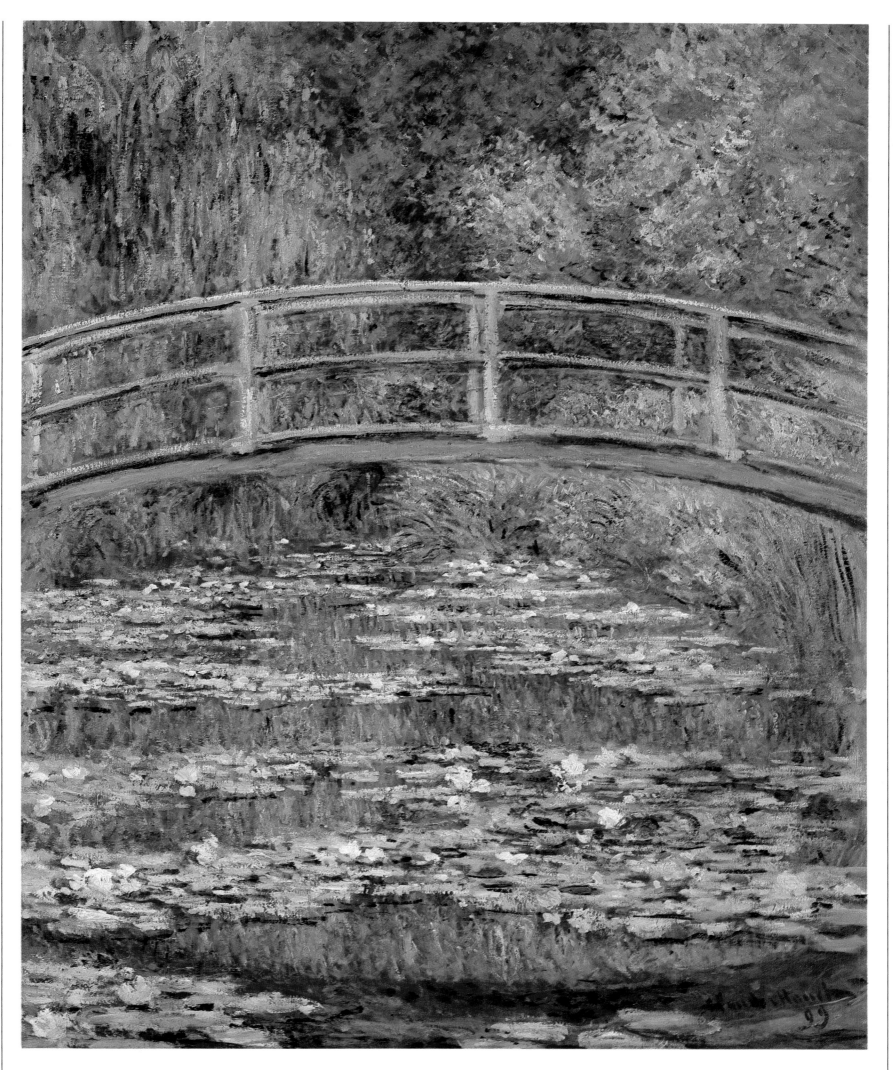

236

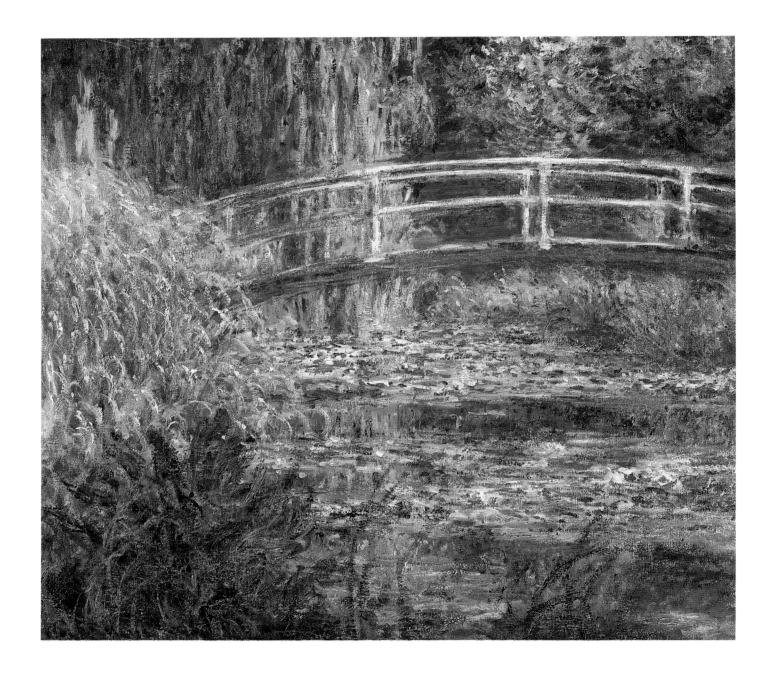

The Water Lily
Pond (Japanese
Bridge), *Giverny,*
spring-summer
1900; oil on canvas;
90 × 100 cm
(35 × 39 in); signed
and dated; Musée
d'Orsay, Paris.

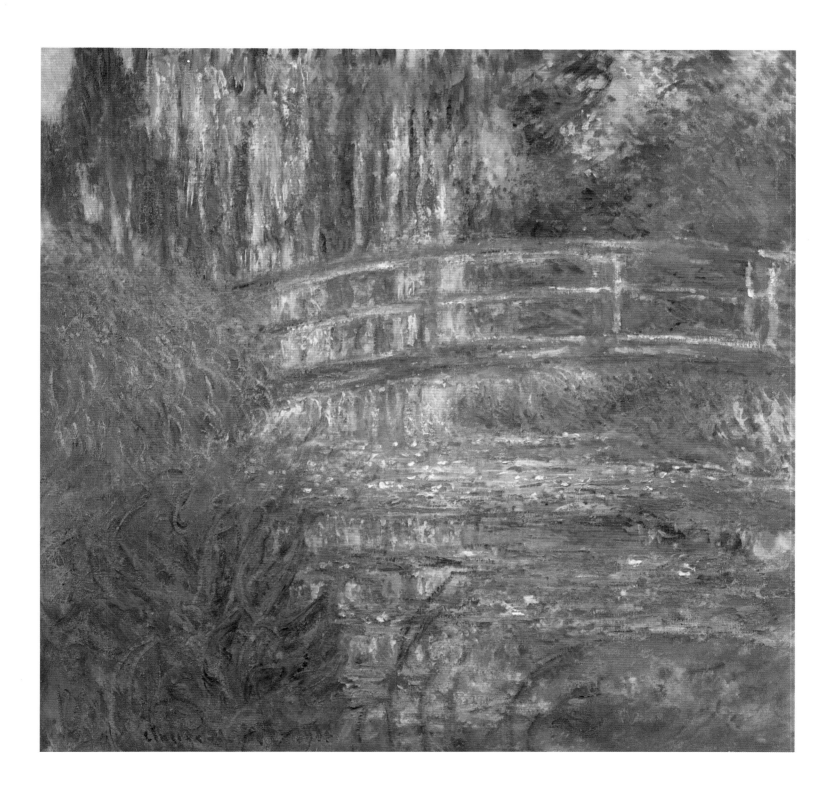

The Water Lily
Pond (Japanese
Bridge), *Giverny,*
spring-summer
1900; oil on canvas;

89 × 93 cm
(34¾ × 36 in);
signed and dated;
Museum of Fine
Arts, Boston.

238

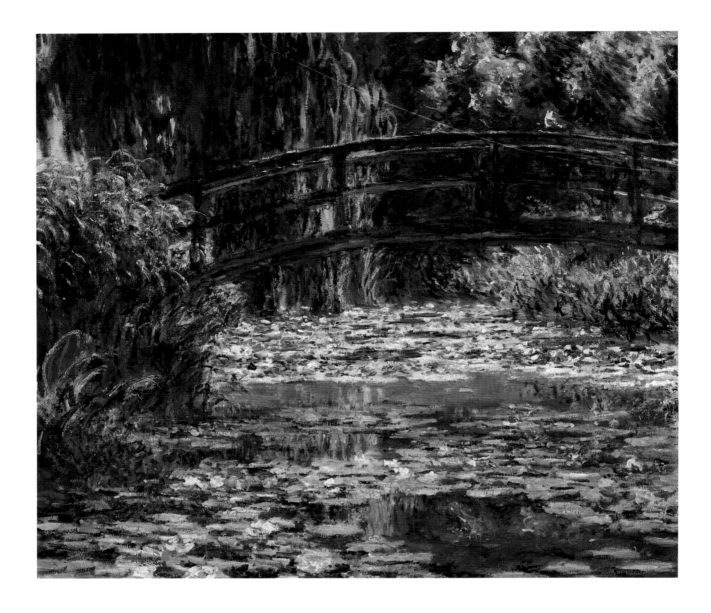

The Water Lily
Pond (Japanese
Bridge), *Giverny,*
spring-summer
1900; oil on canvas;
90 × 99 cm
(35 × 38½ in);
signed and dated;
The Art Institute,
Chicago.

The Artist's Garden
at Giverny,
Giverny, summer
1900; oil on canvas;
81 × 92 cm
(31½ × 35¼ in);
signed and dated;
Musée d'Orsay,
Paris.

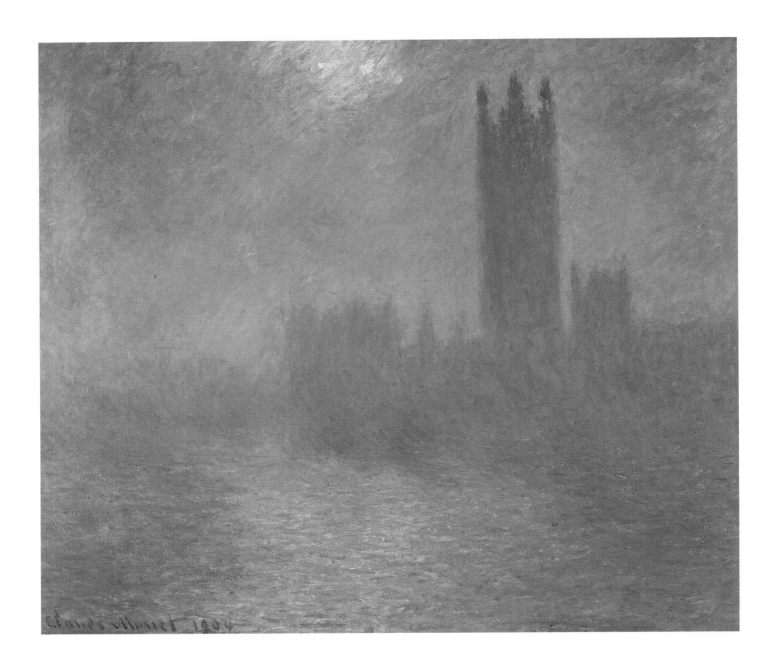

Above: London,
Parliament (Patch
of Sun in the Fog)*;
London, January or
February 1904; oil
on canvas; 81 × 92
cm (31½ × 35¾ in);
signed and dated;
Musée d'Orsay,
Paris.*

Opposite above:
Parliament
(Sunlight Effect in
the Fog)*; London,
January or
February 1904; oil
on canvas; 81 × 92
cm (31½ × 35¾ in);
signed and dated;
Private Collection.*

Opposite below:
The Houses of
Parliament
(Sunset), January
or February, 1904;
oil on canvas;
81 × 92 cm
(31½ × 35¾ in);
signed and dated;
Private Collection.*

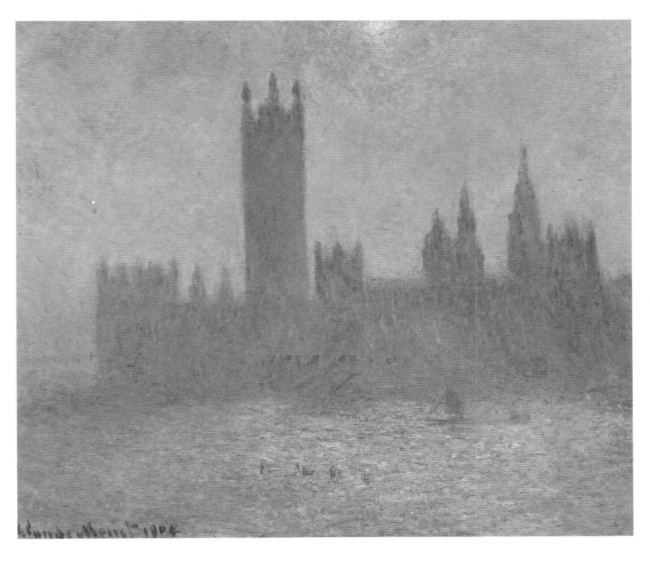

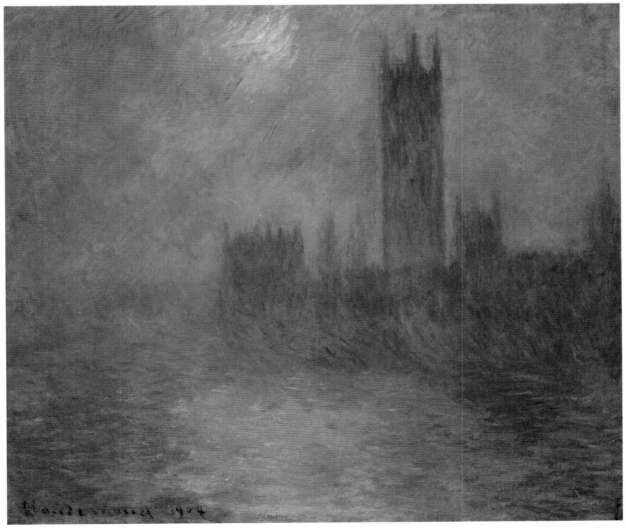

242

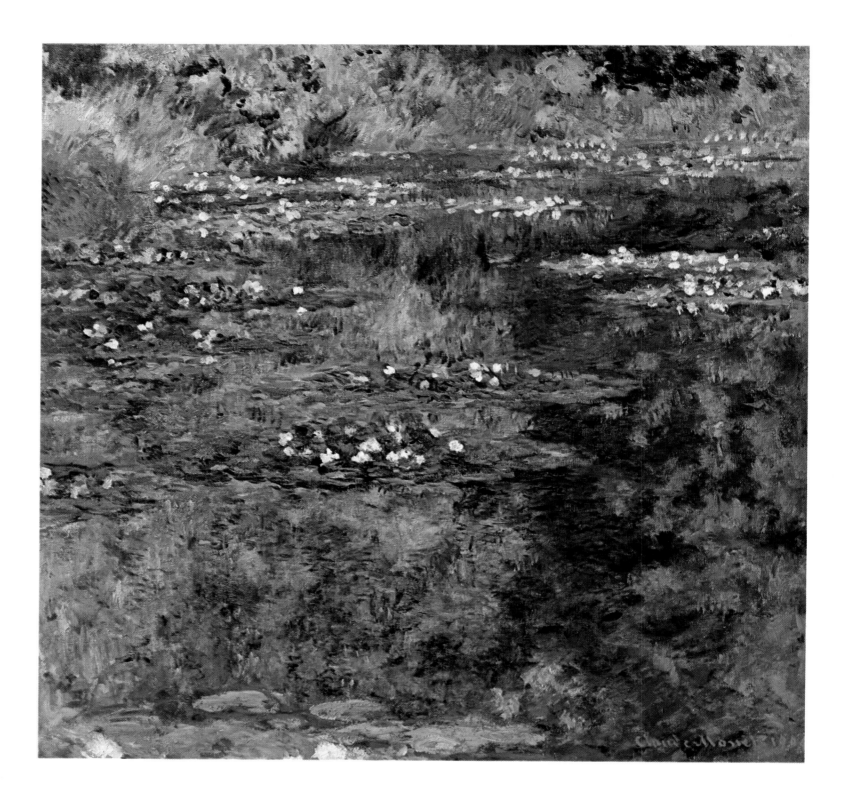

Above: The Water
Lily Pond, *Giverny,*
spring 1904; oil on
canvas; 90 × 92 cm
(35 × 35¼ in);
signed and dated;
Musée de
l'Orangerie, Paris.

Opposite: Water
Lilies, *Giverny,*
1905; oil on canvas;
90 × 100 cm
(35 × 39 in); signed
and dated; Museum
of Fine Arts,
Boston.

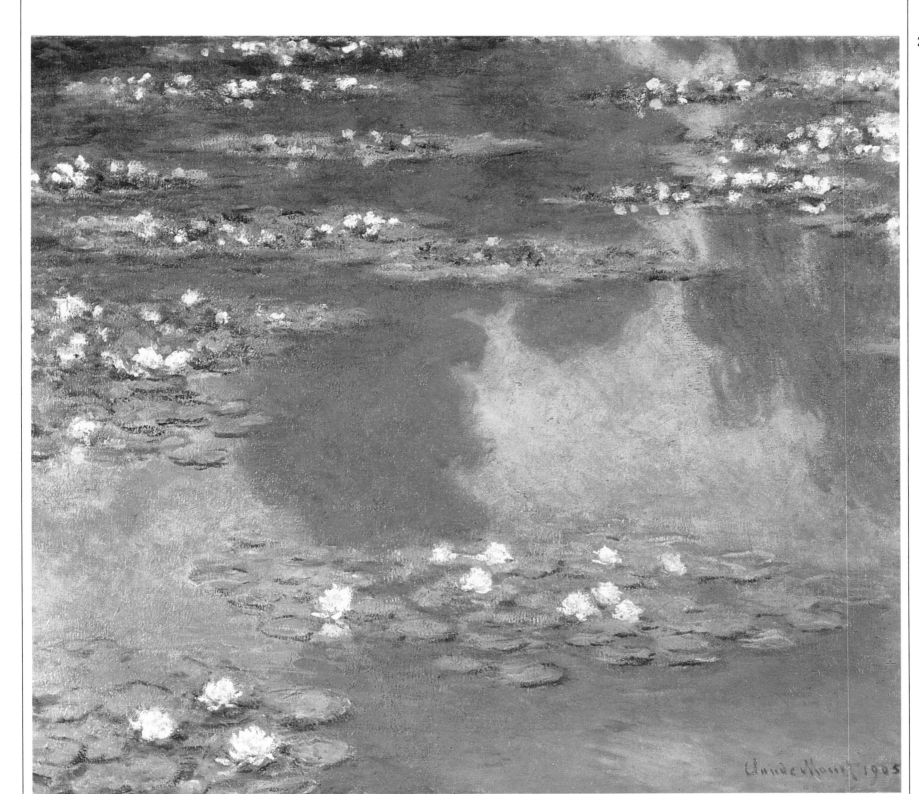

244

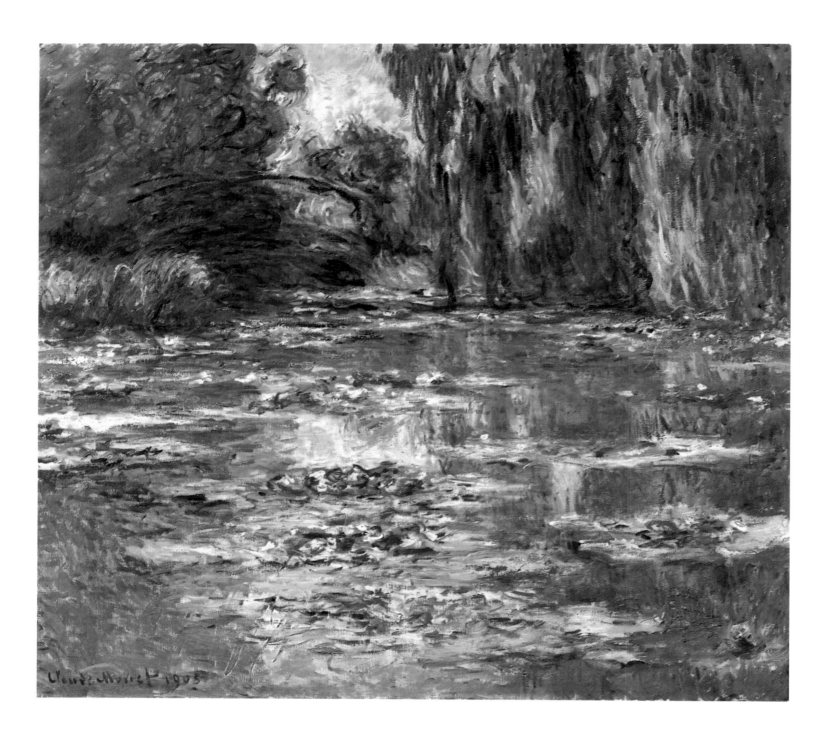

Water Lilies, 1905, (35 × 39 in);
Giverny, 1905; oil signed and dated;
on canvas; Private Collection.
90 × 100 cm

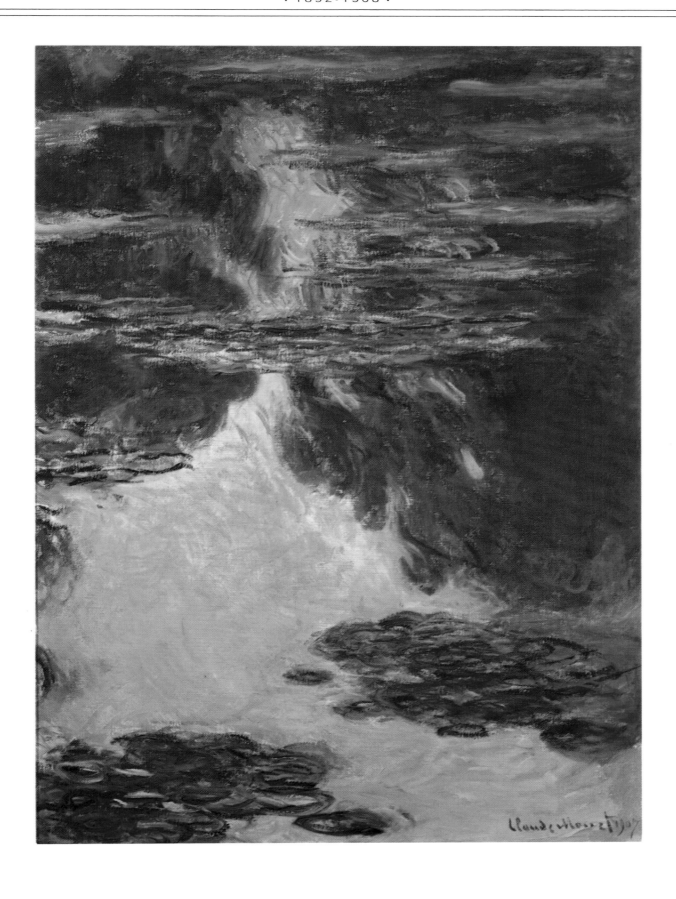

Water Lilies
(Evening); *Giverny,*
1907; oil on canvas;
100 × 73 cm
(39 × 28¼ in);

signed and dated;
Musée Marmottan,
Paris. This work is
part of the Water
Lilies, 1907 *series.*

246

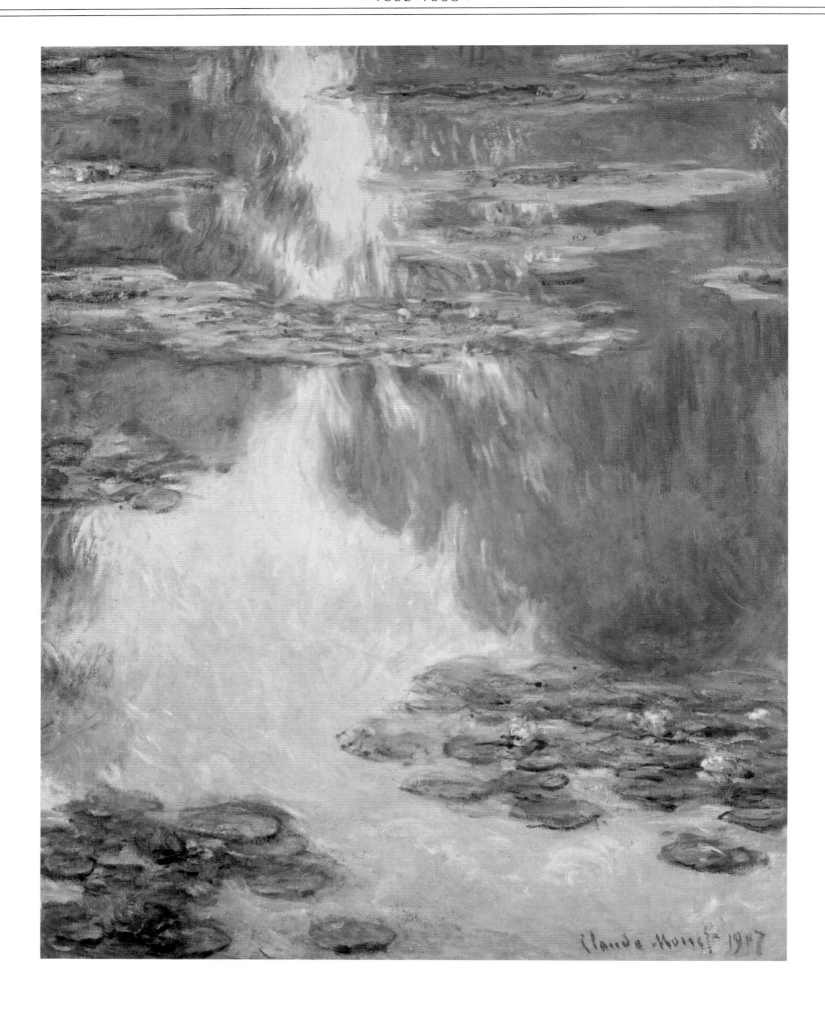

Water Lilies, 1907,
Giverny, 1907; oil
on canvas; 92 × 73

cm (35¾ × 28¾ in);
signed and dated;
Private Collection.

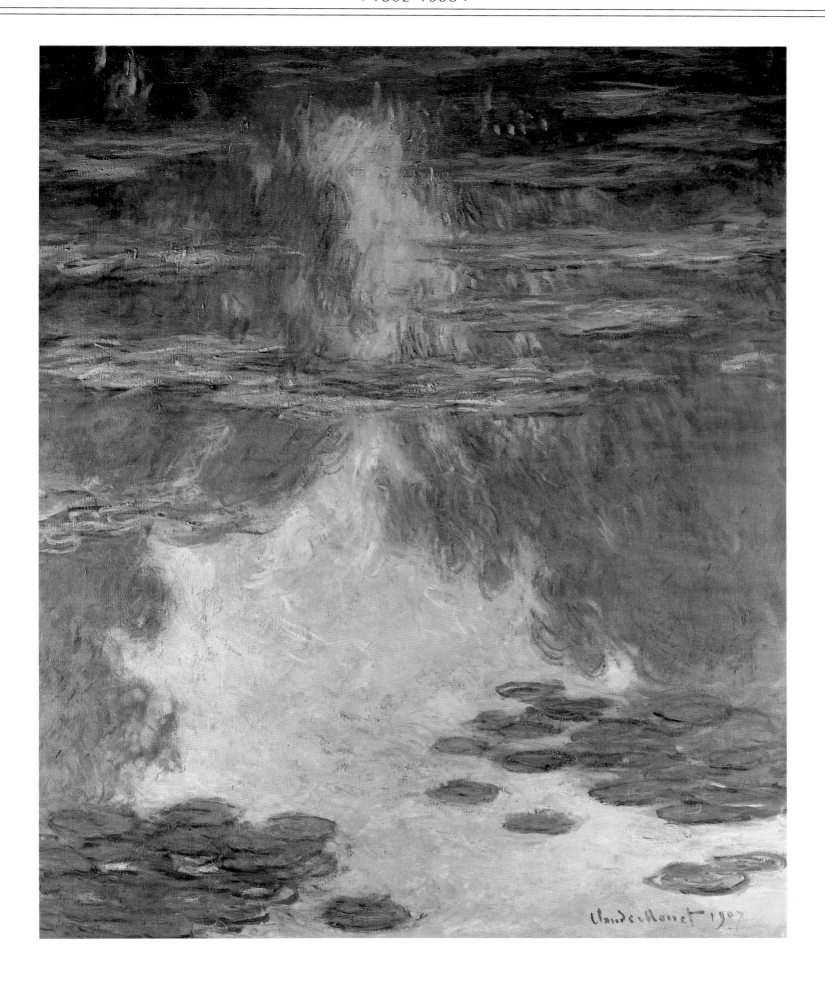

Water Lilies, 1907, (39 × 31½ in);
Giverny, 1907; oil signed and dated;
on canvas; Private Collection.
100 × 81 cm

248

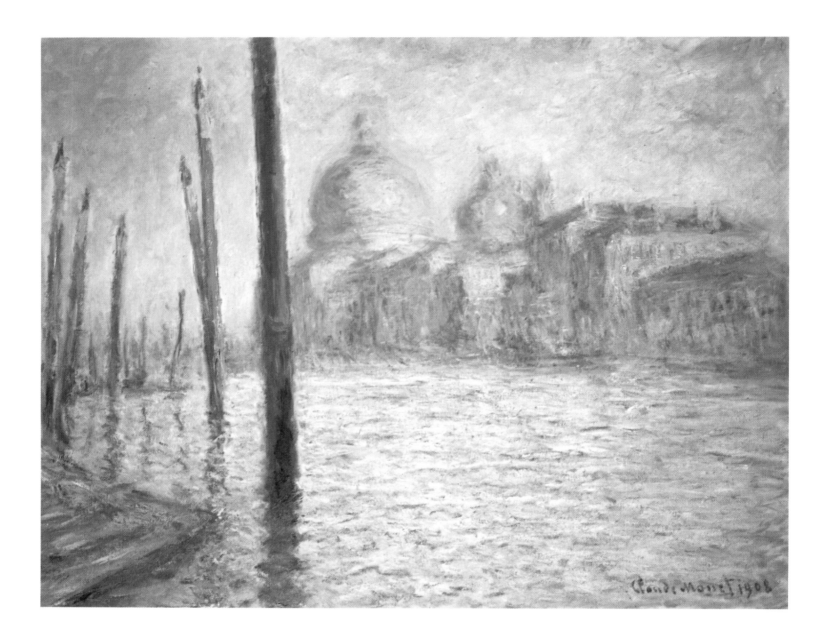

The Grand Canal,
Venice, *Venice,*
September-October
1908; oil on canvas;

73 × 92 cm
(28¼ × 35¼ in);
signed and dated;
Private Collection.

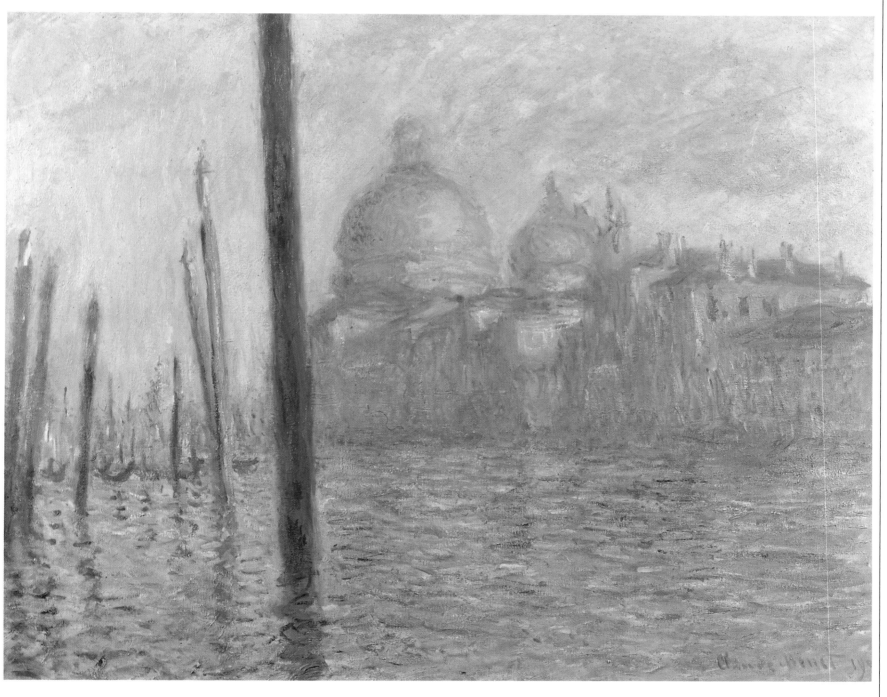

The Grand Canal
and the Salute
Church, *Venice,
September-October
1908; oil on canvas;*
*92.5 × 73.5 cm
(36 × 28½ in);
signed and dated;
Museum of Fine
Arts, Boston.*

250

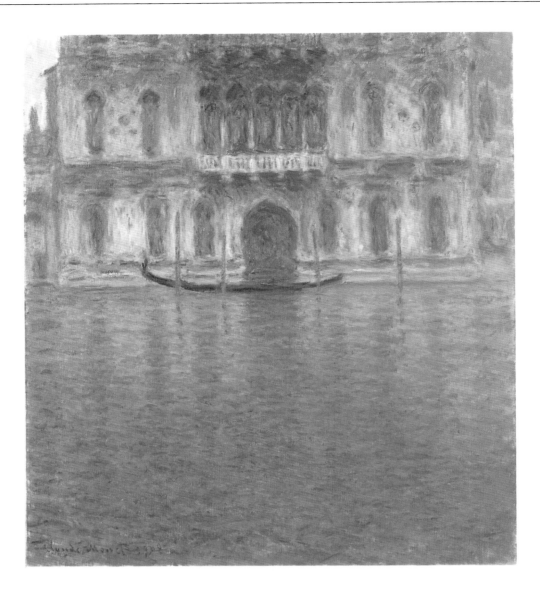

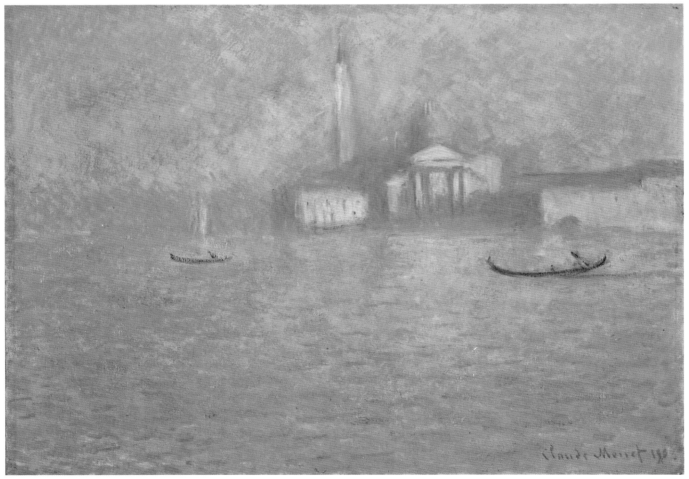

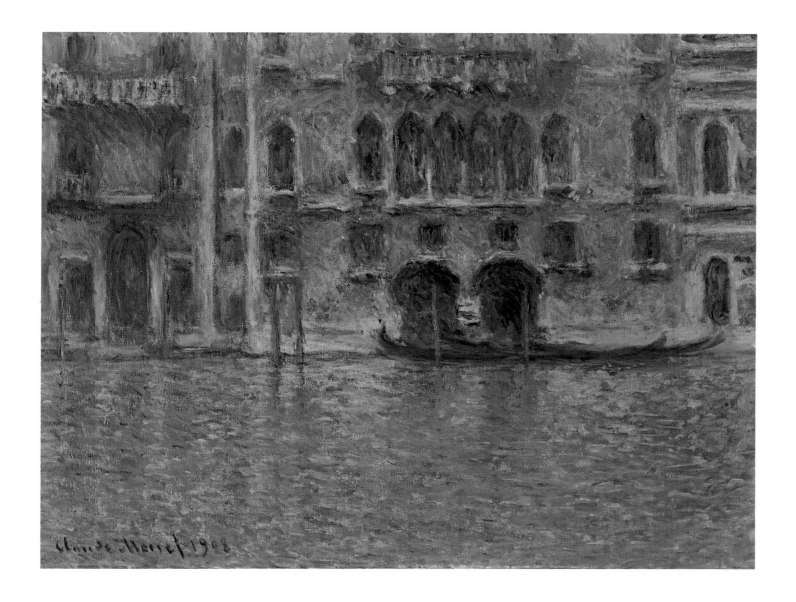

Opposite above:
Palazzo Contarini,
Venice, *Venice,*
September-October
1908; oil on canvas;
92 × 81 cm
(35¼ × 31½ in);
signed and dated;
Kunstmuseum, St.
Gallen.

Opposite below:
San Giorgio
Maggiore, Venice
(Twilight),
September-October
1908; oil on canvas;
63.5 × 81 cm
(24¼ × 31½ in);
signed and dated;
National Museum
of Wales, Cardiff.

Above: Palazzo da
Mula, Venice,
Venice,
September-October
1908; oil on canvas;
62 × 58 cm
(24 × 22½ in);
signed and dated;
National Gallery of
Art, Washington.

The last water lilies

We have already seen how Monet's late works must be viewed from different angles. This is not so much a question of single, well established viewpoints, but rather of a continuous line of vision, a hypothetical straight line perpendicular to the surface of the painting and necessarily limited by the size of the room or hall housing the painting. The pre-established viewpoint – that is, the one based on the perspective of the painting – is eliminated to be replaced by the possibility of moving along the axis of vision. This movement aims at gradually enveloping the viewer in the painting. An understanding of the painting begins with the place in which the total meaning of the work can be viewed, at a certain distance, but is then completed by the viewer moving closer to the work and progressively losing sight of the picture itself. The viewer is asked to plunge so deeply into the painting that the eye is no longer capable of making a synthesis of it, thus losing its figurative sense in order to decipher its hidden pictorial value.

Any intelligent visitor to the Musée Marmottan observing any work by Monet painted after 1890, is perforce tempted to approach the painting so closely that he can no longer see the whole. Normally one moves in front of a painting only to find the ideal position, the point where one can see it better; and it is not important if the person who does so believes he is making a personal choice, for the artist has in fact already established that viewpoint for him. Inevitably, the artist obliges the viewer to look at his work from a particular viewpoint by means of perspective. In Monet's case however, the viewer moves around with another purpose in mind; he is bewitched by the changes the painting undergoes before his very eyes, is captivated by the multiplicity of meanings that are formed and then fade away in his presence. The canvas shifts endlessly from one pole to the other, the model becoming more or less recognizable, the painting becoming more or less visible and ready to change with every step the viewer takes. The onlooker moves around precisely in order to see the canvas change, to increase the number of paintings that lie in that rectangle of framed canvas physically hanging on the wall. He would like to glue his eye to the surface, open a passageway inside the brushwork, dive into the painting and then move away from it in order not to recognize the paints and see them fade away when the figural aspect again becomes visible and dominates.

The subject of the water lily pond, which Monet introduces around 1907, allows him to explore the idea of immersion or envelopment on both the level of symbols and that of content. First of all we note that immersion is really such only when the horizon disappears from the represented space, that is, when the axis of vision is oriented in a flat sense from above to below. So, however impressive and thematically pertinent they may be, the Japanese bridge paintings (1899-1900), in which our glance is parallel to the ground, are in reality only a partial anticipation of immersion; the painting must coincide totally with the mass of water, which must become all-embracing, wholly compelling, before the envelopment can start taking effect. This phenomenon is totally at work in the 1907 versions of the *Water Lilies* and in all the similar works Monet painted later, such as *Water Lilies, The Irises* (1910-1915, Zurich Kunsthaus), *Water Lilies* (1915, Musée Marmottan) and *Water Lily Pond, Giverny* (1919, Private Collection). In these paintings there is no element that does not stem from the aquatic principle, and the world becomes visible only insofar as it is mirrored in the pond.

There is one exception to all this – the grandiose cycle of *Water Lilies* at the Orangerie, which Monet began in 1914 and finished in 1918, and then reworked from 1920 to 1926. These enormous panels with which Monet tried to achieve a sort of global pictorial environment, almost a replica of the pond at Giverny in various guises, sometimes offer something vaster than the surface of the water. In the first half of the Orangerie panels (*Morning, Clouds, Green Reflections, Sunset*) the external elements such as the clouds in the second work are present only as reflections, while in the panels in the other hall (*Morning with Weeping Willows, Two Weeping Willows*, etc.) the trees are placed at the sides and above the pond but without our eye level being raised at all. We should not overlook the fact that in the last period of his life Monet also worked on paintings in which earthly nature remained as a subject, albeit within a web of meanings and appearances; for example in the following series: *Weeping Willow* (1918-19), *Wisteria* (1918-1920), *Japanese Bridge at Giverny* (or *Water Lilies, The Japanese Bridge*, 1923-25), and *The Path with Rose Trellises, Giverny* (1920-1922).

In the Orangerie paintings the pond is the only horizon, a primeval, allegorical site of the birth of vision, the total mirror of the world and our consciousness of it, the dark recess from which the language of painting takes on life among fragments of reality and optical phantoms. The prime motif concerns the presence of a closed-off space that makes the surface of the canvas correspond to a continuous, homogeneous wall (the negation of depth): an opaque screen where the glance comes to a halt. The compactness of this screen, which is only apparently negated by the mirroring qualities of the water, means forgoing the realistic, descriptive faculties of painting. Thus the rejection of the horizon is also a de facto rejection of the "earthly landscape" – the vast world rich in phenomena – that up to this time Monet had for the most part painted. In its place is the teeming but secret dimension of the pond, complete unto itself, a microcosm of strange events: birth, blossoming, encounter, death and decay. This is an obvious invitation to envelop oneself and penetrate another vast, totally independent universe. But we must remember that the pond is not only this. Its surface reflects, so that it bears the memory of the outside world; and it refers to the sky, the foliage of the weeping willows, the irises, the agapanthuses, the grassy banks, the shoots, wisteria and clouds. We can intuit these memories, make out their traces in the colours of the water. But they are merely reflections and allusions. The water neither describes nor enumerates; it is content to suggest. And, by the same token, Monet's painting no longer expresses or narrates, it merely suggests.

We should ask what the pond really is. And, even more forcefully, what it reflects. Various critics have attempted to find an answer to this. Francesco Arcangeli says: "Evidently Monet had chosen

the water lily pond [...] exactly because these horizontal layers were suspended in a sort of aimless drifting and were almost struggling mysteriously with those parts where the water reflects the vegetation above it. [Monet] wants to render the idea of continuous, infinite space in which there is conflict, the alternation of something." So the pond can be seen as a struggle, as different types of reality in conflict, as the impossibility of distinguishing what lies above from what lies below (or inside), as the loss of every clear spatial rule. According to Maurice Merleau-Ponty, the mirror is a metaphor of painting because it demonstrates the problematical nature of the relationship between the figurative sign and the narrated object: "What use is it to daydream about reflections or mirrors? [...] The similarity between the object and its mirror image is only an exterior denomination that belongs to the realm of thought [...] Images lose their power. No matter how vividly [a drawing] represents forests, cities, men, wars and storms for us, it does not resemble them: it is merely a bit of ink set here and there on paper. It can scarcely retain the figure of things, and it is a flat figure on a single plane, deformed; and it must be deformed [...] in order to represent the object. It is its image only insofar as it does not represent it. But if it does not act through similarity, how then does it act? It stirs our thought as do signs and words which in no way resemble the things they signify."

The mirror is proof of the optical illusion that lies at the base of artistic expression. In the specific case of the pond at Giverny, there is no doubt that its surface (more opaque than lucid, both liquid and solid) reflects in the first place the impasse Monet had learned to reckon with – the difficulty in seeing. What is seen is the reflection, but it is also the bottom, the surface, the wall of water. Immersion is possible not so much because the pond shows us something, but exactly because what it shows is hard to decipher. There are three levels of appearance: the substance of the water per se that flows among the water lilies and other plants; the plants that live in the water; lastly, the things mirrored in the water. By carefully studying the panels in the Orangerie, one realizes that it is virtually impossible to establish what they show us (or, rather, what they refuse to show us). Here too, as in the case of the *Gare Saint-Lazare* series, Monet could rejoice at the fact that "hardly anything is recognizable. It is a magic spell, a veritable phantasmagoria," because the function of the pond is to mix the three levels mentioned above, and therefore to confound the reality proper of the pond, the reality reflected, and the screen of reflection. The water refuses to restore the image of what lies above it; it refuses to make what is in it live, and to allow itself to be penetrated so as to reveal its depths. This sets in motion a mechanism whereby another level can be perceived – that of the canvas and the physical matter the artist has applied on to it. Therefore the viewer's moving around in front of the painting takes on added meaning: it is the consequence of the struggle he must undergo in order to interpret the painting and it echoes the inner conflict among the various parts of the painting. Viewing the painting becomes dynamic because no position is wholly satisfactory, because there is no viewpoint from which the work becomes clear. Thus one can easily understand the value of placing the most important cycle of water lilies in the Orangerie du Louvre, when the French state paid homage to Monet by offering to put at his disposal this prestigious pavilion dominating the Place de la Concorde from the Tuileries garden. In this building – refurbished for the occasion under Monet's supervision – the two oval halls were conceived with the aim of creating a total, continuous pictorial environment, a homogeneous site in which the paintings, on long, curved panels, would "enfold" the visitor, assailing him from all sides. Monet was therefore given the opportunity to make a great stride forward, on a personal as well as artistic level, by leaving his studio and changing his sixty year-old creative routine. After 1918 he began reworking some paintings he had either abandoned or left unfinished, transforming them all with a few, essential changes into a decorative whole, a vast sequence of organically related canvases. This body of work was, however, not at all decorative in intent. It represents the realization of an aesthetic which Monet had pursued for a long time: the pictorial artifice as involvement and definitive conviction, as the capacity to fuse space, subject, painting and viewer. The vitality of the water lilies series stems from this perfect fusion. Considering the need that led Monet to organize his late oeuvre into "cycles", it must be said that in this case the result is by far the most convincing: the Orangerie paintings are not exactly a cycle, but rather go to make up a single work.

It is easy to see how the theme of the pond in itself contained the symbolic potential that would lead to such an achievement. "All my efforts are directed simply at realizing the greatest possible number of images intimately connected to unknown realities," Monet said. "My merit lies in having painted only directly from nature, in an attempt to convey my sensations in the presence of the most fleeting effects." These two statements may appear contradictory, but not if one considers the theme that generated these effects. Monet's truth is an extraordinary abstraction. Already in his *Pink Boat* (1887) the natural result was quite mysterious and unfathomable ("I'm trying to do impossible things: grass moving under black water."). And in the water lilies the subject is in itself something that needs to be discovered.

According to Michel Butor, in the Orangerie paintings "the real pond is no longer present as a model (or as an alibi), but as a maestro." This critic underscores the significance of the concepts Monet introduces here, concepts that are the cornerstones of his singular brand of abstractionism: envelopment, the device of the mirror and so on. "The rising horizon, already quite evident before, has now become absolute; by now sky or distance appear only in their being reversed, and the surface of the water becomes straight all around us in a vertical sense, which solicits a dream of flight or immersion [...] There is already something here that defines the canvas as a dense, germinating and flowering mirror, because there are the water lilies, through which everything becomes legible."

253

254

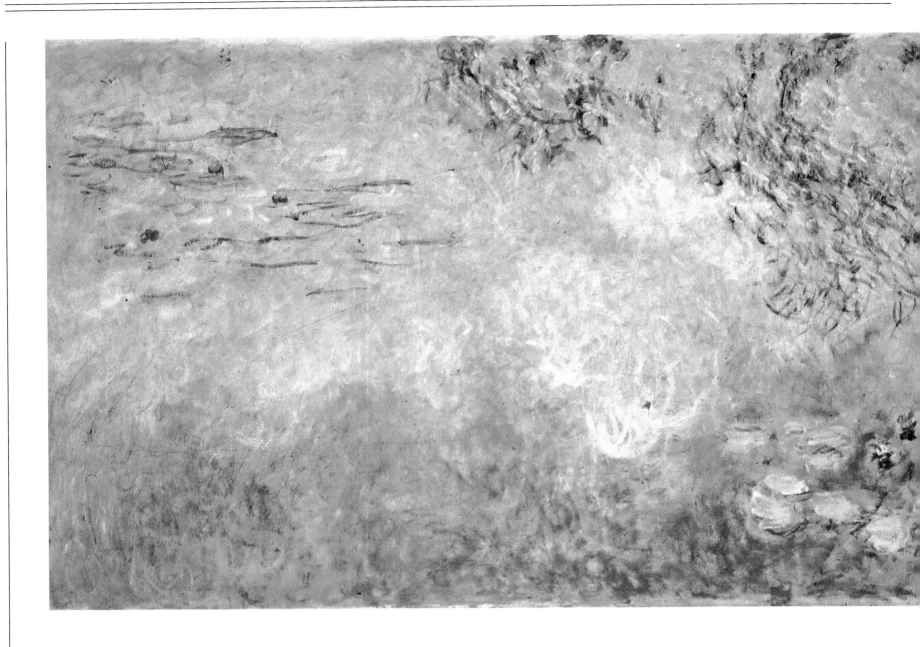

Above: Water Lilies, the Irises, Giverny, c. 1910-15; oil on canvas; 200 × 600 cm (78 × 234 in); Kunsthaus, Zurich. Art scholars have attributed different dates to this work: Rossi Bortolatto says it was painted in 1910, but she gives it the title Water Lilies, Evening Light, perhaps mistaking it for another painting in the Zurich museum; Gordon and Forge date it at the period 1916-26, as if it were one of the panels for the Orangerie; other art historians have dated it at 1915. The almost insoluble problem of dating these works is due to the fact that, in his final creative period, Monet hardly ever bothered to put the date on the canvases (something he had almost always done in previous periods); furthermore, the water lily paintings are similar, stylistically more homogeneous and more constantly rendered over the years than other cycles or phases of his production.

Opposite below: Water Lilies, 1915, Giverny, 1915; oil on canvas; 149 × 200 cm (58 × 78 in); signed; Musée Marmottan, Paris.

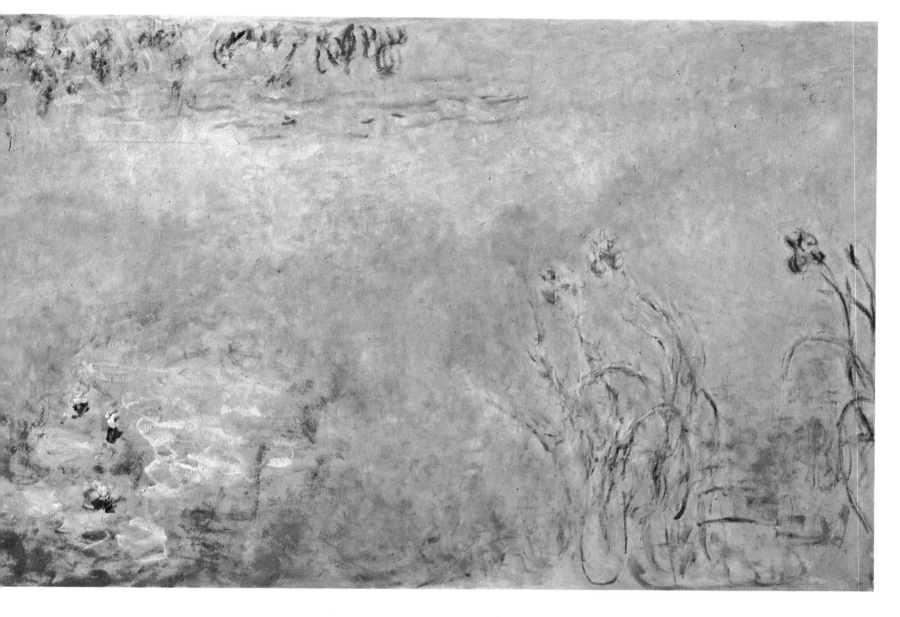

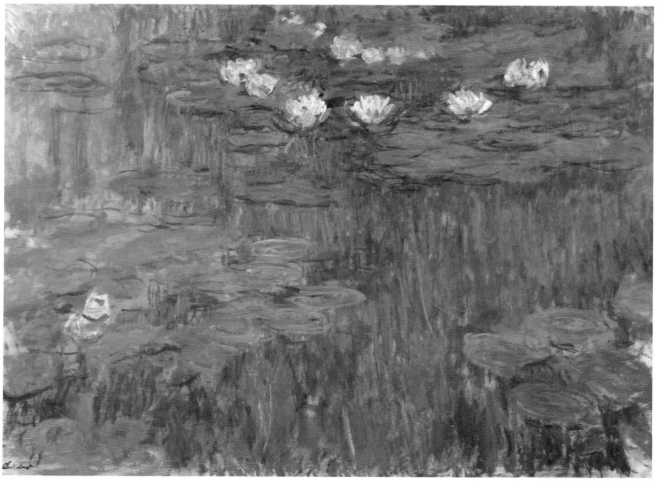

256

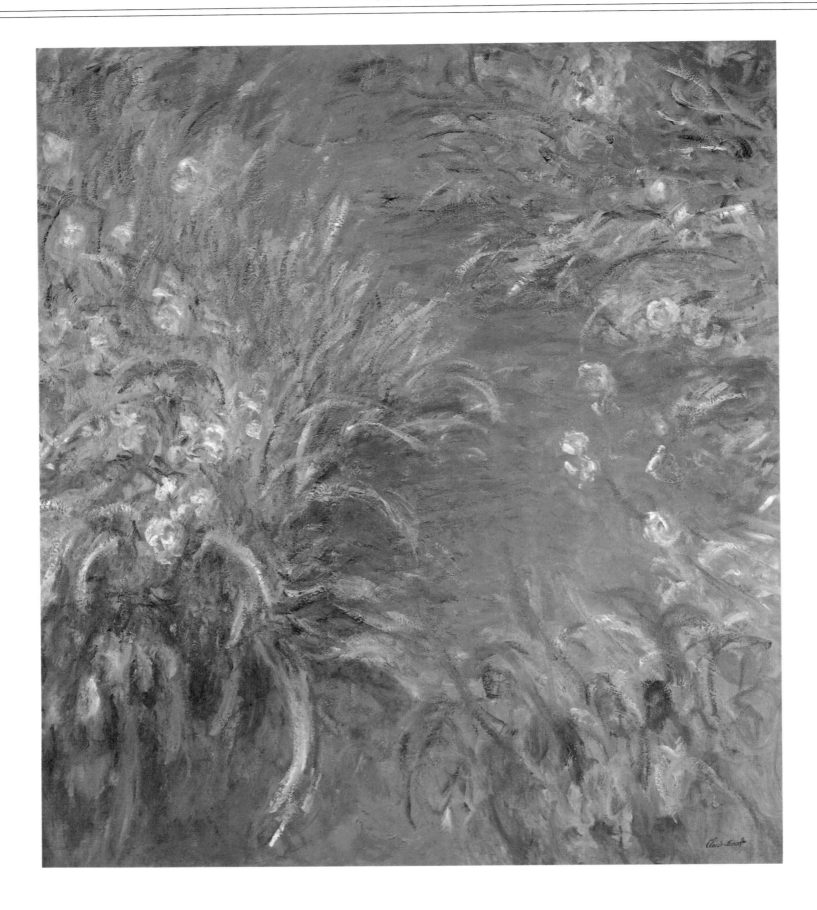

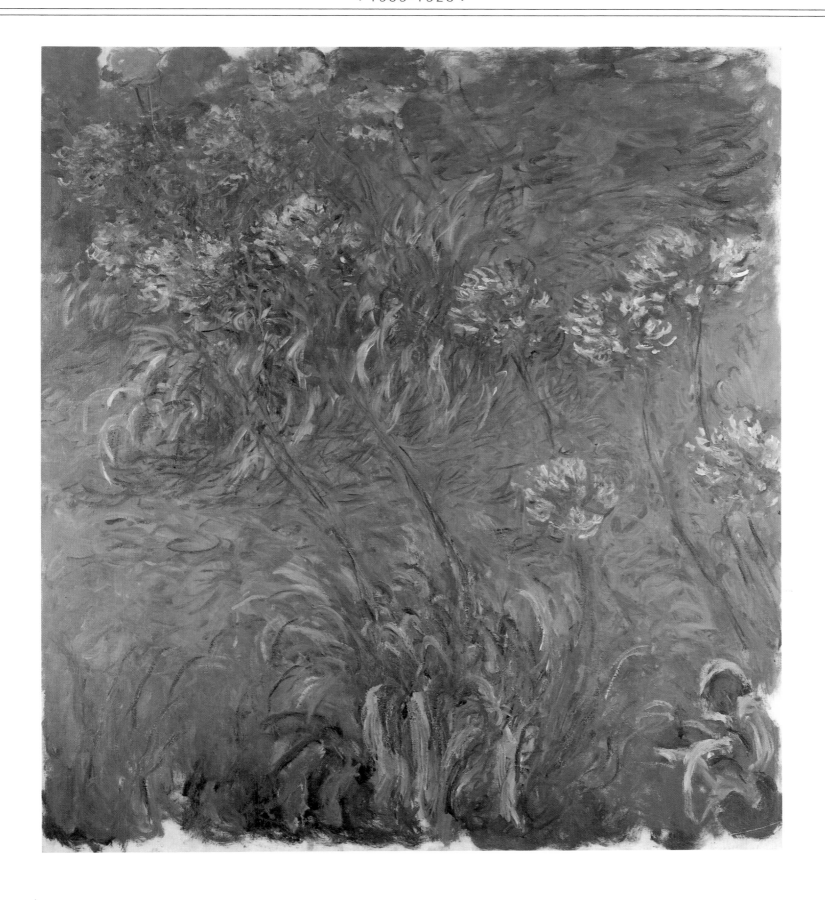

Opposite: The Path
through the Irises,
Giverny, 1916-17;
oil on canvas;
200 × 180 cm
(58 × 70 in);
signed; Private
Collection.

Above:
Agapanthus,
Giverny, 1916-17;
oil on canvas;
200 × 180 cm
(58 × 70 in);
Private Collection.

258

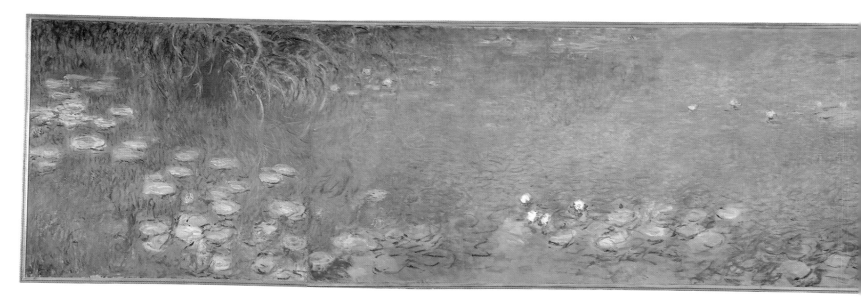

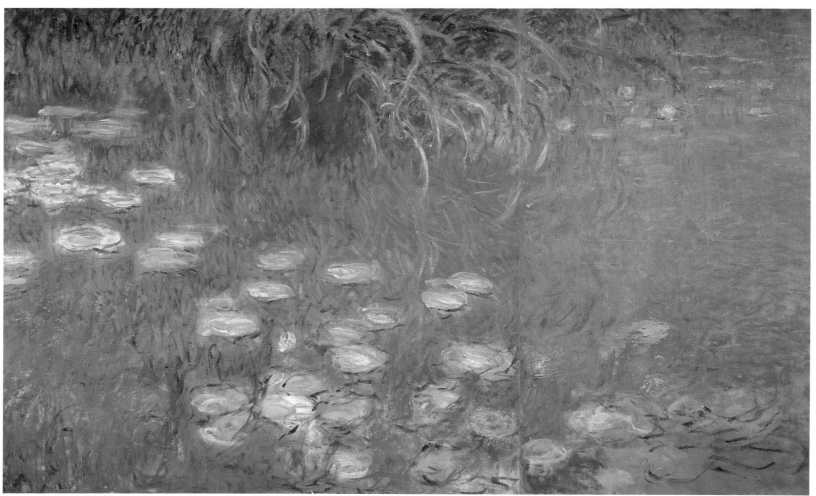

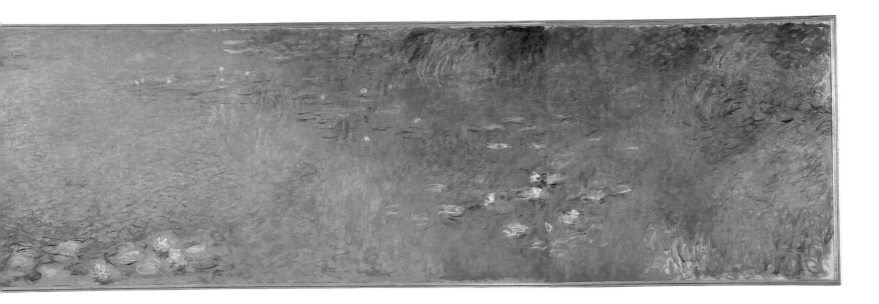

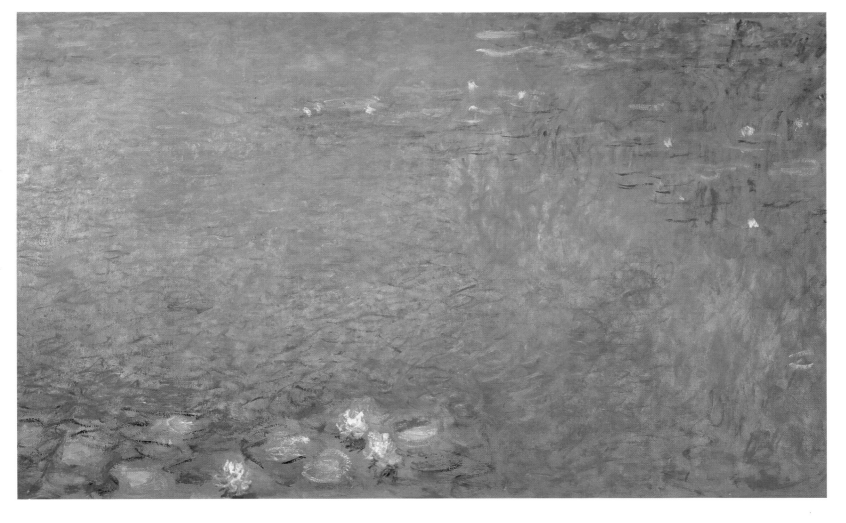

Top: Morning *(details opposite below and above), Giverny-Paris, 1914-26; oil on panel; quadriptych: 200 × 200 cm (58 × 58 in), 200 × 425 cm (58 × 165¼ in), 200 × 425 cm (58 × 165¼ in), 200 × 200 cm (58 × 58 in);* *Musée de l'Orangerie, Paris. It is difficult to furnish reliable dates for this work. We know that Monet had most of the Orangerie panels in his studio already in 1918; but we also know that he worked on them for years, up to the time of his death.*

260

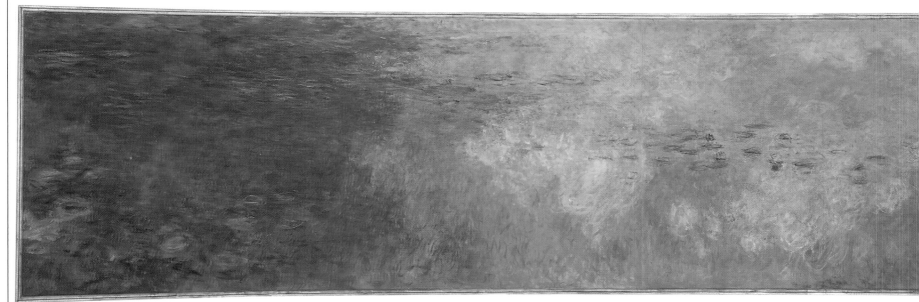

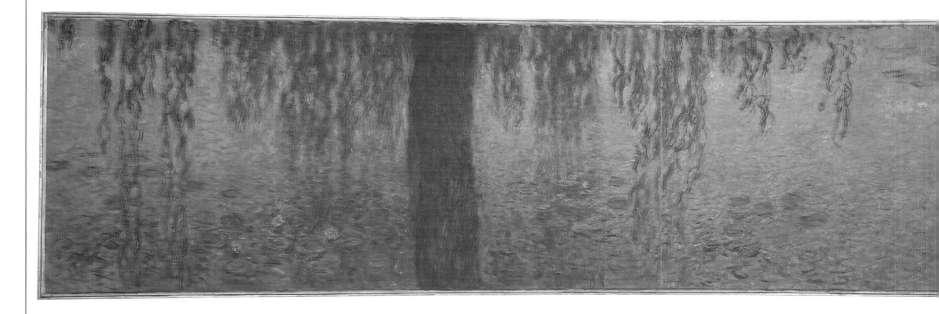

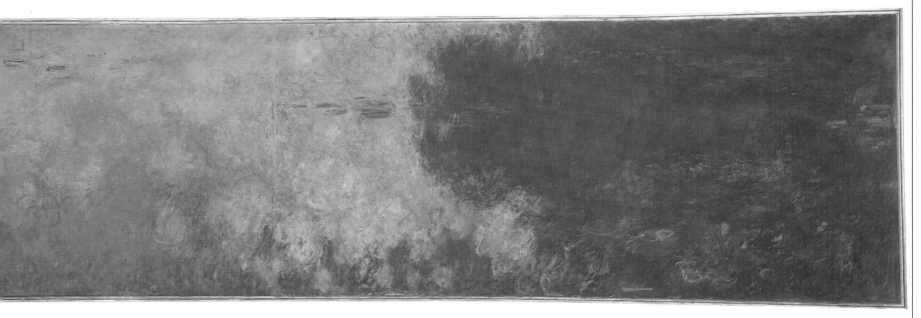

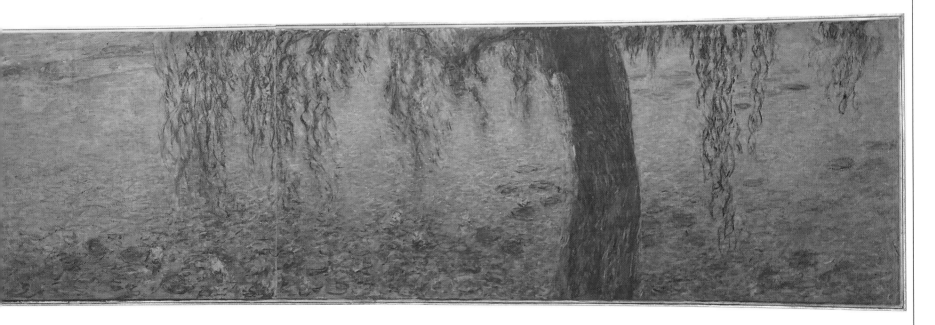

Above: Clouds, *Giverny-Paris, 1914-26; oil on panel, triptych: each section 200 × 425 cm (58 × 165¼ in); Musée de l'Orangerie, Paris.*

Below: Morning with Weeping Willows, *Giverny-Paris, 1914-26; oil on panel; triptych: each section 200 × 425 cm (58 × 165¼ in); Musée de l'Orangerie, Paris.*

262

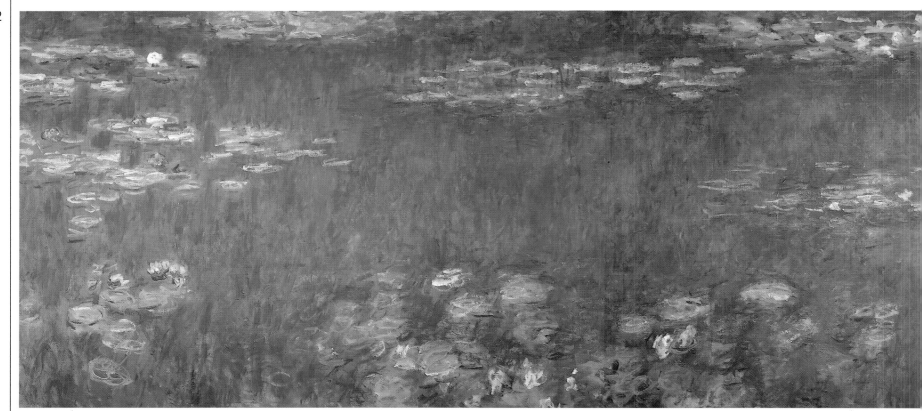

Green Reflections (detail on opposite page below), Giverny-Paris, 1914-26; oil on panel; diptych: each section 200 × 425 cm (58 × 165¼ in); Musée de l'Orangerie, Paris. Monet had to produce these Orangerie panels in sections (diptychs, triptychs and quadriptychs) in order to adapt them to the curved walls of the pavilion. The restructuring of the Orangerie and the placement of the panels were done under Monet's supervision.

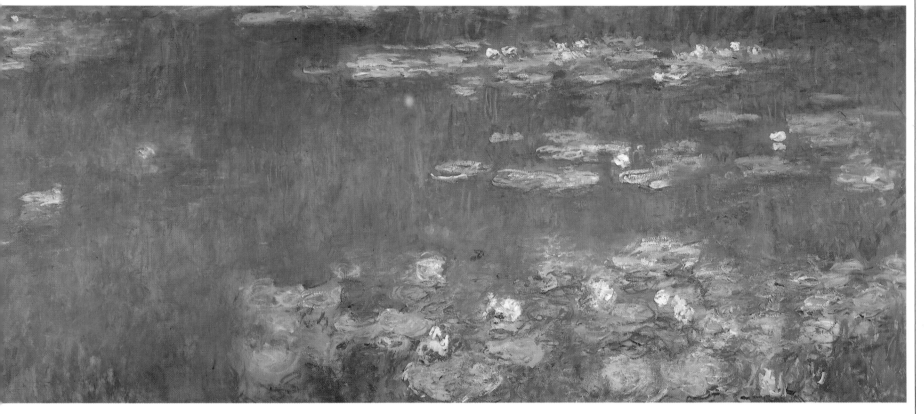

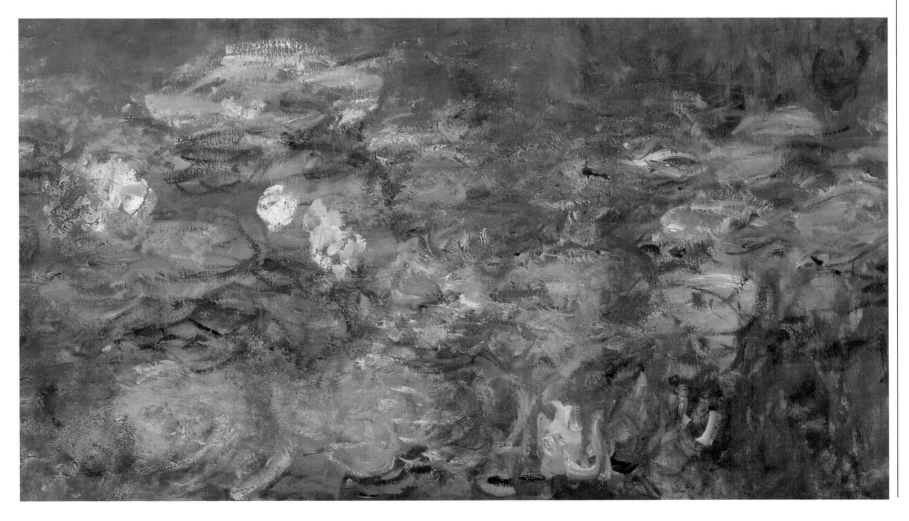

264

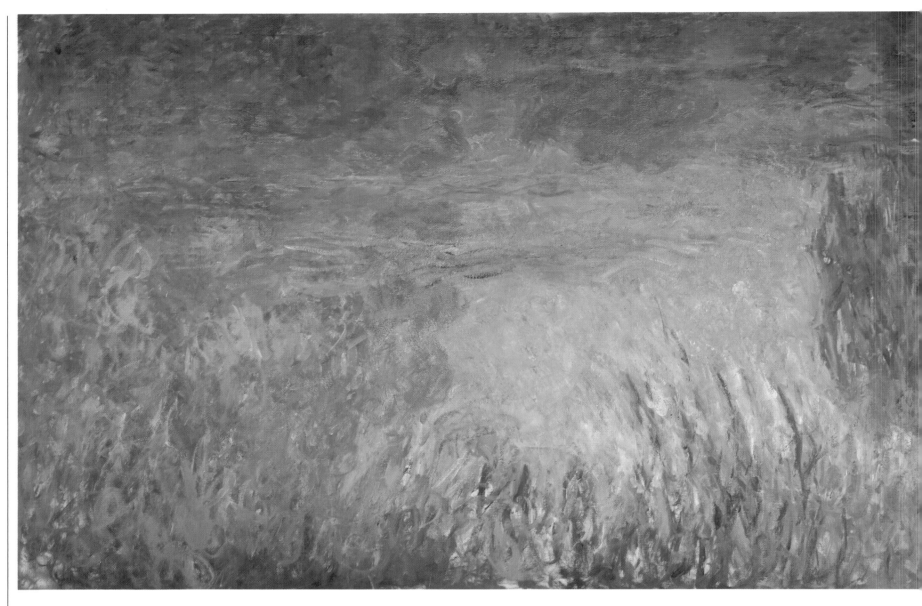

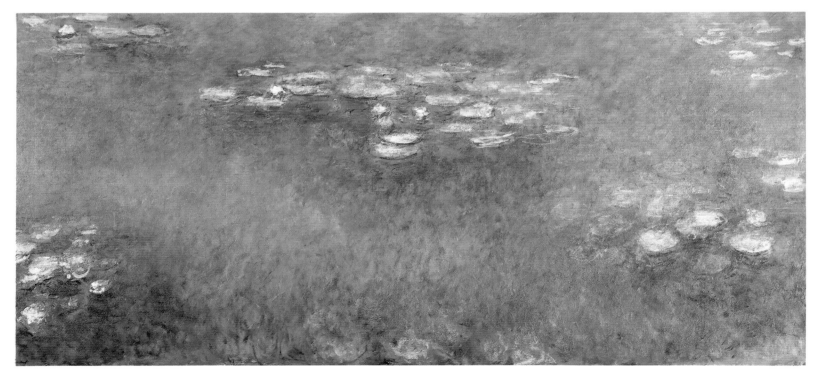

Top: Sunset,
Giverny-Paris,
1914-26; oil on
panel; diptych: each
section 200 × 425
cm (58 × 165¼ in);
Musée de
l'Orangerie, Paris.

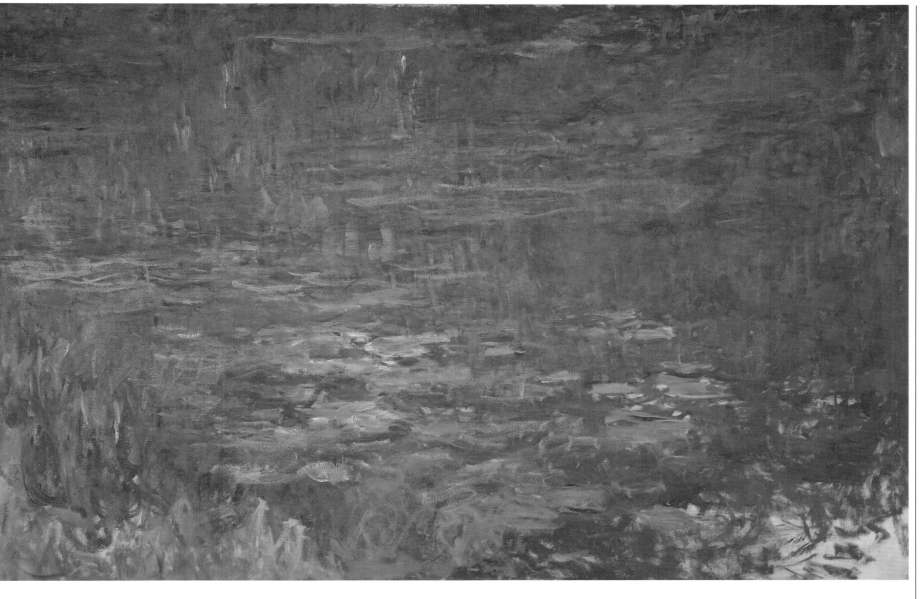

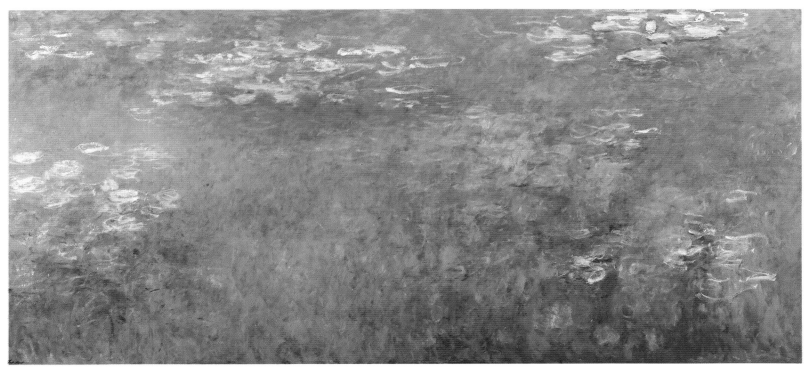

Opposite below and above: two panels from Water Lilies *(formerly Agapanthus),* *Giverny-Paris, 1914-26; oil on panel; triptych: each section 200 × 425 cm* *(58 × 165¾ in); Art Museum, Saint Louis (page 264) and Nelson-Atkins Museum, Kansas* *City (page 265). The third panel is kept in the Cleveland Museum of Art.*

266

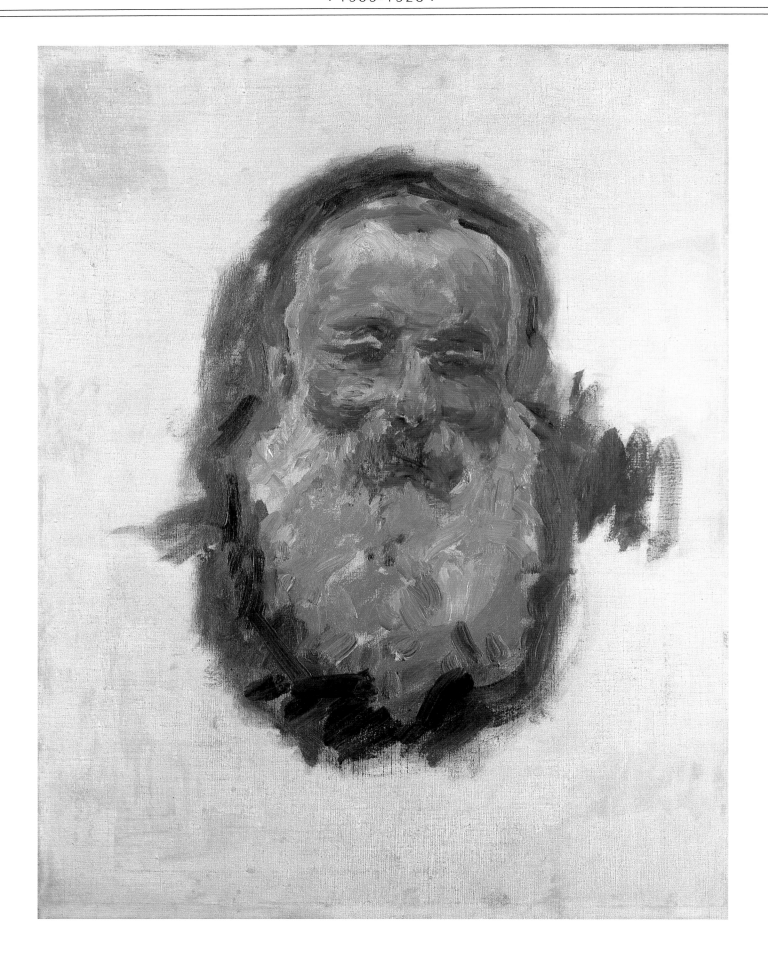

Above:
Self-portrait,
*Giverny, 1917; oil
on canvas; 70 × 55
cm (27 × 21¼ in);
Musée d'Orsay,
Paris.*

Opposite: The
Artist's Garden at
Giverny, *Giverny,
1917; oil on canvas;
Musée des
Beaux-Arts,
Grenoble.*

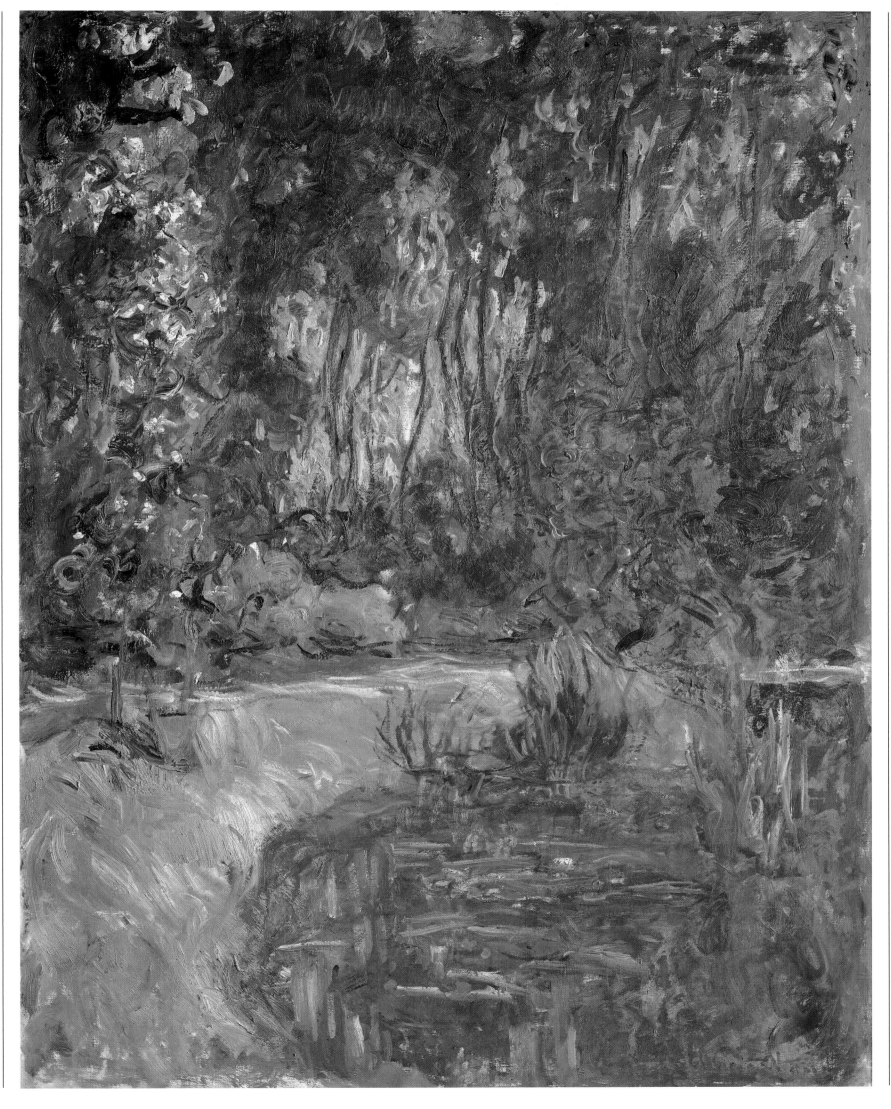

268

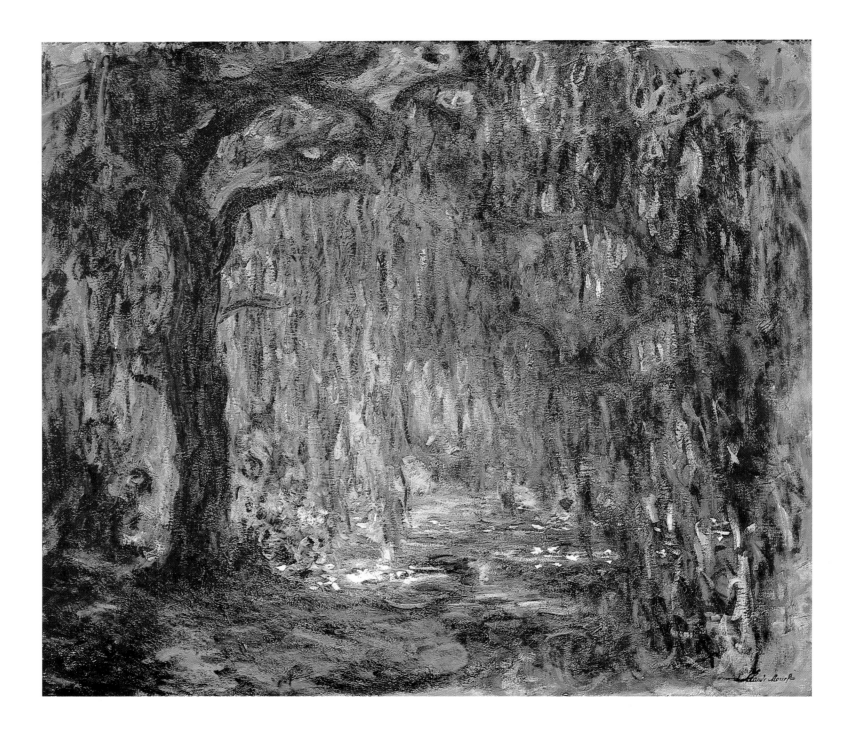

Above: Weeping Willow, *Giverny, 1918; oil on canvas; 127.5 × 152.5 cm (49¾ × 59¾ in); signed; Private Collection.*

Opposite: Landscape, Weeping Willow, Giverny, 1918; oil on canvas; 130 × 110 cm (50¾ × 42¾ in); signed and dated; Private Collection.

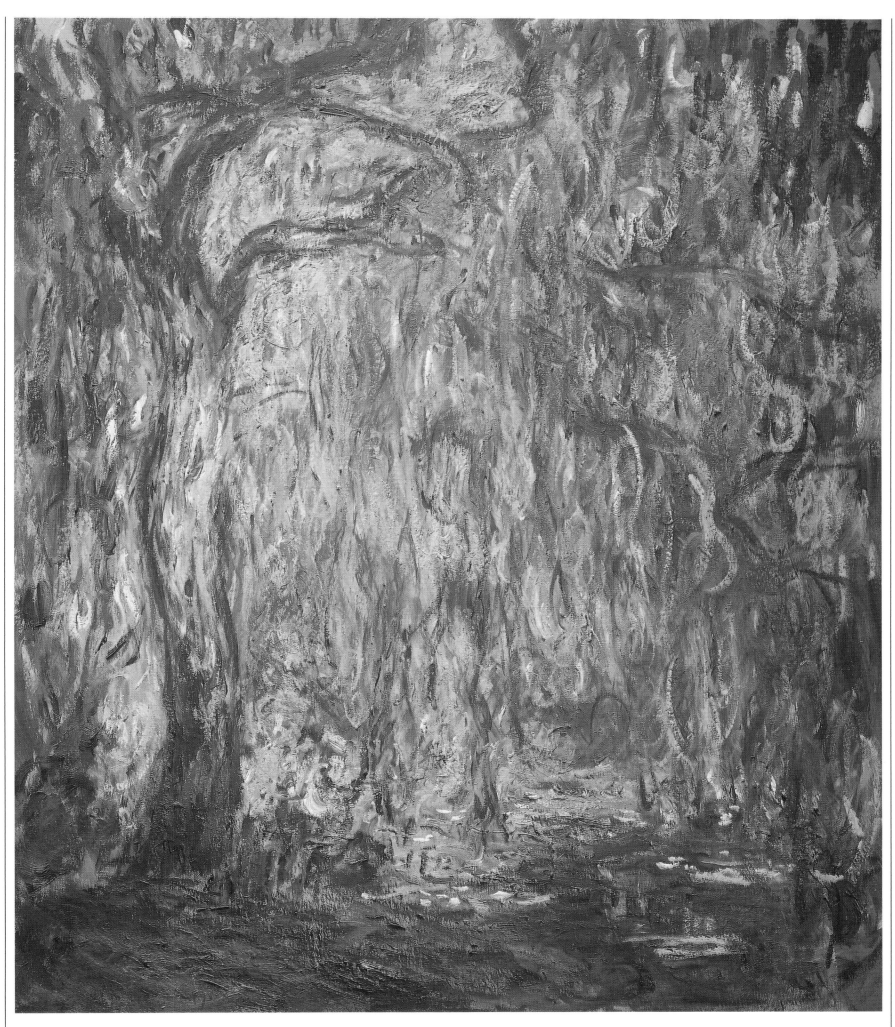

270

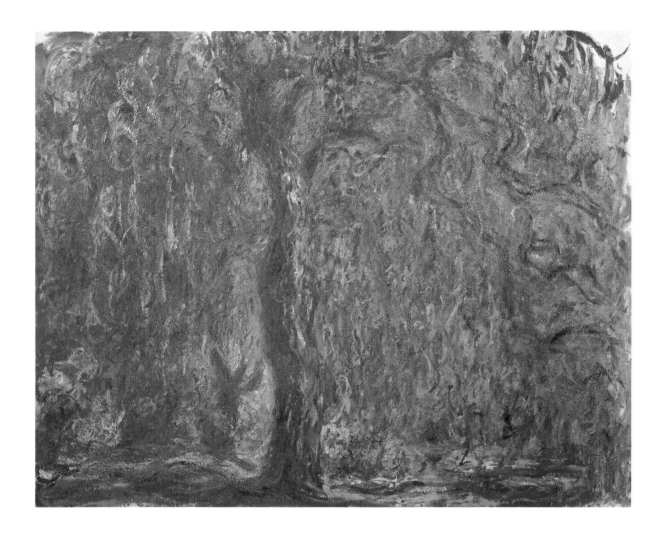

Weeping Willow,
Giverny, 1919;
oil on canvas;
100 × 120 cm
(39 × 46¼ in);
Musée Marmottan,
Paris.

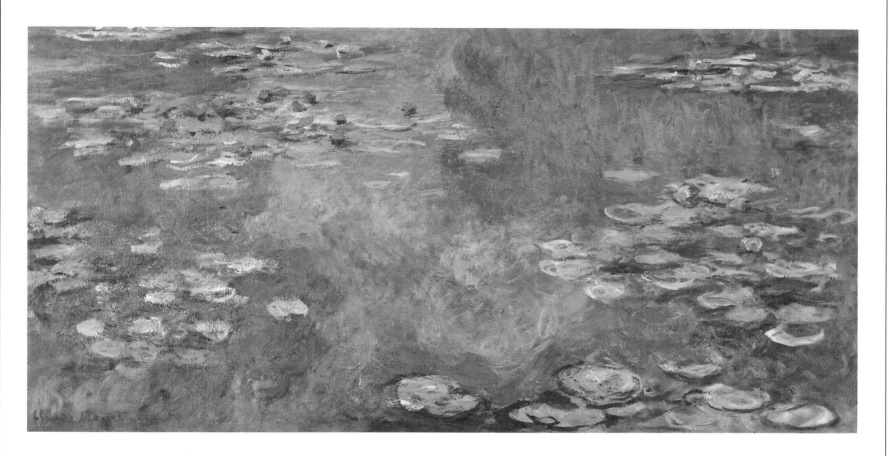

Water Lily Pond,
Giverny, *Giverny,*
spring-summer
1919; oil on canvas;
100 × 200 cm
(39 × 78 in); signed
and dated; Private
Collection.

272

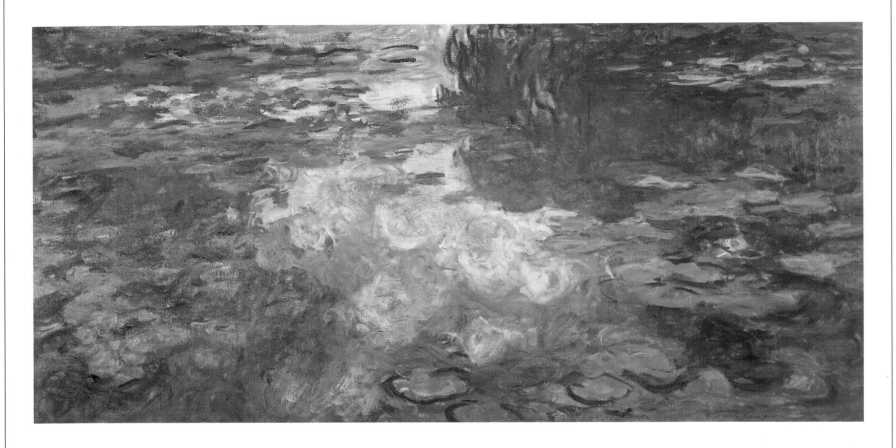

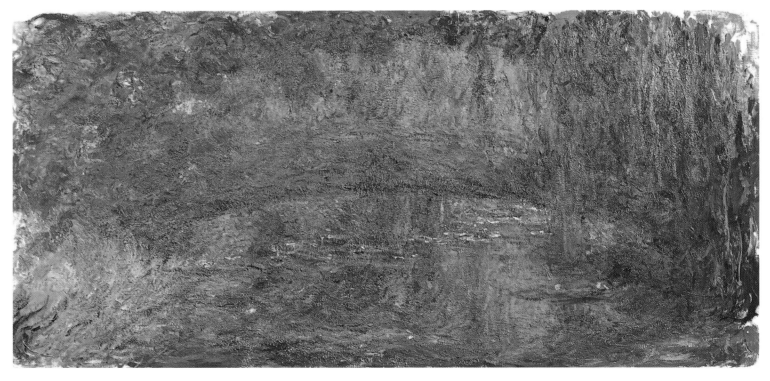

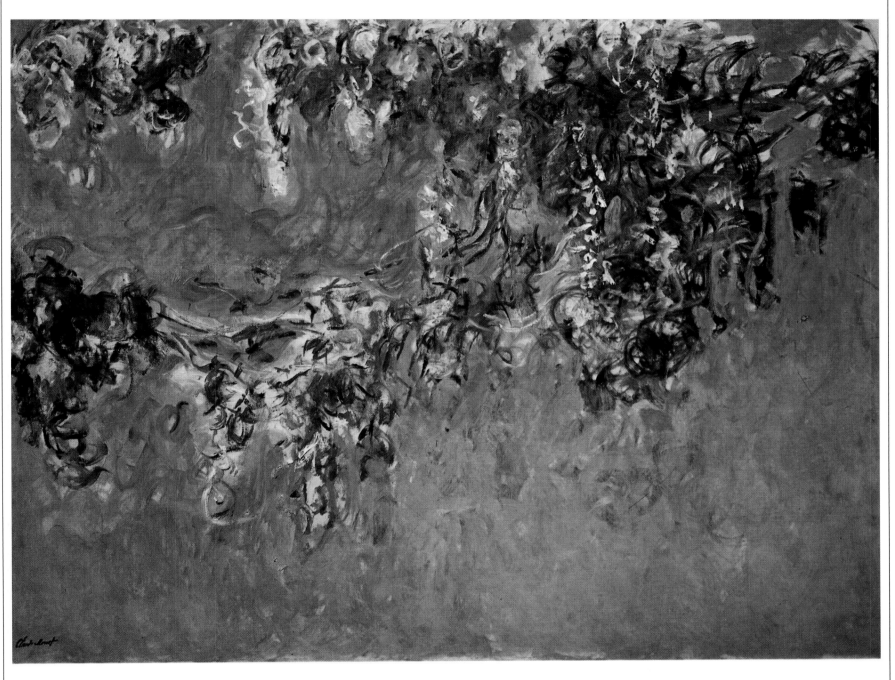

Opposite above:
Water Lilies,
*spring-summer
1919; oil on canvas;
100 × 200 cm
(39 × 78 in);
signed; Private
Collection.*

Opposite below:
The Japanese
Bridge, *Giverny,
spring 1919; oil on
canvas; 100 × 200
cm (39 × 78 in);
Musée Marmottan,
Paris.*

Above: Wisteria,
*Giverny, 1918-20;
oil on canvas;
148 × 197 cm
(57¼ × 76¼ in);
signed; Allen
Memorial Art
Museum, Oberlin.*

274

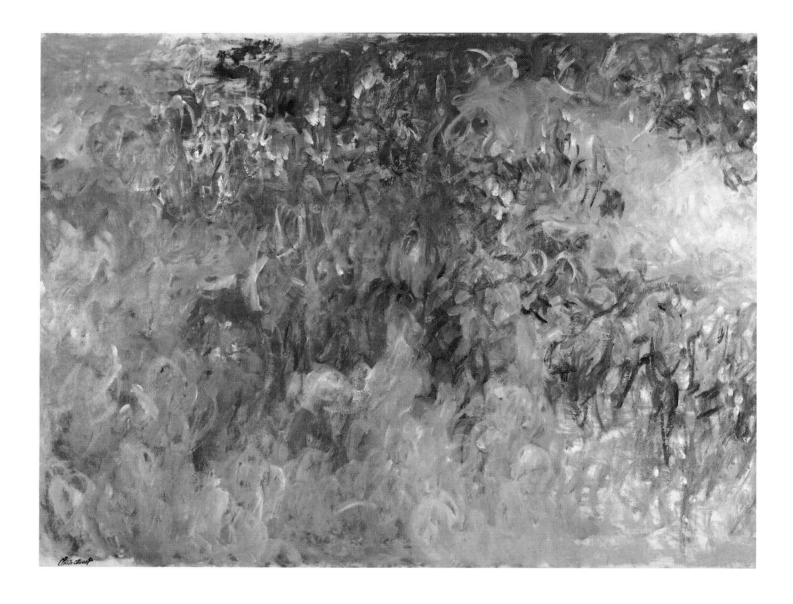

Wisteria, *Giverny,*
1918-20; oil on
canvas; 150 × 200
cm (58½ × 78 in);
signed; Private
Collection. This is
one part of a
diptych, the other
panel of which is on
page 275.

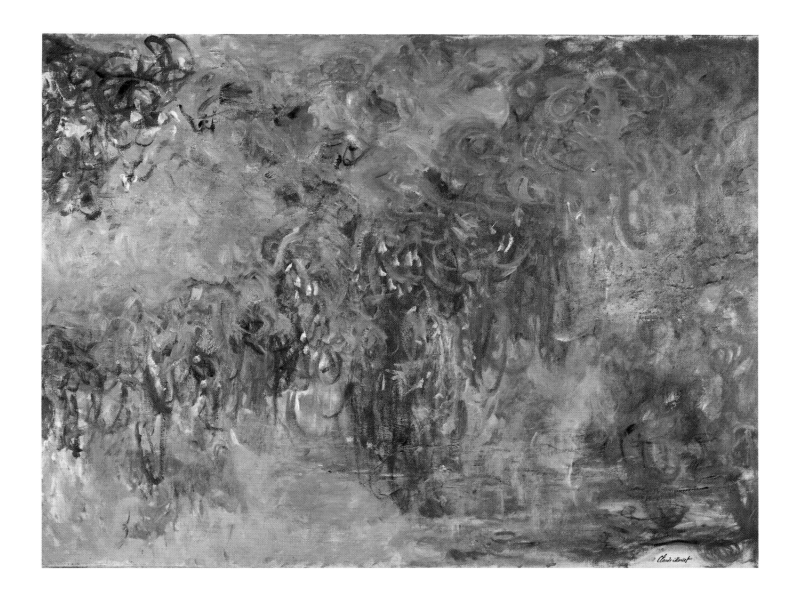

Wisteria, *Giverny, 1918-20; oil on canvas; 150 × 200 cm (58½ × 78 in); signed; Private Collection. This is* *the second panel of the* Wisteria *diptych; the first one is reproduced on page 274.*

276

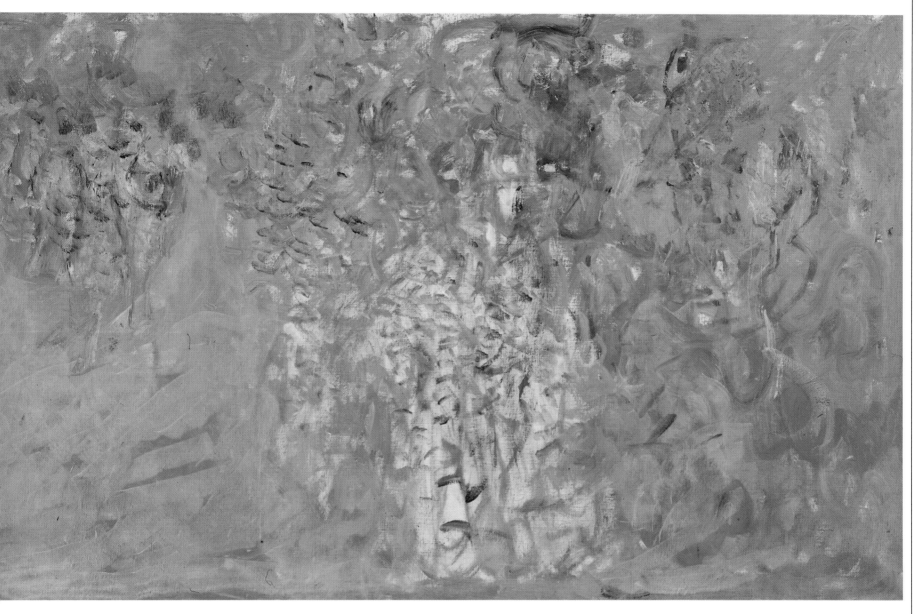

Wisteria, *Giverny,*
1918-20; oil on
canvas; Musée
Marmottan, Paris.
The charm of the
Giverny garden
paintings lies in
Monet's
transposing on to
themes such as
wisteria, willows,
and rose trellises,
the technical and
stylistic
achievements of his
water lily pond
paintings.

278

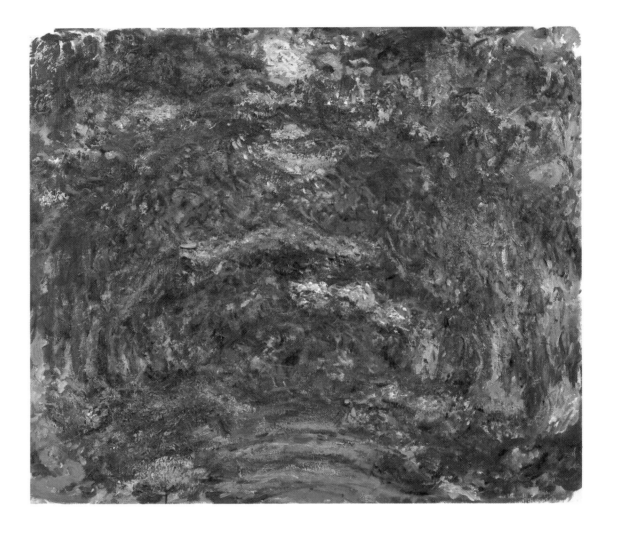

The Path with Rose
Trellises, Giverny,
Giverny, 1920-22;
oil on canvas;

89 × 100 cm
(34¾ × 39 in);
Musée Marmottan,
Paris.

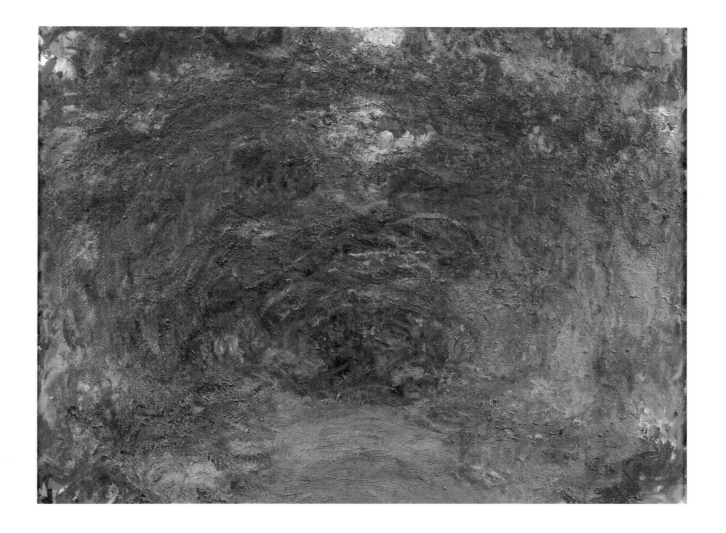

The Path with Rose
Trellises, Giverny,
Giverny, 1920-22;
oil on canvas;
81 × 100 cm
(31½ × 39 in);
Musée Marmottan,
Paris.

280

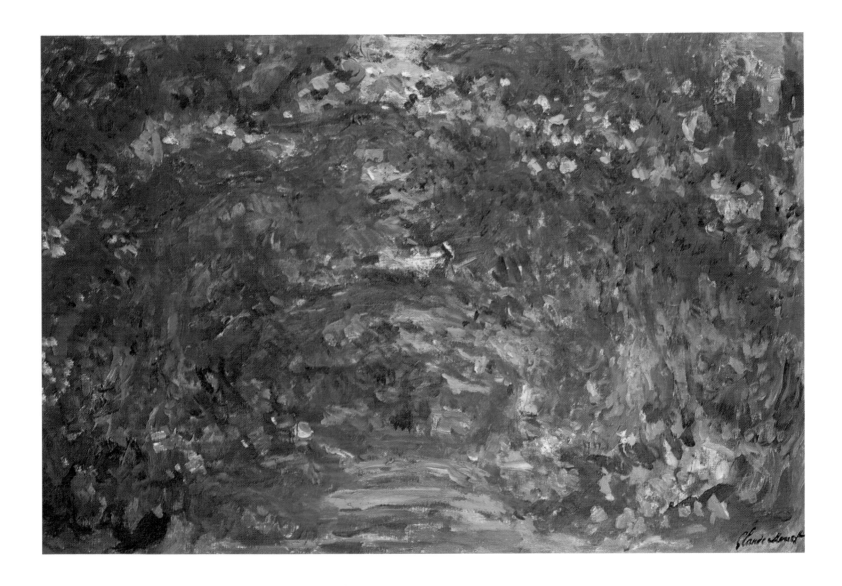

The Path with Rose *73 × 107 cm*
Trellises, Giverny, *(28¼ × 41⅞ in);*
Giverny, 1920-22; *Private Collection.*
oil on canvas;

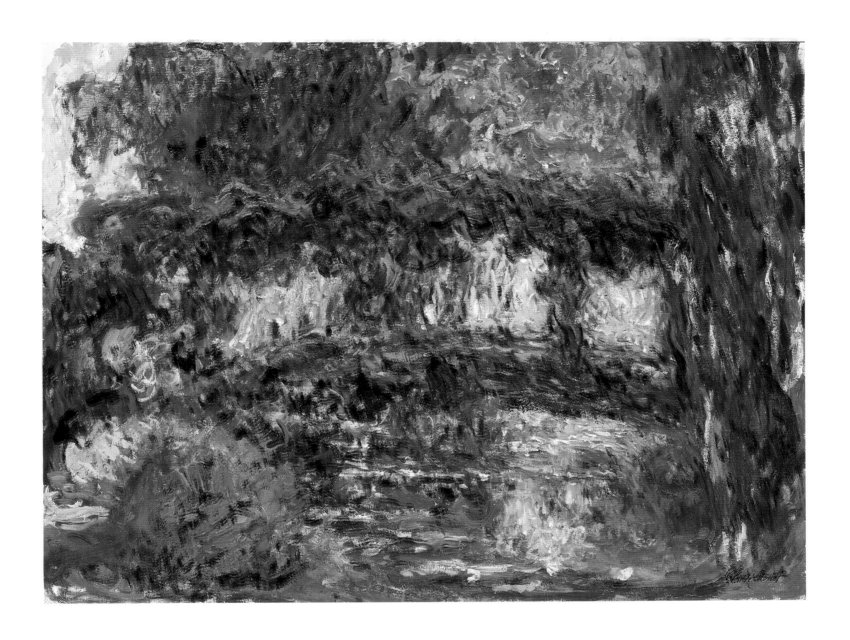

Japanese Bridge at
Giverny (*or* Water
Lilies, the Japanese
Bridge*), Giverny,
1923-25;*

*oil on canvas;
89 × 116 cm
(34¾ × 45 in);
signed; Institute of
Art, Minneapolis.*

282

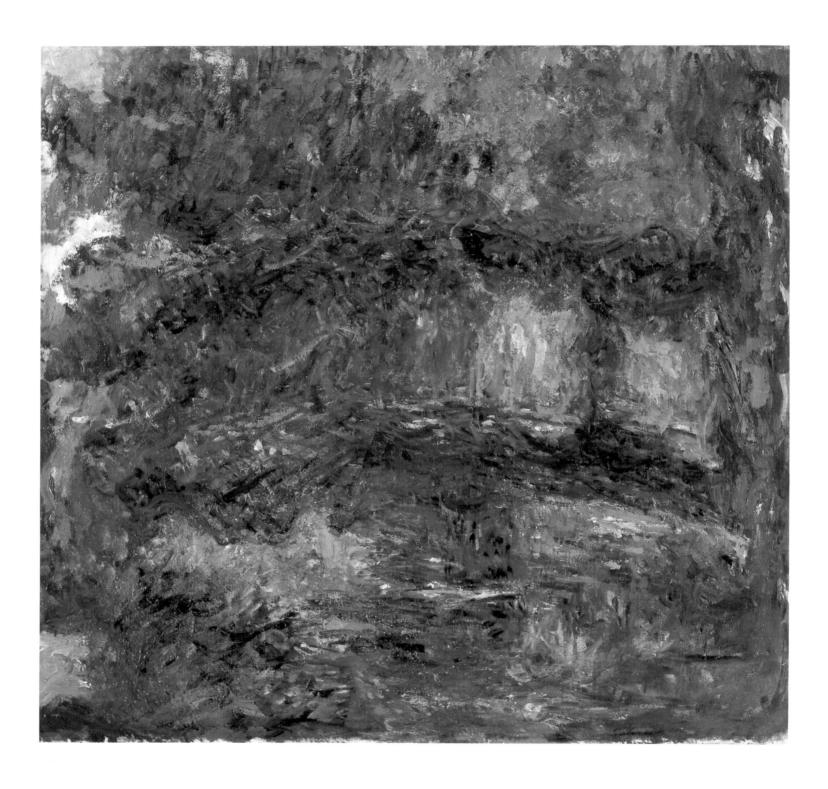

Above: The
Japanese Bridge at
Giverny, *Giverny,
1923-25; oil on
canvas; 89 × 93 cm
(34¼ × 36 in);
Museum of Fine
Arts, Houston.*

Opposite: The
Japanese Bridge at
Giverny, *Giverny,
1923-25; oil on
canvas; Museu de
Arte, São Paolo.*

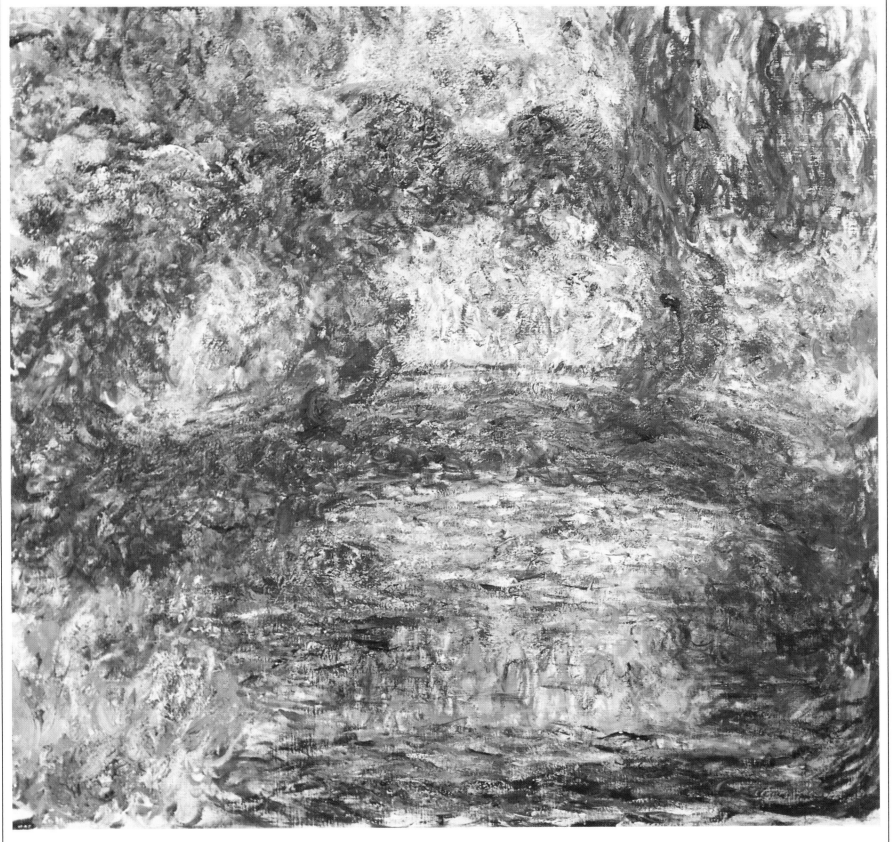

BIBLIOGRAPHY

284

F. ARCANGELI, *Dal romanticismo all'informale*, vol. I, Einaudi, Turin, 1977

F. ARCANGELI, *Monet*, Nuova Alfa, Bologna, 1989 (1962 lectures)

R. BARTHES, *Criticism and Truth*, Athlone Press, London, 1987

C. BAUDELAIRE, *The Mirror of Art. Critical Studies by Baudelaire*, Doubleday & Co.,
New York, 1956

C. BAUDELAIRE, *Oeuvres complètes*, vol. II, Bibliothèque de la Pléiade, Gallimard, Paris,
1975-76

C. BAUDELAIRE, *Selected Writings on Art and Artists*, Cambridge University Press,
Cambridge, 1981

W. BENJAMIN, *Das Passegen-Werk*, Suhrkamp Verlag, Frankfurt am Main, 1982

M. BUTOR, *Claude Monet ou le monde renversé*, in "Art de France" III, Paris, 1963

O. CALABRESI, *Il linguaggio dell'arte*, Bompiani, Milan, 1985

G. CLEMENCEAU, *Claude Monet. Les Nymphéas*, Libraire Plan, Paris, 1928

M. DE FELS, *La vie de Claude Monet*, Libraire Gallimard, Paris, 1925

M. DE MICHELI, *Le avanguardie artistiche del Novecento*, Feltrinelli, Milan, 1966

P. FRANCASTEL, *Lo spazio figurativo dal Rinascimento al Cubismo*, Einaudi, Turin, 1957

G. GEFFROY, *Claude Monet. Sa vie, son temps, son oeuvre*, 2 vols., Crès, Paris, 1922
(revised edition 1924)

E. & J. GONCOURT, *Journal des Goncourt*, Robert Laffont, Paris, 1989

R. GORDON & A. FORGE, *Monet*, Abrams, New York, 1984

R. L. HERBERT, *Impressionism. Art, Leisure, and Parisian Society*, Yale University Press,
New Haven-London, 1988

J. P. HOSCHEDÉ, *Claude Monet ce mal connu*, Pierre Cailler, Geneva, 1960

J. HOUSE, *Monet*, Phaidon, Oxford, 1977, 1981

J. HOUSE, *Monet. Nature into Art*, Yale University Press, New Haven-London, 1986

J. ISAACSON, *Claude Monet. Observation and Reflection*, Phaidon, Oxford, 1978

S. Z. LEVINE, *Monet and His Critics*, Garland Publishing, New York, 1976

J. LEYMARIE, *Impressionisme*, Skira, Geneva, 1959

M. MERLEAU-PONTY, *L'oeil et l'esprit*, Gallimard, Paris, 1964

O. MIRBEAU, *Claude Monet: Vues de la Tamise à Londre (1902-1904)*, Galleries
Durand-Ruel, Paris, 1904

O. MIRBEAU, *Les "Venise" de Claude Monet*, Bernheim-Jeune et Cie, Paris, 1912

C. L. RAGGHIANTI, *L'impressionismo*, Einaudi, Turin, 1944

J. REWALD, *The History of Impressionism*, Museum of Modern Art, New York, 4th
revised edition, 1973

J. REWALD, *Post-Impressionism – from van Gogh to Gauguin*, Museum of Modern Art,
New York, 3rd revised edition, 1978

L. ROSSI BARTOLATTO, *Monet 1870-1889*, I classici dell'arte, Rizzoli, Milan, 1972

G. SEIBERLING, *Monet's Series*, Garland Publishing, New York, 1981

W. C. SEITZ, *Claude Monet – Season and Moments*, exhibition catalogue, Museum of
Modern Art, New York and Los Angeles County Museum, 1960

W. C. SEITZ, *Claude Monet*, Abrams, New York, 1960

T. SISSON, *Claude Monet, les années des épreuves*, in "Le Temps", April 1990

S. SPROCCATI, *Matisse. Espressione e decorazione*, in "Rivista di Estetica", n. 3, 1979

S. SPROCCATI, *Malevic: il corpo della pittura*, in "Rivista di Estetica", n. 10, 1982

E. TABOUREUX, *Claude Monet*, in "La vie moderne", June 1880

P. H. TUCKER, *Monet in the '90s. The Series Paintings*, exhibition catalogue, Museum of
Fine Arts, Boston, 1989

L. VENTURI, *Les Archives de l'Impressionisme*, Durand-Ruel, Paris-New York, 2 vols.,
1939

L. VENTURI, *La via dell'impressionismo. Da Monet a Cézanne*, Einaudi, Turin, 1971
(original edition 1939)

H. L. & C. A. WHITE, *Canvases and Careers: Institutional Change in the French Painting
World*, Johan Wiley & Sons, New York, 1965

D. WILDENSTEIN, *Monet, vie et oeuvre – Biographie et catalogue raisonée*, La
Bibliothèque des Arts, Lausanne-Paris, 4 vols.: 1974, 1979, 1979, 1985

J. WITTGENSTEIN, *Remarks on Colour*, Blackwell, Oxford, 1978

INDEX

Picture Sources

Archivio Fabbri, Milan: 160, 161, 165, 243, 249, 254-5, 269.
Artephot/Bridgeman, Paris: 42a, 81, 83, 87. Artephot/Faillet, Paris: 167,
260-1a, 260-1b. Artephot/Held, Paris: 46-7, 57, 58, 94-5, 138, 139.
Artephot/Routhier, Paris: 276-7. Centro Documentazione Mondadori, Milan:
27b, 31c, 49d, 98b, 194. Fratelli Alinari/Giraudon: 48, 50b, 55, 102, 122,
131a, 145, 152, 166, 258-9, 262-3, 264-5a, 283. Haags Gemeentemuseum, The
Hague: 54. Hubert Josse, Paris: 194-5. Kunsthaus, Zurich: 44. Scala,
Florence: 50a, 66-7, 96, 105, 128, 267.